COLLINS
COMPLETE GUIDE TO
BRITISH
WILD FLOWERS

Paul Sterry

HarperCollins Publishers Ltd.
77-85 Fulham Palace Road
London W6 8JB

www.collins.co.uk

Collins is a registered trademark of HarperCollinsPublishers Ltd.

First published in 2006

14 13 12
10 9 8 7 6 5

A catalogue record for this book is available from the British Library.

ISBN: 978-0-00-723684-8

Collins uses papers that are natural, renewable and recyclable products made from
wood grown in sustainable forests. The manufacturing processes conform to the
environmental regulations of the country of origin.

Colour reproduction by Nature Photographers Ltd.
Edited and designed by D & N Publishing, Hungerford, Berkshire
Printed and bound in China by South China Printing Co. Ltd.

CONTENTS

INTRODUCTION

PEOPLE LIVING IN BRITAIN and Ireland seldom have to travel far to find a wealth of wild flowers and, although the region's plantlife faces significant conservation issues, residents should feel privileged to live in such a flower-rich part of the world. Underpinning our floral diversity is a rich array of habitats, the product of our region's topography, geology and history of land use. Good fortune, in the form of the Gulf Stream, dictates a mild and comparatively equable climate for much of the time, and this, too, contributes to botanical diversity. *Complete British Wild Flowers* has arisen from my personal love for the flora of Britain and Ireland, not to mention half a lifetime devoted to photographing our wild flowers.

THE REGION COVERED BY THIS BOOK

The region covered by this book comprises the whole of mainland England, Wales, Scotland and Ireland, as well as offshore islands including the Shetlands, Orkneys, Hebrides, Isle of Man and the Isles of Scilly. In addition, I have included the Channel Islands because their proximity to, and ecological affinities with, northern France allow them to make a valuable contribution to our flora.

THE CHOICE OF SPECIES

The coverage of the book is restricted mainly to what most people understand to be wild flowers – not a strict botanical term, but taken to mean flowering plants of relatively modest stature, species that in most cases do not exceed 2m in height. For the sake of completeness I have also included a number of woody flowering shrubs, but I have excluded obvious tree species. Terrestrial habitats harbour the lion's share of our flowering plants and this is reflected in the coverage of this book. But I have also included species that are strictly aquatic, both those that occur in freshwater habitats and the limited range of flowering plants that grow in coastal marine environments.

Complete British Wild Flowers is aimed primarily at the botanical novice and those with a moderate degree of botanical experience. Consequently, for the main section of the book, I have selected species that the naturalist stands a reasonable chance of encountering, although a few scarce but spectacular and distinctive species have also been included here for good measure. Some botanical groups are minefields for the beginner: for example, hundreds of so-called 'microspecies' of brambles are recognised by experts and similar complexity is found among dandelions, hawkweeds and eyebrights to name three more. In a book of this size, accurate identification of these subdivisions is impossible to achieve. So rather than baffle the reader, I have chosen to 'lump' the subdivisions together within these complex groups and treat them as species aggregates.

In the hope and expectation that readers' appetites for botanical discoveries are whetted by the book, the last section of *Complete British Wild Flowers* is devoted to botanical hotspots, areas that merit a visit in search of the localised floral treasures they harbour.

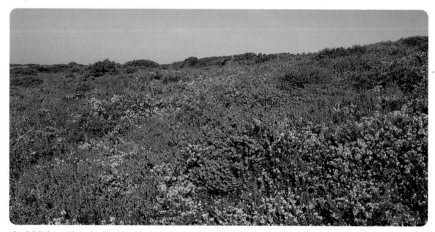

Floral delights such as this heathland have inspired generations of botanists.

HOW TO USE THIS BOOK

THE BOOK HAS BEEN designed so that the text and photographs for each species are on facing pages. A system of labelling clearly states the flower's identity. The text has been written to complement the information conveyed by the photographs. By and large, the order in which the species appear in the main section of the book roughly follows standard botanical classification. However, because parts of the field are in a state of flux, the order may differ slightly from that found in other guides, past, present or future.

SPECIES DESCRIPTIONS

At the start of each species description the plant's most commonly used and current English name is given. This is followed by the scientific name, comprising the genus name first and then by the specific name. In a few instances, where this is pertinent, reference is made, in either the species heading or the main body of the text, to a further subdivision: subspecies. In general, I have followed the nomenclature of Clive Stace's *New Flora of the British Isles* (*see* p.287). However, with orchids I have used the most up-to-date classification system, which differs from that in most currently available floras. The family group to which the plant in question belongs is then given. If a species is anything other than widespread and common, there then follows a measure of its scarcity, indicated by rosette symbols:

✿	Scarce overall, but locally common
✿✿	Scarce, local and seldom common
✿✿✿	Local and rare

These scarcity ratings are based on my own observations, so they are subjective and are not intended as an absolute guide to a species' status. Lastly in the heading, some measure is given of the plant's size. Size and stature vary according to a number of factors so these values should be treated with a degree of caution.

The text has been written in as concise a manner as possible. Each description begins with a summary of the plant and the habitat that it favours. To avoid potential ambiguities, the following headings break up the rest of each description: FLOWERS; FRUITS; LEAVES; STATUS. These sections describe the colour, shape and size of the various plant parts – features that tend to be more constant, and hence more useful for identification, than the overall size of the plant. Text in *italics* relates to key features of identification.

MAPS

The maps provide invaluable information about the distribution and occurrence of each species in the region: the intensity of the colour gives an indication of abundance. In compiling the maps, I have made reference to a number of sources, including *An Atlas of the Wild Flowers of Britain and Northern Europe*, the *New Atlas of the British and Irish Flora* (*see* p.287), various county floras and, of course, my own notes. The maps represent the current ranges of plants in the region in *general* terms. Please bear in mind that, given the size of the maps, small and isolated populations will not necessarily be featured. Note also that the ranges of many species (particularly those influenced by agriculture) are likely to contract further as the years go by.

PHOTOGRAPHS

Great care has gone into the selection of photographs for this book and in many cases the images have been taken specifically for this project. Preference has been given to photographs that serve both to illustrate key identification features of a species when in flower, and to emphasise its beauty. In many instances, smaller inset photographs illustrate useful identification features that are not shown clearly by the main image.

BASIC BOTANY

IN COMMON WITH OTHER living organisms, plants have the abilities to grow, reproduce themselves, respond to stimuli and – to a limited extent compared to most animals – move. What sets them apart from animals in particular, and defines plants as a group, is their ability, in almost all species, to manufacture their own food from inorganic building blocks. Fundamental to this ability is the process called *photosynthesis*, in which plants use energy from sunlight to convert carbon dioxide from the air and water into glucose. Oxygen is a by-product of this reaction. A pigment called *chlorophyll* is the agent that extracts from sunlight the energy needed to fuel the reaction; its coloration is what makes plants green.

The plants covered in this book are the most advanced of their kind in evolutionary terms. All have the ability to reproduce sexually and flowers are the means by which this process is achieved. Flower structure is as varied as it is complex, and the fact that whole books, including this one, can be devoted to detailing its diversity is testament to this. Flower structure is dealt with in more detail on page 10.

Among terrestrial plants the process of photosynthesis is difficult to demonstrate outside the laboratory. However, certain submerged aquatic plants, such as this Water Starwort, produce bubbles of oxygen when they are exposed to bright sunlight, indicating that photosynthesis is indeed taking place.

THE ROLE OF PLANTS IN ECOLOGY

The importance of plants in the global ecosystem, and at the local level, cannot be overstated. Not only do plants generate (through photosynthesis) the atmospheric oxygen that all animals need to breathe but, as a source of food, they underpin food chains across the world. Without plants, life on earth as we know it would not have evolved and could not survive.

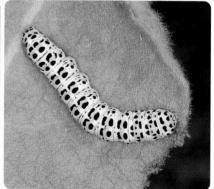

The survival of plants and animals is inextricably linked at the general level, but there are plenty of highly specific instances of dependence, the relationship often hinted at by their English names. Without their namesake-specific foodplants, neither the Figwort Weevil (*left*) nor the Mullein Moth (*right*), shown here as a caterpillar, could survive.

GLOSSARY

Achene – one-seeded dry fruit that does not split.

Acute – sharply pointed.

Alien – introduced by man from another part of the world.

Alternate – not opposite.

Annual – plant that completes its life cycle within 12 months.

Anther – pollen-bearing tip of the stamen.

Appressed (sometimes written as **adpressed** in other books) – pressed closely to the relevant part of the plant.

Auricle – pair of lobes at the base of a leaf.

Awn – stiff, bristle-like projection, seen mainly in grass flowers.

Axil – angle between the upper surface or stalk of a leaf and the stem on which it is carried.

Basal – appearing at the base of plant, at ground level.

Basic – soil that is rich in alkaline (mainly calcium) salts.

Beak – elongate projection at the tip of a fruit.

Berry – fleshy, soft-coated fruit containing several seeds.

Biennial – plant that takes two years to complete its life cycle.

Bog – wetland on acid soil.

Bract – modified, often scale-like, leaf found at the base of flower stalks in some species.

Bracteole – modified, often scale-like, leaf found at the base of individual flowers in some species.

Bulb – swollen underground structure containing the origins of the following year's leaves and buds.

Bulbil – small, bulb-like structure, produced asexually by some plants and capable of growing into a new plant.

Calcareous – containing calcium, the source typically being chalk or limestone.

Calyx – outer part of a flower, comprising the sepals.

Achene Acute

Appressed hairs

Axil

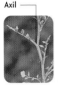

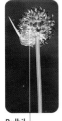

Berry

Bract

Bracteole

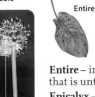

Bulbil

Capsule

Catkin

Cladode

Clasping

Composite

Compound leaf

Cordate

Dentate

Disc floret

Entire

Capsule – dry fruit that splits to liberate its seeds.

Catkin – hanging spike of tiny flowers.

Chlorophyll – green pigment, present in plant leaves and other structures, and essential in the process of photosynthesis.

Cladode – green, leaf-like shoot.

Clasping – referring to leaf bases that have backward-pointing lobes that wrap around the stem.

Composite – member of the daisy family (Asteraceae).

Compound – leaf that is divided into a number of leaflets.

Cordate – heart-shaped at the base.

Corm – swollen underground stem.

Corolla – collective term for the petals.

Cultivar – plant variety created by cultivation.

Deciduous – plant whose leaves fall in autumn.

Decurrent – with the leaf base running down the stem.

Dentate – toothed.

Digitate – resembling the fingers of a splayed hand.

Dioecious – having male and female flowers on separate plants.

Disc floret – one of the inner florets of a composite flower.

Drupe – succulent fruit, the seed inside having a hard coat.

Emergent – a plant growing with its base and roots in water, the rest of the plant emerging above water level.

Entire – in the context of a leaf, a margin that is untoothed.

Epicalyx – calyx-like structure, usually surrounding, and appressed, to the calyx.

Epiphyte – plant that grows on another plant, on which it is not a parasite.

Fen – wetland habitat on alkaline peat.

Filament – stalk part of a stamen.

Flexuous – wavy.

Floret – small flower, part of larger floral arrangement as in composite flowers or umbellifers.

Fruits – seeds of a plant and their associated structures.

Genus (plural **Genera**) – group of closely related species, sharing the same genus name.

Glabrous – lacking hairs.

Gland – sticky structure at the end of a hair.

Glaucous – blue-grey in colour.

Globose – spherical or globular.

Glume – pair of chaff-like scales at the base of a grass spikelet.

Hybrid – plant derived from the cross-fertilisation of two different species.

Inflorescence – the flowering structure in its entirety, including bracts.

Introduced – not native to the region.

Keel – seen in pea family members; the fused two lower petals that are shaped like a boat's keel.

Keel

Lanceolate – narrow and lance-shaped.

Latex – milky fluid.

Lax – open, not dense.

Leaflet – leaf-like segment or lobe of a leaf.

Ligule – somewhat membranous flap at the base of a grass leaf, where it joins the stem.

ABOVE: **Leaflet**
LEFT: **Lanceolate**

Linear – slender and parallel-sided.

Lip – usually the lower part of an irregular flower such as an orchid.

Linear

Lobe – division of a leaf.

Microspecies – division within a species, members of which are only subtly different from members of other microspecies.

Lip

Lobe

Midrib – central vein of a leaf.

Native – occurring naturally in the region and not known to have been introduced.

Node – point on the stem where a leaf arises.

Nut – a dry, one-seeded fruit with a hard outer case.

Nutlet – small nut.

Oblong – leaf whose sides are at least partly parallel-sided.

Midrib

Obtuse – blunt-tipped (usually in the context of a leaf).

Opposite – (usually leaves) arising in opposite pairs on the stem.

Oval – leaf shape. Ovate is oval in outline.

Obtuse

Opposite

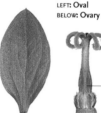

LEFT: **Oval**
BELOW: **Ovary**

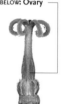

Ovary – structure containing the ovules, or immature seeds.

Ovoid – egg-shaped.

Palmate

Palmate – leaf with finger-like lobes arising from the same point.

Panicle – branched inflorescence.

Pappus – tuft of hairs on a fruit.

Parasite – plant that derives its nutrition entirely from another living organism.

Pedicel – stalk of an individual flower.

Pappus

Perennial – plant that lives for more than two years.

Perfoliate – surrounding the stem.

Perianth – collective name for a flower's petals and sepals.

Petals – inner segments of a flower, often colourful.

Perianth

Petiole – leaf stalk.

Petiole

Pinnate – leaf division with opposite pairs of leaflets and a terminal one.

Pinnate

Pod – elongated fruit, often almost cylindrical, seen in pea family members.

Pollen – tiny grains that contain male sex cells, produced by a flower's anthers.

Pod

Procumbent – lying on the ground.

Prostrate – growing in a manner pressed tightly to the ground.

Ray

Pubescent – with soft, downy hairs.

Ray – one of the stalks of an umbel.

Ray floret – one of the outer florets of a composite flower.

Ray floret

Receptacle – swollen upper part of a stem to which the flower is attached.

Recurved – curving backwards or downwards.

Reflexed – bent back at an angle of more than 90 degrees.

Rhizome – underground, or ground-level, stem.

Reflexed

Rosette

Rosette – clustered, radiating arrangement of leaves at ground level.

Saprophyte – plant that lacks chlorophyll and which derives its nutrition from decaying matter.

Sepal – one of the outer, usually less colourful, segments of a flower.

Sessile – lacking a stalk.

Shrub – branched, woody plant.

Spadix – spike of florets as seen in members of the genus *Arum*.

Saprophyte

Spathe – large, leafy bract surrounding the flower spike as seen in members of the genus *Arum*.

Species – division within classification that embraces organisms that closely resemble one another and that can interbreed to produce a viable subsequent generation.

Spreading – branching horizontally (in the case of a whole plant) or sticking out at right angles (in the case of hairs).

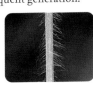

Spreading (hairs)

Stamen – male part of the flower, comprising the anther and filament.

Stigma – receptive surface of the female part of a flower, to which pollen adheres.

Stamen

Stipule – usually a pair of leaf-like appendages at the base of a leaf.

Stolon – creeping stem.

Style – element of the female part of the flower, sitting on the ovary and supporting the stigma.

Subspecies – members of a species that possess significant morphological differences from

Stigma and style

other groups within the species as a whole; in natural situations, different subspecies are often separated geographically.

Succulent – swollen and fleshy.

Tendril – slender, twining growth used by some plants to aid climbing.

Tendril

Tepals – both sepals and petals, when the two are indistinguishable.

Thallus

Thallus – the body of a plant in species where separate structures cannot be distinguished readily.

Tomentose – covered in cottony hairs.

Trifoliate (or **trefoil**) – leaf with three separate lobes.

Trifoliate

Truncate – ending abruptly and squared-off.

Tuber – swollen, usually underground, part of the stem or root.

Umbel

Tubercle – small swelling.

Umbel – complex, umbrella-shaped inflorescence.

Whorl – several leaves or branches arising from the same point on a stem.

FLOWERS

ATTRACTIVE THOUGH MANY OF them may be, flowers are not produced to delight the human eye. Their role is strictly functional – they are the plant's sex organs, there to produce sex cells and ensure the maximum chance of successful fertilisation taking place.

BASIC FLOWER STRUCTURE AND FUNCTION

In a few species, male and female sex cells are borne in separate flowers, or even on different plants, but in most cases they appear together within the same flower. Male sex cells are contained within *pollen*, tiny grains that are produced by structures called *anthers* and borne on slender stems referred to as *filaments*; collectively, anthers and filaments are referred to as *stamens*. The female part of most flowers comprises the *ovary*, containing the female sex cells, above which is borne the *stigma* (which receives the pollen) carried on a stem called the *style*.

Some plants, such as grasses and catkin-bearing shrubs, employ the wind to carry their pollen to others of the same species. Vast quantities of pollen are required to achieve a successful outcome with such a random process. Most other species adopt a more targeted approach and use the services of animals – insects in almost all cases – to transfer pollen. In exchange for a meal, in the form of nectar, insects inadvertently carry pollen on their bodies to the next flowers they visit; with any luck, a neighbouring plant of the same species will be visited while pollen still persists. In almost all species, flower structure has evolved to avoid self-pollination and to maximise the chances of cross-pollination – pollen being transferred to visiting insect pollinators and received from other plants by the same agents.

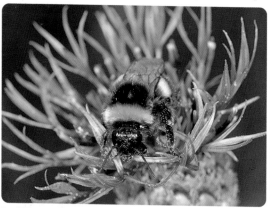

Bumblebees, and bees generally, are the classic insect pollinators. They visit flowers in search of nectar and unwittingly acquire a dusting of pollen, which is slightly sticky, on their hairy bodies; this is then carried to subsequent flowers they visit.

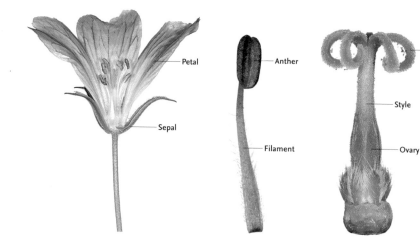

Cross-section through a typical flower, in this case a crane's-bill.

Petal
Sepal

Close-up of a stamen.

Anther
Filament

Close-up of the stigma, style and ovary.

Stigma
Style
Ovary

SEASONED AND EXPERIENCED BOTANISTS are likely to approach the subject of identification by using definitive botanical works (floras) that rely on detailed keys, a thorough understanding of botanical terms, and a willingness to use descriptions rather than pictures to separate species. While this approach has scientific validity, in my experience it is not the way that the average floral enthusiast approaches the problem. Most tend to leaf through illustrated books to find suitable candidate species and then narrow down the field by scrutinising any closely related alternatives. This approach can succeed in most instances, especially if close care is paid to the detailed structure of the plant – leaves and fruits, as well as flowers – in addition to other factors such as flowering time, habitat preferences and distribution. I anticipate that this is how *Complete British Wild Flowers* will be used, initially at least, by most readers, although it will not take long for even the most inexperienced person to be able to detect similarities among plant family members, hence narrowing down the options at a stroke. Nevertheless, for absolute beginners, I felt it would be useful to provide a few pointers to lead in the right direction. I have concentrated on flower families where, in most species, there are sufficient similarities to justify generalisations. Strikingly unusual flowers, and species without large family ties, are not included in the following series of short cuts. I have used flower structure, such as the number of petals, as an initial guide. Note, however, that within several of the families identified, one or more rogue species may defy the family character and will not fall into the appropriate category. For example, although Tormentil is a member of the rose family (characterised by flowers with five petals), its flowers have just four petals.

SHORT CUTS TO FLOWER IDENTITY

3-PETALLED FLOWERS

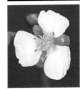

WATER-PLANTAINS – equal-sized petals; white or pinkish petals; aquatic or marginal plants; *see* pp.244–245.

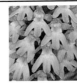

ORCHIDS – flowers comprising 3 petals plus 3 sepals, the latter often petal-like in colour and shape; the lower petal often takes the form of an enlarged or elaborate lip; *see* pp.230–241.

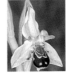
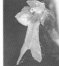

4-PETALLED FLOWERS

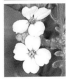

CABBAGE FAMILY MEMBERS – relatively small flowers; equal-sized petals; flowers often in groups; white, yellow or pinkish depending on species; *see* pp.54–67.

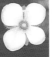

SPEEDWELLS – relatively small flowers; unequal-sized petals; blue, purplish or white depending on species; *see* pp.176–179.

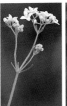

BEDSTRAWS – tiny flowers; equal-sized petals; flowers often in frothy heads; white or yellow depending on species; *see* pp.144–149.

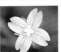

WILLOWHERBS – relatively small flowers in most species; equal-sized petals; flowers in open heads; pinkish, red or white depending on species; *see* pp.116–119.

POPPIES AND ALLIES – relatively large and crinkly, equal-sized petals; flowers usually solitary; red or yellow depending on species; *see* pp.52–55.

 WATER-CROWFOOTS – equal-sized petals; flowers usually solitary; white petals; aquatic; *see* pp.48–51.

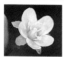 **SUNDEWS** – tiny flowers with equal petals; in spikes but usually only one flower opens at a time; bog plants with sticky, red leaves; white petals; *see* pp.68–69.

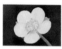 **BUTTERCUPS** – equal-sized, often shiny petals; flowers usually solitary; yellow; *see* pp.46–49.

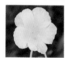 **ROCK-ROSES** – equal-sized, crinkly petals; flowers usually solitary; yellow or white depending on species; *see* pp.110–111.

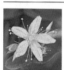 **ST JOHN'S-WORTS** – equal-sized petals; flowers in open heads in most species; yellow but marked with small black dots or streaks in some species; *see* pp.108–111.

 ROSES AND ALLIES – equal-sized petals; flowers solitary or in open heads depending on species; white, pink or yellow depending on species; *see* pp.74–83.

 SAXIFRAGES – equal-sized petals; flowers solitary or in open heads depending on species; white, pinkish or yellow depending on species; *see* pp.70–73.

 MULLEINS – equal-sized or slightly unequal petals; flowers often in tall spikes; yellow or white depending on species; *see* pp.170–171.

 LOOSESTRIFES AND PIMPERNELS – petals fused but 5 distinct and equal lobes present; yellow, red, purple or pink depending on species; *see* pp.132–135.

 PRIMROSE – petals fused but 5 distinct and equal lobes present; yellow or pink depending on species; *see* pp.132–135.

 MALLOWS – equal-sized petals; flowers solitary or in open heads; pink; *see* pp.106–109.

 CENTAURIES – corolla fused but with 5 petal-like lobes; in clusters in most species; petals pink or yellow depending on species; *see* pp.142–143.

 WOOD SORREL AND ALLIES – equal-sized petals; yellow, pinkish or white depending on species; trifoliate leaves; *see* pp.96–97.

 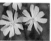 **PINKS, CHICKWEEDS AND STITCHWORTS** – equal-sized petals, often deeply divided; flowers usually solitary; white or pink depending on species; *see* pp.34–43.

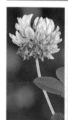 **PEA FAMILY MEMBERS** – unequal petals arranged in a characteristic manner comprising a standard, a keel and wings; yellow, pinkish, purple or white depending on species; *see* pp.84–97.

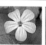 **CRANE'S-BILLS** – equal-sized petals; flowers solitary or in open heads depending on species; pinkish, bluish or purple depending on species; *see* pp.98–101.

 FLAXES – equal-sized petals; flowers usually solitary; bluish or white depending on species; *see* pp.100–101.

 SEA-LAVENDERS – flowers funnel-shaped; petals fused at the base; restricted to coastal habitats; bluish-lilac petals; *see* pp.140–141.

 VIOLETS – unequal petals; spur present; blue, violet or white depending on species; *see* pp.112–115.

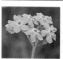 **FORGET-ME-NOTS** – petals fused but 5 petal-like lobes present; in open heads in most species; blue, pinkish or white depending on species; *see* pp.154–155.

TRUMPET-SHAPED FLOWERS

 GENTIANS – trumpet relatively narrow; petals fused but with 4 or 5 pointed or rounded lobes; bluish, purple or pinkish depending on species; see pp.144–145.

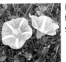 BINDWEEDS – trumpet open and flared; white or pink depending on species; see pp.150–151.

BELL-SHAPED FLOWERS

 BELLFLOWERS – flowers rather open with 5 lobes; blue or purplish depending on species; see pp.192–195.

 HEATHERS – flowers typically small, rather tubular and usually pendent; pink or purple depending on species; see pp.136–139.

TUBULAR OR FUSED FLOWERS

 EYEBRIGHTS – flowers 2-lipped; upper lip hooded, lower lip 3-lobed; white, marked with purple and yellow; see pp.180–181.

 BORAGE AND ALLIES – 5 lobes present; flowers borne in spikes, curved in some species; yellow, pinkish, purple or white depending on species; see pp.150–155.

 TOADFLAXES – flowers spurred and 2-lipped; upper lip 2-lobed, lower lip 3-lobed; yellow or purplish depending on species; see pp.172–175.

 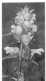 LOUSEWORTS AND COW-WHEATS – flowers 2-lipped; upper lip hooded, lower lip 3-lobed; borne in spike-like heads in most species; pinkish or purple depending on species; see pp.180–183.

 FUMITORIES – flowers 2-lipped; pinkish or yellow depending on species; see pp.52–53.

 FIGWORTS – flowers tiny, globular and 2-lipped; upper lip 2-lobed, lower lip 3-lobed; purplish or yellow depending on species; see pp.172–173.

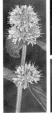 LABIATES – flowers 2-lipped; lower lip often lobed, upper lip often hooded and toothed; borne in spikes in most species; whole plant often aromatic; wide range of colours seen in the different species; see pp.156–167.

 BROOMRAPES – flowers 2-lipped; upper lip hooded, lower lip 3-lobed; flowers the same colour as rest of plant; borne in spikes; see pp.184–185.

MANY-FLOWERED HEADS OR FLOWERS IN CLUSTERED HEADS

UMBELLIFERS OR CARROT FAMILY MEMBERS – individual flowers comprising 5 tiny petals; flowers stalked and arranged in umbrella-shaped heads; white or yellow depending on species; see pp.120–131.

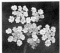

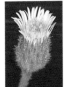 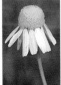

 DAISY FAMILY MEMBERS – numerous tiny flowers; arranged in dense heads in most species; inner disc florets appearing very different from outer ray florets in many species; wide range of colours seen in the different species; see pp.196–219.

 SCABIOUSES – individual flowers with 4 or 5 petals depending on species; borne in dense, domed heads; outer flowers often larger than inner ones; see pp.190–193.

FRUITS AND SEEDS

FRUITS FOLLOW IN THE wake of flowers and are the structures in which a plant's seeds develop and are protected. In many cases, the shape and structure of these fruits, and often the seeds themselves, are designed to assist their dispersal, when ripe, away from the plant that produced them. A number of ingenious methods have evolved to facilitate this process: some seeds are carried by the wind; others attach themselves to the fur of animals; some even float away on water or have evolved to be eaten and digested by birds. The study of fruits and seeds is not only fascinating in its own right but in many instances the structure or appearance of a fruit can be a valuable aid to correct identification.

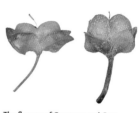

The burred fruits of Lesser Burdock readily become snagged in animal fur, travelling with the creature until the fruit finally disintegrates and liberates the seeds.

The hook-tipped spines on the fruit of Wood Avens catch in animal fur. Subsequently, they also help the fruit to disintegrate, as unattached barbs snag on objects and material that the animal rubs against.

The flowers of Common and Grey Field-speedwells are rather similar. Only by looking at the fruits (Common *left*, Grey *right*) can you be absolutely certain of any given plant's identity.

Cabbage family members produce fruits known as pods, which vary considerably in terms of size and shape according to species. Those of Wild Candytuft, seen here, are particularly attractive.

Dandelion seeds are armed with a tuft of hairs – the pappus – that assists wind dispersal. While it remains intact, the collection of seeds and hairs is often referred to as a 'clock'.

The fruits of Field Gromwell (*above left*) are hard-cased nutlets, designed to be resistant to abrasion and wear, allowing the species to grow as an arable weed, but of course only in the absence of herbicides.

Like other members of the pea family, the fruits of bird's-foot-trefoil (*above*) are elongated pods.

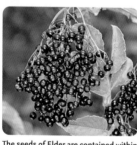

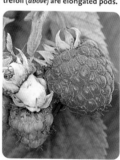

The seeds of Elder are contained within luscious berries. These are eaten by birds and the seeds (protected by a coating resistant to being digested) are dispersed with the droppings.

The fruits of roses are fleshy and known as hips; inside these are seeds (dry achenes).

The fruit of the Common Poppy is a hollow vessel that contains thousands of minute seeds. When the fruit is ripe, holes below its rim allow seeds to escape when the plant is shaken by the wind.

In strict botanical terms, the fruits of the Raspberry are a collection of small drupes – each one a fleshy fruit that contains a hard-coated seed.

LEAVES

BEING THE MAIN STRUCTURES responsible for photosynthesis, a plant's leaves are its powerhouse. They vary from species to species and come in a wide range of shapes and sizes. Their appearance is an evolutionary response to the plant's needs, in particular factors such as the habitat in which it grows, the degree of shading or exposure dictated by its favoured growing location, and rainfall. In most instances, all the leaves on a given plant are likely to be broadly similar to one another, although size tends to decrease up the stem of a plant. However, to complicate matters, basal leaves can be entirely different in appearance from stem leaves. This applies to a number of species, notably some umbellifers.

In essence, leaves are thin and rather delicate structures. However, rigidity is maintained by a network of veins through which pass the ingredients required for photosynthesis, and the products of the process.

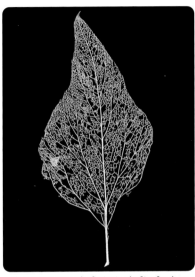

The intricate network of veins in a leaf is often best appreciated after autumn leaf-fall in deciduous species. Softer tissue decomposes before the veins themselves disintegrate, leaving striking leaf skeletons.

Leaf shape is not an infallible guide to plant identity, so its importance as an identifying feature is secondary to the appearance of flowers. There are many instances where entirely unrelated plants have superficially very similar leaves and great care must be taken when using leaf shape alone for identification. However, there are also plenty of instances where leaf shape *is* distinctive and diagnostic, or where it allows the separation of closely related plants that have superficially similar flowers. So it is worth paying attention to the variety of leaf shapes found among British wild flowers, some of which are shown right and overleaf along with the common descriptive name by which their shapes are known. Also shown are a variety of distinctive marginal features.

OVATE

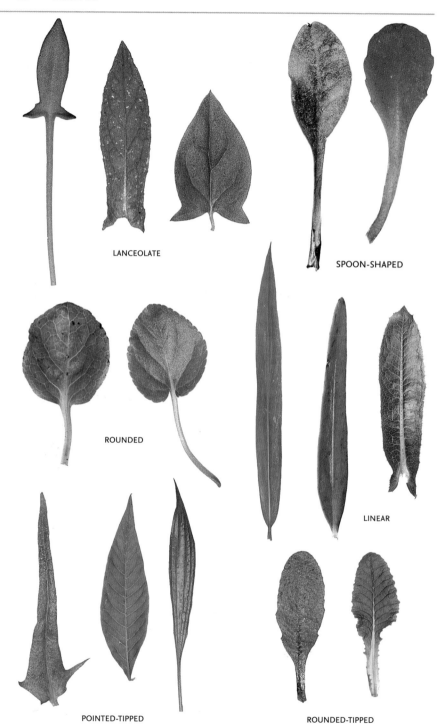

LANCEOLATE

SPOON-SHAPED

ROUNDED

LINEAR

POINTED-TIPPED

ROUNDED-TIPPED

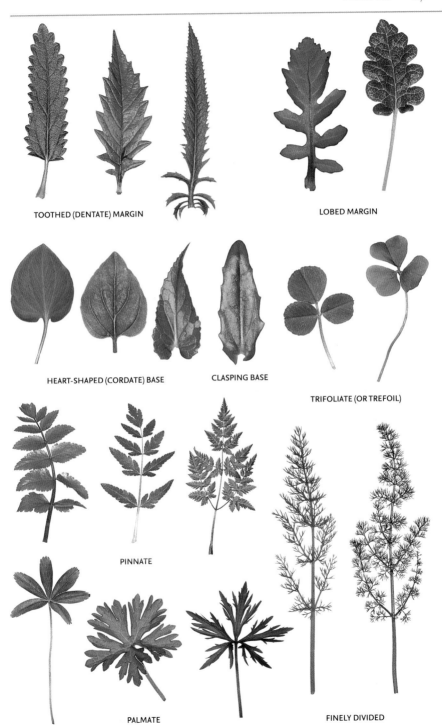

TOOTHED (DENTATE) MARGIN

LOBED MARGIN

HEART-SHAPED (CORDATE) BASE

CLASPING BASE

TRIFOLIATE (OR TREFOIL)

PINNATE

PALMATE

FINELY DIVIDED

HABITATS

WHEREVER CONDITIONS ARE SUITABLE for life then plants are likely to grow. Although some species are rather catholic with regard to where they grow, most are much more specific, influenced by factors such as underlying soil type, whether the soil is waterlogged or free-draining, summer and winter temperature extremes and so on. Consequently, where environmental conditions are broadly similar, the same plant species are likely to be found; where these communities are recognisably distinct they are referred to by specific habitat names. In Britain, many of our most distinct habitats owe their existence to past and present human activity, so they are classed as *semi-natural* in ecological terms.

DECIDUOUS WOODLAND

Woodlands of deciduous trees are found throughout most of the region. They are (or would be, if allowed to flourish) the dominant natural forest type of all regions except in parts of Scotland where evergreen conifers predominate. As their name suggests, deciduous trees have shed their leaves by winter and grow a new set the following spring. The seasonality seen in deciduous woodland is among the most marked and easily observed of any habitat in the region.

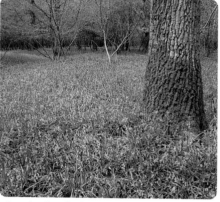

Almost all woodland in the region has been, and still is, influenced in some way by man. This might take the form of simple disturbance by walkers, at one end of the spectrum, or clear-felling at the other. Man's influence is not always to the detriment of wildlife, however. Sympathetic coppicing of Hazel and Ash, for example, can encourage a profusion of wild flowers. In particularly rich locations, carpets of Bluebells, Wood Anemones and Wood Sorrel form the backdrop for more unusual species such as Early Purple Orchid and Greater Butterfly Orchid, Goldilocks Buttercup and Herb-Paris.

Centuries of woodland coppicing have inadvertently created the perfect environment for Bluebells to thrive. A carpet of these lovely plants is a quintessentially English scene.

CONIFEROUS WOODLAND

Areas of native conifer woodland are restricted to a few relict pockets of Caledonian pine forest in the Highlands of Scotland. Conifers that are seen almost everywhere else in Britain and Ireland have either been planted or have seeded themselves from mature plantations. Our native conifer forests harbour an intriguing selection of plants, such as various wintergreen species, Twinflower and Creeping Lady's-tresses, but conifer plantations are usually species-poor.

HEDGEROWS AND SCRUB

Once so much a feature of the British countryside, hedgerows have suffered a dramatic decline in recent decades. Many hedgerows have either been grubbed out by farmers keen to expand arable field sizes or, more insidiously, wrecked – both in terms of appearance and in their value to wildlife – by inappropriate cutting regimes.

The extent of scrub in the landscape has also diminished in recent times. Although scrub is difficult to define in strict habitat terms, most people would understand the word to mean a loose assemblage of tangled, medium-sized shrubs and bushes interspersed with patches of spreading plants such as Bramble and areas of grassland. Scrub is frequently despised by landowners – sometimes even by naturalists too – but its value to many species formerly considered so common and widespread as not to merit conservation attention should not be underestimated.

Hedgerows usually comprise the species, and acquire the character, of any woodland edge in the vicinity. Scrub, too, reflects the botanical composition of the surrounding area. However, because scrub is essentially a colonising habitat, and not an established one, the bushes and shrubs that comprise tend to be those that grow the fastest.

GRASSLAND AND FARMLAND

Full of wild flowers and native grass species, a good grassy meadow is a delight to anyone with an eye for colour and an interest in natural history. Unfortunately, prime sites are comparatively few and far between these days, either lost to the plough or 'improved' by farmers for grazing, by seeding with fast-growing, non-native grass species and by applying selective herbicides. When this happens, the grassland loses its intrinsic botanical interest and value.

It should not be forgotten that, in Britain and Ireland, grassland is a man-made habitat, the result of woodland clearance for grazing in centuries past. If a site is to be maintained as grassland, continued grazing or cutting is needed to ensure that scrub does not regenerate. In the past, the way in which grassland was managed had the beneficial side-effect – from a naturalists' perspective – of increasing botanical diversity. Under modern 'efficient' farming regimes the reverse is the case.

Although arable fields may fall loosely into the category of grasslands (crop species such as wheat, barley and oats are grasses after all), their botanical interest tends to be minimal in many areas. Modern herbicides ensure that 'weeds' are kept to a minimum, and decades of chemical use have resulted in the soil's seed bank being depleted dramatically. Many of the more delicate arable 'weed' species are essentially things of the past, often relegated to a few scraps of marginal land that escape spraying either by luck or, in a few instances, through the foresight of farmers. Arable weeds depend on disturbance, being unable to compete in stable grassland communities. So there is a sad irony to the fact that grant-funded 'conservation' schemes that create wildlife 'headlands' are often the final nail in the coffin for these scarce species, which become crowded out by the vigorous growth of seeded rank grasses and clovers.

HEATHLAND

Heathlands are essentially restricted to southern England, with the majority of sites concentrated in Surrey, Hampshire and Dorset. However, further isolated examples of heathland can be found further afield, in south Devon and Suffolk, for example, and in coastal districts of Cornwall and Pembrokeshire. This fragmented distribution adds to the problems that beset the habitat: 'island' populations of plants and animals have little chance of receiving genetic input from other sites.

Heathland owes its existence to man, and came about following forest clearance on acid, sandy soils. Regimes of grazing, cutting and periodic burning in the past have helped maintain heathland, and continued management is needed to ensure an appropriate balance between scrub encroachment and the maintenance of an open habitat. Ironically, man is also the biggest threat to the habitat: uncontrolled burns cause damage that takes decades or more to repair, while the destruction of heathland for housing developments obviously means the loss of this unique habitat for good.

The habitat's name is clearly derived from the presence, and often dominance, of members of the heath family of plants, all of which flourish on acid soils. For the ultimate visual display, visit an area of heathland in July, August and September when these plants are in full bloom.

UPLANDS

Together with more remote stretches of coastline, upland areas are perhaps the only parts of our region to retain a sense of isolation for the visitor. Many of these places appear wild and untamed, although in reality this is often just an illusion: few areas can be said to be truly pristine.

In centuries gone by, all but the highest peaks would have been wooded. Clearance of trees and subsequent, often excessive, grazing by sheep ensured that the natural woodland disappeared and cannot regenerate. In general terms, moorland is the dominant habitat in upland areas although the characteristic plants and appearance vary considerably from region to region, and are profoundly influenced by soil type and climate; communities dominated by Heather or moorland grass species form the two extremes. In a few areas, mountains dominate the landscape, sometimes rising to altitudes above the level at which trees would grow if they were allowed to do so; these areas harbour unique communities of plants, many restricted to rocky gullies and crags that escape nibbling by sheep. Highlights include Moss Campion and an intriguing range of saxifrage species.

FRESHWATER HABITATS

Freshwater habitats have the same magnetic appeal as coastal habitats. In Britain and Ireland, we are indeed fortunate in having a wealth of examples, from small ponds and streams to large lakes and river systems; few people have to travel excessive distances to visit one or more of these habitats.

Flowing water has a charm all of its own and a trip to a river or stream will invariably yield discoveries of showy marginal species such as Yellow Iris and Ragged Robin, while specialised aquatic plants flourish in areas where the water is not too polluted.

Bodies of standing water often harbour a strikingly different range of plants from those found in flowing water. Many seemingly natural lakes are man-made, or at least man-influenced, and within this category fall flooded gravel pits, and more obviously, reservoirs and canals. By mid summer a rich growth of aquatic plants, such as pondweed species, dominates many of our smaller ponds as well as the margins of lakes. Pond and lake margins are fascinating places for the botanist to explore, with bur-marigold species, Golden Dock, Mudwort and Six-stamened Waterwort among the highlights. Left to their own devices, the margins are soon encroached by stands of more robust emergent plants, and species such as Common Reed sometimes form extensive beds around larger lakes.

The encroachment of vegetation into areas of open water leads to the creation of habitats know as mires, which are more popularly referred to in a general context as marshes. Marshes often form on neutral soils, but where they are base-rich (alkaline) then the resultant habitat is called a *fen*. Conversely, acid soils encourage the formation of *bogs*. The nature of the underlying soil has a profound influence not only on the appearance of the mire in question but also on the plant species that grow there. Some wetland plants, such as Bogbean, will grow in both moderately acid and mildly alkaline conditions while others are more selective. Thus, for example, we find that certain plants, such as cotton-grasses, sundews and butterworts, are essentially restricted to acid soils while fens are home to a range of interesting sedges, plus more showy plants including Great Meadow-rue, Marsh Valerian, Marsh Pea and Greater Water-parsnip.

Portland Spurge is just one of the delights to greet visiting botanists on a spring trip to the extensive dune system of Braunton Burrows in Devon.

COASTAL HABITATS

In habitat terms the coastline is arguably Great Britain's crowning glory. Although development has marred some areas, particularly in southern England, those that remain unspoilt there, and elsewhere in Britain and Ireland, are truly wonderful and harbour a rich array of specialised plants.

For breathtaking scenery and a sense of untamed nature, coastal cliffs offer unrivalled opportunities for the naturalist. Botanical highlights include carpets of Thrift that dominate the vegetation in many western parts of the region, with species such as Sea Carrot, Sea Campion and various sea-spurreys in attendance.

To the unenlightened eye, an estuary may seem like a vast expanse of mudflats, studded with a mosaic of bedraggled-looking vegetation and very little else. For the botanist, however, nothing could be further from the truth. Specialised plants including glassworts, sea-lavenders and Sea Purslane have evolved to cope with twice-daily inundation by sea water. Above the high tideline, intriguing salt-tolerant species thrive.

In botanical terms, the stabilised shingle at Chesil Beach in Dorset is arguably the finest of its kind in Europe. Here, extensive carpets of Horseshoe Vetch can be seen, but Bird's-foot-trefoil and Thrift also thrive in abundance.

Sandy shores are beloved of holidaymakers but have much to offer the botanist too. On the landward side of the beach, colonising plants – notably Marram Grass – establish stable dune systems and subsequently these are colonised by maritime plants such as Sea Spurge as well as grassland species such as Viper's-bugloss and Common Bird's-foot-trefoil. Coastal shingle is a more challenging environment for a plant and it tends to be the domain of hardy specialists such as Sea-holly, Yellow Horned-poppy and Sea-kale.

CONSERVATION

WORKING ON THIS PROJECT gave me the opportunity to visit many wonderful botanical locations across our region, the best of which are protected, to a degree, by nature reserve status and hence are still in good order. I also revisited many unprotected wayside botanical sites that I had not seen for several years. Sadly, most had become botanically impoverished and some had even lost the special plants for which they had been known. It will come as no surprise to learn that the majority of these sites were on areas of farmland.

It has come to something when the discovery of Spreading Hedge-parsley, once a widespread arable 'weed', is a cause for botanical celebration. Without changes in agricultural practices, species such as this – already extinct at a local level in many areas – could disappear from Britain completely.

WHAT'S GONE WRONG?

Threats to the countryside are all too obvious these days: the swallowing of land for housing, road schemes and the like, industrial and domestic pollution, and above all changes in agricultural practices – namely the unquestioning use of ever-more 'efficient' herbicides since the 1950s. And problems for wild flowers in the countryside do not stop with farming. Many landowners view the land they own as something to be exploited, if not for economic gain then as a playground, without a thought for conservation.

WHAT CAN BE DONE?

Legislation and agricultural grants relating to the way the countryside is managed need to target wildlife more intelligently than is currently the case, and development and change of land use should be subject to as much restriction as exists in the world of town planning. Easy to say, but much harder to put into practice. And there seems little cause for optimism, given that statutory bodies commanded with the responsibility for nature conservation are funded by government, itself perceived as being more receptive to economic than to environmental lobbies.

WHAT CAN YOU DO?

Object to, and oppose, all major development in the countryside and support organisations that are critical of the way intensive farming and insidious urbanisation have changed the botanical face of the landscape. On a small scale, grow as much of your own food as you can, garden organically, and use local organic sources for your additional needs whenever possible. Another way that the individual can help safeguard the British countryside is to donate as much money as possible to conservation organisations for the purchase of land to remove it from the threat of intensive farming or development. Suitable recipients of donations would include organisations such as Plantlife International, the various county Wildlife Trusts, the Woodland Trust, the National Trust and the RSPB.

Thankfully, it is still possible to find agricultural fields where Cornflowers and other arable weeds thrive alongside the desired crop plant, either by design or where non-intensive farming methods are used. Let us hope that sights such as this become more commonplace as enlightenment, or financial inducements, change the way some of the land is farmed.

Although walks in the countryside sometimes induce a sense of gloomy pessimism, budding botanists should not despair. Remarkably few flowering plant species have been lost entirely from Britain and Ireland in the last century and there are still plenty of wonderful botanically rich locations around the country. Nature reserves are thriving and, with your support and enthusiasm, things can only get better.

Juniper *Juniperus communis* (Cupressaceae) ✿ **HEIGHT** to 5m (sometimes prostrate) Dense shrub of well-drained soils, from chalk downland to mountains. **FLOWERS** On separate-sex plants; those on female plants are green and oval (much of year). **FRUITS** Ripening in second year to form *blue-black berry-like cones.* **LEAVES** Stiff, bluish green, *needle-like*, in whorls of 3. **STATUS** Widespread and locally common.

Hazel *Corylus avellana* (Betulaceae) **HEIGHT** to 12m Dense woodland shrub or small tree; often coppiced. **FLOWERS** Catkins (male) or small red, tufted structures (female) (Jan–Mar). **FRUITS** Hard-cased nuts, green, ripening brown in autumn. **LEAVES** Appearing after flowers, 6–8cm long, circular to oval, with double-toothed margins. **STATUS** Common and widespread.

Hazel catkins

Bog-myrtle *Myrica gale* (Myricaceae) ✿ **HEIGHT** to 1m Woody, brown-stemmed shrub that is characteristic of boggy habitats, usually on acid soils. **FLOWERS** Orange, ovoid male catkins or pendulous brown female catkins; on separate plants (Apr). **FRUITS** Brownish nuts. **LEAVES** Oval, grey-green, *smelling of resin when crushed.* **STATUS** Widespread but local; sometimes locally dominant.

Berries

Mistletoe *Viscum album* (Viscaceae) ✿ **DIAMETER** to 1m Woody, evergreen parasite with evenly forked branches. Forms large, spherical clumps among branches of host trees, mainly apple (often in cultivation), lime and poplar. **FLOWERS** Inconspicuous (Feb–Apr). **FRUITS** White, sticky berries. **LEAVES** Oval, yellowish green, in opposite pairs. **STATUS** Widespread but local.

Bastard-toadflax *Thesium humifusum* (Santalaceae) ✿✿ **PROSTRATE** Low-growing plant of chalk grassland with sparse branches and a woody base. **FLOWERS** Cup-shaped, fused; white inside, yellowish green outside; 4 or 5 pointed lobes create a starlike appearance (June–Aug). **FRUITS** Greenish, ovoid. **LEAVES** 5–15mm long, oval, yellowish green. **STATUS** Extremely local and habitat-specific.

Hop *Humulus lupulus* (Cannabaceae) ✿ **HEIGHT** to 6m Twining, hairy hedgerow climber. Grows on a range of soils, often a relict of cultivation. **FLOWERS** Clustered; greenish yellow (male) or green and hop-like (female) (June–Aug). **FRUITS** Familiar hops, ripening brown in autumn. **LEAVES** Divided into 3–5 coarse-toothed lobes. **STATUS** Widespread, locally common only in the south.

Common Nettle

Common Nettle *Urtica dioica* (Urticaceae) **HEIGHT** to 1m The familiar *stinging* nettle. **FLOWERS** Pendulous catkins; borne on separate-sex plants (June–Oct). **FRUITS** Superficially resembling flowers. **LEAVES** Oval, with pointed tips, toothed, in opposite pairs; 8cm long and longer than stalks. **STATUS** Widespread and common, doing best on nitrogen-enriched and disturbed soils.

Small Nettle *Urtica urens* (Urticaceae) ✿ **HEIGHT** to 50cm Similar to Common Nettle but smaller and annual. **FLOWERS** Pendulous catkins, male and female on same plant (June–Sep). **FRUITS** Superficially resembling female flowers. **LEAVES** Oval, with pointed tips, toothed; up to 4cm long; lower leaves shorter than their stalks. **STATUS** Widespread and locally common on disturbed ground.

Pellitory-of-the-wall *Parietaria judaica* (Urticaceae) ✿ **HEIGHT** to 7cm Spreading, downy perennial with reddish stems. Colonises walls, roadsides and rocky ground. **FLOWERS** Clustered at leaf bases (June–Oct). **FRUITS** Clustered at leaf bases. **LEAVES** Oval, up to 5cm long and long-stalked. **STATUS** Widespread in England, Wales and Ireland; commonest in coastal areas and in the west.

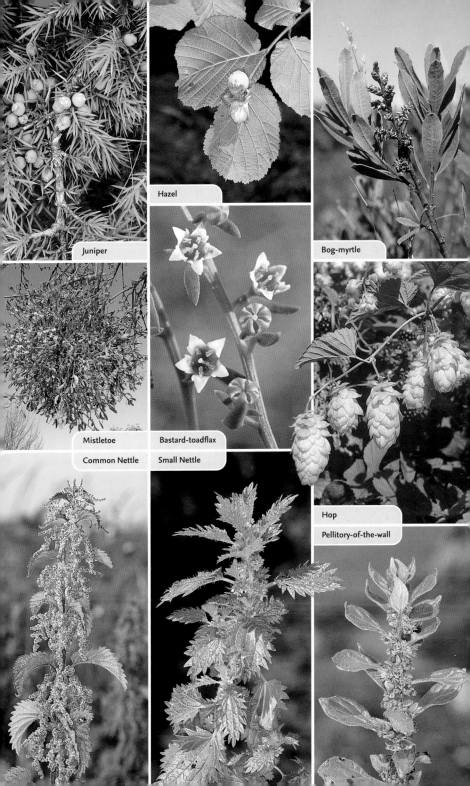

Juniper

Hazel

Bog-myrtle

Mistletoe

Bastard-toadflax

Common Nettle

Small Nettle

Hop

Pellitory-of-the-wall

Mind-your-own-business *Soleirolia soleirolii* (Urticaceae) 🌸🌸 **PROSTRATE**
Mat-forming perennial with wiry, threadlike stems. **FLOWERS** Minute, pink
(May–Aug). **FRUITS** Minute, hard to discern. **LEAVES** Tiny, rounded, untoothed
and evergreen. **STATUS** A garden escape, colonising walls and paths, mainly in the
south-west.

Asarabacca *Asarum europaeum* (Aristolochiaceae) 🌸🌸 **HEIGHT** to 30cm
Evergreen perennial associated with shady banks and woodland margins. Creeping,
hairy stems. In suitable locations, forms carpets often alongside ivy.
FLOWERS Purplish brown, 15mm long, bell-shaped with 3 terminal lobes
(May–Aug). **FRUITS** Brownish capsules. **LEAVES** Dark green, shiny, kidney-shaped.
STATUS Native in a few locations but also naturalised.

Birthwort

Birthwort *Aristolochia clematis* (Aristolochiaceae) 🌸🌸🌸
HEIGHT to 80cm
Upright, unbranched perennial of scrubby places.
FLOWERS Yellow, tubular, 20–30mm long, fetid-smelling,
the swollen base trapping pollinating insects; in
clusters (June–Aug). **FRUITS** Green, pear-shaped.
LEAVES Heart-shaped, strongly veined. **STATUS** Rare and
declining; a relict of cultivation for midwifery.

Japanese Knotweed *Fallopia japonica*
(Polygonaceae) 🌸 **HEIGHT** to 2m
Fast-growing, invasive perennial, quick to colonise roadsides
and other wayside places; hard to eradicate. **FLOWERS** Whitish, in loose, pendulous
spikes arising from leaf bases (Aug–Oct). **FRUITS** Papery. **LEAVES** Large, triangular,
on red, zigzag stems. **STATUS** Alien, but now a widespread garden escape.

Knotgrass *Polygonum aviculare* (Polygonaceae) **HEIGHT** to 1m (often prostrate)
Much-branched annual of bare soil and open ground. **FLOWERS** Pale pink, in leaf
axils (June–Oct). **FRUITS** Nut-like, enclosed by the withering flower. **LEAVES** Oval,
leathery, alternate with a silvery basal sheath; *main stem leaves larger than those on
side branches.* **STATUS** Widespread and common.

Equal-leaved Knotgrass *Polygonum arenastrum* (Polygonaceae) **PROSTRATE**
Mat-forming annual of bare ground and disturbed soil. Superficially like Knotgrass.
FLOWERS Pale pink, in leaf axils (June–Oct). **FRUITS** Nut-like, enclosed by the
withering flower. **LEAVES** Oval, *equal in size on main stem and side branches*
(cf. Knotgrass). **STATUS** Widespread and common.

Ray's Knotgrass *Polygonum oxyspermum* (Polygonaceae) 🌸🌸 **PROSTRATE**
Mat-forming annual of undisturbed coastal sand and shingle beaches. **FLOWERS**
Pinkish white, in leaf axils (Aug–Sep). **FRUITS** Nut-like, protruding beyond the
withering flower. **LEAVES** Oval, leathery, alternate, sometimes with slightly
inrolled margins. **STATUS** Local and commonest in the west.

Buckwheat *Fagopyrum esculentum* (Polygonaceae) 🌸🌸 **HEIGHT** to 30cm
Hairless, upright annual, usually with reddish stems. Associated with
disturbed or waste ground. **FLOWERS** Pinkish, in stalked, branched clusters
(July–Sep). **FRUITS** Smooth, 3-sided nuts. **LEAVES** Broad, arrow-shaped,
the upper ones clasping the stem. **STATUS** Widespread but occasional,
a relict of cultivation.

Common Bistort *Persicaria bistorta* (Polygonaceae) 🌸 **HEIGHT** to 60cm
Attractive perennial of damp meadows, forming patches in suitable
locations. **FLOWERS** Pink, in dense, 30–40mm terminal spikes (June–Aug).
FRUITS Nut-like. **LEAVES** Oval or arrow-shaped, the lower ones stalked, the
upper ones almost stalkless. **STATUS** Locally common in the north but rare in
the south.

Common Bistort

■ *See also* Sea Knotgrass (p.270)

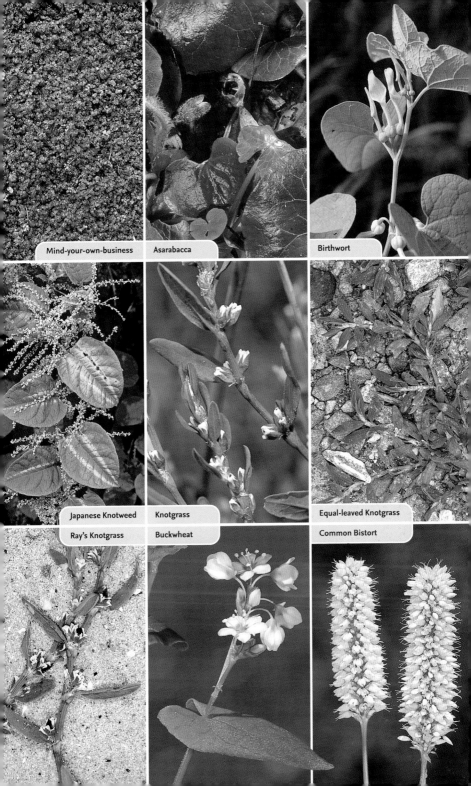

Mind-your-own-business

Asarabacca

Birthwort

Japanese Knotweed

Knotgrass

Equal-leaved Knotgrass

Ray's Knotgrass

Buckwheat

Common Bistort

Amphibious Bistort *Persicaria amphibia* HEIGHT to 40cm

Perennial of ponds and nearby dry land. Aquatic form has floating stems. FLOWERS Pink, in cylindrical spikes (June–Sep). FRUITS Nut-like. LEAVES Narrow; aquatic forms hairless, truncate at the base and long-stalked; terrestrial forms downy, rounded at the base and short-stalked. STATUS Locally common.

Alpine Bistort *Persicaria vivipara* ❀❀ HEIGHT to 30cm

Upright, unbranched perennial of upland and northern grassland. FLOWERS In terminal spikes; upper ones pale pink, lower ones reddish-brown bulbils (a means of vegetative reproduction) (June–Aug). FRUITS Nut-like. LEAVES Narrow, grass-like, the margins inrolled. STATUS Locally common from N Wales northwards.

Water-pepper *Persicaria hydropiper* HEIGHT to 70cm

Upright, branched annual, characteristic of damp, bare ground such as winter-wet ruts, and shallow water. FLOWERS Pale pink, in long spikes that droop at the tip (July–Sep). FRUITS Small and nut-like. LEAVES Narrow, oval, with a *peppery taste when chewed.* STATUS Widespread and common, except in the north. **Small Water-pepper** *P. minor* is similar but much smaller (to 30cm), with shorter, narrower leaves (5–8mm across) that are not peppery. Local and scarce on bare pond margins.

Redshank

Pale
Persicaria

Redshank *Persicaria maculosa* HEIGHT to 60cm

Upright or sprawling *hairless* annual with much-branched *reddish stems.* Found on disturbed ground and arable field margins. FLOWERS Pink, in terminal spikes (June–Oct). FRUITS Nut-like. LEAVES Narrow, oval, usually showing a *dark central mark.* STATUS Widespread and common throughout.

Pale Persicaria *Persicaria lapathifolia* HEIGHT to 60cm

Upright or sprawling annual. Similar to Redshank but stems usually *greenish and hairy.* Found on disturbed ground and arable field margins. FLOWERS Greenish white, in terminal spikes (June–Oct). FRUITS Nut-like. LEAVES Narrow, oval. STATUS Widespread and generally common throughout.

Black-bindweed *Fallopia convolvulus* HEIGHT to 1m

Extremely common, clockwise-twining annual that both trails on the ground and climbs among wayside plants. FLOWERS Greenish and rather dock-like, in loose spikes arising from leaf axils (July–Oct). FRUITS Nut-like, blackish. LEAVES Arrow-shaped, on angular stems. STATUS Widespread and common. **Copse-bindweed** *F. dumetorum* is similar but has much longer fruit stalks (4–8mm). Scarce.

Mountain Sorrel *Oxyria digyna* ❀ HEIGHT to 30cm

Upright, hairless perennial of damp ground in upland areas; often found beside streams. FLOWERS Greenish with red margins, in loose, upright spikes (July–Aug). FRUITS Flat, broad-winged. LEAVES Entirely basal; rounded to kidney-shaped. STATUS Widespread and locally common in upland and northern areas.

Common Sorrel *Rumex acetosa* HEIGHT to 60cm

Variable perennial of grassy habitats. Whole plant often turns red as it goes over. FLOWERS Reddish, in slender spikes (May–July). FRUITS Nut-like with a small tubercle. LEAVES Deep green, arrow-shaped, narrow; tasting mildly of vinegar. STATUS Widespread and common.

Sheep's
Sorrel

Sheep's Sorrel *Rumex acetosella* HEIGHT to 25cm

Short, upright perennial of bare, well-drained acid soils. FLOWERS Greenish, in loose, slender spikes (May–Aug). FRUITS Nut-like. LEAVES Arrow-shaped but with basal lobes pointing forwards; upper leaves clasp the stem. STATUS Widespread and common in suitable habitats.

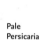

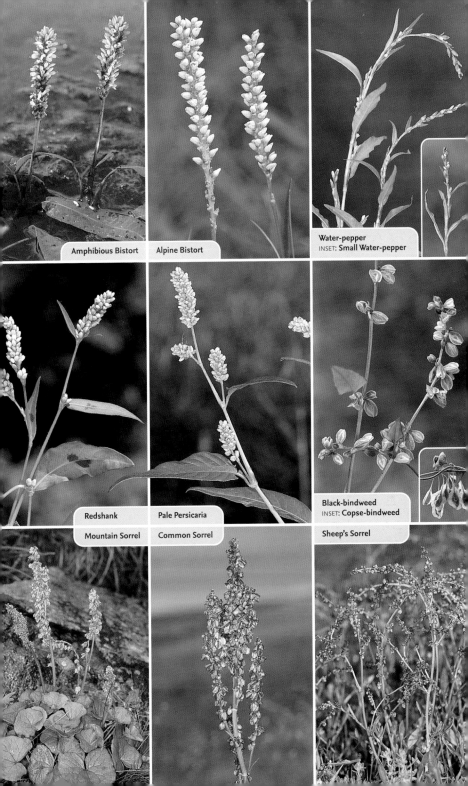

Amphibious Bistort

Alpine Bistort

Water-pepper
INSET: Small Water-pepper

Redshank

Pale Persicaria

Black-bindweed
INSET: Copse-bindweed

Mountain Sorrel

Common Sorrel

Sheep's Sorrel

Curled
Dock
leaf

Fruit

Curled Dock *Rumex crispus* HEIGHT to 1m
Upright perennial of rough meadows and disturbed soils. **FLOWERS** Flattened, oval, in dense, *leafless spikes* that do not spread away from the stem (June–Oct). **FRUITS** Oval, untoothed, usually with a single tubercle. **LEAVES** Narrow, to 25cm long and with *wavy edges*. **STATUS** Widespread and common.

Northern Dock *Rumex longifolius* ❀ HEIGHT to 1.5m
Upright perennial of disturbed ground, often beside rivers and roads, or near the coast. Rather similar to Curled Dock. **FLOWERS** Pale green, in narrow spikes. **FRUITS** Heart-shaped, lacking teeth and tubercles (July–Sep). **LEAVES** To 80cm long, broader than those of Curled Dock. **STATUS** Locally common only in central Scotland.

Water Dock *Rumex hydrolapathum* HEIGHT to 2m
Large, unbranched perennial, associated with damp habitats such as ditches, river banks, canals and marshes. **FLOWERS** In tall, dense spikes (July–Sep). **FRUITS** Triangular, with few small teeth and 3 tubercles. **LEAVES** Oval, to 1m long, tapering at base. **STATUS** Widespread but absent from the north; commonest in S and E England.

Scottish Dock *Rumex aquaticus* ❀❀❀ HEIGHT to 1.5m
Similar to Water Dock but more slender and less branched. Associated with waterside vegetation but restricted to Loch Lomond. **FLOWERS** In tall, dense spikes (July–Sep). **FRUITS** Triangular, lacking tubercles. **LEAVES** Long, triangular, with a broad base. **STATUS** Found only along E shores of Loch Lomond.

Broad-leaved Dock *Rumex obtusifolius* HEIGHT to 1m
Familiar upright perennial of field margins and disturbed meadows. **FLOWERS** In loose spikes that are leafy at the base (June–Aug). **FRUITS** With prominent teeth and 1 tubercle. **LEAVES** Broadly oval, heart-shaped at the base; up to 25cm long. **STATUS** Widespread and extremely common throughout.

Clustered Dock *Rumex conglomeratus* HEIGHT to 1m
Upright perennial with a zigzag stem and spreading branches. Found in meadows and woodland margins, often on damp soil. **FLOWERS** In *leafy spikes*. **FRUITS** Small, untoothed, with 3 elongated tubercles (June–Aug). **LEAVES** Oval; basal ones heart-shaped at base and often waisted. **STATUS** Mostly common but rare in Scotland.

Fruit

Wood Dock *Rumex sanguineus* HEIGHT to 1m
Upright, straggly and branched perennial of grassy woodland rides and shady meadows. **FLOWERS** In spikes; leafy only at the base (June–Aug). **FRUITS** With a single elongated wart. **LEAVES** Oval; basal ones heart-shaped at base, sometimes red-veined and never waisted. **STATUS** Widespread and common, mainly absent from Scotland.

Leaf Fruit

Fiddle Dock *Rumex pulcher* ❀ HEIGHT to 30cm
Upright to spreading perennial with branches spreading at right angles. Favours well-drained soil, often near the coast. **FLOWERS** On spikes in widely separated whorls (June–Aug). **FRUITS** Toothed, with 3 tubercles. **LEAVES** To 10cm, *waisted and violin-shaped*. **STATUS** Local, and restricted to S England and S Wales.

Golden Dock *Rumex maritimus* ❀❀ HEIGHT to 70cm
Annual or biennial of muddy freshwater margins. *Turns golden yellow in fruit.* **FLOWERS** In dense, widely separated whorls (June–Aug). **FRUITS** With 3 tubercles and *teeth longer than valves.* **LEAVES** Lanceolate. **STATUS** Widespread but local, mainly in the south. **Marsh Dock** *R. palustris* is similar but *does not turn yellow; fruit teeth shorter than valve.*

Golden Marsh
Dock Dock
fruit fruit

■ *See also* Shore Dock (p.270)

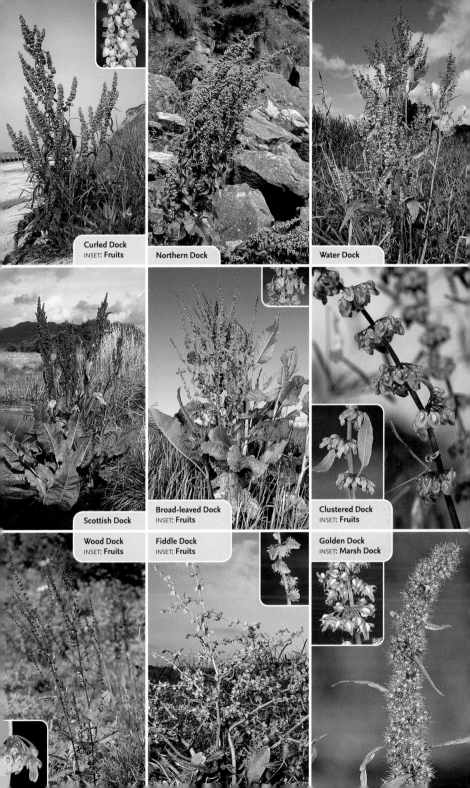

Curled Dock
INSET: Fruits

Northern Dock

Water Dock

Scottish Dock

Broad-leaved Dock
INSET: Fruits

Clustered Dock
INSET: Fruits

Wood Dock
INSET: Fruits

Fiddle Dock
INSET: Fruits

Golden Dock
INSET: Marsh Dock

Springbeauty *Claytonia perfoliata* (Portulacaceae) ❀ **HEIGHT** to 30cm
Annual, introduced from N America; naturalised on dry, sandy soil. **FLOWERS**
White, 5-petalled, 5mm across; in loose spikes (Apr–July). **FRUITS** Capsules. **LEAVES**
Oval and stalked at the base; flowering stems bear fused pairs of perfoliate leaves.
STATUS Widespread and locally abundant.

Pink Purslane *Claytonia sibirica* (Portulacaceae) ❀ **HEIGHT** to 30cm
Annual or perennial, introduced from N America. Favours damp woods. **FLOWERS**
Pink with darker veins, 5-petalled, 15–20mm across (Apr–July). **FRUITS** Capsules.
LEAVES Oval, stalked at the base; flowering stems carry opposite pairs of unstalked
leaves. **STATUS** Widely naturalised.

Blinks *Montia fontana* (Portulacaceae) **USUALLY PROSTRATE**
Low-growing, sometimes mat-forming plant of bare, damp ground; sometimes
grows partly submerged in water. Stems sometimes reddish. **FLOWERS** Tiny, white;
in terminal clusters (May–Oct). **FRUITS** Rounded capsules. **LEAVES** Narrow oval,
opposite. **STATUS** Widespread and common but least so in the south.

Hottentot-fig *Carpobrotus edulis* (Aizoaceae) ❀❀ **CREEPING**
Exotic-looking fleshy perennial, introduced from S Africa. Forms carpets on coastal
cliffs and banks. **FLOWERS** Usually yellow (sometimes fade pinkish), 7–10cm across,
many-petalled (May–Aug). **FRUITS** Swollen and succulent. **LEAVES** Dark green,
succulent, 3-sided, 6–7cm long and narrow. **STATUS** Naturalised in the south-west.

Fat-hen *Chenopodium album* (Chenopodiaceae) **HEIGHT** to 1m
Upright, branched annual of disturbed arable land. Often has a *mealy
appearance.* **FLOWERS** Whitish green, in leafy spikes (June–Oct). **FRUITS**
Rounded, and surrounded by 5 sepals, in a ring. **LEAVES** Green, matt-
looking due to a mealy coating; varying from oval to diamond-shaped.
STATUS Common. **Fig-leaved Goosefoot** *C. ficifolium* is similar but with fig-like
leaves. The flowers are greenish (July–Oct). Local on clay in central and S England.

Fat-
hen

Red Goosefoot *Chenopodium rubrum* (Chenopodiaceae)
HEIGHT to 60cm
Variable upright annual, of manure-enriched soils. Stems
often turn red in old plants. **FLOWERS** Small, numerous,
in upright, leafy spikes. **FRUITS** Rounded, enclosed by
2–4 sepals (July–Oct). **LEAVES** *Shiny, diamond-shaped,
toothed.* **STATUS** Common only in S England.

Many-seeded Goosefoot *Chenopodium polyspermum*
(Chenopodiaceae) ❀ **HEIGHT** to 60cm
Spreading or upright annual *stems square and usually reddish.*
Favours light, disturbed soils. **FLOWERS** Small, numerous, in long
spikes (July–Sep). **FRUITS** Partly enclosed by sepals. **LEAVES** *Oval,
untoothed,* decreasing in size up stem. **STATUS** Widespread in England.

Fig-leaved
Goosefoot

Red
Goosefoot

Good-King-Henry *Chenopodium bonus-henricus*
(Chenopodiaceae) ❀❀ **HEIGHT** to 50cm
Upright introduced perennial; stems often streaked red. Favours
disturbed arable land and waste ground. **FLOWERS** Numerous, in
narrow, leafless spikes (May–Aug). **FRUITS** Ringed
by sepals at the base. **LEAVES** Mealy when young but
dark green with age; triangular in outline. **STATUS** Local.

(far left)
Many-seeded Goosefoot
(left) Good-King-Henry

Frosted Orache *Atriplex laciniata* (Chenopodiaceae) ❀❀ **USUALLY PROSTRATE**
Distinctive *silvery-grey plant* that is characteristic of sandy beaches. Stems usually
flushed with pink. **FLOWERS** Whitish, in clusters (July–Sep). **FRUITS** Diamond-
shaped, toothed. **LEAVES** *Fleshy, mealy,* toothed, diamond-shaped. **STATUS**
Widespread, locally common but exclusively coastal.

■ *See also* Saltmarsh Goosefoot (p.276)

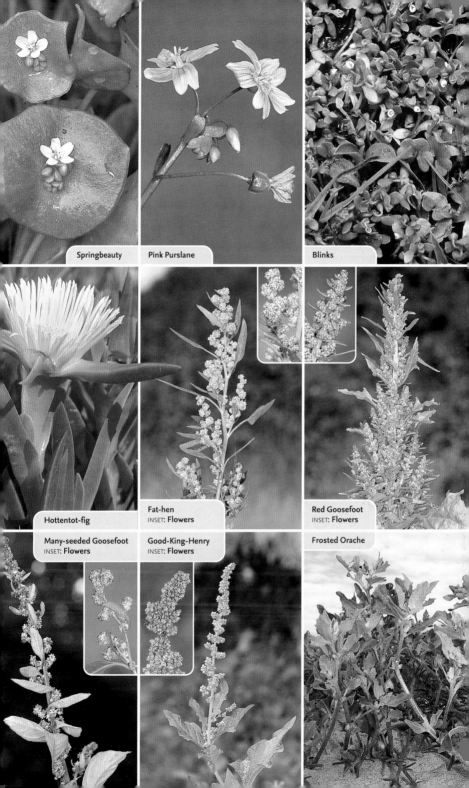

Springbeauty

Pink Purslane

Blinks

Hottentot-fig

Fat-hen
INSET: **Flowers**

Red Goosefoot
INSET: **Flowers**

Many-seeded Goosefoot
INSET: **Flowers**

Good-King-Henry
INSET: **Flowers**

Frosted Orache

Babington's Orache *Atriplex glabriuscula* ✿ **PROSTRATE**

A spreading, mealy annual. Restricted to stabilised shingle and bare, coastal ground. *Stems usually reddish; whole plant often turns red in autumn.* **FLOWERS** In leafy spikes (July–Sep). **FRUITS** Diamond-shaped, maturing silvery white. **LEAVES** Triangular or diamond-shaped. **STATUS** Locally common.

Common Orache

Common Orache *Atriplex patula* **HEIGHT** to 60cm

Variable, branched annual; sometimes upright but often prostrate. Found on bare ground. **FLOWERS** Small, greenish, in leafy spikes (July–Sep). **FRUITS** Diamond-shaped, toothless, lacking warts. **LEAVES** Toothed; *upper ones lanceolate; lower ones triangular.* **STATUS** Widespread and common.

Spear-leaved Orache *Atriplex prostrata* **HEIGHT** to 70cm

Upright annual; stems often tinged red. Favours waste and bare ground near the sea. **FLOWERS** In rather short spikes (July–Sep). **FRUITS** Triangular; surrounded by green bracts. **LEAVES** Triangular in outline; toothed; *basal, largest teeth are at right angles to the stalk.* **STATUS** Widespread and locally common.

Grass-leaved Orache *Atriplex littoralis* **HEIGHT** to 1m

Upright annual of bare coastal ground. **FLOWERS** Small, greenish, in spikes with small leaves (July–Sep). **FRUITS** Greenish, toothed, warty. **LEAVES** *Long and narrow,* sometimes with shallow teeth. **STATUS** Locally common.

Sea Beet *Beta vulgaris* ssp. *maritima* **HEIGHT** to 1m

Sprawling, clump-forming perennial of cliffs, shingle beaches and other coastal habitats. **FLOWERS** Green, in dense, leafy spikes (July–Sep). **FRUITS** Spiky; often sticking together in a clump. **LEAVES** *Dark green, glossy and leathery with reddish stems;* shape varying from oval to triangular. **STATUS** Locally common.

Sea Purslane *Atriplex portulacoides* **HEIGHT** to 1m

Spreading, mealy perennial that sometimes forms rounded clumps. Entirely coastal, and restricted to the drier reaches of saltmarshes. **FLOWERS** Yellowish, in spikes (July–Oct). **FRUITS** Lobed. **LEAVES** Grey-green, oval at the base but narrow further up the stem. **STATUS** Widespread and locally common.

Common Glasswort *Salicornia europaea* **HEIGHT** to 30cm

Fleshy, yellowish-green annual; fancifully recalls a tiny cactus. Often appears segmented. Entirely coastal. A classic saltmarsh plant that tolerates tidal immersion in sea water. **FLOWERS** Tiny; appearing at stem junctions, of *equal size* and in 3s (Aug–Sep). **FRUITS** Minute seeds. **LEAVES** Small, paired, fleshy. **STATUS** Locally abundant.

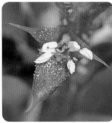

Perennial Glasswort *Sarcocornia perennis* ✿ **HEIGHT** to 30cm

Branched and patch-forming succulent perennial with woody lower stems that turn orange with age. Entirely coastal; restricted to drier reaches of saltmarshes. **FLOWERS** Small, yellow, appearing at stem junctions, in 3s, *the central one largest* (Aug–Oct). **FRUITS** Minute. **LEAVES** Small, paired, fleshy. **STATUS** Local in S and E England, and S Wales.

Prickly Saltwort *Salsola kali* **HEIGHT** to 50cm

Spiky-looking, prickly annual that is typical of sandy beaches, usually growing near the strandline. Occasionally found beside regularly salted roads inland. **FLOWERS** Tiny, yellowish; appearing at leaf bases (July–Oct). **FRUITS** Similar to flowers. **LEAVES** *Swollen, flattened-cylindrical, spiny-tipped.* **STATUS** Locally common.

Perennial Glasswort flowers

Prickly Saltwort flowers

Babington's Orache

Common Orache
INSET: Flowers

Spear-leaved Orache

Grass-leaved Orache

Sea Beet

Sea Purslane
*with Common
Sea-lavender*

Common Glasswort

Perennial Glasswort

Prickly Saltwort

Annual Sea-blite *Suaeda maritima* (Chenopodiaceae) **HEIGHT** to 50cm
Much-branched *annual* of saltmarshes. Forms small clumps that vary from yellowish green to reddish. **FLOWERS** Tiny, green; 1–3 appearing in axils of upper leaves (Aug–Oct). **FRUITS** Producing dark, flattish seeds. **LEAVES** Succulent, *cylindrical, pointed.* **STATUS** Widespread and locally common on all suitable coasts.

Shrubby Sea-blite *Suaeda vera* (Chenopodiaceae) ❀❀ **HEIGHT** to 1m
Much-branched, evergreen *perennial* with woody stems. Restricted to coastal shingle and upper saltmarshes. **FLOWERS** Tiny, yellowish green; 1–3 appearing in leaf axils (June–Oct). **FRUITS** Producing rounded, black seeds. **LEAVES** Succulent, bluish green, blunt and almost *semicircular in cross-section.* **STATUS** Locally common in SE England.

Thyme-leaved Sandwort *Arenaria serpyllifolia* (Caryophyllaceae) **USUALLY PROSTRATE**
Downy, grey-green annual of dry, bare soils. **FLOWERS** White, 5-petalled, 5–7mm across (May–Sep); green sepals shorter than petals. **FRUITS** Pear-shaped. **LEAVES** Oval; in opposite pairs on slender stems. **STATUS** Widespread and common.

Three-nerved Sandwort

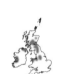

Three-nerved Sandwort *Moehringia trinervia* (Caryophyllaceae) **HEIGHT** to 40cm
Straggly, downy annual of undisturbed woodlands. **FLOWERS** White, 5-petalled, 5–6mm across; on long stalks (Apr–July). White-margined green sepals are twice as long as the petals. **FRUITS** Capsules. **LEAVES** Ovate, with 3–5 *obvious veins beneath.* **STATUS** Widespread and locally common.

Spring Sandwort *Minuartia verna* (Caryophyllaceae) ❀❀ **HEIGHT** to 10cm
Slightly downy perennial that is characteristic of bare limestone soils or spoil from lead-mines. **FLOWERS** White, 5-petalled, 7–9mm across (May–Sep). Green sepals shorter than petals. **FRUITS** Capsules. **LEAVES** Narrow, 3-veined; in whorls on slender stems. **STATUS** Local and extremely habitat-specific.

Cyphel *Minuartia sedoides* (Caryophyllaceae) ❀❀ **HEIGHT** to 3cm
Distinctive, *cushion-forming perennial* of damp, stony ground on mountain tops. **FLOWERS** Yellow, 4mm across; lacking petals (June–Aug). **FRUITS** Capsules. **LEAVES** Narrow, fleshy, densely packed. **STATUS** Restricted to mountains in the Scottish Highlands and a few Scottish islands.

Sea Sandwort *Honckenya peploides* (Caryophyllaceae) **PROSTRATE**
Mat-forming perennial that is familiar on stabilised coastal shingle and sandy beaches. **FLOWERS** Greenish white, 6–8mm across (May–Aug). Petals slightly shorter than sepals. **FRUITS** *Yellowish green, pea-like.* **LEAVES** Oval, fleshy; in opposite pairs on creeping stems. **STATUS** Locally common around coasts.

Greater Stitchwort *Stellaria holostea* (Caryophyllaceae) **HEIGHT** to 50cm
Familiar perennial of open woodland, woodland rides and hedgerows. Note *rough-edged stems.* **FLOWERS** White, with 5 notched petals; on slender stems (Apr–June). **FRUITS** Capsules. **LEAVES** Narrow, *fresh green, rough-edged* and grass-like; easily overlooked in the absence of flowers. **STATUS** Widespread and common.

Marsh Stitchwort *Stellaria palustris* (Caryophyllaceae) ❀❀ **HEIGHT** to 60cm
Rather straggly perennial of fens and marshes. Similar to Greater Stitchwort but with *smooth stems* and *smooth-edged leaves.* **FLOWERS** White, 12–20mm across, with 5 deeply notched petals (May–Aug). **FRUITS** Capsules. **LEAVES** *Grey-green,* narrow. **STATUS** Extremely local.

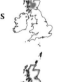
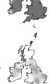

■ *See also* Arctic Sandwort (p.283)

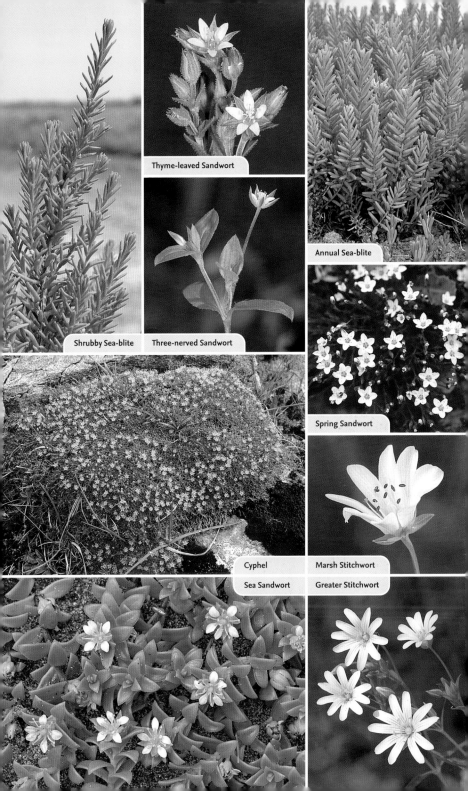

Thyme-leaved Sandwort

Annual Sea-blite

Shrubby Sea-blite

Three-nerved Sandwort

Spring Sandwort

Cyphel

Marsh Stitchwort

Sea Sandwort

Greater Stitchwort

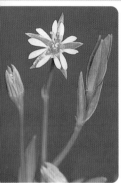

Bog Stitchwort

Lesser Stitchwort *Stellaria graminea* HEIGHT to 50cm
Perennial of open woodland, meadows and hedgerows, mainly on acid soils. Note *smooth-edged stems.* FLOWERS White, 5–15mm across, with 5 deeply divided petals (May–Aug). FRUITS Capsules. LEAVES Long, narrow, smooth-edged and grass-like. STATUS Widespread and common throughout.
Bog Stitchwort *S. alsine* is similar but tiny and straggling. Flowers 5–7mm across, petals deeply divided and shorter than sepals (May–June). Widespread in damp places.

Wood Stitchwort *Stellaria nemorum* 🌢🌢 HEIGHT to 60cm
Rather straggly perennial with hairy stems. Found in damp woodland. FLOWERS White, 15–20mm across, the petals deeply divided into narrow lobes (May–Aug). Petals twice as long as sepals. FRUITS Capsules. LEAVES Oval, pointed; the lower ones stalked, the upper ones sessile. STATUS Widespread but local.

Common Chickweed *Stellaria media* HEIGHT to 30cm
Annual of disturbed ground. Sometimes prostrate. Stems hairy in lines on alternate sides between leaf nodes. FLOWERS White, 5-petalled, 5–10mm across; *3–8 stamens* (Jan–Dec). FRUITS Capsules on long, drooping stalks. LEAVES Oval, fresh green and opposite; upper ones unstalked. STATUS Widespread and common.

Greater Chickweed *Stellaria neglecta* 🌢 HEIGHT to 50cm
Annual or short-lived perennial of damp, shady ground. Similar to Common Chickweed but more robust. Stems hairy in lines on alternate sides between leaf nodes. FLOWERS White, 5-petalled, 10–12mm across; *10 stamens* (Apr–July). FRUITS Capsules. LEAVES Oval, in opposite pairs. STATUS Local.

Common Mouse-ear *Cerastium fontanum* HEIGHT to 30cm
Hairy perennial, found in gardens and grasslands, and on disturbed ground. Flowering and non-flowering shoots occur. FLOWERS White, 5–7mm across, with 5 deeply notched petals (Apr–Oct). FRUITS Capsules. LEAVES Grey-green, in opposite pairs. STATUS Widespread and common throughout.

Sticky Mouse-ear *Cerastium glomeratum* HEIGHT to 40cm
Annual with *sticky, glandular hairs.* Found on dry, bare ground. FLOWERS White, 10–15mm across, with 5 deeply notched petals; in compact, clustered heads (Apr–Oct). FRUITS Capsules. LEAVES Pointed-ovate, in opposite pairs. STATUS Widespread and common throughout.

Alpine Mouse-ear *Cerastium alpinum* 🌢🌢 HEIGHT to 10cm
Tufted, mat-forming perennial whose *stems and leaves bear long white hairs.* Found on stony ground on mountains. FLOWERS White, 18–25mm across, with 5 notched petals (June–Aug). FRUITS Capsules. LEAVES Ovate, the bracts having membranous margins. STATUS Local and scarce, restricted to mountains.

Field Mouse-ear *Cerastium arvense* 🌢 HEIGHT to 30cm
Spreading, downy perennial of dry, free-draining ground, mainly on calcareous or gravelly soils. Sometimes forms sizeable patches. FLOWERS White, 12–20mm across, with 5 deeply notched petals (Apr–Aug). FRUITS Capsules. LEAVES Ovate, paired. STATUS Local, mainly in E England.

Sea Mouse-ear *Cerastium diffusum* 🌢 HEIGHT to 30cm
Low annual that is sometimes prostrate. Covered in *sticky hairs* and found on sandy ground, mainly near the sea. FLOWERS White, 3–6mm across, with 4 notched petals (Apr–July). FRUITS Capsules. LEAVES Ovate, dark green; bracts do not have transparent margins. STATUS Locally common near the coast but scarce inland.

■ *See also* Shetland Mouse-ear (p.285)

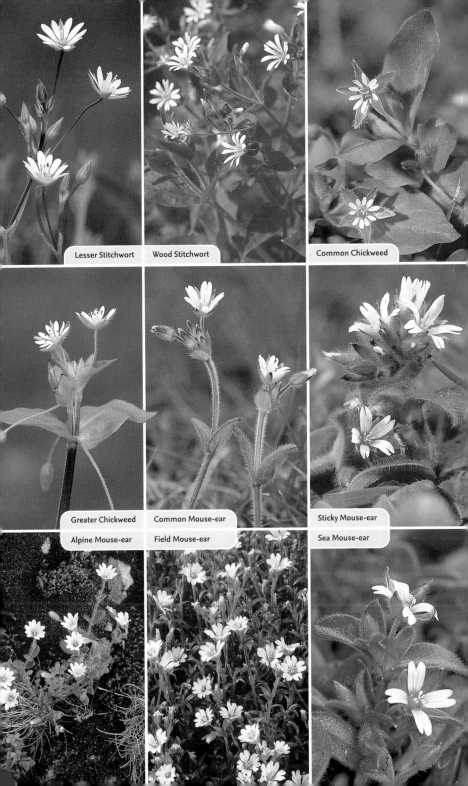

Lesser Stitchwort

Wood Stitchwort

Common Chickweed

Greater Chickweed

Common Mouse-ear

Sticky Mouse-ear

Alpine Mouse-ear

Field Mouse-ear

Sea Mouse-ear

Water Chickweed *Myosoton aquaticum* HEIGHT to 1m
Straggling perennial of damp, grassy ground and river margins. FLOWERS White, 12–20mm across, with 5 deeply divided petals *(much longer than sepals)* (June–Oct). FRUITS Capsules. LEAVES Heart-shaped with wavy edges; in opposite pairs, upper leaves unstalked. STATUS Common in England and Wales; scarce elsewhere.

Upright Chickweed *Moenchia erecta* ✿ HEIGHT to 8cm
Tiny, upright annual of short, dry grassland, typically on gravelly or sandy soils. FLOWERS White with 4 petals, opening only in bright sunshine (Apr–June). Sepals *white-edged and longer than petals.* FRUITS Capsules. LEAVES Waxy grey-green, stiff, narrow. STATUS Local in England and Wales only.

Annual Pearlwort *Sagina apetala* HEIGHT to 8cm
Straggling, wiry annual of short, dry grassland and bare ground, usually on sandy soils. No basal rosette. FLOWERS With minute greenish petals and 4 longer *greenish sepals that spread in fruit;* on long stems (Apr–Aug). FRUITS Capsules. LEAVES Narrow, bristle-tipped, with hairy margins. STATUS Widespread and common.

Sea Pearlwort *Sagina maritima* ✿ HEIGHT to 8cm
Wiry annual that is similar to Annual Pearlwort but *fleshy.* Found on bare, dry ground, mainly near the sea. FLOWERS With minute greenish petals and 4 longer *purplish sepals that do not spread in fruit* (May–Sep). FRUITS Capsules. LEAVES Fleshy, blunt (no bristle). STATUS Widespread but local.

Heath Pearlwort *Sagina subulata* ✿ HEIGHT to 10cm
Mat-forming, downy perennial with a basal rosette. Found on dry, sandy or gravelly soils. FLOWERS With 5 white petals that are equal to, or longer than, sepals; on slender, stickily hairy stalks (May–Aug). FRUITS Capsules. LEAVES Narrow, *bristle-tipped* and downy. STATUS Locally common in the north and west; scarce or absent elsewhere.

Knotted Pearlwort *Sagina nodosa* ✿ HEIGHT to 12cm
Wiry perennial; stems look 'knotted' due to clustered arrangement of leaves. Found on damp, sandy soils; often coastal. FLOWERS White, 10mm across, with 5 petals that are twice as long as sepals; 5 styles (cf. Spring Sandwort, p.34) (July–Sep). FRUITS Capsules. LEAVES Short, clustered. STATUS Widespread but local.

Procumbent Pearlwort *Sagina procumbens* PROSTRATE
Creeping perennial of damp, bare ground. Forms mats comprising a central rosette with radiating shoots that root at intervals, giving rise to erect flowering stems. FLOWERS *Green, petal-less* and borne on side shoots (May–Sep). FRUITS Capsules. LEAVES Narrow, bristle-tipped but not hairy. STATUS Widespread and common. **Four-leaved Allseed** *Polycarpon tetraphyllum* is a much-branched annual with leaves in 2s and 4s. Flowers are tiny and whitish. Common only on Isles of Scilly; rare near coast in SW England.

Four-leaved Allseed

Corn Spurrey *Spergula arvensis* HEIGHT to 30cm
Straggling, stickily hairy annual. A weed of arable land with sandy soils. FLOWERS 4–7mm across, with 5 whitish petals (May–Aug). FRUITS Capsules; longer than sepals and drooping at first. LEAVES Narrow, in whorls along the stems. STATUS Widespread but less common than formerly, through herbicide use.

Rock Sea-spurrey *Spergularia rupicola* ✿ HEIGHT to 20cm
Stickily hairy perennial, often with purplish stems. Found on cliffs and rocky places near the sea. Sometimes forms clumps with woody bases. FLOWERS Pink, 8–10mm across, with 5 petals (petals and sepals equal) (June–Sep). FRUITS Capsules. LEAVES Narrow, flattened and fleshy, in whorls. STATUS Locally common in the west.

■ *See also* Strapwort (p.270), Fringed Rupturewort (p.272), Coral-necklace (p.275), Smooth Rupturewort (p.279) and Alpine Pearlwort (p.283)

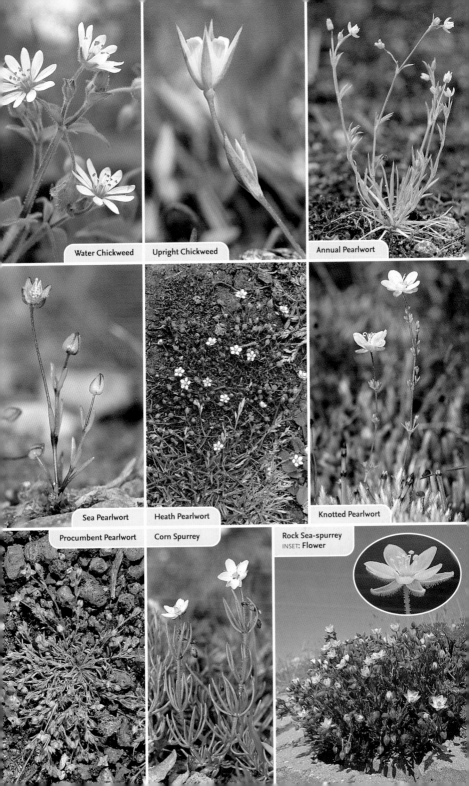

Water Chickweed

Upright Chickweed

Annual Pearlwort

Sea Pearlwort

Heath Pearlwort

Knotted Pearlwort

Procumbent Pearlwort

Corn Spurrey

Rock Sea-spurrey
INSET: Flower

Greater Sea-spurrey *Spergularia media* HEIGHT to 10cm
Robust, fleshy perennial associated with the drier, upper reaches of saltmarshes. FLOWERS Pinkish white, 7–12mm across, the 5 petals *longer than the sepals* (June–Sep). FRUITS Capsules. LEAVES Fleshy, bristle-tipped, semicircular in cross-section. STATUS Widespread and common around coasts.

Lesser Sea-spurrey *Spergularia marina* PROSTRATE
Straggling, often stickily hairy annual. Found on the drier, grassy upper margins of saltmarshes. FLOWERS Deep pink, 6–8mm across; 5 petals *shorter than the sepals* (May–Aug). FRUITS Capsules. LEAVES Narrow, fleshy, pointed; in opposite pairs on trailing stems. STATUS Widespread and locally common around the coast.

Sand Spurrey *Spergularia rubra* PROSTRATE
Straggling, stickily hairy annual or biennial. Found on dry, sandy ground. FLOWERS Pink, 3–5mm across; 5 petals shorter than sepals (May–Sep). FRUITS Capsules. LEAVES Grey-green, narrow, bristle-tipped; in whorls with silvery, lanceolate stipules. STATUS Widespread and locally common.

Bladder Campion *Silene vulgaris* HEIGHT to 80cm
Upright perennial of dry grassland on well-drained soil; often on chalk. FLOWERS White, drooping, 16–18mm across (June–Aug); petals deeply divided; *calyx swollen to form a purple-veined bladder.* FRUITS Capsules. LEAVES Grey-green, oval; in opposite pairs. STATUS Widespread but common only in the south.

Sea Campion *Silene uniflora* HEIGHT to 20cm
Cushion-forming perennial that is confined to coastal habitats, notably cliffs and shingle beaches. FLOWERS White, 20–25mm across, with overlapping petals; on upright stems (June–Aug). FRUITS Capsules. LEAVES Grey-green, waxy, fleshy. STATUS Widespread and locally common around the coast.

White Campion *Silene latifolia* HEIGHT to 1m
Hairy, branched perennial of disturbed ground and grassy habitats. Sometimes hybridises with Red Campion. FLOWERS White, 25–30mm across, with 5 petals; dioecious, male flowers smaller than females (May–Oct). FRUITS With erect teeth. LEAVES Oval, in opposite pairs. STATUS Widespread and common.

Moss Campion *Silene acaulis* ✿✿ PROSTRATE
Charming, *cushion-forming perennial*. Found on mountain tops and rocky ledges, but also near the sea in the far north. FLOWERS Pink, 9–12mm across, with 5 petals (June–Aug). FRUITS Capsules. LEAVES Narrow, densely packed, giving the cushion a moss-like appearance. STATUS Local on suitable mountains, from Wales northwards.

Moss Campion

Red Campion *Silene dioica* HEIGHT to 1m
Hairy biennial or perennial of hedgerows, grassy banks and wayside places generally. FLOWERS Reddish pink, 20–30mm across; male flowers smaller than females and on separate plants (Mar–Oct). FRUITS Revealing 10 reflexed teeth when ripe. LEAVES Hairy, in opposite pairs. STATUS Widespread and common.

Nottingham Catchfly *Silene nutans* ✿✿
HEIGHT to 50cm
Slightly downy and sticky perennial of calcareous grassland and shingle beaches. FLOWERS Nodding, 17mm across; pinkish-white petals are inrolled in the daytime but roll back at dusk (May–July). FRUITS Capsules. LEAVES Oval; lower ones stalked but stem leaves unstalked. STATUS Local and scattered.

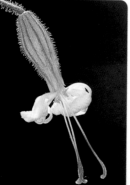

Nottingham Catchfly
flower in daytime

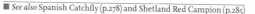
■ See also Spanish Catchfly (p.278) and Shetland Red Campion (p.285).

Lesser Sea-spurrey

Greater Sea-spurrey

Sand Spurrey

Bladder Campion

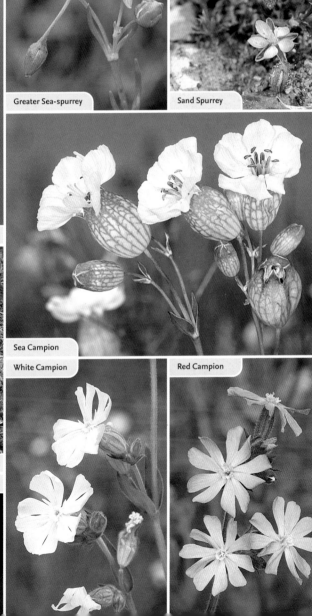

Sea Campion

White Campion

Red Campion

Moss Campion

Nottingham Catchfly

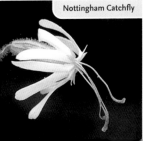

Night-flowering Catchfly *Silene noctiflora* ✿✿✿ HEIGHT to 60cm

Stickily hairy annual of arable fields, mainly on chalk or sandy soils. FLOWERS Similar to White Campion but with petals pinkish above, yellowish below; *inrolled by day, opening at night*, when they are scented (May–July). FRUITS Capsules with 6 reflexed teeth. LEAVES Ovate. STATUS Local and declining.

Small-flowered Catchfly *Silene gallica* ✿✿

HEIGHT to 40cm
Stickily hairy annual of arable land and disturbed, mainly sandy soils. FLOWERS Pinkish or white, and sometimes flushed red at the base (var. *quinquevulnera*, *see* photo left), 10–12mm across; in 1-sided spikes (June–Oct). FRUITS Inflated capsules. LEAVES Hairy, upper ones narrower than basal ones. STATUS Widespread but local and generally scarce. Restricted to unimproved arable fields.

Sand Catchfly *Silene conica* ✿✿✿ HEIGHT to 35cm

Upright, stickily hairy, greyish-green annual. Found on sandy soils, mainly coastal. FLOWERS 4–5mm across, with 5 notched and pinkish petals; in clusters (May–July). FRUITS Forming within *inflated, flagon-shaped capsules*. LEAVES Narrow, downy. STATUS Local and scarce, restricted mainly to coastal SE England.

Soapwort *Saponaria officinalis* ✿ HEIGHT to 1m

Straggling, hairless perennial with brittle stems. Found on roadside verges and waste ground, and in damp woodland. FLOWERS Pink, 25–35mm across (June–Aug). FRUITS Capsules. LEAVES Narrowly oval, distinctly veined. STATUS Possibly native in a few sites but mainly a naturalised garden escape.

Ragged-robin *Lychnis flos-cuculi* HEIGHT to 65cm

Delicate-looking perennial of damp meadows, fens and marshes. FLOWERS Pink, with 5 petals, each divided into 4 'ragged' lobes (May–Aug). FRUITS Capsules. LEAVES Narrow, grass-like, rough; upper ones in opposite pairs. STATUS Widespread and common, but decreasing through agricultural changes (e.g. land drainage).

Maiden Pink *Dianthus deltoides* ✿✿✿ HEIGHT to 20cm

Hairy perennial that sometimes forms clumps. Associated with dry, sandy soils. FLOWERS 18–20mm across, with 5 pink petals that show white basal spots and have toothed margins (June–Sep). FRUITS Capsules. LEAVES Narrow, rough-edged, grey-green. STATUS Widespread but extremely local.

Deptford Pink *Dianthus armeria* ✿✿✿ HEIGHT to 60cm

Dark green, slightly hairy annual. Found in dry, grassy places, mainly on chalk or sandy soils. FLOWERS 9–13mm across, with reddish-pink petals that have toothed margins and pale spots; in clusters (June–Aug). Note the long bracts. FRUITS Capsules. LEAVES Narrow. STATUS Scarce and local.

Corncockle *Agrostemma githago* ✿✿✿ HEIGHT to 70cm

Distinctive, downy annual. Associated with arable fields. FLOWERS 30–45mm across, with 5 pinkish-purple petals and long, narrow and radiating sepals (May–Aug). FRUITS Capsules. LEAVES Narrow, grass-like. STATUS Formerly widespread and common but now extremely scarce and erratic because of agricultural herbicides.

Annual Knawel *Scleranthus annuus* HEIGHT to 10cm

Yellowish-green annual. Associated with dry, bare soil and arable land. FLOWERS Comprising green, pointed sepals and no petals; in clustered heads (May–Aug). FRUITS Capsules. LEAVES Narrow, pointed; in opposite pairs along the wiry stems. STATUS Locally common throughout.

Annual Knawel

■ *See also* Cheddar Pink (p.270), Childing Pink (p.276), Alpine Catchfly (p.281) and Perennial Knawel (p.281)
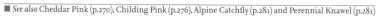

Night-flowering Catchfly

Sand Catchfly

Small-flowered Catchfly

Annual Knawel

Ragged-robin

Maiden Pink

Soapwort

Deptford Pink

Corncockle

Stinking Hellebore *Helleborus foetidus* ❀❀ HEIGHT to 75cm
Robust, strong-smelling perennial of woodland on calcareous soils. FLOWERS Green with *purple margins*, 15–30mm across, bell-shaped; in clusters (Jan–May). FRUITS Dry, many-seeded and splitting. LEAVES Divided into toothed lobes; lower ones persist through winter. STATUS Local and restricted to central and S England and Wales.

Green Hellebore *Helleborus viridis* ❀❀ HEIGHT to 60cm
Scentless perennial of woodland on calcareous soils. FLOWERS *Green (including the margins)* with pointed sepals but no petals; in clusters (Feb–Apr). FRUITS Dry, many-seeded and splitting. LEAVES Divided into bright green, elongate lobes; not evergreen. STATUS Local and scarce, in central and S England and Wales.

Winter Aconite *Eranthis hyemalis* ❀❀ HEIGHT to 10cm
Attractive perennial that sometimes forms carpets on woodland floors. FLOWERS 12–15mm across, with 6 yellow sepals; on upright stems, above the leaves (Jan–Apr). FRUITS Dry, many-seeded and splitting. LEAVES Spreading (3 per stem) and each divided into 3 lobes. STATUS Introduced but widely naturalised.

Love-in-a-mist *Nigella damascena* ❀❀ HEIGHT to 40cm
Upright, hairless annual, associated with disturbed ground and roadside verges. FLOWERS Comprising 5 petal-like blue sepals; solitary and terminal (June–July). FRUITS Inflated capsules. LEAVES Divided into narrow segments and arranged as a ruff below the flowers. STATUS Widely cultivated and sometimes naturalised briefly.

Marsh-marigold *Caltha palustris* HEIGHT to 25cm
Widespread perennial with stout, hollow stems. Found in damp woodland, marshes and wet meadows. FLOWERS Yellow, 25–30mm across, with 5 petal-like sepals but no petals (Mar–July). FRUITS Capsules. LEAVES Kidney-shaped, shiny, up to 10cm across. STATUS Widespread and locally common, but range is contracting.

Globeflower *Trollius europaeus* ❀❀ HEIGHT to 60cm
Attractive perennial of damp, upland and northern meadows. FLOWERS Spherical, 30–40mm across, with 10–15 yellow sepals; on long, upright stems (May–Aug). FRUITS Many-seeded, dry. LEAVES Palmately divided into toothed lobes. STATUS Absent from the south but very locally common from N Wales to Scotland, also NW Ireland.

Baneberry *Actaea spicata* ❀❀ HEIGHT to 70cm
Robust and hairless perennial of woodland (typically Ash) on limestone, and limestone pavements. FLOWERS White and feathery with 4–6 petals; in spikes (May–June). FRUITS Berries, green at first but ripening black. LEAVES Pinnately divided into toothed lobes. STATUS Local, restricted to N England.

Monk's-hood

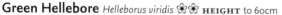

Monk's-hood *Aconitum napellus* ❀❀ HEIGHT to 1m
Dark green, almost hairless perennial of damp woodland, often beside streams. FLOWERS Bluish violet, 20mm across, helmeted; in upright spikes (May–Aug). FRUITS Dry, many-seeded. LEAVES Deeply divided into palmate lobes. STATUS Local, mainly in the south and south-west. Beware confusion with naturalised garden *Aconitum* species.

Larkspur *Consolida ajacis* ❀❀ HEIGHT to 30cm
Downy annual that is occasionally found in arable field margins. FLOWERS Bluish, comprising 5 petal-like sepals and a long, backward-pointing spur; in loose spikes (June–Aug). FRUITS Dry, many-seeded. LEAVES Deeply divided into palmate lobes. STATUS Introduced (often grown in gardens) and occasional.

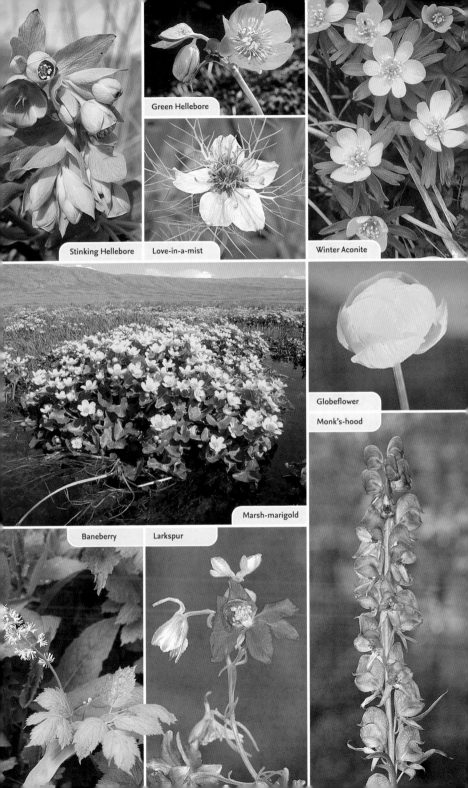

Stinking Hellebore

Green Hellebore

Love-in-a-mist

Winter Aconite

Marsh-marigold

Globeflower

Monk's-hood

Baneberry

Larkspur

Pheasant's-eye *Adonis annua* **HEIGHT** to 40cm
Branched, hairless annual of arable fields on chalky soils. **FLOWERS** Comprising 5–8 bright red petals that are blackish at the base (June–Aug). **FRUITS** Long-stalked, elongate, wrinkled. **LEAVES** Pinnately divided and feathery, upper ones partly shrouding flowers. **STATUS** Rare and decreasing because of agricultural herbicides.

Mousetail *Myosurus minimus* 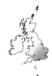 **HEIGHT** to 10cm
Tufted, inconspicuous annual of arable field margins, often on sandy soil. **FLOWERS** Long-stalked, 5mm across, with yellowish-green petals and sepals (Mar–July). **FRUITS** Elongate, plantain-like (*see* pp.188–189), to 7cm long. **LEAVES** Narrow, grass-like. **STATUS** Scarce and declining, mainly in S England.

Meadow Buttercup *Ranunculus acris* **HEIGHT** to 1m
Downy perennial of damp grassland habitats. **FLOWERS** 18–25mm across, comprising 5 shiny, yellow petals with upright sepals; on long, unfurrowed stalks (Apr–Oct). **FRUITS** Hook-tipped, in a rounded head. **LEAVES** Rounded outline, but divided into 3–7 lobes; upper ones unstalked. **STATUS** Widespread and abundant throughout.

Meadow Buttercup

Creeping Buttercup *Ranunculus repens* **HEIGHT** to 50cm
Often unwelcome perennial of lawns and other grassy places. Long, rooting runners aid its spread. **FLOWERS** 20–30mm across, with 5 yellow petals and upright sepals; on furrowed stalks (May–Aug). **FRUITS** In rounded heads. **LEAVES** Hairy; divided into 3 lobes; *middle lobe is stalked*. **STATUS** Widespread and common.

Creeping Buttercup

Bulbous Buttercup

Bulbous Buttercup *Ranunculus bulbosus* **HEIGHT** to 40cm
Hairy perennial of dry grassland, including chalk downs. Note the swollen stem base. **FLOWERS** 20–30mm across with 5 *bright yellow petals and reflexed sepals*; on furrowed stalks (Mar–July). **FRUITS** Smooth. **LEAVES** Divided into 3 lobes, each of which is stalked. **STATUS** Widespread and often abundant.

Hairy Buttercup *Ranunculus sardous* 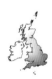 **HEIGHT** to 40cm
Hairy annual of grassy places, especially near the coast. **FLOWERS** 15–25mm across with 5 *pale yellow petals and reflexed sepals* (May–Oct). **FRUITS** With a green border, inside which they are adorned with warts. **LEAVES** Divided into 3 lobes; mainly basal. **STATUS** Local, mainly in the south and in coastal habitats.

Corn Buttercup *Ranunculus arvensis* **HEIGHT** to 40cm
Downy annual of arable fields. **FLOWERS** 10–12mm across with 5 *pale lemon-yellow petals* (May–July). **FRUITS** Distinctly *spiny and bur-like*. **LEAVES** *Divided into narrow lobes*. **STATUS** Formerly widespread but now scarce, local and declining because of agricultural herbicide use; regular only in S England.

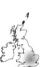
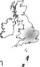
Goldilocks Buttercup

Goldilocks Buttercup *Ranunculus auricomus* 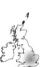 **HEIGHT** to 30cm
Slightly hairy perennial of damp, undisturbed woodland. **FLOWERS** 15–25mm across with *yellow petals, 1 or more of which is sometimes imperfect or absent* (Apr–May). **FRUITS** Roughly hairy. **LEAVES** Rounded, 3-lobed basal leaves, *narrowly lobed stem leaves*. **STATUS** Widespread but local and declining.

Small-flowered Buttercup *Ranunculus parviflorus* **HEIGHT** to 30cm
Sprawling, hairy annual of dry, bare ground, often on sandy soils. **FLOWERS** *3–5mm across with pale yellow petals*; on furrowed stalks, often arising from the fork of a branch (May–July). **FRUITS** Roughly hairy. **LEAVES** Rounded and lobed (basal leaves); stem leaves narrowly lobed. **STATUS** Local in S England and S Wales.

■ *See also* Scilly Buttercup (p.273) and Jersey Buttercup (p.274)

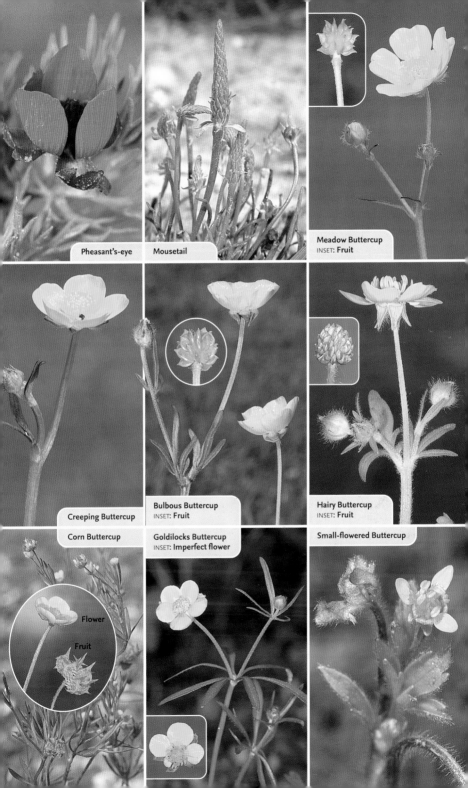

Pheasant's-eye

Mousetail

Meadow Buttercup
INSET: **Fruit**

Creeping Buttercup

Bulbous Buttercup
INSET: **Fruit**

Hairy Buttercup
INSET: **Fruit**

Corn Buttercup

Goldilocks Buttercup
INSET: **Imperfect flower**

Small-flowered Buttercup

Flower

Fruit

Greater Spearwort *Ranunculus lingua* ✿ HEIGHT to 1m
Robust, upright perennial of fens and the shallow margins of ponds and lakes.
Plant has long runners. FLOWERS 20–40mm across with 5 yellow petals; on furrowed
stalks (June–Sep). FRUITS Rough, winged, with a curved beak. LEAVES Narrow,
25cm long, sometimes toothed. STATUS Widespread but local.

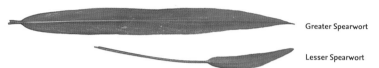

Greater Spearwort

Lesser Spearwort

Lesser Spearwort *Ranunculus flammula* HEIGHT to 50cm
Upright or creeping perennial. Often roots where leaf nodes touch the ground.
Favours damp ground, often beside rivers. FLOWERS 5–15mm across, usually solitary;
on furrowed stalks (June–Oct). FRUITS Beaked but not winged. LEAVES Oval basal
leaves; stem leaves narrow. STATUS Widespread, commonest in the north.

Celery-leaved Buttercup *Ranunculus sceleratus* HEIGHT to 50cm
Yellowish-green annual with hollow stems. Favours marshes and wet
grazing meadows, often on trampled ground. FLOWERS 5–10mm
across with pale yellow petals; in clusters (May–Sep). FRUITS With
elongated heads. LEAVES *Celery-like, divided into 3 lobes* (basal leaves);
stem leaves less divided. STATUS Locally common in the south.

Celery-leaved
Buttercup

Lesser Celandine *Ranunculus ficaria* HEIGHT to 25cm
Perennial of hedgerows and open woodland; sometimes forms patches.
FLOWERS 20–30mm across with 8–12 shiny yellow petals and 3 sepals
(Mar–May); opening only in sunshine. FRUITS In a rounded head.
LEAVES *Heart-shaped, glossy, dark green.* STATUS Common.

Common Water-crowfoot *Ranunculus aquatilis* FLOATING
Annual or perennial found in both slow-flowing and still waters.
FLOWERS 12–20mm across with 5 white petals (Apr–Aug). FRUITS In
rounded heads. LEAVES *Thread-like submerged leaves and floating ones
that are entire but with toothed lobes.* STATUS Widespread and common.

Lesser Celandine

Stream Water-crowfoot *Ranunculus pencillatus* ✿ FLOATING
Annual or perennial of fast-flowing chalk streams and rivers. FLOWERS 15–25mm
across with 5 white petals (May–July). FRUITS In rounded heads. LEAVES *Lobed,
rounded floating leaves and long, thread-like submerged ones that collapse out of water.*
STATUS Locally common, but mainly in the south.

Ivy-leaved Crowfoot *Ranunculus hederaceus* ✿ CREEPING
Creeping annual or biennial, associated with bare muddy places close to water.
FLOWERS 3–6mm across with 5 white petals, and sepals of similar length
(May–Aug). FRUITS In rounded heads. LEAVES *Vaguely ivy-like, being rounded or
kidney-shaped with lobed margins.* STATUS Widespread but local.

Pond Water-crowfoot *Ranunculus peltatus* FLOATING
Annual or perennial of ponds, lakes and other areas of still water. FLOWERS
15–30mm across with 5 white petals (May–Aug). FRUITS In rounded, long-stalked
heads. LEAVES *Lobed, rounded floating leaves and short, rigid, thread-like submerged
ones.* STATUS Widespread and common throughout.

Brackish Water-crowfoot *Ranunculus baudotii* ✿ FLOATING
Annual or perennial of brackish pools, ditches and channels near the coast.
FLOWERS 12–18mm across with 5 white petals (Apr–Aug). FRUITS In rounded,
long-stalked heads. LEAVES *Deeply lobed floating leaves and thread-like submerged
ones that do not collapse out of water.* STATUS Local around the coast.

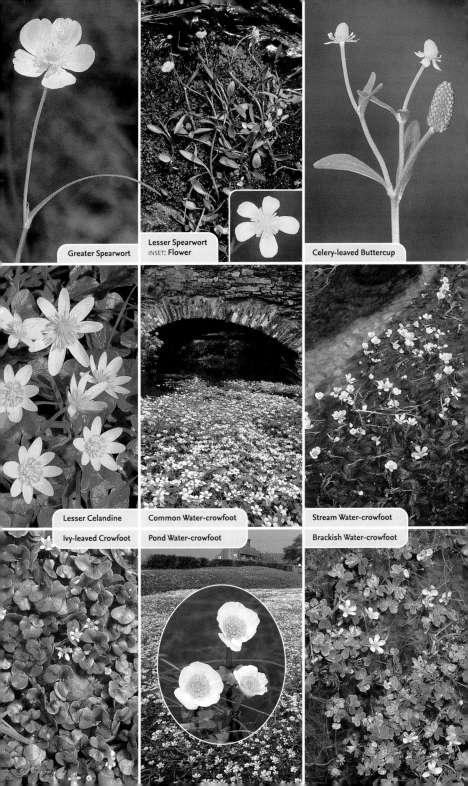

Greater Spearwort

Lesser Spearwort
INSET: **Flower**

Celery-leaved Buttercup

Lesser Celandine

Common Water-crowfoot

Stream Water-crowfoot

Ivy-leaved Crowfoot

Pond Water-crowfoot

Brackish Water-crowfoot

Round-leaved Crowfoot *Ranunculus omiophyllus* ✿ FLOATING

Creeping annual or biennial. Favours damp, muddy places, often water seepages.
FLOWERS 8–12mm across, with 5 white petals twice as long as sepals (May–Aug).
FRUITS In rounded heads. **LEAVES** *Lobed and rounded.* **STATUS** Rather local and
restricted mainly to S and W England and Wales, and S Ireland.

River Water-crowfoot *Ranunculus fluitans* FLOATING

Robust perennial. Forms extensive carpets in suitable fast-flowing streams and
rivers. **FLOWERS** 20–30mm across with 5 white, overlapping petals (May–Aug).
FRUITS In rounded heads. **LEAVES** Divided into *narrow, thread-like segments;*
submerged leaves only. **STATUS** Widespread in England but scarce elsewhere.

Columbine *Aquilegia vulgaris* ✿✿ HEIGHT to 1m

Familiar garden perennial but also a native plant, favouring
open woods on calcareous soils. **FLOWERS** Nodding, purple,
30–40mm long, the petals with hook-tipped spurs (May–July).
FRUITS Dry, many seeded. **LEAVES** Grey-green and comprising
3-lobed leaflets. **STATUS** Widespread but extremely local as a
native species.

Columbine

Wood Anemone *Anemone nemorosa* HEIGHT to 30cm

Perennial that sometimes forms large carpets on suitable woodland floors.
FLOWERS Solitary, comprising 5–10 white or pinkish petal-like sepals (Mar–May).
FRUITS Beaked, in rounded clusters. **LEAVES** On stems, long-stalked and divided
into 3 lobes, each being further divided. **STATUS** Widespread and locally common.

Pasqueflower *Pulsatilla vulgaris* ✿✿✿ HEIGHT to 25cm

Silkily-hairy perennial of dry, calcareous grassland. **FLOWERS** Purple, bell-shaped
with 6 petal-like sepals; upright at first, then nodding (Apr–May). **FRUITS**
Comprising seeds with long silky hairs. **LEAVES** Divided 2 or 3 times and comprising
narrow leaflets. **STATUS** Rare and restricted to a few sites in S and E England.

Traveller's-joy *Clematis vitalba* ✿ LENGTH to 20m

Scrambling hedgerow perennial of chalky soils. **FLOWERS** Creamy, with prominent
stamens; in clusters (July–Aug). **FRUITS** Comprising clusters of seeds with woolly,
whitish plumes, hence plant's alternative name of **Old Man's Beard**. **LEAVES** Divided
into 3–5 leaflets. **STATUS** Locally common in central and S England, and Wales.

Common Meadow-rue *Thalictrum flavum* ✿ HEIGHT to 1m

Upright perennial of damp meadows, ditches and fens; favours basic soils.
FLOWERS With small petals that drop, but showy, yellow anthers; in dense clusters
(June–Aug). **FRUITS** Dry, papery. **LEAVES** Fern-like and pinnately divided 2 or 3
times into toothed lobes. **STATUS** Widespread but local, common only in the
south and east.

Lesser Meadow-rue *Thalictrum minus* ✿✿ HEIGHT to 1m

Variable, often short perennial of dunes, dry grassland and rocky
slopes; mainly on basic soils. **FLOWERS** Yellowish, tinged
purple, with prominent dangling stamens; in open clusters,
flowers drooping at first then erect (June–Aug). **FRUITS** Dry,
papery. **LEAVES** Pinnately divided 3 or 4 times. **STATUS** Widespread
but local.

Alpine Meadow-rue *Thalictrum alpinum* ✿✿ HEIGHT to 15cm

Short, easily overlooked perennial of upland grassland and
mountain ledges. **FLOWERS** With purplish sepals and stamens
and yellow anthers; in terminal clusters on slender stems
(May–July). **FRUITS** Dry, papery. **LEAVES** Twice trifoliate with dark
green, rounded leaflets. **STATUS** Local from N Wales to Scotland;
scarce in W Ireland.

Lesser Meadow-rue

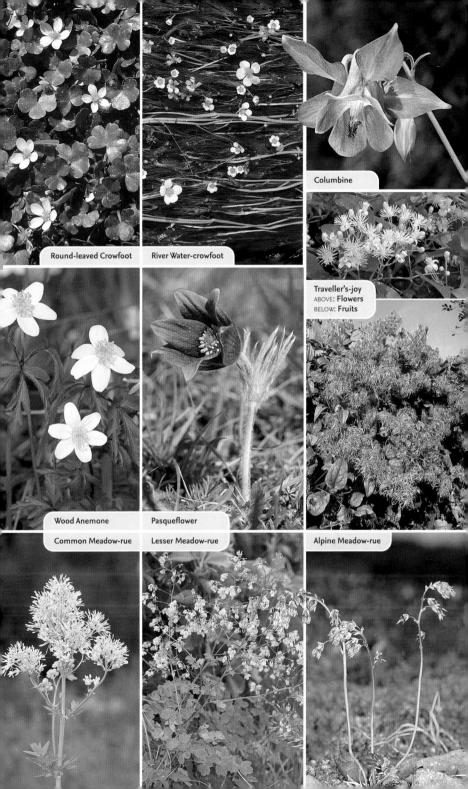

Round-leaved Crowfoot

River Water-crowfoot

Columbine

Traveller's-joy
ABOVE: **Flowers**
BELOW: **Fruits**

Wood Anemone

Pasqueflower

Alpine Meadow-rue

Common Meadow-rue

Lesser Meadow-rue

Common Fumitory *Fumaria officinalis* (Fumariaceae) **HEIGHT** to 10cm
Scrambling annual of well-drained arable soils. **FLOWERS** 6–7mm long, pink with crimson tips, spurred and 2-lipped, the *lower petal paddle-shaped*; in elongating spikes (Apr–Oct). **FRUITS** Globular, 1-seeded. **LEAVES** Grey-green, much divided; lobes all in one plane. **STATUS** Widespread and common.

Common Ramping-fumitory

Common Ramping-fumitory *Fumaria muralis* (Fumariaceae) **HEIGHT** to 10cm
Spreading or upright annual of arable land, banks and walls. **FLOWERS** 9–11mm long, pinkish purple with dark tips, the *lower petal almost parallel-sided* (not paddle-shaped) with erect margins; in spikes of 12–15 flowers (Apr–Oct). **FRUITS** Globular, 1-seeded. **LEAVES** Much divided. **STATUS** Widespread and fairly common.

Tall Ramping-fumitory *Fumaria bastardii* (Fumariaceae) ❀
HEIGHT to 15cm
Robust upright annual of arable fields and waste ground. **FLOWERS** 9–11mm long, pink with a purple tip, the *lower petal parallel-sided* (not paddle-shaped); in spikes of 15–25 flowers (Apr–Oct). **FRUITS** Globular, 1-seeded. **LEAVES** Much divided. **STATUS** Widespread and fairly common only in W.

Climbing Corydalis *Ceratocapnos claviculata* (Fumariaceae) ❀❀ **HEIGHT** to 70cm
Delicate, climbing annual of woodland and scrub, mainly on acid soils. **FLOWERS** Creamy white, 5–6mm long; in clusters (June–Sep). **FRUITS** 2- to 3-seeded capsules. **LEAVES** Much divided, ending in tendrils that assist climbing. **STATUS** Widespread and common in W Britain but rare in Ireland.

Yellow Corydalis *Pseudofumaria lutea* (Fumariaceae) ❀ **HEIGHT** to 30cm
Tufted, hairless perennial found on rocky ground and old walls. **FLOWERS** 12–18mm long, bright yellow, 2-lipped; in clusters opposite the upper leaves (May–Sep). **FRUITS** Capsules. **LEAVES** 2 to 3 times pinnately divided; greyish green. **STATUS** Naturalised as a garden escape.

Common Poppy

Common Poppy *Papaver rhoeas* (Papaveraceae) **HEIGHT** to 60cm
Annual of arable land and disturbed ground. **FLOWERS** 6–8cm across with 4 papery, overlapping *scarlet* petals *(often dark at the base)*; on slender stalks with spreading hairs (June–Aug). **FRUITS** *Ovoid, flat-topped capsules.* **LEAVES** Much divided into narrow segments. **STATUS** Widespread, commonest in S and E England; scarce in the north and west.

Long-headed Poppy *Papaver dubium* (Papaveraceae) **HEIGHT** to 60cm
Annual of arable land and disturbed ground. **FLOWERS** 3–7cm across with 4 papery, *orange-red* overlapping petals with *no dark basal blotch*; on stalks with appressed hairs (June–Aug). **FRUITS** *Narrow, elongated, hairless capsules.* **LEAVES** Much divided into narrow segments. **STATUS** Widespread and fairly common, including the north.

Rough Poppy *Papaver hybridum* (Papaveraceae) ❀❀ **HEIGHT** to 40cm
Hairy annual of arable fields, mainly on calcareous soils. **FLOWERS** 2–5cm across with 4 *crimson*, overlapping petals with *dark-blotched bases* (June–Aug). **FRUITS** *Ovoid to spherical with spreading, yellowish hairs.* **LEAVES** Much divided and bristle-tipped. **STATUS** Scarce and declining, mainly in S England.

Rough Poppy

Prickly Poppy *Papaver argemone* (Papaveraceae) ❀❀ **HEIGHT** to 30cm
Delicate annual of arable land, mainly on sandy soils. **FLOWERS** 2–6cm across with *4 pale red petals that typically do not overlap* but which do have a *dark basal blotch* (May–Aug). **FRUITS** *Narrow, elongated and ribbed with prickle-like bristles.* **LEAVES** Much divided; bristle-tipped. **STATUS** Local and scarce, mainly in S England.

■ *See also* Western Ramping-fumitory (p.273)

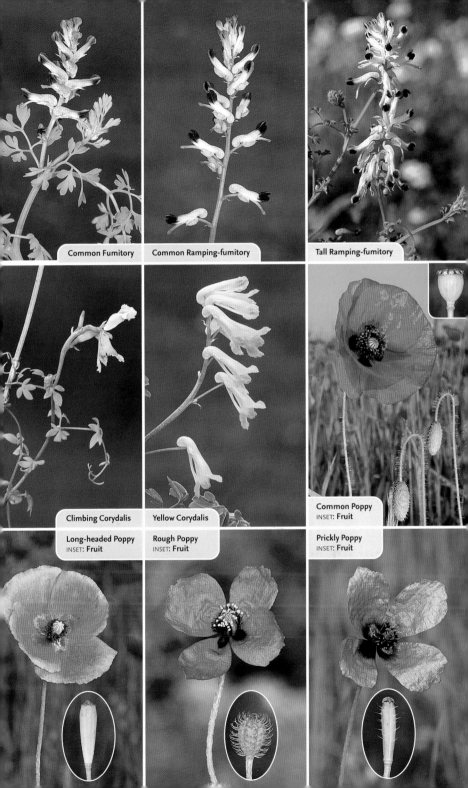

Common Fumitory

Common Ramping-fumitory

Tall Ramping-fumitory

Climbing Corydalis

Yellow Corydalis

Common Poppy
INSET: **Fruit**

Long-headed Poppy
INSET: **Fruit**

Rough Poppy
INSET: **Fruit**

Prickly Poppy
INSET: **Fruit**

Yellow Horned-poppy
Glaucium flavum (Papaveraceae) ❀ **HEIGHT** to 50cm
Blue-grey, clump-forming perennial of *shingle beaches*. **FLOWERS** 5–7cm across with overlapping *yellow petals* (June–Sep). **FRUITS** Elongated, *curved capsules, to 30cm long*. **LEAVES** Pinnately divided, the clasping upper ones having shallow, toothed lobes. **STATUS** Locally common on most suitable coasts except far N.

Welsh Poppy
Meconopsis cambrica (Papaveraceae) ❀❀ **HEIGHT** to 50cm
Showy perennial of *shady woods*. **FLOWERS** 4–6cm across with 4 overlapping, *bright yellow petals*; on slender stems (June–Aug). **FRUITS** 4- to 6-ribbed capsules that split when ripe. **LEAVES** Pinnately divided, toothed, stalked. **STATUS** Native to Wales, SW England and Ireland; naturalised as a garden escape elsewhere.

Greater Celandine
Chelidonium majus (Papaveraceae) **HEIGHT** to 80cm
Tall, brittle-stemmed perennial. Found in hedgerows and along woodland rides. **FLOWERS** 2–3cm across and comprising 4 non-overlapping bright yellow petals (Apr–Oct). **FRUITS** Narrow capsules that split from below when ripe. **LEAVES** Grey-green, pinnately divided. **STATUS** Native but also naturalised.

Barberry
Berberis vulgaris (Berberidaceae) ❀❀❀ **HEIGHT** to 2m
Small, deciduous shrub with grooved twigs and 3-forked prickles. Found in hedgerows and scrub, mainly on calcareous soils. **FLOWERS** Small, yellow; in hanging clusters (May–June). **FRUITS** Ovoid, reddish berries. **LEAVES** Sharp-toothed, oval; borne in tufts from axils of prickles. **STATUS** Scarce native; also naturalised.

Fruit

Tall Rocket
Sisymbrium altissimum (Brassicaceae) ❀❀❀ **HEIGHT** to 2m
Upright annual of waste ground; hairless above but hairy below. **FLOWERS** 1cm across, yellow petals, twice the length of sepals (June–Aug). **FRUITS** Slender, narrow and up to 10cm long. **LEAVES** Have very narrow lobes. **STATUS** Introduced but established in S and E England. **Eastern Rocket** *S. orientale* is similar but with smaller flowers and divided leaves that are spear-shaped overall. Waste ground, in S.

False London-rocket
Sisymbrium loeselii (Brassicaceae) ❀❀❀ **HEIGHT** to 60cm
Straggly, upright annual with bristly hairy lower stems. Found on waste ground. **FLOWERS** 4–6mm across, with 4 yellow petals twice as long as the sepals (June–Aug). **FRUITS** Pods 2–4cm long that do not overtop the flowers. **LEAVES** Deeply pinnately lobed. **STATUS** Casual in S; sometimes naturalised, mainly in London. **London Rocket** *S. irio* is similar but hairless. Petals equal to, or slightly longer than, sepals (Jun–Aug); slender pods overtop flowers. Wasteground, mainly London and Dublin.

Hedge Mustard
Sisymbrium officinale (Brassicaceae) **HEIGHT** to 90cm
Tough, upright annual or biennial of waste ground and disturbed soil. **FLOWERS** 3mm across with 4 yellow petals; in terminal clusters (May–Oct). **FRUITS** Cylindrical, 1–2cm long, pressed close to the stem. **LEAVES** Variable: lower leaves deeply divided, stem leaves narrow. **STATUS** Widespread and common throughout.

Hedge Mustard

Flixweed
Descurainia sophia (Brassicaceae) ❀ **HEIGHT** to 80cm
Much-divided, bushy, hairy annual found on waste and bare ground, usually on sandy soils. **FLOWERS** 3mm across, with 4 pale yellow petals equal to the sepals; in terminal clusters (June–Aug). **FRUITS** Slender, cylindrical pods up to 4cm long. **LEAVES** *Grey-green, finely divided*. **STATUS** Widespread but distinctly local.

Treacle-mustard
Erysimum cheiranthoides (Brassicaceae) ❀ **HEIGHT** to 1m
Slender, upright annual with angled stems. Found on waste ground and arable field margins. **FLOWERS** 6–10mm across, with 4 yellow petals longer than the sepals; in terminal clusters (June–Sep). **FRUITS** 25mm long, slender. **LEAVES** Shallowly lobed, narrow. **STATUS** Introduced and naturalised.

Flixweed

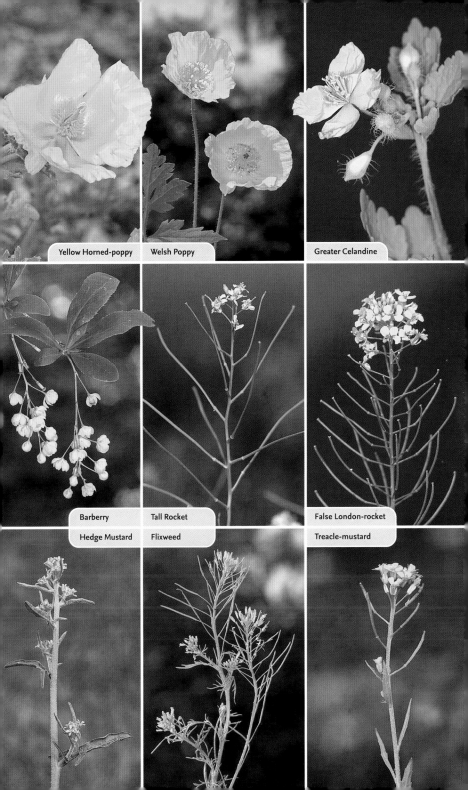

Yellow Horned-poppy Welsh Poppy

Greater Celandine

Barberry Tall Rocket

False London-rocket

Hedge Mustard Flixweed

Treacle-mustard

Wallflower *Erysimum cheiri* HEIGHT to 60cm
Showy perennial with a woody-based stem and branched hairs. Associated with cliffs and old walls. **FLOWERS** 2–3cm across with 4 orange-yellow petals; in terminal clusters (Mar–June). **FRUITS** Flattened, 7cm long. **LEAVES** Narrow, untoothed. **STATUS** Widely naturalised as a garden escape.

Dame's-violet *Hesperis matronalis* ✿ HEIGHT to 90cm
Hairy biennial or perennial associated with hedgerows and wayside places. **FLOWERS** Fragrant, 17–20mm across, with 4 violet or pinkish-white petals; in terminal clusters (May–Aug). **FRUITS** Long, flattened, curving upwards. **LEAVES** Narrow, pointed, untoothed, stalked. **STATUS** Widely naturalised as a garden escape.

Hoary Stock *Matthiola incana* ✿✿ HEIGHT to 80cm
Downy, greyish annual or perennial with a *woody-based stem*. Associated with sea cliffs. **FLOWERS** Fragrant, 25–30mm across, with 4 white to purple petals (Apr–July). **FRUITS** Cylindrical pods to 13cm long. **LEAVES** Narrow, untoothed. **STATUS** Scarce and doubtfully native although possibly so in S England and S Wales.

Sea Stock *Matthiola sinuata* ✿✿✿ HEIGHT to 80cm
Downy, grey-green perennial, the *base of which is not woody*. Associated with coastal dunes and sea cliffs. **FLOWERS** Fragrant, 25–30mm across, with 4 pinkish petals (June–Aug). **FRUITS** Narrow, elongated pods. **LEAVES** Narrow, with toothed or lobed margins. **STATUS** Rare; SW England, S Wales, S Ireland and Channel Islands only.

Winter-cress

Medium-flowered Winter-cress

Winter-cress *Barbarea vulgaris* HEIGHT to 80cm
Upright, hairless perennial of damp ground. **FLOWERS** 7–9mm across with 4 yellow petals; in terminal heads (May–Aug). **FRUITS** Long, narrow, 4-sided pods. **LEAVES** Dark green, shiny; lower ones divided, the end lobe large and oval; *upper stem leaves entire*. **STATUS** Widespread but commonest in the south.

Medium-flowered Winter-cress *Barbarea intermedia* ✿ HEIGHT to 80cm
Upright, hairless perennial of waste ground. **FLOWERS** 5–6mm across with 4 yellow petals; in terminal heads (Mar–Aug). **FRUITS** Long, narrow, 4-sided pods. **LEAVES** Dark green, shiny; *all lobed*. **STATUS** Introduced, occasional but seemingly increasing.

Marsh Yellow-cress

Marsh Yellow-cress *Rorippa palustris* HEIGHT to 50cm
Annual of damp, marshy hollows, sometimes growing in shallow water. *Stems upright, angular, hollow*. **FLOWERS** 3mm across with 4 yellow *petals equal in length to sepals*; in terminal heads (June–Oct). **FRUITS** Elliptical pods, 4–6mm long. **LEAVES** Pinnately lobed. **STATUS** Locally common throughout, except in the north.

Creeping Yellow-cress

Creeping Yellow-cress *Rorippa sylvestris* ✿ HEIGHT to 50cm
Sprawling annual of damp, bare ground, with *solid, not hollow, stems*. **FLOWERS** 5mm across with 4 yellow *petals twice as long as sepals*; in terminal heads (June–Oct). **FRUITS** Elliptical pods, 8–15mm long. **LEAVES** Pinnately lobed. **STATUS** Locally common in England and Wales; scarce elsewhere.

Great Yellow-cress *Rorippa amphibia* ✿ HEIGHT to 1.2m
Robust, hairless perennial with *stout, hollow stems*. Favours damp ground and the margins of freshwater habitats. **FLOWERS** 5–7mm across with 4 yellow *petals twice as long as sepals*; in terminal heads (June–Sep). **FRUITS** Elliptical pods, 3–6mm long. **LEAVES** Shallowly lobed. **STATUS** Locally common in south but absent from north.

Great Yellow-cress

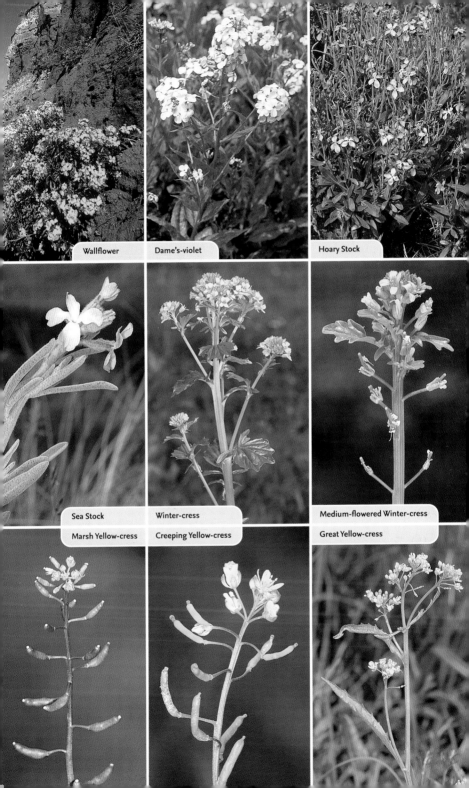

Wallflower

Dame's-violet

Hoary Stock

Sea Stock

Winter-cress

Medium-flowered Winter-cress

Marsh Yellow-cress

Creeping Yellow-cress

Great Yellow-cress

Water-cress *Rorippa nasturtium-aquaticum* HEIGHT to 15cm

Usually creeping perennial of shallow streams and ditches. FLOWERS 4–6mm across with 4 white petals; in terminal heads (May–Oct). FRUITS Narrow pods, 16–18mm long, containing 2 rows of seeds. LEAVES Dark green and pinnately divided; persisting through winter. STATUS Widespread and common; widely cultivated in S England.

Hairy Bitter-cress *Cardamine hirsuta* HEIGHT to 30cm

Upright annual with *hairless stems*. Found on damp, disturbed ground. FLOWERS 2–3mm across (petals sometimes absent) and terminal (Feb–Nov). FRUITS Curved, up to 2.5cm long, *overtopping flowers*. LEAVES Pinnately divided with rounded lobes; seen mainly as a basal rosette plus *1–4 stem leaves*. STATUS Widespread and common.

Hairy Bitter-cress

Wavy Bitter-cress *Cardamine flexuosa* HEIGHT to 50cm

Similar to Hairy Bitter-cress but taller and with *wavy, hairy stems*. Favours damp and disturbed ground. FLOWERS 3–4mm across with 4 white petals (Mar–Sep). FRUITS Curved, *barely overtopping flowers*. LEAVES Pinnately divided with rounded lobes; seen as a basal rosette plus *4–10 stem leaves*. STATUS Widespread and common.

Large Bitter-cress *Cardamine amara* ✿ HEIGHT to 60cm

Upright perennial found in damp, shady places in woods and marshes. FLOWERS 12mm across with 4 white petals and violet anthers (Apr–June). FRUITS Slender, beaked pods, up to 4cm long. LEAVES Pinnately divided, with slightly toothed oval lobes. STATUS Widespread but local; scarce in, or absent from, W England and S Ireland.

Wavy Bitter-cress

Cuckooflower *Cardamine pratensis* HEIGHT to 50cm

Variable perennial of damp, grassy places. Also known as **Lady's-smock**. FLOWERS 12–20mm across with 4 pale lilac or white flowers (Apr–June). FRUITS Elongated, beaked. LEAVES Seen mainly in a basal rosette of pinnately divided leaves with rounded lobes; narrow stem leaves also present. STATUS Widespread and locally common.

Coralroot *Cardamine bulbifera* ✿✿ HEIGHT to 70cm

Perennial of undisturbed woodland on calcareous or sandy soils. FLOWERS 12–18mm across with 4 pink petals; in terminal heads (Apr–May). FRUITS Narrow, 3.5cm long. LEAVES Pinnately divided (upper ones less so) with 1–3 pairs of leaflets; borne up stem with *brown bulbils in axils*. STATUS Scarce and local; SE England only.

Northern Rock-cress *Arabis petraea* ✿✿✿ HEIGHT to 30cm

Cuckooflower

Variable perennial of rocky places in mountains. FLOWERS 5–7mm across with 4 whitish or lilac petals (June–Aug). FRUITS Curved, 4cm long. LEAVES Basal rosette of pinnately lobed, stalked leaves plus narrow, toothed stem leaves. STATUS Local. **Tower Mustard** *A. glabra* is tall (to 1m); greyish, arrow-shaped, clasping leaves and tiny pale flowers. Scarce on dry ground in south.

Hairy Rock-cress *Arabis hirsuta* HEIGHT to 60cm

Variable, hairy biennial found in calcareous grassland. FLOWERS 3–5mm across with 4 white petals; in dense, terminal heads (May–Aug). FRUITS Cylindrical, upright pods 3.5cm long. LEAVES Barely toothed, oval; basal ones in a rosette, stem leaves clasping. STATUS Widespread but only locally common.

Hutchinsia *Hornungia petraea* ✿✿✿ HEIGHT to 15cm

Delicate, usually branching annual of limestone and sandy soils. FLOWERS 1mm across with 4 whitish petals (Mar–May). FRUITS Flattened, elliptical pods. LEAVES Pinnately divided; basal ones stalked and forming a rosette; stems leaves unstalked. STATUS Local and scarce in the west, mainly Mendips and Gower to N Yorkshire.

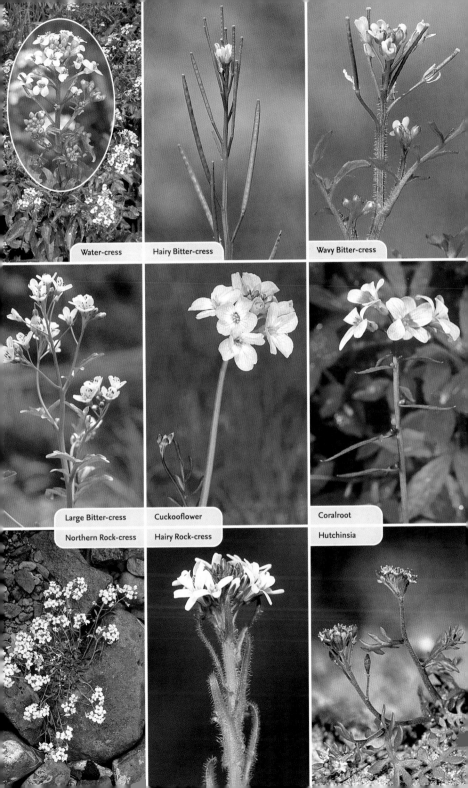

Water-cress

Hairy Bitter-cress

Wavy Bitter-cress

Large Bitter-cress

Cuckooflower

Coralroot

Northern Rock-cress

Hairy Rock-cress

Hutchinsia

Honesty *Lunaria annua* ✿ HEIGHT to 1.5m
Branched, hairy biennial. Usually found in hedgerows and banks, typically close to habitation. FLOWERS 25–30mm across with 4 reddish-purple petals (Apr–June). FRUITS *Circular or oval, flattened pods.* LEAVES Irregularly toothed; lower leaves stalked, upper ones unstalked. STATUS Frequent as a garden escape.

Sweet Alison *Lobularia maritima* ✿✿ HEIGHT to 20cm
Hairy perennial found in hedgerows and wayside places, usually near habitation. FLOWERS 5–6mm across, with 4 white petals; *sweet-smelling* (June–Oct). FRUITS Small oval pods, on long stalks. LEAVES Narrow, entire and grey-green. STATUS Familiar as a garden plant but also widely naturalised as an escape.

Common Whitlowgrass *Erophila verna* HEIGHT to 20cm
Variable, hairy annual of dry, bare places. FLOWERS 3–6mm across, with 4 deeply notched whitish petals (Mar–May). FRUITS Elliptical pods, on long stalks. LEAVES Narrow, toothed; forming a basal rosette from the centre of which the flowering stalk arises. STATUS Common and widespread throughout.

Yellow Whitlowgrass *Draba aizoides* ✿✿✿ HEIGHT to 12cm
Compact, tufted perennial. Associated with limestone cliffs and walls. FLOWERS 8–9mm across, with 4 yellow petals; in dense terminal clusters (Mar–May). FRUITS Elliptical, 8–12mm long. LEAVES Narrow, with marginal and terminal bristles; forming a basal rosette. STATUS Rare, restricted to the Gower Peninsula.

Hoary Whitlowgrass *Draba incana* ✿✿ HEIGHT to 30cm
Upright, hairy biennial of upland limestone rocks and (rarely) on sand dunes in the north. FLOWERS 3–5mm across with 4 slightly notched white petals (June–July). FRUITS *Cylindrical but twisted.* LEAVES Lanceolate; untoothed ones in basal rosette plus toothed stem leaves. STATUS Local, restricted to N Wales, Scotland and NW Ireland.

Wall Whitlowgrass *Draba muralis* ✿✿ HEIGHT to 30cm
Hairy annual, somewhat similar to Hoary Whitlowgrass. Found on limestone rocks and walls. FLOWERS 3–5mm across with 4 slightly notched petals; in terminal clusters (Apr–May). FRUITS *Elliptical but not twisted.* LEAVES Oval; appearing as a basal rosette and clasping stem leaves. STATUS Local, restricted to SW and N England.

Thale Cress *Arabidopsis thaliana* HEIGHT to 50cm
Distinctive annual of dry, sandy soils; often on paths. FLOWERS 3mm across with 4 white petals; in terminal clusters (Mar–Oct). FRUITS Cylindrical, 20mm long. LEAVES Broadly toothed, oval, forming a basal rosette; upright flowering stems also bear a few small leaves. STATUS Widespread and fairly common in lowland areas.

Thale
Cress

Shepherd's-purse *Capsella bursa-pastoris* HEIGHT to 35cm
Distinctive annual of arable fields, tracks, gardens and wayside ground. FLOWERS 2–3mm across with 4 white petals; in terminal clusters (Jan–Dec). FRUITS Green, *triangular, notched.* LEAVES Varying from lobed to entire; upper ones usually toothed and clasping the stem. STATUS Widespread and rather common throughout.

Shepherd's-cress *Teesdalia nudicaulis* ✿ HEIGHT to 25cm
Tufted, often hairless annual. Found on bare, sandy ground or shingle. FLOWERS 2mm across with 4 white petals, *2 of them much shorter than the other 2* (Apr–June). FRUITS *Heart-shaped, notched.* LEAVES Pinnately lobed, appearing mainly as a basal rosette. STATUS Only locally common in the south; rare elsewhere.

Shepherd's-purse

■ See also Rock Whitlowgrass (p.282)

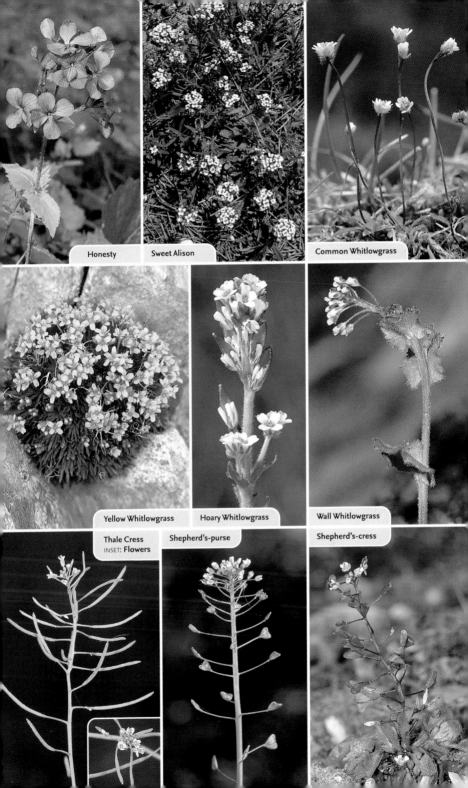

Honesty

Sweet Alison

Common Whitlowgrass

Yellow Whitlowgrass

Hoary Whitlowgrass

Wall Whitlowgrass

Thale Cress
INSET: Flowers

Shepherd's-purse

Shepherd's-cress

Common Scurvygrass *Cochlearia officinalis* HEIGHT to 50cm
Biennial or perennial of saltmarshes, coastal walls and cliffs, and mountains inland. FLOWERS 8–10mm across with 4 white petals (Apr–Oct). FRUITS Rounded to ovoid, 4–7mm long; *longer than stalk*. LEAVES Kidney-shaped basal leaves more than 2cm long; clasping, arrow-shaped leaves on stem. STATUS Locally common.

Pyrenean Scurvygrass *Cochlearia pyrenaica* 🏵🏵 HEIGHT to 30cm
Variable biennial or perennial of mountains, rocky slopes and upland stream margins and meadows. FLOWERS 5–8mm across with 4 white petals (June–Sep). FRUITS Elliptical, *shorter than stalk*. LEAVES Kidney-shaped basal leaves less than 2cm long; clasping stem leaves. STATUS Local in the west and north of the region.

Danish Scurvygrass *Cochlearia danica* HEIGHT to 20cm
Compact, often *prostrate* annual of sandy soils, shingle and walls, mainly around the coast. FLOWERS 4–6mm across with 4 white petals (Jan–Aug). FRUITS Ovoid, 6mm long. LEAVES Long-stalked, heart-shaped basal leaves; stalked, *ivy-shaped stem leaves*. STATUS Widespread and common around most coasts.

English Scurvygrass *Cochlearia anglica* 🏵 HEIGHT to 35cm
Biennial or perennial of estuaries and coastal mudflats. FLOWERS 10–14mm across with 4 white petals (Apr–July). FRUITS Elliptical, 10–15mm long. LEAVES *Long-stalked, narrow*; basal leaves tapering gradually to the base; *stem leaves clasping the stem*. STATUS Locally common around most coasts in suitable habitats.

Field Penny-cress *Thlaspi arvense* HEIGHT to 50cm
Annual that emits an *unpleasant smell when crushed*. Found in arable fields and on waste ground. FLOWERS 4–6mm across with 4 white petals (May–Sep). FRUITS *Oval pods with a terminal notch*. LEAVES Narrow, arrow-shaped leaves clasping the upright stem; no basal rosette. STATUS Widespread and common throughout.

Alpine Penny-cress *Thlaspi caerulescens* 🏵🏵 HEIGHT to 25cm
Hairless perennial of limestone scree and old lead workings. FLOWERS 3–4mm across with white or lilac petals and violet anthers (Apr–Aug). FRUITS *Narrowly heart-shaped, flattened, with a beak*. LEAVES Oval, entire and tapering gradually to the stalk. STATUS Local, from the Mendips northwards to central Scotland.

Wild Candytuft *Iberis amara* 🏵🏵 HEIGHT to 30cm
Downy annual of calcareous grassland. Favours disturbed soil, often beside Rabbit burrows. FLOWERS With 4 white or mauve petals, 2 of them much longer than the others (July–Aug). FRUITS Rounded, winged, notched. LEAVES Toothed, spoon-shaped, becoming smaller up the stem. STATUS Local, mainly in the Chilterns.

Awlwort *Subularia aquatica* 🏵🏵 HEIGHT to 8cm (usually much smaller)
Wild
Candytuft
Aquatic annual. Found on margins of gravelly upland lakes and usually submerged. FLOWERS Tiny, white, on short stems (June–Sep). FRUITS Ovoid, 2mm long, on short stems. LEAVES Up to 5cm long, slender, cylindrical, pointed; in a basal rosette. STATUS Local in west and north, least so in Scotland.

Hoary Cress *Lepidium draba* HEIGHT to 60cm
Variable, often hairless perennial of disturbed ground. FLOWERS Tiny, white; in large, frothy terminal clusters (May–Oct). FRUITS Heart-shaped, inflated. LEAVES Grey-green, lanceolate, variably toothed; stem leaves clasping the stem. STATUS Introduced; now locally common in England, occasional elsewhere.

■ See also Perfoliate Penny-cress (p.280)

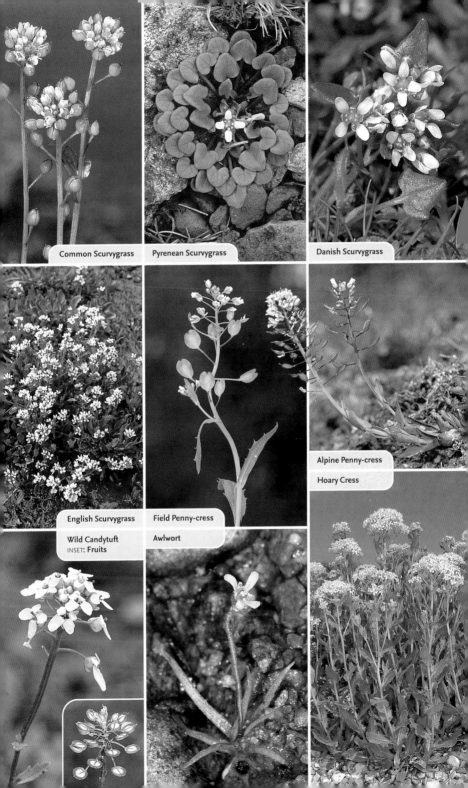

Common Scurvygrass

Pyrenean Scurvygrass

Danish Scurvygrass

English Scurvygrass

Field Penny-cress

Alpine Penny-cress

Hoary Cress

Wild Candytuft
INSET: Fruits

Awlwort

Hoary Mustard *Hirschfeldia incana* ⚛ HEIGHT to 1m

Much-branched, upright annual of disturbed and waste ground. FLOWERS 6–8mm across, pale yellow; in terminal heads (May–Oct). FRUITS Slender, 15–17mm long and pressed close to stem. LEAVES Hoary; lower ones pinnate with an oblong terminal lobe, upper leaves unlobed. STATUS Introduced and casual, commonest in south.

Smith's Pepperwort *Lepidium heterophyllum* ⚛ HEIGHT to 40cm

Grey-green, hairy perennial of dry, bare soil. FLOWERS 2–3mm across with 4 white petals and *violet anthers*; in dense heads (May–Aug). FRUITS Smooth, oval, notched at the tip, with a projecting style. LEAVES Oval, *untoothed basal leaves* and arrow-shaped, clasping ones on stem. STATUS Locally common, especially in S and W. **Field Pepperwort** *L. campestre* is similar but pods lack a projecting style. Favours similar habitats and locally common. **Narrow-leaved Pepperwort** *L. ruderale* is similar but with pinnate leaves and tiny, greenish flowers; petals usually absent. Local, disturbed ground in south.

Hoary
Mustard

Smith's
Pepperwort

Field Pepperwort
fruit

Swine-cress *Coronopus squamatus* PROSTRATE

Creeping annual or biennial of disturbed and waste ground, often near the sea. FLOWERS White, 2–3mm across; in compact clusters (June–Sep). FRUITS Knobbly and flattened. LEAVES Pinnately divided, toothed, sometimes forming a dense mat on the ground. STATUS Common in S and E England but scarce elsewhere.

Lesser Swine-cress *Coronopus didymus* ⚛ PROSTRATE

Creeping annual or biennial of dry, disturbed soils and waste ground. Similar to Swine-cress but *flowers even smaller and leaves more finely divided*. FLOWERS Tiny; petals often absent (June–Oct). FRUITS Flattened, rounded, smooth. LEAVES Deeply pinnately divided; toothed. STATUS Common only in S and SW Britain.

Annual Wall-rocket *Diplotaxis muralis* ⚛ HEIGHT to 60cm

Branched annual with a strong smell when crushed. Found on waste ground, mainly on sandy soils. FLOWERS 10–15mm across, with 4 yellow petals (May–Sep). FRUITS Cylindrical with 2 rows of seeds. LEAVES Pinnately lobed; mainly basal. STATUS Widespread but local, mainly in the south.

Annual
Wall-rocket

Perennial Wall-rocket *Diplotaxis tenuifolia* ⚛⚛ HEIGHT to 80cm

Branched perennial with an unpleasant smell when crushed; waste ground, usually near sea. FLOWERS 15–30mm across with 4 yellow petals (May–Sep). FRUITS Cylindrical with 2 rows of seeds. LEAVES Pinnately lobed. STATUS Mainly coastal.

Perennial
Wall-rocket

Garlic Mustard *Alliaria petiolata* HEIGHT to 1m

Familiar wayside biennial, often found in hedgerows and on roadside verges. FLOWERS 6mm across, with 4 white petals (Apr–June). FRUITS Cylindrical, ribbed, 4–5cm long. LEAVES Heart-shaped, toothed, *smelling of garlic when crushed*; borne up stem. STATUS Widespread and common, but least so in the north and west of the region.

Sea Radish *Raphanus raphanistrum* ssp. *maritimus* ⚛⚛ HEIGHT to 60cm

Roughly hairy annual of coastal habitats. FLOWERS Yellow (May–July). FRUITS Pods with up to *5 beaded segments*. LEAVES Pinnate lower leaves; narrow, entire upper ones. STATUS Locally common in south and south-west only. **Wild Radish** *R. r.* ssp. *raphanistrum* has violet-veined white petals and beaded pods with up to 10 segments. Widespread relict of cultivation.

Wild
Turnip

Wild Turnip *Brassica rapa* ssp. *campestris* ⚛ HEIGHT to 1.2m

Grey-green annual or biennial of arable land. FLOWERS 6–13mm across, with yellow petals (May–Sep). FRUITS Cylindrical pods. LEAVES Pinnately lobed basal leaves that wither; unlobed, clasping stem leaves. STATUS Common.

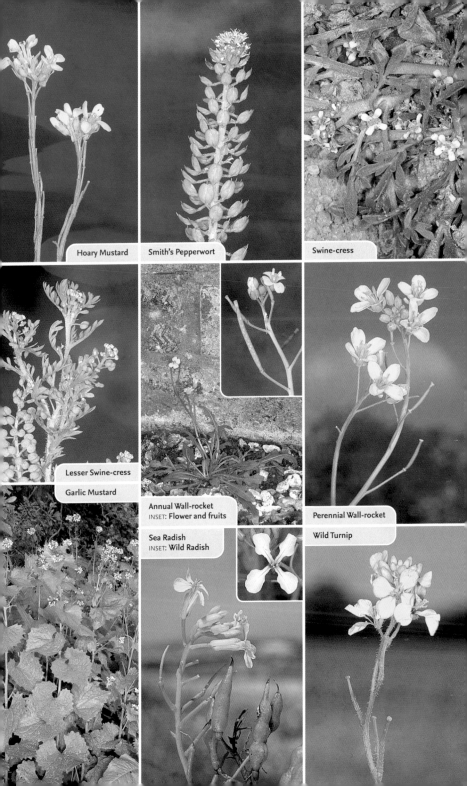

Hoary Mustard

Smith's Pepperwort

Swine-cress

Lesser Swine-cress

Garlic Mustard

Annual Wall-rocket
INSET: Flower and fruits

Perennial Wall-rocket

Sea Radish
INSET: Wild Radish

Wild Turnip

Cabbage *Brassica oleracea* (Brassicaceae) 🌸🌸 **HEIGHT** to 1.25m

Tough perennial. Wild Cabbage is native on coastal chalk cliffs; garden escapes found inland. **FLOWERS** 25–35mm across; in elongated heads (Apr–Aug). **FRUITS** Cylindrical, 8cm long. **LEAVES** Grey-green; lower ones large, fleshy and often ravaged by the larvae of the Large White butterfly. **STATUS** Local, native in SW England and W Wales.

Rape *Brassica napus* (Brassicaceae) **HEIGHT** to 1.25m

Greyish-green annual or biennial of arable fields and waste ground. **FLOWERS** 25–35mm across with 4 yellow petals, often overtopped by buds (Apr–Sep). **FRUITS** Cylindrical, 10cm long. **LEAVES** Pinnate basal leaves that soon wither; clasping stem leaves. **STATUS** Widely cultivated but also casual in many places.

Black Mustard *Brassica nigra* (Brassicaceae) **HEIGHT** to 2m

Robust, greyish annual. Often found on sea cliffs, river banks and waste ground. **FLOWERS** 12–15mm across, with 4 yellow petals (May–Aug). **FRUITS** Flattened; pressed close to stem. **LEAVES** Stalked; lower ones pinnately lobed and bristly. **STATUS** Locally common in England and Wales; rather scarce elsewhere.

Black
Mustard

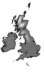

Charlock *Sinapis arvensis* (Brassicaceae) **HEIGHT** to 1.5m

Annual of arable and waste ground. Stems often dark reddish. **FLOWERS** 15–20mm across, with 4 yellow petals (Apr–Oct). **FRUITS** Cylindrical, short-stalked pods, with a rounded beak. **LEAVES** Dark green, large, coarsely toothed; lower ones stalked and hairy, upper ones entire and unstalked. **STATUS** Widespread and common.

White Mustard *Sinapis alba* (Brassicaceae) **HEIGHT** to 1.5m

Charlock

Annual of arable and waste ground. Superficially similar to Charlock. **FLOWERS** 15–20mm across, with 4 yellow petals (May–Sep). **FRUITS** Cylindrical pods with a flattened beak; covered in white hairs. **LEAVES** All pinnately divided. **STATUS** Sometimes cultivated but also grows casually, especially in SE England.

Sea
Rocket

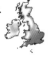

Sea Rocket *Cakile maritima* (Brassicaceae) 🌸 **HEIGHT** to 25cm

Straggling, *fleshy*, hairless annual found on sandy and shingle beaches. **FLOWERS** 10–15mm across, pink or pale lilac; in terminal clusters (June–Sep). **FRUITS** *Waisted pods, the upper half largest.* **LEAVES** Shiny; pinnately lobed. **STATUS** Widespread and locally common around coasts of Britain and Ireland.

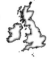

Sea-kale *Crambe maritima* (Brassicaceae) 🌸 **HEIGHT** to 50cm

Robust perennial. Forms domed, expansive clumps on shingle and sandy beaches. **FLOWERS** 6–12mm across, with 4 whitish petals; in flat-topped clusters (June–Aug). **FRUITS** Oval pods. **LEAVES** Fleshy with wavy margins; lower ones 25cm long and long-stalked. **STATUS** Very locally common around coasts of England, Wales and Ireland.

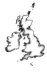

Weld *Reseda luteola* (Resedaceae) **HEIGHT** to 1.2m

Upright, *hollow-stemmed* biennial of disturbed calcareous ground. **FLOWERS** Yellow-green, with *4 petals*; in tall spikes in the plant's second year (June–Aug). **FRUITS** Globular pods. **LEAVES** *Narrow*; forming a basal rosette in the first year but appearing as stem leaves in the second. **STATUS** Widespread and fairly common, except in the north and west.

Wild Mignonette *Reseda lutea* (Resedaceae) **HEIGHT** to 70cm

Upright, *solid-stemmed* biennial of disturbed calcareous ground. Superficially similar to Weld. **FLOWERS** Yellowish green, with *6 petals*; in compact spikes (June–Aug). **FRUITS** Erect, oblong pods. **LEAVES** *Pinnately divided with wavy edges.* **STATUS** Widespread and locally common but almost absent from Scotland.

■ *See also* Lundy Cabbage (p.270)

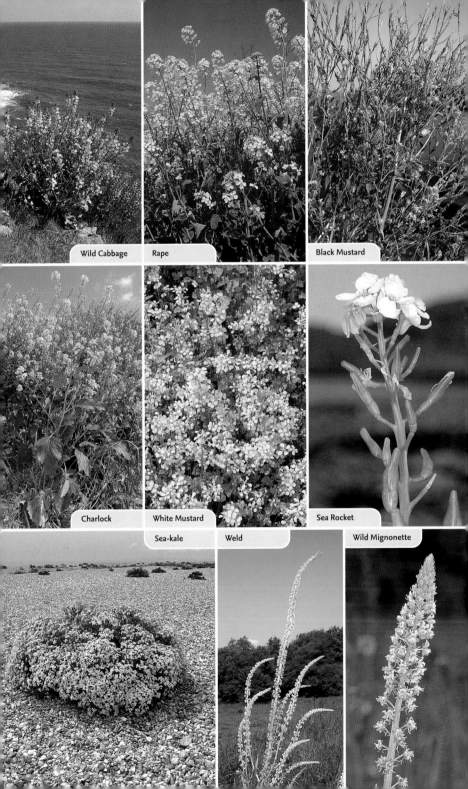

Wild Cabbage

Rape

Black Mustard

Charlock

White Mustard

Sea Rocket

Sea-kale

Weld

Wild Mignonette

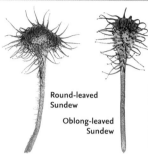

Round-leaved
Sundew

Oblong-leaved
Sundew

Round-leaved Sundew *Drosera rotundifolia*
(Droseraceae) ❀ HEIGHT to 20cm
Insectivorous plant of boggy heaths and moors.
FLOWERS White; in spikes on stalks that are much
longer than leaves (June–Aug). FRUITS Capsules.
LEAVES Reddish, *rounded*, 1cm across, long-stalked;
covered with sticky hairs that trap insects and appear as a
basal rosette. STATUS Widespread and locally common.

Oblong-leaved Sundew *Drosera intermedia*
(Droseraceae) ❀ HEIGHT to 20cm
Insectivorous perennial of wet heaths and moors.
FLOWERS White; in spikes on stalks that are a similar
length to leaves (June–Aug). FRUITS Capsules. LEAVES Reddish, *1cm long, narrow
and tapering abruptly* to long stalk; covered in sticky hairs that trap insects and appear
as a basal rosette. STATUS Locally common throughout.

Great Sundew *Drosera anglica* (Droseraceae) ❀ HEIGHT to 30cm
Insectivorous plant of waterlogged peat bogs and moors. FLOWERS White; in spikes
on stalks that are twice the length of the leaves (June–Aug). FRUITS Capsules. LEAVES
Reddish, *narrow, tapering, 3cm long*; covered in sticky hairs and appearing as a basal
rosette. STATUS Locally common in north and west, but scarce elsewhere.

Pitcherplant
flower

Pitcherplant *Sarracenia purpurea* (Sarraceniaceae) ❀❀❀ HEIGHT to 40cm
Bizarre-looking insectivorous perennial of bogs. FLOWERS 5cm across,
purple and nodding; on long stalks (June–July). FRUITS Capsules. LEAVES
10–15cm long, shaped like pitchers; insects are digested by enzyme-rich
liquid contained within. STATUS Introduced from N America; natu-
ralised locally in S England and Ireland.

Navelwort *Umbilicus rupestris* (Crassulaceae) ❀ HEIGHT to 15cm
Distinctive perennial found on walls and banks, often growing in partial
shade. FLOWERS Whitish, tubular and drooping; in spikes (June–Aug).
FRUITS Dry, splitting. LEAVES Rounded and fleshy with a depressed centre
above the leaf stalk. STATUS Widespread in W Britain and Ireland; scarce
elsewhere.

New Zealand Pigmyweed *Crassula helmsii* (Crassulaceae) PROSTRATE ON LAND
Unwelcome creeping perennial that colonises ponds and their margins, eventually
excluding all native species. FLOWERS Tiny, with 5 white or pink petals (June–Sep).
FRUITS Dry, splitting. LEAVES Narrow, fleshy, 5–10mm long. STATUS Introduced,
spreading and a major threat to native aquatic plants.

Mossy Stonecrop *Crassula tillaea* (Crassulaceae) ❀❀ PROSTRATE
Tiny, often reddish annual that is easily overlooked. Found on bare and usually
damp sandy soil and gravel. FLOWERS Tiny, whitish; arising from leaf axils (June–
Sep). FRUITS Dry, splitting. LEAVES 1–2mm long, oval and densely crowded on the
slender stems. STATUS Extremely local, mainly in S and E England.

Roseroot *Sedum rosea* (Crassulaceae) ❀ HEIGHT to 30cm
Distinctive, greyish perennial associated with mountain ledges and sea cliffs.
FLOWERS Yellow, with 4 petals; in terminal, rounded clusters (May–July). FRUITS
Orange; superficially like the flowers. LEAVES Succulent, oval, overlapping.
STATUS Locally common in W Wales, N England, Scotland and Ireland.

Orpine *Sedum telephium* (Crassulaceae) ❀ HEIGHT to 50cm
Elegant perennial of shady woodland and scrub. FLOWERS Reddish purple, with
5 petals; in rounded, terminal heads (July–Aug). FRUITS Dry, splitting. LEAVES
Green, fleshy, oval, irregularly toothed; on reddish stems. STATUS Locally
common in England and Wales but scarce elsewhere.

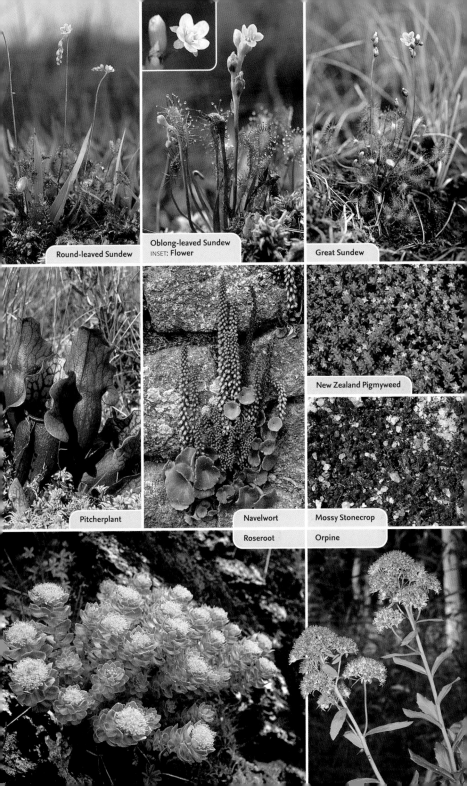

Round-leaved Sundew

Oblong-leaved Sundew
INSET: Flower

Great Sundew

Pitcherplant

Navelwort

Roseroot

New Zealand Pigmyweed

Mossy Stonecrop

Orpine

English Stonecrop *Sedum anglicum* (Crassulaceae) ✿ **HEIGHT** to 5cm
Mat-forming perennial with wiry stems. Found on rocky ground, shingle and old
walls. **FLOWERS** Star-shaped, 12mm across, with 5 white petals that are pink below
(June–Sep). **FRUITS** Dry, red. **LEAVES** 3–5mm long, fleshy, often tinged red. **STATUS**
Widespread and locally common, especially in W Britain and Ireland.

Biting Stonecrop *Sedum acre* (Crassulaceae) **HEIGHT** to 10cm
Distinctive mat-forming perennial. Found on well-drained ground such as sand
dunes and old walls. **FLOWERS** Star-shaped, 10–12mm across, with 5 bright yellow
petals (May–July). **FRUITS** Dry, splitting. **LEAVES** Fleshy, crowded, pressed close to
stem; hot-tasting. **STATUS** Widespread and locally common.

Rock Stonecrop *Sedum forsterianum* (Crassulaceae) ✿✿ **HEIGHT** to 20cm
Greyish-green, mat-forming perennial of free-draining rocky ground and old walls.
FLOWERS Star-shaped, yellow; in terminal clusters that nod in bud (June–Aug).
FRUITS Dry, splitting. **LEAVES** Fleshy, pressed close to stem; terminal clusters on
non-flowering shoots. **STATUS** Local in SW England; naturalised elsewhere.

White Stonecrop *Sedum album* (Crassulaceae) ✿✿ **HEIGHT** to 15cm
Mat-forming, evergreen perennial of rocky ground and old walls. **FLOWERS** Star-
shaped, 6–9mm across, white above but often pinkish below; in terminal clusters
(June–Sep). **FRUITS** Dry, splitting. **LEAVES** 6–12mm long, fleshy, shiny, green or
reddish. **STATUS** Local, mainly in SW England and often naturalised elsewhere.

Hairy Stonecrop *Sedum villosum* (Crassulaceae) ✿✿ **HEIGHT** to 15cm
Upright, unbranched biennial or perennial of damp, stony ground and stream
margins. **FLOWERS** 6–8mm across, pink, stalked; upright (not drooping) in bud
(June–Aug). **FRUITS** Dry, splitting. **LEAVES** Fleshy, flat above, covered in sticky hairs;
arranged spirally up stems. **STATUS** Local from N England to central Scotland.

Meadow Saxifrage *Saxifraga granulata* (Saxifragaceae) ✿ **HEIGHT** to 45cm
Attractive, hairy perennial of grassy meadows, mainly on neutral or basic soils.
FLOWERS 20–30mm across, with 5 white petals; in open clusters (Apr–June).
FRUITS Dry capsules. **LEAVES** Kidney-shaped with blunt teeth; bulbils produced
at leaf axils in autumn. **STATUS** Local, commonest in E England.

Purple Saxifrage *Saxifraga oppositifolia* (Saxifragaceae) ✿✿ **CREEPING**
Mat-forming perennial with trailing stems. Found on mountains, but also on
coastal rocks in the north. **FLOWERS** 10–15mm across, purple (Mar–Apr). **FRUITS**
Dry capsules. **LEAVES** Small, dark green, with bristly margins; in opposite pairs.
STATUS Locally common in N England and Scotland; rare in N Wales and NW
Ireland.

Yellow Saxifrage *Saxifraga aizoides* (Saxifragaceae) ✿ **HEIGHT** to 20cm
Colourful, clump-forming perennial of stream sides and damp ground in mountains.
FLOWERS 10–15mm across, with bright yellow petals; in clusters of 1–10 (June–Sep).
FRUITS Dry capsules. **LEAVES** Fleshy, narrow, toothed, unstalked. **STATUS** Locally
common in N England, Scotland and N Ireland.

Marsh Saxifrage *Saxifraga hirculus* (Saxifragaceae) ✿✿✿ **HEIGHT** to 20cm
Downy perennial of damp, grassy ground on moors and mountains. Easily overlooked
when not in flower. **FLOWERS** 20–30mm across, with bright yellow petals; solitary
or in clusters of up to 3 (June–Sep). **FRUITS** Dry capsules. **LEAVES** Short, narrow,
stalked. **STATUS** Local and rare in N England, Scotland and Ireland.

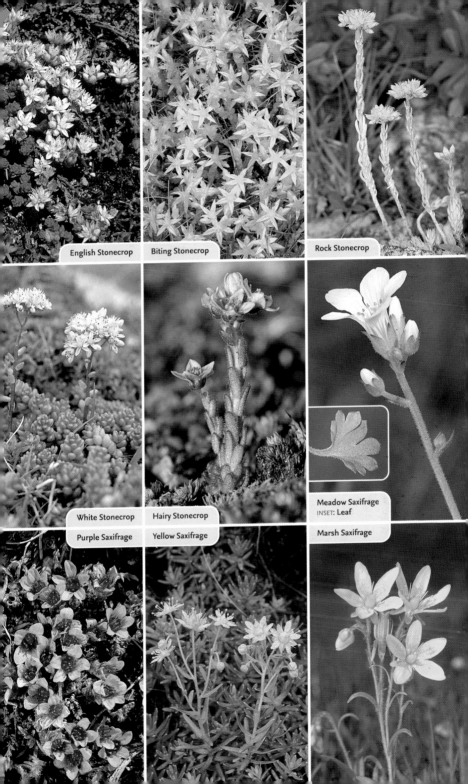

English Stonecrop

Biting Stonecrop

Rock Stonecrop

White Stonecrop

Hairy Stonecrop

Meadow Saxifrage
INSET: Leaf

Purple Saxifrage

Yellow Saxifrage

Marsh Saxifrage

Starry Saxifrage *Saxifraga stellaris* ✿ HEIGHT to 25cm

Perennial of damp ground and stream margins. FLOWERS Star-shaped, with 5 white petals and red anthers; *petals have yellow basal spots but no red spots above*; on slender stalks (June–Aug). FRUITS Dry capsules. LEAVES Oblong, toothed; forming a basal rosette. STATUS Locally common in upland N Wales, N Britain and Ireland.

St Patrick's-cabbage *Saxifraga spathularis* ✿✿ HEIGHT to 30cm

Tufted perennial of damp rocky places. FLOWERS Star-shaped, white; the five *petals have yellow basal spots and red spots above*; on slender stalks (June–Aug). FRUITS Dry capsules. LEAVES Spoon-shaped, toothed, stalked; appearing as a basal rosette. STATUS Very locally common in W Ireland and Wicklow.

Mossy Saxifrage *Saxifraga hypnoides* ✿ HEIGHT to 20cm

Mat-forming, upland perennial of rocks and damp, bare ground. FLOWERS 10–15mm across with 5 white petals; in clusters (May–July). FRUITS Dry capsules. LEAVES Pointed and lobed; non-flowering shoots procumbent; leafy bulbils form in the leaf axils; the overall effect is of a moss-like plant. STATUS Locally common in N England and Scotland; generally scarce elsewhere.

Irish Saxifrage *Saxifraga rosacea* ✿ HEIGHT to 20cm

Mat-forming perennial that recalls Mossy Saxifrage. Favours damp, rocky places, in mountains and by the coast. FLOWERS 12–18mm across with 5 white petals; in terminal clusters (June–Aug). FRUITS Dry capsules. LEAVES Palmately divided with pointed lobes. STATUS Local in S and W Ireland.

Rue-leaved Saxifrage *Saxifraga tridactylites* ✿ HEIGHT to 15cm

Stickily hairy annual with reddish, zigzag stems. Found on dry, bare ground and old walls, mainly on sandy or calcareous soils. FLOWERS 4–6mm across with 5 white petals; in clusters (June–Sep). FRUITS Dry capsules. LEAVES Pinnately divided into 1–5 finger-like lobes. STATUS Widespread and very locally common.

Alternate-leaved Golden Saxifrage *Chrysosplenium alternifolium*
✿ HEIGHT to 15cm

Patch-forming perennial of damp woodland and mountains, usually found on basic soils. FLOWERS 5–6mm across, yellow, lacking petals; in flat-topped clusters with toothed yellowish bracts below (Mar–June). FRUITS Dry capsules. LEAVES Kidney-shaped, blunt-toothed, long-stalked. Flower stems sometimes bear alternate leaves. STATUS Locally common in England, Wales and S Scotland.

Opposite-leaved Golden Saxifrage *Chrysosplenium oppositifolium*
✿ HEIGHT to 15cm

Patch-forming perennial of shady stream banks and damp woodland flushes. FLOWERS 3–5mm across, yellow, lacking petals; in flat-topped clusters with yellowish bracts below (Mar–July). FRUITS Dry capsules. LEAVES Rounded, short-stalked; in opposite pairs. STATUS Locally common, mainly in the north and west.

Grass-of-Parnassus *Parnassia palustris* ✿ HEIGHT to 25cm

Distinctive, tufted, hairless perennial of damp, peaty grassland, marshes and moors. FLOWERS 15–20mm across, superficially buttercup-like, with 5 white petals and greenish veins; on upright stalks with clasping leaves (June–Sep). FRUITS Dry capsules. LEAVES Deep green; basal leaves heart-shaped and stalked. STATUS Locally common in N Britain and Ireland; scarce in, or absent from, the south.

leaf

■ *See also* Tufted Saxifrage (p.281), Drooping Saxifrage (p.282) and Alpine Saxifrage (p.282)

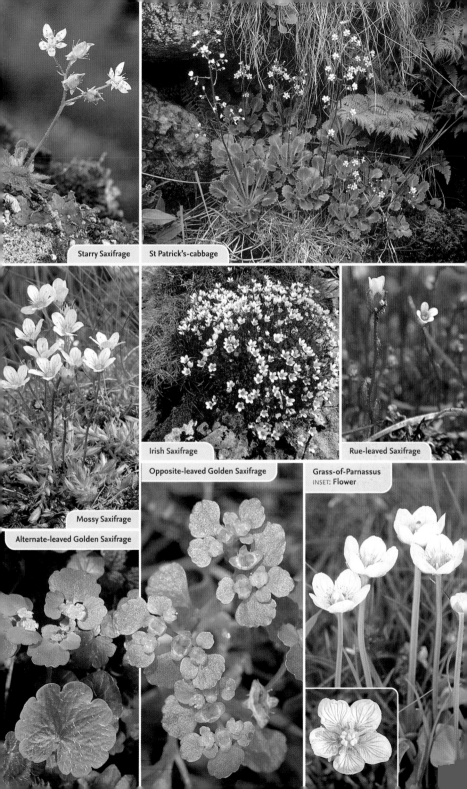

Starry Saxifrage

St Patrick's-cabbage

Mossy Saxifrage

Irish Saxifrage

Rue-leaved Saxifrage

Opposite-leaved Golden Saxifrage

Grass-of-Parnassus
INSET: Flower

Alternate-leaved Golden Saxifrage

Gooseberry *Ribes uva-crispa* (Grossulariaceae) **HEIGHT** to 1m
Deciduous shrub with spiny stems. Found in woodlands and hedgerows. **FLOWERS**
To 1cm across, yellowish; in clusters (Mar–May). **FRUITS** Green, hairy, eventually
swelling to form familiar gooseberries. **LEAVES** Rounded, irregularly lobed.
STATUS Widespread and fairly common native; also widely naturalised.

Black Currant *Ribes nigrum* (Grossulariaceae) ❀ **HEIGHT** to 2m
Deciduous shrub, found in damp woodlands and hedgerows. **FLOWERS** Greenish,
bell-shaped, pendent; in clusters of up to 10 (Apr–May). **FRUITS** Black berries.
LEAVES Rounded, irregularly 5-lobed, stickily hairy and aromatic when bruised.
STATUS Locally common native; also widely naturalised.

Red Currant *Ribes rubrum* (Grossulariaceae) ❀ **HEIGHT** to 2m
Deciduous shrub, found in damp woodland and beside streams and rivers. **FLOWERS**
Greenish, bell-shaped, pendent; in clusters of up to 20 (Apr–May). **FRUITS** Red,
shiny berries. **LEAVES** Rounded, irregularly 5-lobed and not aromatic when bruised.
STATUS Widespread and locally common native; also widely naturalised.

Raspberry *Rubus idaeus* (Rosaceae) **HEIGHT** to 1.5m
Upright perennial with biennial, arching stems that bear weak thorns. **FLOWERS**
1cm across, with 5 white petals; in clusters of up to 10 (June–Aug). **FRUITS** Red,
with many segments. **LEAVES** Pinnately divided with 3–7 leaflets that are downy
below. **STATUS** Widespread and fairly common throughout.

Bramble *Rubus fruticosus* agg. (Rosaceae) **HEIGHT** to 3m
Scrambling shrub that comprises hundreds of microspecies. Arching stems are
armed with variably shaped prickles and root when they touch the ground. Found
in hedgerows and scrub. **FLOWERS** 2–3cm across, white or pink (May–Aug). **FRUITS**
Familiar blackberries. **LEAVES** With 3–5 toothed leaflets. **STATUS** Widespread and
common.

Stone Bramble *Rubus saxatilis* (Rosaceae) ❀ **HEIGHT** to 40cm
Creeping perennial with slender stems that bear either weak
prickles or none at all. Favours rocky ground. **FLOWERS** 5–10mm
across with 5 narrow, white petals (June–Aug). **FRUITS** Shiny,
red, with 2–6 segments. **LEAVES** Trifoliate with toothed leaflets
that are downy below. **STATUS** Locally common, but mainly in the
west and north.

Stone Bramble fruit

Cloudberry *Rubus chamaemorus* (Rosaceae) ❀ **HEIGHT** to 20cm
Creeping, downy perennial that lacks prickles. Associated with
upland moors. **FLOWERS** 15–25mm across, with 5 white petals (June–Aug). **FRUITS**
Rather large, with many segments; red at first, ripening orange. **LEAVES** Rounded,
palmately lobed. **STATUS** Locally common in N England and Scotland; scarce in
N Wales and N Ireland.

Dewberry *Rubus caesius* (Rosaceae) ❀ **HEIGHT** to 10cm
Creeping perennial whose biennial stems bear weak prickles. Found in dry, grassy
places but also in fens and dune slacks. **FLOWERS** 2–2.5cm across, with 5 white petals
(June–Aug). **FRUITS** Bluish black, the large segments covered in a plum-like bloom.
LEAVES Trifoliate and toothed. **STATUS** Widespread and locally common.

Agrimony *Agrimonia eupatoria* (Rosaceae) **HEIGHT** to 50cm
Upright perennial of grassy places, hedgerows and roadside verges.
FLOWERS 5–8mm across, with 5 yellow petals; in upright spikes (June–Aug).
FRUITS Bur-like and covered in spines. **LEAVES** Comprising 3–6 pairs of
oval, toothed leaflets with smaller leaflets between. **STATUS** Widespread
and generally common throughout. **Bridewort** *Spiraea salicifolia*, one of
several related garden escapes, is often naturalised in hedgerows.

Bridewort

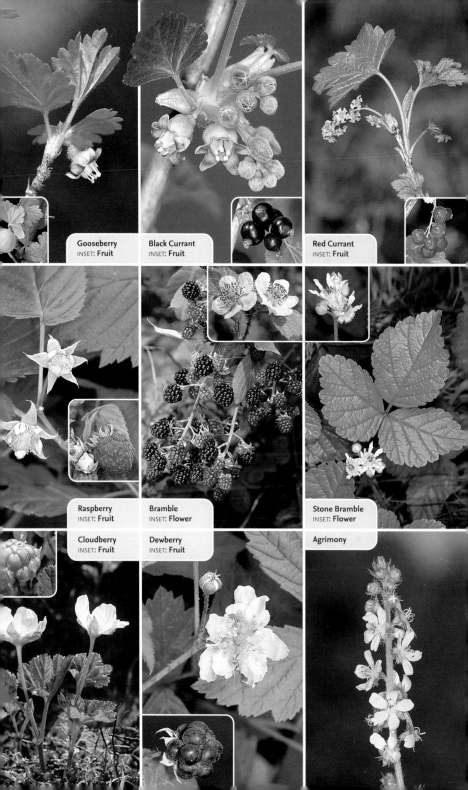

Gooseberry
INSET: **Fruit**

Black Currant
INSET: **Fruit**

Red Currant
INSET: **Fruit**

Raspberry
INSET: **Fruit**

Bramble
INSET: **Flower**

Stone Bramble
INSET: **Flower**

Cloudberry
INSET: **Fruit**

Dewberry
INSET: **Fruit**

Agrimony

Meadowsweet *Filipendula ulmaria* HEIGHT to 1.25m

Perennial of damp meadows, marshes and stream margins. FLOWERS 5–6mm across, fragrant, creamy white; in sprays (June–Sep). FRUITS Spirally twisted, 1-seeded. LEAVES Dark green, comprising 3–5 pairs of oval leaflets with smaller leaflets between. STATUS Common.

Dropwort *Filipendula vulgaris* ❀ HEIGHT to 50cm

Perennial of calcareous grassland. FLOWERS 10–20mm across, unscented, creamy white above and reddish below; in flat-topped sprays (May–Aug). FRUITS Downy. LEAVES Comprising 8–20 pairs of large leaflets with smaller leaflets between. STATUS Widespread but local.

Meadowsweet

Field-rose leaf

Dog-rose *Rosa canina* HEIGHT to 3m

Scrambling hedgerow shrub; long, arching stems bear *curved thorns.* FLOWERS 3–5cm across, fragrant, with 5 pale pink petals and yellow stamens; in clusters of up to 4 flowers (June–July). FRUITS Red, egg-shaped hips *shed their sepals before they ripen.* LEAVES 5–7 hairless leaflets. STATUS Common. **Round-leaved Dog-rose** *R. obtusifolia* has more rounded leaves. Central England.

Field-rose *Rosa arvensis* HEIGHT to 1m

Clump-forming shrub whose weak, trailing, purplish stems carry small numbers of *curved thorns.* Associated with woodland margins, hedgerows and scrub. FLOWERS 3–5cm across with 5 white petals; styles united to form a column at least as long as the stamens; borne in clusters of up to 6 (July–Aug). FRUITS Rounded to ovoid red hips, with *sepals not persisting.* LEAVES Comprising 5–7 oval leaflets. STATUS Widespread and common in England, Wales and Ireland; almost absent from Scotland.

Sweet-briar fruit

Sweet-briar *Rosa rubiginosa* ❀ HEIGHT to 3m

Compact hedgerow shrub. Upright stems bear short, *curved thorns,* bristles and glands. FLOWERS 2–3cm across, pink; in clusters of up to 3 (June–July). FRUITS Ovoid, red hips with *persisting sepals.* LEAVES 5–7 oval, toothed, sweet-smelling leaflets. STATUS Locally common. **Small-leaved Sweet-briar** *R. agrestis* has smaller flowers and reflexed, falling sepals. Scarce.

Japanese Rose *Rosa rugosa* HEIGHT to 1.5m

Showy shrub with upright stems with rather *straight thorns.* FLOWERS 6–9cm across, with 5 pinkish-purple or white petals (June–Aug). FRUITS Spherical red hips, 2–5cm across. LEAVES 5–9 oval leaflets, shiny above. STATUS Planted beside roads and also naturalised.

Japanese Rose fruit

Harsh Downy-rose *Rosa tomentosa* HEIGHT to 2m

Dense shrub of hedgerows, scrub and woodland margins with arching stems that bear rather *straight thorns.* FLOWERS 3–4cm across, with 5 pink or white petals; in clusters of up to 5 (June–July). FRUITS Rounded, red hips covered with bristles. LEAVES 5–7 oval leaflets that are downy on both sides. STATUS Fairly common, but mainly in the south. **Sherard's Downy-rose** *R. sherardii* has narrower thorns and smaller darker flowers. Northern. **Soft Downy-rose** *R. mollis* has scented leaves and deep pink flowers. Northern.

Burnet Rose

Burnet Rose *Rosa pimpinellifolia* ❀ HEIGHT to 50cm

Clump-forming shrub with suckers and stems that bear numerous straight thorns and stiff bristles. Associated mainly with sand dunes, calcareous grasslands, limestone pavements and heaths. FLOWERS 3–5cm across with 5 creamy-white petals; usually solitary (May–July). FRUITS Spherical, 5–6mm across and purplish black when ripe. LEAVES Comprising 7–11 oval leaflets. STATUS Widespread but local.

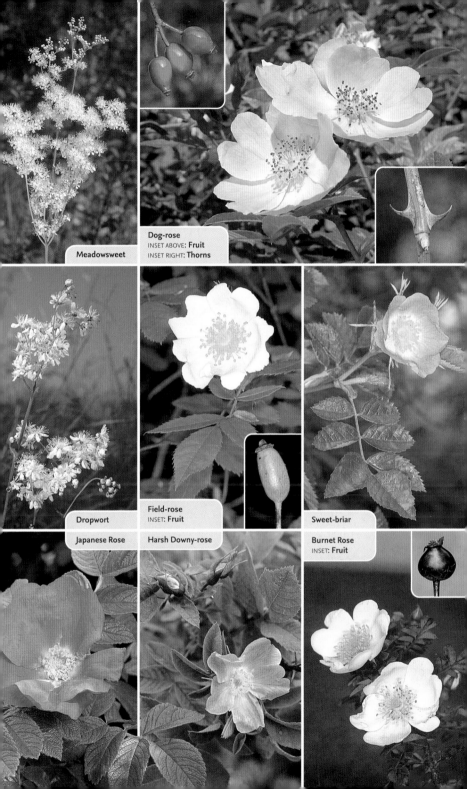

Meadowsweet

Dog-rose
INSET ABOVE: **Fruit**
INSET RIGHT: **Thorns**

Dropwort

Field-rose
INSET: **Fruit**

Sweet-briar

Japanese Rose

Harsh Downy-rose

Burnet Rose
INSET: **Fruit**

Great Burnet *Sanguisorba officinalis* ❀ **HEIGHT** to 1m
Elegant, hairless perennial of damp grassland and river banks. **FLOWERS** Tiny, reddish purple; in dense, ovoid heads on long stalks (June–Sep). **FRUITS** Dry, papery. **LEAVES** Pinnately divided, comprising 3–7 pairs of oval, toothed leaflets. **STATUS** Local and declining, and common only in central and N England.

Salad Burnet *Sanguisorba minor* **HEIGHT** to 35cm
Perennial of chalk grassland that is hairy below. Smells of cucumber when crushed. **FLOWERS** Tiny, green with red styles; in dense, rounded heads (May–Sep). **FRUITS** Ridged, 4-sided. **LEAVES** Pinnately divided, comprising 4–12 pairs of rounded, toothed leaflets; basal leaves in a rosette. **STATUS** Locally common.

Pirri-pirri-bur *Acaena novae-zelandiae* ❀❀ **HEIGHT** to 15cm
Creeping, much-divided, downy perennial. Favours dry, sandy places, often near the coast. **FLOWERS** Tiny, whitish; in compact, rounded heads (June–July). **FRUITS** *Reddish, spiny and bur-like.* **LEAVES** Pinnately divided with 4–5 pairs of leaflets. **STATUS** Introduced from New Zealand and now established locally.

Lady's-mantle *Alchemilla vulgaris* agg. **HEIGHT** to 30cm
Grassland perennial. Aggregate of several native species and the familiar herbaceous border ornamental *A. mollis*. **FLOWERS** Yellowish green, in flat-topped clusters (May–Sep). **FRUITS** Dry, papery. **LEAVES** *Rounded, palmately lobed*; leaf shape variation used to separate aggregated species. **STATUS** Widespread.

Alpine Lady's-mantle *Alchemilla alpina* ❀ **HEIGHT** to 25cm
Tufted perennial of grassy upland sites. **FLOWERS** Tiny, yellowish green, in flat-topped clusters (June–Aug). **FRUITS** Dry, papery. **LEAVES** Palmately lobed, the *lobes typically divided to the base or nearly so*; undersurface of leaf is silkily hairy. **STATUS** Widespread but locally common in NW England and Scotland only.

Parsley-piert *Aphanes arvensis* **CREEPING**
Easily overlooked on dry, bare ground and arable field margins; greyish-green downy annual. **FLOWERS** Minute, petal-less and green; in dense, unstalked clusters along stems (Apr–Oct). **FRUITS** Dry, papery. **LEAVES** Fan-shaped, deeply divided into 3 lobes and parsley-like. **STATUS** Widespread and generally common. **Slender Parsley-piert** *A. australis* is green with ovate, not triangular stipules. Sandy soils.

Mountain Avens *Dryas octopetala* ❀❀ **HEIGHT** to 6cm
Creeping perennial; on basic rocks, in mountains and, locally, to sea-level. **FLOWERS** 3–4cm across, with 8 or more white petals and a mass of yellow stamens (June–July). **FRUITS** Dry, 1-seeded, with feathery plumes. **LEAVES** Dark green, oblong, toothed. **STATUS** Locally common, Scotland and W Ireland.

Wood Avens *Geum urbanum* **HEIGHT** to 50cm
Hairy perennial of hedgerows and woodland. **FLOWERS** 8–15mm across, with 5 yellow petals; upright in bud but dropping when fully open (May–Aug). **FRUITS** Bur-like, with red, hooked spines. **LEAVES** Basal leaves with 3–6 pairs of side leaflets and a large terminal one; stem leaves 3-lobed. **STATUS** Widespread and common.

Water Avens *Geum rivale* **HEIGHT** to 50cm
Downy perennial of damp meadows, marshes and mountain ledges, mostly on base-rich soils. **FLOWERS** Nodding, bell-shaped and comprising dark red sepals and pink petals (May–Sep). **FRUITS** Bur-like but feathery. **LEAVES** Pinnate basal leaves; trifoliate ones on stem. **STATUS** Locally common.

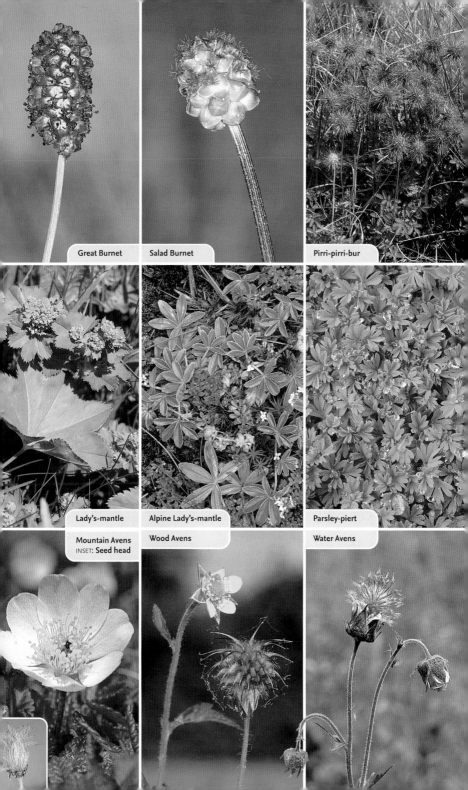

Great Burnet

Salad Burnet

Pirri-pirri-bur

Lady's-mantle

Alpine Lady's-mantle

Parsley-piert

Mountain Avens
INSET: Seed head

Wood Avens

Water Avens

Marsh Cinquefoil *Potentilla palustris* **HEIGHT** to 40cm
Hairless perennial of marshes and damp meadows. **FLOWERS** Star-shaped, upright, with 5 reddish sepals and smaller purple petals (May–July). **FRUITS** Dry, papery. **LEAVES** Greyish, pinnately divided into 3 or 5 toothed, oval leaflets. **STATUS** Widespread but local; common only in N England and Ireland.

Marsh Cinquefoil

Sulphur Cinquefoil

Shrubby Cinquefoil *Potentilla fruticosa* ❀❀ **HEIGHT** to 1m
Deciduous, downy shrub. Favours damp, rocky ground and river banks, usually on basic soils. **FLOWERS** 2cm across, with 5 yellow petals; in clusters (May–July). **FRUITS** Dry, papery. **LEAVES** Greyish green, pinnately divided into 3 or 5 untoothed leaflets. **STATUS** Rare; native to Teesdale, Lake District and W Ireland only.

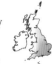

Sulphur Cinquefoil *Potentilla recta* ❀❀ **HEIGHT** to 70cm
Upright, hairy perennial with stiff stems. Favours dry, grassy places and waste ground. **FLOWERS** 2–2.5cm across, with 5 pale yellow petals; in terminal clusters (June–Sep). **FRUITS** Dry, papery. **LEAVES** Palmately divided into 5 or 7 finger-like lobes. **STATUS** Occasionally naturalised in S and E England.

Alpine Cinquefoil *Potentilla crantzii* ❀❀ **HEIGHT** to 25cm
Hairy perennial of upland, rocky ground and mountain ledges. **FLOWERS** 15–25mm across, the 5 yellow petals often with an orange basal spot (June–July). **FRUITS** Dry, papery. **LEAVES** Pinnately divided into 5 finger-like, toothed lobes. **STATUS** Scarce and local in N Wales, N England and the Scottish Highlands.

Hoary Cinquefoil *Potentilla argentea* ❀❀ **HEIGHT** to 50cm
Spreading perennial of dry, gravelly soils. Stems are coated in silvery hairs. **FLOWERS** 8–12mm across, with 5 yellow petals; in branched clusters (May–June). **FRUITS** Dry, papery. **LEAVES** Digitate with narrow leaflets, the undersides coated with silvery hairs. **STATUS** Local, mainly in SE England.

Spring Cinquefoil *Potentilla neumanniana* ❀❀ **HEIGHT** to 15cm
Creeping, mat-forming perennial with woody stem bases. Found in dry, calcareous grassland. **FLOWERS** 1–2cm across, with 5 yellow petals; in loose clusters (Apr–June). **FRUITS** Dry, papery. **LEAVES** Palmate basal leaves with 5–7 leaflets, and trifoliate stem leaves. **STATUS** Widespread but extremely local.

Tormentil *Potentilla erecta* **HEIGHT** to 30cm
Creeping, downy perennial of grassy places, heaths and moors. **FLOWERS** 7–11mm across, with 4 yellow petals; on slender stalks (May–Sep). **FRUITS** Dry, papery. **LEAVES** Unstalked, trifoliate but *appear 5-lobed because of 2 large, leaflet-like stipules at the base.* **STATUS** Widespread and often abundant. **Trailing Tormentil** *P. anglica* is similar but, like the next species, it roots at the nodes. Widespread but local.

Trailing Tormentil

Creeping Cinquefoil *Potentilla reptans* **HEIGHT** to 20cm
Creeping perennial whose trailing stems root at the nodes (unlike Tormentil). Found in grassy places, including verges. **FLOWERS** 7–11mm across, with 4 yellow petals (June–Sep). **FRUITS** Dry, papery. **LEAVES** Long-stalked, hairless, *divided into 5–7 leaflets.* **STATUS** Widespread and common throughout.

Silverweed *Potentilla anserina* **CREEPING**
Low-growing perennial with long, creeping stems. Found in damp, grassy places and on bare ground. **FLOWERS** 15–20mm across, with 5 yellow petals (May–Aug). **FRUITS** Dry, papery. **LEAVES** Divided into up to 12 pairs of leaflets, *covered in silvery, silky hairs.* **STATUS** Widespread and common.

Creeping Cinquefoil

Silverweed

■ See also Rock Cinquefoil (p.283)

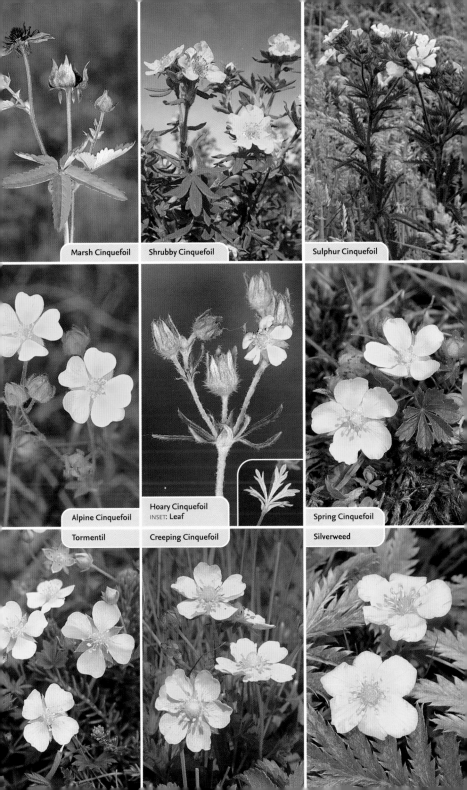

Marsh Cinquefoil

Shrubby Cinquefoil

Sulphur Cinquefoil

Alpine Cinquefoil

Hoary Cinquefoil
INSET: Leaf

Spring Cinquefoil

Tormentil

Creeping Cinquefoil

Silverweed

Barren Strawberry *Potentilla sterilis* HEIGHT to 15cm

Hairy perennial with long, rooting runners. Favours dry, grassy places and woodland rides. FLOWERS 10–15mm across, with 5 white, widely separated petals (Mar–May). FRUITS *Dry, papery.* LEAVES Bluish green, trifoliate; *terminal tooth of end leaflet shorter than adjacent ones.* STATUS Widespread and common.

Barren Strawberry

Wild Strawberry

Wild Strawberry *Fragaria vesca* HEIGHT to 30cm

Low perennial with long, rooting runners. Found in dry, grassy places. FLOWERS 12–18mm across, with 5 white petals (Apr–July). FRUITS *Tiny strawberries.* LEAVES Comprising 3 oval, toothed leaflets that are hairy beneath; *terminal tooth of end leaflet usually longer than adjacent ones.* STATUS Widespread and common.

Garden Strawberry *Fragaria × ananassa* HEIGHT to 40cm

Distinctive and familiar perennial. Sometimes found in grassy places near gardens. FLOWERS 25–30mm across, with 5 white petals; on short stalks (May–July). FRUITS Ripening to form luscious, bright red strawberries. LEAVES Trifoliate with stalked leaflets. STATUS Widely cultivated and occasionally naturalised.

Sibbaldia *Sibbaldia procumbens* ✿✿ PROSTRATE

Creeping, tufted perennial of bare ground, short grassland and rocky places in mountains. FLOWERS 5mm across, with yellow petals that are sometimes absent (July–Aug). FRUITS Dry, papery. LEAVES Bluish green, trifoliate, the leaflets ovate with 3 terminal teeth. STATUS Local in Scottish Highlands.

Blackthorn *Prunus spinosa* HEIGHT to 5m

Thorny shrub that often forms dense thickets. Common in hedgerows and on sea cliffs. FLOWERS 14–18mm across, with 5 white petals; they appear before the leaves (Mar–Apr). FRUITS (Sloes) purplish with a powdery bloom, and resembling tiny plums. LEAVES Oval, 2–4cm long, with toothed margins. STATUS Common and widespread.

Hawthorn

Blackthorn

Hawthorn *Crataegus monogyna* HEIGHT to 12m

Thorny shrub or small tree; a common hedgerow species. FLOWERS 15–25mm across with 5 white petals; in clusters (May–June). FRUITS Clusters of bright red berries. LEAVES Shiny, roughly oval and divided into 3–7 pairs of lobes. STATUS Common.

Wild Cotoneaster *Cotoneaster cambricus* ✿✿ HEIGHT to 90cm

Dense, deciduous shrub. Found in rocky places, typically on limestone. FLOWERS Tiny, with 5 pink petals; in clusters of 2–3 (Apr–June). FRUITS Bright red, spherical berries. LEAVES 15–40mm long, rounded-oval, downy grey beneath. STATUS Rare and restricted to Great Orme's Head in N Wales.

Small-leaved Cotoneaster *Cotoneaster microphyllus* ✿✿ PROSTRATE

Low-growing, stiff, evergreen undershrub with twigs that are downy when young. Found on coastal limestone. FLOWERS Small with white, spreading petals; usually solitary (May–June). FRUITS Spherical, crimson berries. LEAVES 5–10mm long, oval but blunt or notched at the tip. STATUS Introduced and locally naturalised.

Wall Cotoneaster *Cotoneaster horizontalis* HEIGHT to 50cm

Stiff shrub with branches that divide and spread in a flat plane. Deciduous, but leaves appear early. FLOWERS Pink, solitary (May–July). FRUITS Bright red, spherical berries. LEAVES 5–10mm long, glossy above, hairless below. STATUS Widely grown in gardens and occasionally naturalised, mainly on calcareous soils.

Barren Strawberry

Wild Strawberry

Garden Strawberry

Sibbaldia

Blackthorn
INSET: Fruits

Hawthorn
INSET: Fruits

Wild Cotoneaster

Small-leaved Cotoneaster

Wall Cotoneaster

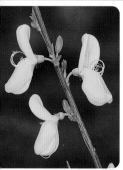

Broom Cytisus scoparius HEIGHT to 2m
Deciduous, branched and spineless shrub with ridged, 5-angled green twigs. Found on heaths and in hedgerows, favouring acid soils. FLOWERS 2cm long, bright yellow, solitary or in pairs (Apr–June). FRUITS Oblong, blackening pods that explode on dry, sunny days. LEAVES Usually trifoliate. STATUS Widespread and common.

Broom

Gorse Ulex europaeus HEIGHT to 2m
Evergreen shrub with straight, *grooved spines*, 15–25mm long. Found on heaths and grassy places, mainly on acid soils. FLOWERS 2cm long, bright yellow, coconut-scented, with *basal bracts 4–5mm long* (Jan–Dec, but mainly Feb–May). FRUITS Hairy pods. LEAVES Trifoliate when young. STATUS Widespread and common throughout.

Western Gorse Ulex gallii ❀ HEIGHT to 1.5m
Dense evergreen shrub with *spines that are almost smooth* and 25mm long. Found on acid soils, often near coasts. FLOWERS 10–15mm long, bright yellow with *basal bracts 0.5mm long* (July–Sep). FRUITS Hairy pods. LEAVES Trifoliate when young. STATUS Restricted mainly to W Britain and Ireland; common on coastal cliffs in the west.

Dwarf Gorse Ulex minor ❀ HEIGHT to 1m
Spreading evergreen shrub with spines that are *soft, smooth and 10mm long*. Found on acid soils, mainly on heaths. FLOWERS 10–15mm long, pale yellow with *basal bracts 0.5mm long* (July–Sep). FRUITS Hairy pods. LEAVES Trifoliate when young. STATUS Local and restricted mainly to heaths in SE and E England.

Dyer's Greenweed Genista tinctoria ❀ HEIGHT to 1m
Spineless, deciduous grassland shrub, usually found on clay or chalk soils. FLOWERS 15mm long, bright yellow, Broom-like; in leafy, stalked spikes (Apr–July). FRUITS Oblong, flat, hairless pods. LEAVES Narrow, sometimes downy. STATUS Locally common in England, Wales and S Scotland.

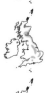

Petty Whin Genista anglica ❀ HEIGHT to 1m
A rather spindly, hairless shrub, armed with strong spines. Found on heaths and moors, usually growing among Ling. FLOWERS 15mm long, deep yellow; in terminal clusters (Apr–June). FRUITS Hairless, inflated. LEAVES Narrow, hairless, waxy. STATUS Widespread but local in England, Wales and S Scotland.

Wild Liquorice Astragalus glycyphyllos ❀ HEIGHT to 30cm
Sprawling, hairless perennial with branched, zigzag stems. Found in dry, grassy places on calcareous soils. FLOWERS 10–15mm long, yellowish green; in clusters (June–Aug). FRUITS Curved, to 4cm long. LEAVES 15–20cm long with oval leaflets and large basal stipules. STATUS Local, mainly E England and S Scotland.

Purple Milk-vetch Astragalus danicus ❀❀ HEIGHT to 30cm
Attractive downy, spreading perennial of dry, calcareous grassland. FLOWERS 15–18mm long, purple; in stalked clusters (May–July). FRUITS Pods covered in white hairs. LEAVES Hairy, pinnate, with 6–12 pairs of oval leaflets. STATUS Local in E England and S Scotland; scarce in Ireland.

Purple Oxytropis Oxytropis halleri ❀❀❀ HEIGHT to 20cm
Tufted perennial, covered in silky hairs. Found on mountain rocks and sea cliffs (in the far north), on calcareous soils. FLOWERS 20mm long, deep purple, with a pointed tip to the keel; in stalked heads (May–June). FRUITS Downy, 25mm-long pods. LEAVES To 15cm long with 10–15 pairs of narrow leaflets. STATUS Extremely local.

■ *See also* Hairy Greenweed (p.272), Alpine Milk-vetch (p.283) and Yellow Oxytropis (p.283)

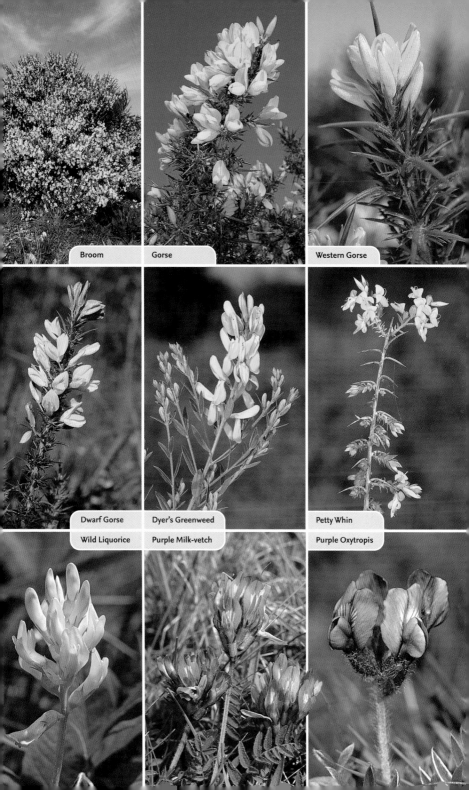

Broom

Gorse

Western Gorse

Dwarf Gorse

Dyer's Greenweed

Petty Whin

Wild Liquorice

Purple Milk-vetch

Purple Oxytropis

Tufted Vetch *Vicia cracca* HEIGHT to 2m

Slightly downy, scrambling perennial. Found in grassy places, hedgerows and scrub. FLOWERS 8–12mm long, bluish purple; in one-sided spikes up to 8cm tall (June–Aug). FRUITS Hairless pods. LEAVES Comprising up to 12 pairs of narrow leaflets and ending in a branched tendril. STATUS Widespread and common throughout.

Wood Vetch *Vicia sylvatica* ❀❀ HEIGHT to 1.5m

Elegant, straggling perennial of shady woods and steep, coastal slopes. FLOWERS 12–20mm long, white with purple veins; in spikes of up to 20 (June–Aug). FRUITS Black, hairless pods. LEAVES Comprising 6–12 pairs of oblong leaflets and *ending in a branched tendril*. STATUS Widespread but local; commonest in the west.

Wood Bitter-vetch *Vicia orobus* ❀❀ HEIGHT to 60cm

Scrambling or upright, downy perennial. Found in grassy places among scrub. FLOWERS 12–15mm long, pale pinkish lilac with purple veins; in spikes (May–July). FRUITS Oblong, hairless pods. LEAVES Comprising 5–10 pairs of oblong leaflets and *no terminal tendril*. STATUS Widespread but extremely local and found mainly in the west.

Bush Vetch *Vicia sepium* HEIGHT to 1m

Scrambling, slightly downy perennial of rough, grassy places and scrub. FLOWERS 12–15mm long, pale lilac; in groups of 2–6 (Apr–Oct). FRUITS Black, hairless pods. LEAVES Comprising 6–12 pairs of broadly oval leaflets and ending in branched tendrils. STATUS Common and widespread throughout.

Common Vetch *Vicia sativa* HEIGHT to 75cm

Scrambling, downy annual of grassy places and hedgerows. FLOWERS Pinkish purple, 2–3cm long; appearing singly or in pairs (Apr–Sep). FRUITS Pods that ripen black. LEAVES Comprising 3–8 pairs of oval leaflets, ending in tendrils. STATUS Widespread and fairly common throughout; sometimes seen as a relict of cultivation.

Spring Vetch *Vicia lathyroides* ❀❀ HEIGHT to 20cm

Rather delicate, spreading, downy annual. Found in short grassland, mainly on sandy soils and near the sea. FLOWERS 5–8mm long, reddish purple, solitary (Apr–June). FRUITS Black, hairless pods. LEAVES Comprising 2–4 pairs of bristle-tipped leaflets and unbranched tendrils. STATUS Local throughout.

Smooth Tare *Vicia tetrasperma* HEIGHT to 50cm

Slender, scrambling annual that is easily overlooked. Found in grassy places and hedgerows. FLOWERS 4–8mm long, pinkish lilac; appearing *singly or in pairs* (May–Aug). FRUITS *Smooth pods, usually containing 4 seeds.* LEAVES Comprising 2–5 pairs of narrow leaflets and ending in tendrils. STATUS Locally common in England and Wales. **Slender Tare** V. *tenuissima* has flowers in groups of 2–5, pods with 4–6 seeds. Rare, arable fields.

Hairy Tare *Vicia hirsuta* HEIGHT to 60cm

Scrambling, downy annual. Found in grassy places, especially on neutral or calcareous soils. FLOWERS 2–4mm long, pale lilac; in *groups of 1–9* (May–Aug). FRUITS *Hairy, 2-seeded pods.* LEAVES Comprising 4–10 pairs of leaflets and ending in branched tendrils. STATUS Widespread and fairly common throughout, except in the north and Ireland.

Yellow Vetch *Vicia lutea* ❀❀ HEIGHT to 50cm

Rather prostrate, hairless, greyish-green annual. Found in coastal grassy places and on stabilised shingle. FLOWERS 25–35mm long, pale yellow; in groups of 1–3 (June–Sep). FRUITS Hairy, brown pods up to 4cm long. LEAVES Comprising 3–10 pairs of bristle-tipped leaflets and tendrils. STATUS Very local, found mainly in the south.

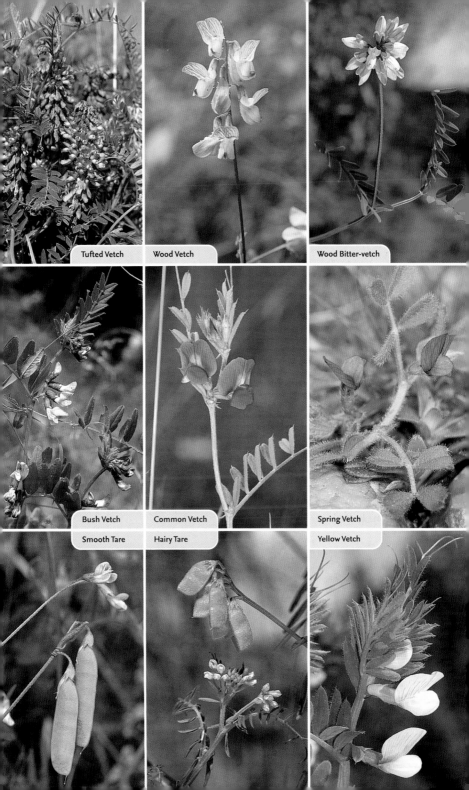

Tufted Vetch | Wood Vetch | Wood Bitter-vetch

Bush Vetch | Common Vetch | Spring Vetch

Smooth Tare | Hairy Tare | Yellow Vetch

Bithynian Vetch *Vicia bithynica* ❀❀ **HEIGHT** to 60cm
Scrambling perennial. Found in grassy places, often near the coast. **FLOWERS**
15–20mm long, the creamy-white keel and wings shrouding the purple standard;
singly or in pairs (May–June). **FRUITS** Brown, hairy pods 3–5cm long. **LEAVES**
Comprising 2–3 pairs of oval leaflets, branched tendrils and large stipules.
STATUS Very local in the south.

Meadow Vetchling *Lathyrus pratensis* **HEIGHT** to 50cm
Scrambling perennial with long, angled stems. Favours grassy places. **FLOWERS**
15–20mm long, yellow; in open, long-stalked terminal clusters of 4–12 (May–Aug).
FRUITS Pods 25–35mm long, ripening black. **LEAVES** Comprising 1 pair of narrow
leaflets with a tendril and large stipules. **STATUS** Widespread and common.

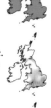

Yellow Vetchling *Lathyrus aphaca* ❀❀ **HEIGHT** to 80cm
Hairless, scrambling annual with angled stems and a waxy, grey-green appearance.
Restricted to chalk grassland. **FLOWERS** 12mm long, yellow; solitary, on long stalks
(June–Aug). **FRUITS** Curved, brown pods. **LEAVES** Reduced to tendrils but note the
leaf-like stipules. **STATUS** Locally common in S England only.

Sea Pea *Lathyrus japonicus* ❀❀ **HEIGHT** to 12cm
Spreading grey-green perennial with stems up to 1m long. Entirely restricted to
coastal shingle and sand. **FLOWERS** 2cm long, purple fading to blue; in heads of
2–15 (June–Aug). **FRUITS** Swollen pods, 5cm long. **LEAVES** Comprising 2–5 pairs of
oval leaflets and angular stipules. **STATUS** Mainly S and E England.

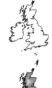

Bitter-vetch *Lathyrus linifolius* **HEIGHT** to 50cm
Upright, almost hairless perennial with winged stems. Found in grassy places,
heaths and woods, mainly on acid soils. **FLOWERS** 15mm long, red fading to blue
or green; in groups of 5–12 (Apr–July). **FRUITS** Brown pods, 4cm long. **LEAVES**
Comprising 2–4 pairs of narrow leaflets and no tendril. **STATUS** Locally common.

Marsh Pea *Lathyrus palustris* ❀❀ **HEIGHT** to 1m
Slender, climbing perennial with winged stems. Found in fens and damp, grassy
places on calcareous soils. **FLOWERS** 2cm long, pinkish purple; in long-stalked
groups of 2–8 (May–July). **FRUITS** Flat pods, 5cm long. **LEAVES** Comprising
2–5 pairs of narrow leaflets and branched tendrils. **STATUS**
Extremely local.

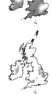

Narrow-leaved Everlasting-pea *Lathyrus sylvestris*
❀❀ **HEIGHT** to 3m
Hairless perennial with winged stems. Found in hedges
and grassy places, often coastal. **FLOWERS** 2cm long, pinkish,
flushed with yellow; in long-stalked groups of 3–12 (June–Aug).
FRUITS Long pods. **LEAVES** Comprising 1 pair of narrow leaflets
10–15cm long, narrow stipules and branched tendrils. **STATUS** Very local.

Broad-leaved
Everlasting-pea

Broad-leaved Everlasting-pea *L. latifolius* is similar but larger in all
respects, with broader leaves. Naturalised as a garden escape.

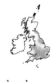

Grass Vetchling *Lathyrus nissolia* ❀ **HEIGHT** to 90cm
Upright, hairless or slightly downy perennial. Easily overlooked when not in flower,
in its favoured grassy habitat. **FLOWERS** 18mm long, crimson; solitary or paired on
long, slender stalks (May–July). **FRUITS** Narrow pods. **LEAVES** Reduced to 1 pair of
narrow, extremely grass-like leaflets. **STATUS** Locally common in SE England.

Kidney Vetch *Anthyllis vulneraria* **HEIGHT** to 30cm
Perennial covered in silky hairs. Found on calcareous grassland and coastal slopes.
FLOWERS Yellow, orange or red; in paired, kidney-shaped heads, 3cm across
(May–Sep). **FRUITS** Short pods. **LEAVES** Comprising pairs of narrow leaflets, the
terminal one largest. **STATUS** Widespread and locally common.

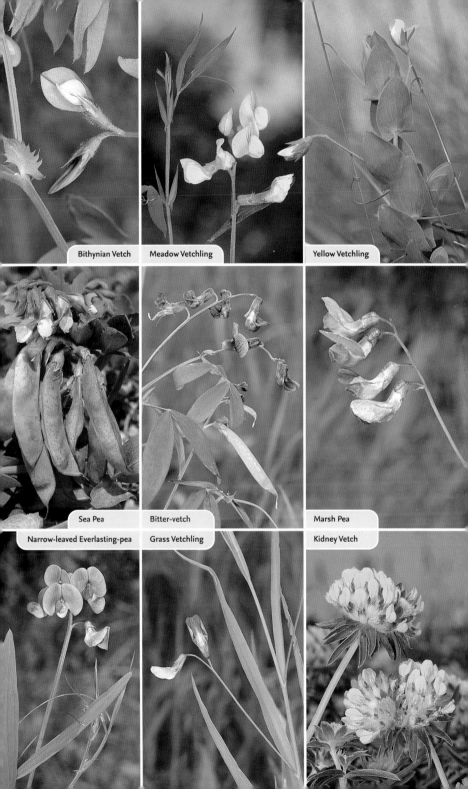

Bithynian Vetch

Meadow Vetchling

Yellow Vetchling

Sea Pea

Bitter-vetch

Marsh Pea

Narrow-leaved Everlasting-pea

Grass Vetchling

Kidney Vetch

Sainfoin *Onobrychis viciifolia* ❀ HEIGHT to 75cm

Distinctive straggly, slightly downy perennial. Found in dry, calcareous grassland. FLOWERS Pink with red veins; in conical spikes to 8cm long (June–Aug). FRUITS Oval, warty pods. LEAVES Comprising 6–14 pairs of oval leaflets. STATUS Possibly native in SE England but a relict of cultivation elsewhere.

Common Restharrow *Ononis repens* HEIGHT to 70cm

Robust, creeping, woody perennial with hairy, *spineless stems*. Restricted to calcareous soils. FLOWERS 10–15mm long, pink, the wings and keel similar in length; in clusters (July–Sep). FRUITS Pods shorter than the calyx. LEAVES Stickily hairy; trifoliate with oval leaflets. STATUS Local. Beware, a rare spiny form occurs and can be confused with Spiny Restharrow.

Sainfoin

Spiny Restharrow *Ononis spinosa* ❀ HEIGHT to 70cm

Similar to Common Restharrow but upright and much more bushy, with *spiny stems*. Favours grassland on clay and heavy soils. FLOWERS 10–15mm long, deep pink, the wings shorter than the keel (July–Sep). FRUITS Pods longer than the calyx. LEAVES Trifoliate with narrow, oval leaflets. STATUS Local, mainly in England.

Small Restharrow *Ononis reclinata* ❀❀❀ HEIGHT to 15cm

Spreading, stickily hairy, spineless annual. Favours dry, grassy places near the sea. FLOWERS 10mm long, pink, the petals barely longer than the calyx (June–July). FRUITS Pendent pods. LEAVES Trifoliate with oval leaflets. STATUS Restricted to Berry Head in Devon, the Gower Peninsula and the Channel Islands.

Ribbed Melilot *Melilotus officinalis* HEIGHT to 1.5m

Attractive upright, hairless biennial. Found in grassy places and on waste ground. FLOWERS Bright yellow, in spikes to 7cm long (June–Sep). FRUITS Brown, wrinkled pods. LEAVES Comprising 3 oblong leaflets. STATUS Locally common and possibly native in S England and Wales; introduced elsewhere.

White Melilot *Melilotus albus* ❀ HEIGHT to 1m

Distinctive upright, hairless biennial. Found in grassy places and disturbed soils on waste ground. FLOWERS White, in spikes to 7cm long (June–Aug). FRUITS Brown, veined pods. LEAVES Comprising 3 oblong leaflets. STATUS Introduced but locally established in parts of S and E England.

Horseshoe Vetch *Hippocrepis comosa* ❀ HEIGHT to 10cm

Spreading, hairless perennial restricted to calcareous grassland. FLOWERS 1cm long, yellow; in circular heads (May–July). FRUITS Wrinkled, the segments fancifully horseshoe-shaped. LEAVES Comprising pairs of narrow leaflets. STATUS Locally common on chalk and limestone in E and SE England only.

Common Bird's-foot-trefoil *Lotus corniculatus* HEIGHT to 10cm

Sprawling, *solid-stemmed, usually hairless perennial*. Found in grassy places. FLOWERS Red in bud but yellow and 15mm long when open; in heads on *stalks to 8cm long* (May–Sep). FRUITS Slender pods; splayed like a bird's foot when ripe. LEAVES Comprising 5 leaflets but appearing trifoliate (lower pair at stalk base). STATUS Common.

Common Bird's-foot-trefoil

Greater Bird's-foot-trefoil *Lotus pedunculatus* HEIGHT to 50cm

Hairy, hollow-stemmed perennial found in damp grassy places and fens. FLOWERS 15mm long, yellow; in heads on stalks to 15cm long (June–Aug). FRUITS Slender pods; splayed like a bird's foot when ripe. LEAVES Comprising 5 dark green leaflets but appearing trifoliate (lower pair sited at stalk base). STATUS Locally common.

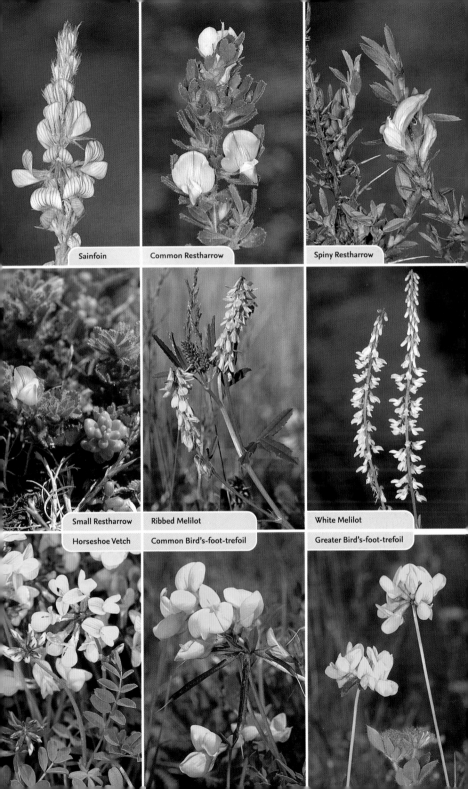

Sainfoin

Common Restharrow

Spiny Restharrow

Small Restharrow

Ribbed Melilot

White Melilot

Horseshoe Vetch

Common Bird's-foot-trefoil

Greater Bird's-foot-trefoil

Narrow-leaved Bird's-foot-trefoil *Lotus glaber* ❀ **HEIGHT** to 10cm

Rather upright, hairless perennial of damp grassy places on clay. Similar to Common Bird's-foot-trefoil but *more slender*. **FLOWERS** 10mm long; on relatively *short stalks, in heads of 2–4* (May–Aug). **FRUITS** Slender pods. **LEAVES** Comprising 5 *narrow, pointed leaflets*, but appearing trifoliate. **STATUS** Local, mainly in the south.

Dragon's-teeth *Tetragonolobus maritimus* ❀❀ **HEIGHT** to 10cm

Hairy, grey-green, sprawling perennial. Found in grassy places on calcareous soils. **FLOWERS** 2–2.5cm long, pale yellow; solitary, on long stalks (May–Aug). **FRUITS** *5cm long, deep brown, 4-angled.* **LEAVES** Trifoliate with triangular stipules. **STATUS** Extremely local in SE England and probably introduced.

Goat's-rue *Galega officinalis* ❀❀ **HEIGHT** to 1.5m

Bushy, much-branched perennial that is hairless or slightly downy. Found on disturbed and waste ground. **FLOWERS** 10mm long, pale bluish lilac; in elongated spikes to 5cm long (May–Aug). **FRUITS** Cylindrical pods. **LEAVES** Comprising 9–17 oval leaflets. **STATUS** Naturalised in central and S England, often on roadside verges.

Crown Vetch *Securigera varia* ❀❀ **HEIGHT** to 1m

Straggling, hairless perennial. Found in grassy places, usually on calcareous soils. **FLOWERS** 10–15mm long, pink and white; in long-stalked, spherical heads of 10–20 (June–Aug). **FRUITS** 4-angled pods, 6cm long. **LEAVES** Comprising 7–12 pairs of oval leaflets and a terminal leaflet. **STATUS** Naturalised locally.

Lucerne *Medicago sativa* ssp. *sativa* ❀ **HEIGHT** to 75cm

Downy or hairless perennial. Found in grassy places but also culti-vated. **FLOWERS** 7–8mm long, in stalked heads of 5–40 (June–Sep). **FRUITS** Spirally twisted pods. **LEAVES** Trifoliate with narrow, toothed leaflets that broaden towards the tip. **STATUS** Widely naturalised as a relict of cultivation.

Lucerne fruits

Black Medick *Medicago lupulina* **HEIGHT** to 20cm

Downy annual of short grassland and waste places. **FLOWERS** Small, yellow; in dense, spherical heads (8–9mm across) of 10–50 (Apr–Oct). **FRUITS** *Spirally coiled, spineless, black when ripe.* **LEAVES** Trifoliate, each leaflet bearing a point at the centre of its apex. **STATUS** Widespread and rather common.

Black Medick fruits

Black Medick leaf

Spotted Medick *Medicago arabica*
❀ **PROSTRATE**

Creeping annual of dry, grassy places, often near the sea. **FLOWERS** Small, yellow; in heads (5–7mm across) of 1–6 (Apr–Sep). **FRUITS** *Spirally coiled, spiny pods.* **LEAVES** Trifoliate, the heart-shaped leaflets bearing a *dark central spot.* **STATUS** Local in S and E England, and mainly coastal.

Bird's-foot *Ornithopus perpusillus* **HEIGHT** to 30cm

Low-growing, often trailing downy annual of dry, sandy places. **FLOWERS** 3–5mm long, creamy, red-veined; in heads of 3–8 flowers (May–Aug). **FRUITS** Constricted pods, *arranged like a bird's foot when ripe.* **LEAVES** Comprising 5–13 pairs of leaflets. **STATUS** Locally common in England and Wales but scarce elsewhere.

Bird's-foot Clover *Trifolium ornithopodioides* ❀❀ **PROSTRATE**

Low-growing, hairless annual that is easily overlooked. Found in dry, grassy places, usually on sand or gravel. **FLOWERS** 5–8mm long, white or pale pink; in heads of 1–5 (May–Oct). **FRUITS** Small pods. **LEAVES** Clover-like, trifoliate with toothed, oval leaflets. **STATUS** Very local in S England, Wales and Ireland.

■ *See also* Orange Bird's-foot (p.273) and Sickle Medick (p.279)

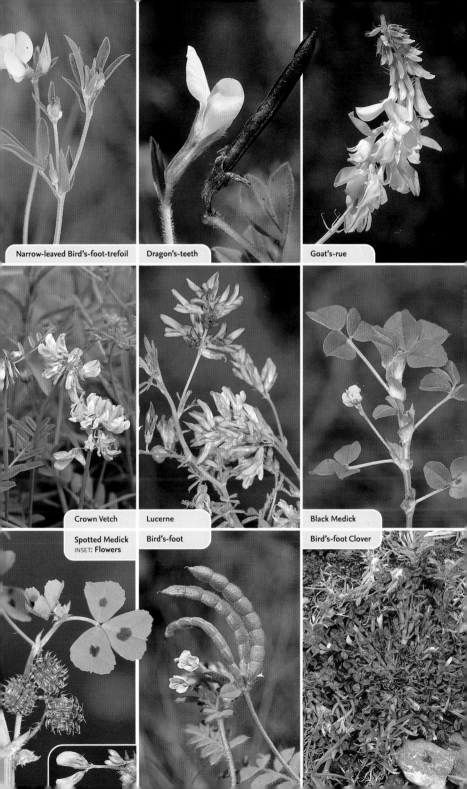

Narrow-leaved Bird's-foot-trefoil

Dragon's-teeth

Goat's-rue

Crown Vetch

Lucerne

Black Medick

Spotted Medick
INSET: Flowers

Bird's-foot

Bird's-foot Clover

Subterranean Clover *Trifolium subterraneum* ❀ PROSTRATE
Low-growing, hairy annual, found in short grassland on sand and gravel, usually near the coast. FLOWERS 8–12mm long, creamy white; in clusters of 2–6 in leaf axils (May–June). FRUITS Pods that 'burrow' into the soil, pushed by elongating stalks. LEAVES Trifoliate with broadly oval, notched leaflets. STATUS Local, mainly in the south.

Subterranean Clover

Hop Trefoil *Trifolium campestre* HEIGHT to 25cm
Low-growing, *hairy* annual. Found in dry grassland. FLOWERS 4–5mm long, yellow; in compact, rounded heads, *12–15mm across* (May–Oct). FRUITS Pods, cloaked by brown dead flowers in *hop-like heads*. LEAVES Trifoliate; terminal leaflet with longest stalk. STATUS Widespread and generally common; local in the north and Ireland.

Lesser Trefoil *Trifolium dubium* HEIGHT to 20cm
Low-growing annual. Similar to Hop Trefoil but *hairless*. Found in dry, grassy places. FLOWERS 3–4mm long, yellow; in compact, rounded heads, *8–9mm across* (May–Oct). FRUITS Pods, cloaked by brown dead flowers in *hop-like heads*. LEAVES Trifoliate with oval leaflets. STATUS Widespread and common throughout the region.

Slender Trefoil *Trifolium micranthum* ❀ HEIGHT to 10cm
Upright, slender annual that is easily overlooked. Favours dry, grassy places, mainly on sandy or gravelly soils. FLOWERS 2–3mm long, deep yellow; in long-stalked heads of 2–6 (May–Aug). FRUITS Brown pods. LEAVES Trifoliate with short-stalked leaflets. STATUS Widespread but only locally common.

Hare's-foot Clover *Trifolium arvense* HEIGHT to 25cm
Charming and distinctive annual covered in soft hairs. Found in dry, grassy areas, typically on sandy or gravelly soils. FLOWERS Pale pink, shorter than the filament-like calyx teeth; borne in dense egg-shaped to cylindrical heads, 2–3cm long (June–Sep). FRUITS Concealed by the calyx. LEAVES Trifoliate, comprising narrow leaflets that are barely toothed. STATUS Widespread and locally common in England and Wales; absent from N Scotland and mainly coastal in Ireland.

Alsike Clover *Trifolium hybridum* ❀ HEIGHT to 60cm
Hairless perennial. Similar to White Clover but *upright* (not creeping), never roots at the nodes and has *unmarked leaves*. Found in grassy places and on verges. FLOWERS Whitish at first but turning pink or brown with age; in stalked heads, 2cm across (June–Oct). FRUITS Concealed by calyx. LEAVES Trifoliate with unmarked leaflets. STATUS Widespread and fairly common, often as a relict of cultivation.

Red Clover *Trifolium pratense* HEIGHT to 40cm
Familiar downy perennial found in grassy places on a wide range of soil types. FLOWERS Pinkish red, in dense, unstalked heads 2–3cm across (May–Oct). FRUITS Concealed by calyx. LEAVES Trifoliate, the oval leaflets each bearing a *white crescent-shaped mark*; stipules triangular and bristle-tipped. STATUS Widespread and often extremely common throughout.

Red Clover

Zigzag Clover *Trifolium medium* ❀ HEIGHT to 50cm
Downy perennial of undisturbed grassy places. Similar to Red Clover but has *zigzag stems*. FLOWERS Reddish purple, in short-stalked heads 2–3cm across (May–July). FRUITS Concealed by calyx. LEAVES Trifoliate with narrow leaflets; stipules not bristle-tipped. STATUS Locally common, except in the north.

■ *See also* Long-headed Clover (p.272) and Suffocated Clover (p.276)

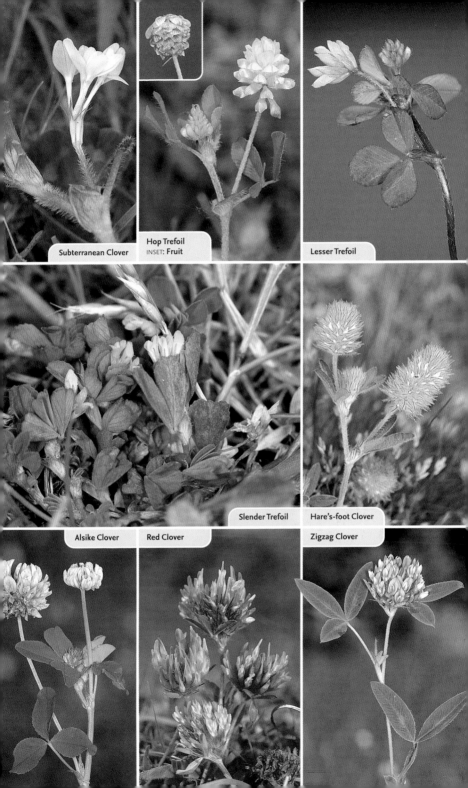

Subterranean Clover

Hop Trefoil
INSET: **Fruit**

Lesser Trefoil

Slender Trefoil

Hare's-foot Clover

Alsike Clover

Red Clover

Zigzag Clover

White Clover *Trifolium repens* (Fabaceae) **HEIGHT** to 40cm
Creeping, hairless perennial that roots at the nodes. Found in grassy places on a wide range of soil types. **FLOWERS** Creamy white, becoming brown with age; in long-stalked, rounded heads 2cm across (May–Oct). **FRUITS** Concealed by calyx. **LEAVES** Trifoliate, the *rounded leaflets often bearing a white mark and having translucent lateral veins.* **STATUS** Widespread and often extremely common throughout.

White Clover

Sulphur Clover *Trifolium ochroleucon* (Fabaceae) 🌸🌸 **HEIGHT** to 50cm
Subtly attractive, downy perennial. Found in grassy places and on verges, mainly on clay soils. **FLOWERS** Pale lemon-yellow; in short-stalked heads 2–3cm across (June–July). **FRUITS** Concealed by calyx. **LEAVES** Trifoliate; narrowly oval leaflets sometimes marked with white. **STATUS** Very local in E England.

Sea Clover *Trifolium squamosum* (Fabaceae) 🌸🌸 **HEIGHT** to 30cm
Downy annual of coastal grassland; often found on grassy sea walls built to protect low-lying land. **FLOWERS** Pinkish, in rounded to egg-shaped heads, 1cm long (June–July). **FRUITS** Egg-shaped, *resembling miniature Teasel heads.* **LEAVES** Trifoliate, with narrow leaflets. **STATUS** Scarce, local and possibly declining in some areas.

Knotted Clover *Trifolium striatum* (Fabaceae) **HEIGHT** to 20cm
Hairy annual of dry, grassy places, often on sand or gravel. **FLOWERS** Pink, in unstalked, egg-shaped heads 15mm long (May–July). **FRUITS** Concealed by calyx. **LEAVES** Trifoliate, with spoon-shaped leaflets that are hairy on both sides but *lack obvious lateral veins.* **STATUS** Locally common, mainly in the south.

Rough Clover *Trifolium scabrum* (Fabaceae) 🌸 **HEIGHT** to 15cm
Downy annual of bare grassland, often on gravel. **FLOWERS** White, in unstalked heads 10mm long (May–July). **FRUITS** Concealed by calyx. **LEAVES** Trifoliate, with oval leaflets that are hairy on both sides and have *obvious lateral veins.* **STATUS** Locally common in S England and S Wales but mainly coastal.

Strawberry Clover *Trifolium fragiferum* (Fabaceae) 🌸 **HEIGHT** to 15cm
Perennial with creeping stems that root at the nodes. Found in grassy places, mainly on clay and often near the sea. **FLOWERS** Pink, in globular heads 10–15mm across (July–Sep). **FRUITS** *Inflated, pinkish heads that resemble pale berries.* **LEAVES** Trifoliate with oval, unmarked leaflets. **STATUS** Local in the south; mainly coastal.

Wood Sorrel *Oxalis acetosella* (Oxalidaceae) **HEIGHT** to 10cm
Charming creeping perennial. An indicator of ancient, undisturbed woodlands and hedges. **FLOWERS** 1cm across, bell-shaped and white or pale pink with lilac veins; on stalks (Apr–June). **FRUITS** Hairless capsules. **LEAVES** Trifoliate, folding down at night; on long stalks. **STATUS** Widespread and locally common.

Wood Sorrel

Procumbent Yellow-sorrel *Oxalis corniculata* (Oxalidaceae)
🌸 **PROSTRATE**
Creeping, downy perennial of dry, bare ground. **FLOWERS** 6–10mm across, bright yellow; on stalks (May–Sep). **FRUITS** Capsules, on reflexed stalks. **LEAVES** Trifoliate, with notched leaflets. **STATUS** Garden escape, naturalised locally.

Pink-sorrel *Oxalis articulata* (Oxalidaceae) 🌸🌸 **HEIGHT** to 25cm
Tufted, downy perennial of dry, bare ground. **FLOWERS** 15–25mm across, pink; in stalked umbels (May–Sep). **FRUITS** Capsules. **LEAVES** Trifoliate marked with orange spots below. **STATUS** A familiar garden plant that is naturalised locally.

■ *See also* Upright Clover (p.272), Bermuda-buttercup (p.273) and Western Clover (p.273)

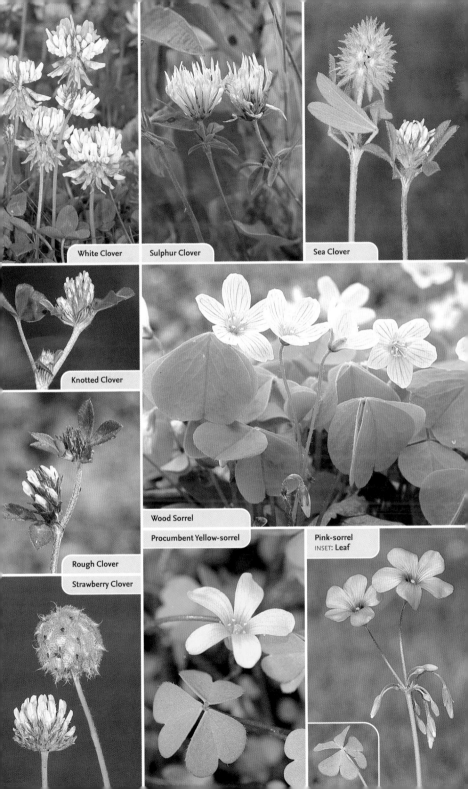

White Clover

Sulphur Clover

Sea Clover

Knotted Clover

Rough Clover

Strawberry Clover

Wood Sorrel

Procumbent Yellow-sorrel

Pink-sorrel
INSET: **Leaf**

Meadow
Crane's-bill

Meadow Crane's-bill *Geranium pratense* ❀ HEIGHT to 75cm
Attractive, hairy, clump-forming perennial of meadows and verges, mostly on base-rich soils. FLOWERS 3–3.5cm across with 5 rounded, bluish-lilac petals; in pairs on stalks (June–Aug). FRUITS Ending in a long 'beak'. LEAVES Deeply divided into 5–7 jagged lobes. STATUS Locally common, except in SE England, N Scotland and Ireland.

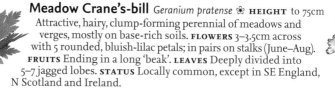

Wood Crane's-bill *Geranium sylvaticum* ❀ HEIGHT to 60cm
Showy, tufted perennial found in damp upland meadows and open woodlands, usually on base-rich soils. FLOWERS 2–3cm across with 5 reddish-purple petals (June–Aug). FRUITS Ending in a long 'beak'. LEAVES Deeply divided into 5–7 lobes but appearing rather rounded overall. STATUS Absent from much of S England but locally common elsewhere.

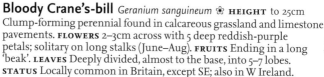

Bloody Crane's-bill *Geranium sanguineum* ❀ HEIGHT to 25cm
Clump-forming perennial found in calcareous grassland and limestone pavements. FLOWERS 2–3cm across with 5 deep reddish-purple petals; solitary on long stalks (June–Aug). FRUITS Ending in a long 'beak'. LEAVES Deeply divided, almost to the base, into 5–7 lobes. STATUS Locally common in Britain, except SE; also in W Ireland.

Wood Crane's-bill
fruit

Dusky Crane's-bill

Dusky Crane's-bill *Geranium phaeum* ❀❀ HEIGHT to 50cm
Distinctive hairy perennial, found on verges, usually near gardens. FLOWERS 15–20mm across with dark maroon, wavy-edged petals that open flat (May–June). FRUITS Ending in a long 'beak'. LEAVES Deeply divided into 5–7 lobes and *often marked with dark blotches*. STATUS Sometimes naturalised.

Hedgerow Crane's-bill *Geranium pyrenaicum* ❀ HEIGHT to 60cm
Upright, hairy perennial found in rough, grassy places and on roadside verges. FLOWERS 12–18mm across with pink, deeply notched petals; in pairs (June–Aug). FRUITS Ending in a long 'beak'. LEAVES Rounded but divided halfway into 5–7 lobes. STATUS Probably introduced but locally common in S and E England.

Herb-Robert

Herb-Robert *Geranium robertianum* HEIGHT to 30cm
Straggling, hairy annual of shady hedgerows, rocky banks and woodlands. FLOWERS 12–15mm across with pink petals and *orange pollen*; in loose clusters (Apr–Oct). FRUITS Hairy, ending in a long 'beak'. LEAVES Hairy; deeply cut into 3 or 5 pinnately divided lobes; often tinged red. STATUS Common and widespread throughout.

Little Robin *Geranium purpureum* ❀❀ HEIGHT to 30cm
Similar to Herb-Robert but overall more slender and straggly. Restricted to dry banks and coastal shingle. FLOWERS 7–14mm across with pink petals and *yellow pollen* (Apr–Sep). FRUITS Distinctly wrinkled. LEAVES Hairy; deeply cut into 3 or 5 pinnately divided lobes. STATUS Local in SW England, S Wales and S Ireland.

Long-stalked Crane's-bill *Geranium columbinum* ❀ HEIGHT to 60cm
Elegant, hairy annual, sometimes tinged red. Found on short, dry grassland, mainly on calcareous soils. FLOWERS 12–18mm across with pink petals not notched; on *long, slender stalks* and often nodding (June–Aug). FRUITS Hairless, smooth. LEAVES Divided to the base, the lower ones long-stalked. STATUS Local.

Cut-leaved Crane's-bill *Geranium dissectum* HEIGHT to 45cm
Straggly, hairy annual found on disturbed ground and cultivated soils. FLOWERS 8–10mm across with pink, notched petals; on short stalks (May–Sep). FRUITS Downy. LEAVES Deeply dissected to the base, the lobes narrow and jagged. STATUS Generally common throughout although scarce in N Scotland.

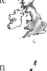
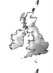

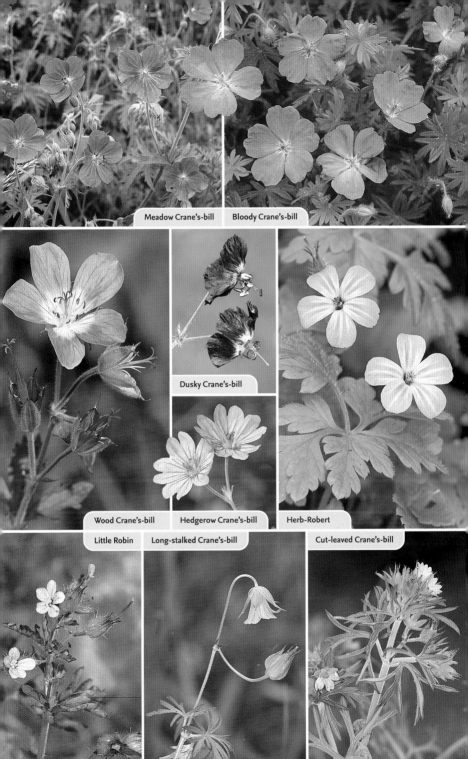

Meadow Crane's-bill Bloody Crane's-bill

Dusky Crane's-bill

Wood Crane's-bill Hedgerow Crane's-bill Herb-Robert

Little Robin Long-stalked Crane's-bill Cut-leaved Crane's-bill

Dove's-foot Crane's-bill *Geranium molle* (Geraniaceae)
HEIGHT to 20cm
Spreading, branched, extremely hairy annual of dry, grassy places including roadside verges. **FLOWERS** *5–10mm across* with notched pink petals; in pairs (Apr–Aug). **FRUITS** Hairless. **LEAVES** Hairy, rounded, with the margins cut into 5–7 lobes. **STATUS** Common and widespread, especially in the south.

Dove's-foot
Crane's-bill

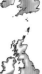

Small-flowered Crane's-bill *Geranium pusillum* (Geraniaceae) **HEIGHT** to 30cm
Spreading, branched annual. Similar to Dove's-foot Crane's-bill but with shorter hairs. Found in dry, grassy places and on bare ground. **FLOWERS** *4–6mm across* with notched pink petals (June–Sep). **FRUITS** Hairy. **LEAVES** Deeply cut into 5–7 narrow lobes. **STATUS** Widespread but commonest in S and E England.

Round-leaved Crane's-bill *Geranium rotundifolium* (Geraniaceae) ❀❀
HEIGHT to 40cm
Downy annual that recalls Dove's-foot Crane's-bill. Found in dry, grassy places, on calcareous and sandy soils. **FLOWERS** 10–12mm across, with pink, barely notched petals; usually in pairs (June–July). **FRUITS** Hairy; not wrinkled. **LEAVES** Rounded, only shallowly lobed. **STATUS** Distinctly local, mainly in S England.

Shining Crane's-bill *Geranium lucidum* (Geraniaceae) ❀ **HEIGHT** to 30cm
Branched, hairless annual, sometimes tinged red. Found on shady banks and rocky slopes, mainly on limestone. **FLOWERS** 10–15mm across; petals pink and not notched, sepals inflated (Apr–Aug). **FRUITS** Hairless. **LEAVES** *Shiny and rounded*, the margins cut into 5–7 lobes. **STATUS** Widespread but local.

Common Stork's-bill *Erodium cicutarium* (Geraniaceae)
HEIGHT to 30cm
Stickily hairy annual of bare, grassy places, often coastal. **FLOWERS** 8–14mm across, with pink petals that are easily lost; in loose heads (May–Aug). **FRUITS** Long, beak-like. **LEAVES** *Finely divided and feathery; stipules narrow.* **STATUS** Widespread and locally common, especially in SE England and near the sea. **Musk Stork's-bill** *E. moschatum* is similar, with flowers up to 3cm across, less divided leaves, and *smelling of musk*. Local and mainly coastal.

Sea Stork's-bill *Erodium maritimum* (Geraniaceae) ❀❀ **HEIGHT** to 10cm
Stickily hairy annual; often prostrate. Found in short grass and on walls, invariably within sight of the sea. **FLOWERS** 3–5mm across; petals tiny, whitish, often absent; usually fall by 9am anyway (May–July). **FRUITS** Long, beak-like. **LEAVES** Oval, lobed. **STATUS** Local; coastal, mainly in south-west.

Musk
Stork's-bill

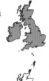

Fairy Flax *Linum catharticum* (Linaceae) ❀ **HEIGHT** to 12cm
Slender, delicate annual that is easily overlooked when not in flower. Found in both wet and dry grassland, mainly on calcareous soils. **FLOWERS** 4–6mm across, white; in loose, terminal clusters (May–Sep). **FRUITS** Globular. **LEAVES** Narrow, 1-veined and in opposite pairs. **STATUS** Widespread and locally common.

Pale Flax *Linum bienne* (Linaceae) ❀ **HEIGHT** to 60cm
Slender annual, biennial or perennial with wiry, branched stems. Found in dry, calcareous grassland; mainly coastal. **FLOWERS** 12–18mm across and lilac-blue (Jun–Jul). **FRUITS** Globular. **LEAVES** Narrow, 3-veined and pointed. **STATUS** Commonest around SW coasts. **Perennial Flax** *L. perenne* has flowers 20–25mm across; rare in chalk grassland in E England.

Allseed *Radiola linoides* (Linaceae) ❀ **HEIGHT** to 5cm
Low-growing, rather bushy annual found in damp conditions, usually on sandy or peaty ground and acid soils. **FLOWERS** 1–2mm across with tiny white petals; in dense terminal clusters (July–Aug). **FRUITS** Globular. **LEAVES** Oval, 1-veined and in opposite pairs. **STATUS** Widespread but local, most common in SW England.

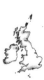

Dove's-foot Crane's-bill

Small-flowered Crane's-bill

Round-leaved Crane's-bill

Shining Crane's-bill

Common Stork's-bill

Fairy Flax

Pale Flax
INSET: Perennial Flax

Sea Stork's-bill
INSET: Flower

Allseed

Wood Spurge *Euphorbia amygdaloides* ❀ HEIGHT to 80cm
Upright, downy, unbranched perennial. Found in woodland and scrub. FLOWERS Yellow, with petal-like bracts (true petals and sepals absent); in umbel-like heads (Apr–June). FRUITS Smooth. LEAVES Dark green, 6cm long. STATUS Locally common in S England and Wales; rare or absent elsewhere.

Sea Spurge *Euphorbia paralias* ❀ HEIGHT to 60cm
Upright perennial of sandy beaches and dunes. FLOWERS Yellowish, with petal-like bracts and horned lobes (petals and sepals absent); in umbel-like heads (June–Oct). FRUITS Smooth. LEAVES Grey-green, fleshy, closely packed up stems. STATUS Widespread and locally common on coasts of S and W England, Wales and Ireland.

Sun Spurge *Euphorbia helioscopia* HEIGHT to 50cm
Upright, hairless, yellowish-green annual. Found on disturbed ground and in cultivated soils. FLOWERS Lacking sepals and petals; yellow with green lobes; in flat-topped umbel-like clusters with 5 leaf-like basal bracts (May–Nov). FRUITS Smooth. LEAVES *Spoon-shaped, toothed.* STATUS Widespread and common.

Petty Spurge *Euphorbia peplus* HEIGHT to 30cm
Upright, hairless annual that often branches from the base. Found on arable land and cultivated ground. FLOWERS Greenish, with oval bracts (sepals and petals absent); in flattish umbel-like clusters (Apr–Oct). FRUITS Smooth. LEAVES *Oval, blunt-tipped,* stalked. STATUS Widespread and common almost throughout.

Dwarf Spurge *Euphorbia exigua* HEIGHT to 30cm
Slender, low-growing annual that is grey-green, often branching from base. Found on cultivated ground, often on chalk. FLOWERS Yellowish (lacking sepals and petals), the lobes bearing horns; in open, umbel-like clusters (June–Oct). FRUITS Smooth. LEAVES *Untoothed, very narrow.* STATUS Locally common in the south only.

Portland Spurge *Euphorbia portlandica* ❀ HEIGHT to 40cm
Hairless, greyish perennial; branching at the base. Found in grassland and on cliffs near the sea. FLOWERS Having lobes with long, crescent-shaped horns (petals and sepals absent); in umbel-like clusters (Apr–Sep). FRUITS Rough. LEAVES Spoon-shaped with a prominent midrib. STATUS Locally common on coasts of SW and W Britain.

Cypress Spurge *Euphorbia cyparissias* ❀❀ HEIGHT to 45cm
Patch-forming, bushy perennial; often turning red late in the season. Found in short grassland on calcareous soils. FLOWERS Yellow, the lobes with short, crescent-shaped horns; in umbel-like clusters (May–Aug). FRUITS Warty. LEAVES Narrow, linear. STATUS Local in S England; also occurs as a garden escape.

Irish Spurge *Euphorbia hyberna* ❀❀ HEIGHT to 55cm
Attractive, tufted and hairless perennial. Found in shady woodland and hedgerows. FLOWERS Yellow with rounded lobes (petals and sepals absent); in flat-topped umbel-like clusters (May–July). FRUITS With long, slender warts. LEAVES Oval, tapering, stalkless. STATUS Local, confined to SW England and SW Ireland.

Cypress Spurge

Caper Spurge *Euphorbia lathyris* ❀❀ HEIGHT to 1.5m
Upright, grey-green biennial of woodland and hedgerows. FLOWERS Fresh green with elongated, heart-shaped bracts (petals and sepals absent); in open clusters (June–July). FRUITS 15–17mm across, *green, 3-sided, caper-like.* LEAVES Narrow; in opposite pairs. STATUS Doubtfully native; often naturalised in the south.

■ *See also* Purple Spurge (p.274)

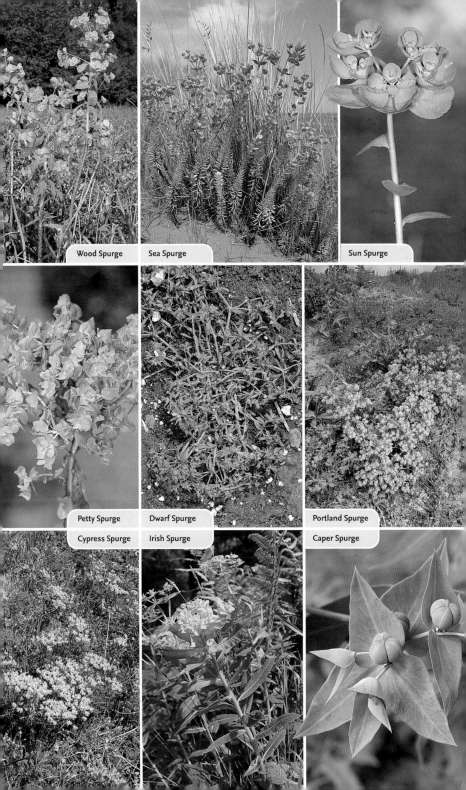

Wood Spurge

Sea Spurge

Sun Spurge

Petty Spurge

Dwarf Spurge

Portland Spurge

Cypress Spurge

Irish Spurge

Caper Spurge

Annual Mercury *Mercurialis annua* (Euphorbiaceae) ❀ **HEIGHT** to 50cm
Hairless, branched, bushy annual. Found on waste ground and in cultivated soils,
often near the sea. **FLOWERS** Yellowish green; in spikes on separate-sex plants
(July–Oct). **FRUITS** Bristly. **LEAVES** Narrowly ovate, shiny, toothed. **STATUS** Locally
common in the south but mainly coastal.

Dog's Mercury *Mercurialis perennis* (Euphorbiaceae) **HEIGHT** to 35cm
Hairy, creeping perennial with a fetid smell. Found in woodlands (sometimes forms
carpets); also on limestone pavements. **FLOWERS** Yellowish, rather tiny; in open
spikes on separate-sex plants (Feb–Apr). **FRUITS** Hairy. **LEAVES** Oval, shiny, toothed.
STATUS Widespread and generally common but scarce in N Scotland and Ireland.

Common Milkwort *Polygala vulgaris* (Polygalaceae) **HEIGHT** to 30cm
Trailing or upright, hairless perennial. Found in grassland on all but the most acid
soils. **FLOWERS** 6–8mm long; blue, pink or white; in open, terminal spikes of
10–40 when mature (May–Sep). **FRUITS** Flattened. **LEAVES** *Alternate*, narrow, point-
ed. **STATUS** Common and widespread throughout.

Heath Milkwort *Polygala serpyllifolia* (Polygalaceae) **HEIGHT** to 20cm
Trailing, hairless perennial. Similar to Common Milkwort but smaller and with
basal leaves in opposite pairs. Found on acid grassland and heaths. **FLOWERS** 5–6mm
long, usually blue; in short spikes of 5–10 when mature (May–Sep). **FRUITS** Flat-
tened. **LEAVES** Narrow, pointed. **STATUS** Locally common throughout.

Chalk Milkwort *Polygala calcarea* (Polygalaceae) ❀ **HEIGHT** to 20cm
Small but attractive hairless perennial. Restricted to short, calcareous grassland.
FLOWERS 5–6mm long, usually bright blue; in short spikes of 6–20 when mature
(May–June). **FRUITS** Flattened. **LEAVES** Blunt, narrowly ovate; *crowded at the base
and appearing to form a rosette.* **STATUS** Local in S and SE England only.

Indian Balsam *Impatiens glandulifera* (Balsaminaceae) ❀ **HEIGHT** to 2m
Distinctive annual with reddish stems. Found along river banks and on
damp waste ground. **FLOWERS** 3–4cm long, pinkish purple with a short,
curved spur; on stalks in clusters (July–Oct). **FRUITS** Club-shaped,
explosive. **LEAVES** Oval, toothed, in opposite pairs or whorls of 3.
STATUS Widely naturalised.

Touch-me-not Balsam *Impatiens noli-tangere* (Balsaminaceae)
❀❀ **HEIGHT** to 1.5m
Upright, hairless annual. Found in damp woodlands and shady
places. **FLOWERS** 2–3cm long, yellow, with a curved spur; pendent, on
stalks arising from leaf axils (July–Sep). **FRUITS** Cylindrical, explosive.
LEAVES Alternate, oval, each side having *7–16 sharp teeth.* **STATUS** Locally
common in N England and N Wales.

Indian
Balsam

Orange Balsam *Impatiens capensis* (Balsaminaceae) ❀ **HEIGHT** to 1.5m
Upright, hairless, bushy annual. Found in damp ground beside rivers.
FLOWERS 2–3cm long, orange with brown blotches and a curved spur; on
stalks that arise from leaf axils (June–Aug). **FRUITS** Explosive capsules.
LEAVES Wavy, with *fewer than 10 teeth.* **STATUS** Naturalised locally in
England and Wales.

Small Balsam *Impatiens parviflora* (Balsaminaceae) ❀
HEIGHT to 1.5m
Slender, rather straggly, hairless annual of shady, disturbed
ground and waste places. **FLOWERS** 13–16mm long, yellow, with
a rather straight spur (June–Sep). **FRUITS** Explosive capsules.
LEAVES Oval with *20–35 teeth on both sides.* **STATUS** Introduced and
naturalised locally, mainly in England and Wales.

Small Balsam

 ■ See also Dwarf Milkwort (p.277)

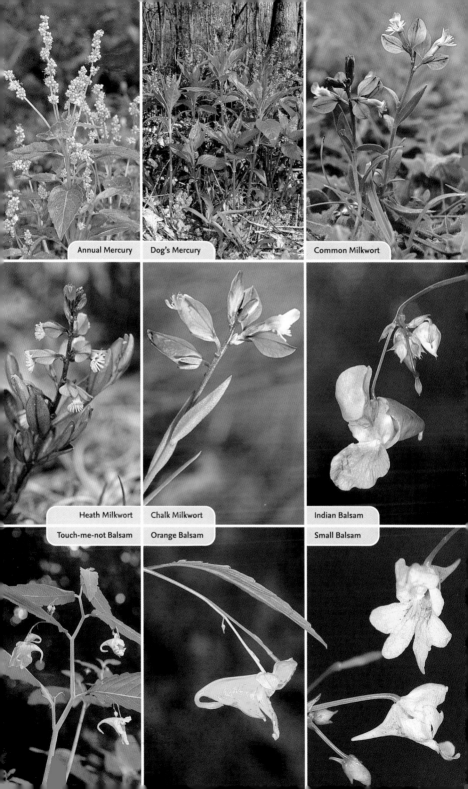

Annual Mercury

Dog's Mercury

Common Milkwort

Heath Milkwort

Chalk Milkwort

Indian Balsam

Touch-me-not Balsam

Orange Balsam

Small Balsam

Holly *Ilex aquifolium* (Aquifoliaceae) **HEIGHT** to 10m
Evergreen shrub or small tree, familiar as a Christmas decoration. Found in woods and hedgerows. **FLOWERS** 6–8mm across, whitish, 4-petalled; in crowded clusters (May–July). **FRUITS** Bright red berries. **LEAVES** Stiff and leathery with spiny margins; shiny dark green above but paler below. **STATUS** Widespread and common.

Spindle *Euonymus europaeus* (Celastraceae) **HEIGHT** to 6m
Deciduous shrub or small tree. Found in scrub and hedgerows, mostly on calcareous soils. **FLOWERS** 7–9mm across, greenish; in leaf axils (May–June). **FRUITS** Pinkish and orange, 4-lobed. **LEAVES** Narrow-oval and pointed, with toothed margins; green in summer but turning reddish in autumn. **STATUS** Locally common in the south of the region.

Buckthorn *Rhamnus cathartica* (Rhamnaceae) **HEIGHT** to 8m
Deciduous thorny shrub or small tree. Found in woodland and scrub, mainly on calcareous soils. **FLOWERS** 4–5mm across, greenish yellow; in clusters (May). **FRUITS** Berries that ripen black; in clusters. **LEAVES** 3–6cm long, oval, finely toothed, opposite. **STATUS** Locally common in E England only.

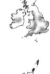

Alder Buckthorn *Frangula alnus* (Rhamnaceae) **HEIGHT** to 5m
Open, thornless bush or small tree. Found in damp hedgerows and scrub, usually on acid soils. **FLOWERS** 3mm across, pale green, with 5 petals (May). **FRUITS** Berries, green then ripening black. **LEAVES** Oval with wavy margins; dark green in summer, turning yellow in autumn. **STATUS** Locally common only in England and Wales.

Alder
Buckthorn

Box *Buxus sempervirens* (Buxaceae) 🌐🌐 **HEIGHT** to 5m
Dense evergreen shrub or small tree. Familiar as a garden plant, used in hedging and topiary. Native on chalky soils. **FLOWERS** Tiny, yellowish green, lacking petals (Mar–May). **FRUITS** 3-horned capsules. **LEAVES** 1.5–3cm long, oval and leathery, with inrolled margins. **STATUS** Widely planted but native only in SE England.

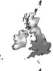

Musk-mallow *Malva moschata* (Malvaceae) **HEIGHT** to 75cm
Branched, hairy perennial. Found in dry, grassy places. **FLOWERS** 3–6cm across, pale pink; in terminal clusters (July–Aug). **FRUITS** Round, flat capsules. **LEAVES** Rounded and 3-lobed at base of plant but increasingly dissected up the stem. **STATUS** Widespread and locally common in England and Wales; scarce elsewhere.

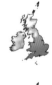

Common Mallow *Malva sylvestris* (Malvaceae) **HEIGHT** to 1.5m
Upright or spreading perennial of grassy verges and disturbed ground. **FLOWERS** 25–40mm across with 5 purple-veined pink petals, much longer than sepals; in clusters from leaf axils (June–Oct). **FRUITS** Round, flat capsules. **LEAVES** Rounded at base of plant, 5-lobed on stem. **STATUS** Widespread and common in the south; scarce elsewhere.

Dwarf Mallow *Malva neglecta* (Malvaceae) 🌐 **HEIGHT** to 1.5m
Upright or spreading perennial of disturbed and waste ground. **FLOWERS** 1–2cm across, with purple-veined and notched pale lilac petals; in clusters along stems (June–Sep). **FRUITS** Round, flat capsules. **LEAVES** Rounded with shallow lobes. **STATUS** Widespread and locally common in the south but scarce elsewhere.

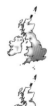

Tree Mallow *Lavatera arborea* (Malvaceae) 🌐🌐 **HEIGHT** to 3m
Imposing woody biennial, covered in starry hairs. Favours rocky ground near the coast, often near seabird colonies. **FLOWERS** 3–5cm across with dark-veined pinkish-purple petals; in terminal clusters (June–Sep). **FRUITS** Round, flat capsules. **LEAVES** With 5–7 lobes. **STATUS** Locally common on W coasts of Britain and S and W Ireland.

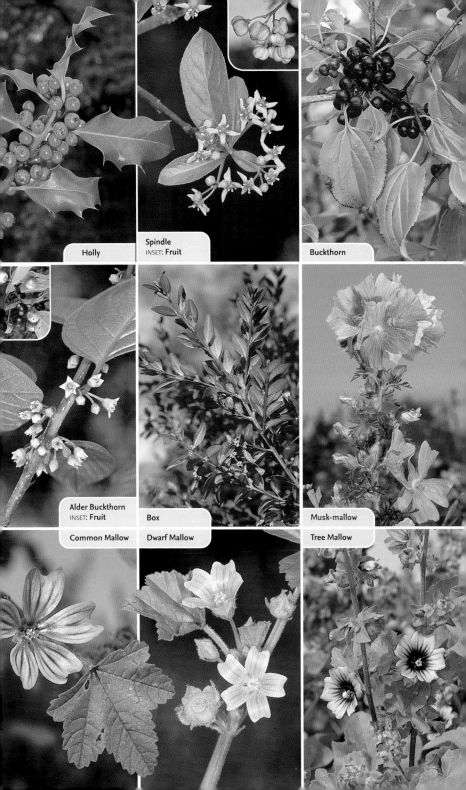

Holly

Spindle
INSET: **Fruit**

Buckthorn

Alder Buckthorn
INSET: **Fruit**

Box

Musk-mallow

Common Mallow

Dwarf Mallow

Tree Mallow

Marsh-mallow *Althaea officinalis* (Malvaceae) ❀ **HEIGHT** to 2m
Attractive, downy perennial with starry hairs; *very soft to touch*. Found
in coastal wetlands and often on the upper reaches of saltmarshes.
FLOWERS 35–40mm across, pale pink (Aug–Sep). **FRUITS** Rounded
flat capsules. **LEAVES** Triangular with shallow lobes. **STATUS**
Locally common on S coasts of Britain and Ireland.

Marsh-mallow

Rough Marsh-mallow *Althaea hirsuta* (Malvaceae) ❀❀❀
HEIGHT to 60cm
Upright annual with simple, starry hairs. Found on downland
and arable margins. **FLOWERS** 25mm across, cup-shaped, long-
stalked; pink petals similar in length to sepals (June–July). **FRUITS**
Rounded flat capsules. **LEAVES** Rounded at plant base but dissected up
stem. **STATUS** Rare, possibly native to Kent and Somerset.

Mezereon *Daphne mezereum* (Thymelaeaceae) ❀❀❀ **HEIGHT** to 2m
Deciduous shrub of woods and shady scrub on calcareous soils. **FLOWERS** 8–12mm
across, with 4 pink, petal-like sepals (petals absent); in clusters appearing just
before leaves (Feb–Apr). **FRUITS** Berry-like, bright red. **LEAVES** Alternate, pale
green and mainly terminal. **STATUS** Local and scarce, mainly in central S England.

Spurge Laurel *Daphne laureola* (Thymelaeaceae) ❀ **HEIGHT** to 1m
Hairless evergreen shrub found in woods and scrub on calcareous soils. **FLOWERS**
8–12mm across, yellowish, with 4 petal-like sepal lobes; in clusters (Jan–Apr).
FRUITS Berry-like; black when ripe. **LEAVES** Dark green, shiny, oval; in clusters at
top of stem. **STATUS** Widespread but local in England and Wales.

Sea-buckthorn *Hippophae rhamnoides* (Elaeagnaceae) ❀ **HEIGHT** to 10m
Branched, dense, thorny shrub. Native to stabilised coastal sand dunes but also
widely planted. **FLOWERS** Tiny, greenish; male and female flowers on separate
plants (Mar–Apr). **FRUITS** Bright orange berries (on female plants only). **LEAVES**
Narrow, greyish green. **STATUS** Native to E coast but planted elsewhere.

Tutsan *Hypericum androsaemum* (Clusiaceae) ❀ **HEIGHT** to 80cm
Upright, hairless, semi-evergreen shrub with 2-winged stems. Found in shady
woods and hedgerows. **FLOWERS** 2cm across with 5 yellow petals (June–Aug).
FRUITS *Berries that ripen from red to black.* **LEAVES** Oval, up to 15cm long, in opposite
pairs. **STATUS** Locally common in S and W Britain and Ireland only.

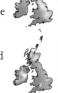

Trailing St John's-wort *Hypericum humifusum* (Clusiaceae) **PROSTRATE**
Creeping, hairless perennial with trailing, 2-ridged stems. Found on bare ground
on heaths and moors with acid soils. **FLOWERS** 8–10mm across, with pale yellow
petals (June–Sep). **FRUITS** Dry capsules. **LEAVES** With translucent dots; borne
in pairs along the stems. **STATUS** Widespread but commonest in W Britain and
W Ireland.

Marsh St John's-wort *Hypericum elodes* (Clusiaceae) ❀ **HEIGHT** to 15cm
Creeping, *greyish-green, hairy* perennial of peaty ground and marshes on acid soils.
FLOWERS 10–15mm across, yellow, terminal (June–Aug). **FRUITS** Dry capsules.
LEAVES Rounded to oval, grey-green, clasping the stem. **STATUS** Rather local and
confined mainly to SW England and Ireland.

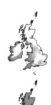

Slender St John's-wort *Hypericum pulchrum* (Clusiaceae) **HEIGHT** to 60cm
Hairless perennial with rounded stems. Found in dry, grassy places and heaths,
mostly on acid soils. **FLOWERS** 15mm across, the *deep yellow petals marked with red
spots and dark, marginal dots (latter also on sepals)* (July–Aug). **FRUITS** Dry capsules.
LEAVES Paired and oval, with translucent spots. **STATUS** Widespread and
common.

■ *See also* Flax-leaved St John's-wort (p.271)

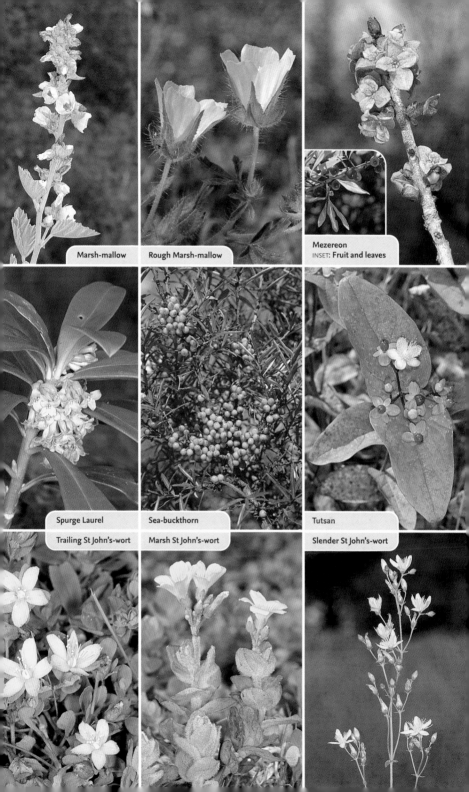

Marsh-mallow

Rough Marsh-mallow

Mezereon
INSET: Fruit and leaves

Spurge Laurel

Sea-buckthorn

Tutsan

Trailing St John's-wort

Marsh St John's-wort

Slender St John's-wort

Hairy St John's-wort *Hypericum hirsutum* (Clusiaceae) **HEIGHT** to 1m
Downy perennial with *round stems*. Found in scrub and open woods on calcareous soils. **FLOWERS** 15mm across, with *pale yellow petals and pointed sepals with marginal, stalked black glands*; in spikes (July–Aug). **FRUITS** Dry capsules. **LEAVES** Oval with *distinct veins and translucent spots*. **STATUS** Widespread but local.

Pale St John's-wort *Hypericum montanum* (Clusiaceae) ✿ **HEIGHT** to 80cm
Perennial with *round stems*. Similar to Hairy St John's-wort but *almost hairless*. Found in scrub on calcareous soils. **FLOWERS** 10–15mm across with *pale yellow petals* (July–Sep). **FRUITS** Dry capsules. **LEAVES** *Lacking translucent dots but with marginal black dots below*. **STATUS** Local, in England and Wales.

Perforate St
John's-wort

Perforate St John's-wort *Hypericum perforatum* (Clusiaceae)
HEIGHT to 80cm
Upright, hairless perennial with *2-lined stems*. Found in grassland, scrub and open woodland, usually on calcareous soils. **FLOWERS** 2cm across, the *deep yellow petals often with black marginal spots* (June–Sep). **FRUITS** Dry capsules. **LEAVES** *Oval with translucent and black spots*; in opposite pairs. **STATUS** Widespread; commonest in the south.

Stem

Imperforate St John's-wort *Hypericum maculatum* (Clusiaceae) ✿ **HEIGHT** to 1m
Upright, hairless perennial with *square, unwinged stems*. Found in woodland and scrub. **FLOWERS** 2cm across with yellow petals (June–Aug). **FRUITS** Dry capsules. **LEAVES** *Oval, lacking translucent dots*. **STATUS** Widespread and locally common throughout, except in the north.

Imperforate
St John's-wort

Stem

Stem

Square-stalked St John's-wort *Hypericum tetrapterum* (Clusiaceae) **HEIGHT** to 1m
Upright, hairless perennial. Similar to Imperforate St John's-wort but with *square stems distinctly winged*. Found in damp ground. **FLOWERS** 2cm across with *yellow petals and undotted, pointed sepals* (June–Sep). **FRUITS** Dry capsules. **LEAVES** Oval with translucent dots. **STATUS** Locally common, except in the north.

Square-stalked
St John's-wort

Wavy St John's-wort *Hypericum undulatum* (Clusiaceae) ✿✿ **HEIGHT** to 1m
Perennial with winged, square stems and *wavy margins to leaves*. Favours boggy ground. **FLOWERS** 2cm across, yellow above, tinged red below; sepals broad and spotted (Aug–Sep). **FRUITS** Dry capsules. **LEAVES** Wavy-edged, tinged red. **STATUS** SW Britain only.

Wavy St
John's-wort

Common Rock-rose *Helianthemum nummularium* (Cistaceae)
HEIGHT to 40cm
Branched undershrub of dry, chalky grassland. **FLOWERS** 2.5cm across, with 5 crinkly yellow petals (June–Sep). **FRUITS** Capsules. **LEAVES** Narrow-oval, downy white below, paired; margins slightly inrolled. **STATUS** Locally common only in SE and E England but scarce further north and west.

White Rock-rose *Helianthemum apenninum* (Cistaceae) ✿✿✿ **HEIGHT** to 40cm
Attractive branched, spreading shrubby perennial. Found in dry, grassy places on limestone. **FLOWERS** 2.5cm across with 5 crinkly white petals (May–July). **FRUITS** Capsules. **LEAVES** Narrow-oval, downy white above and below, with inrolled margins. **STATUS** Local, restricted to coastal areas of Devon and Somerset.

Hoary Rock-rose *Helianthemum oelandicum* (Cistaceae) ✿✿ **HEIGHT** to 40cm
Branched, hairy perennial of limestone grassland. **FLOWERS** 10–15mm across with 5 crinkly yellow petals (May–July). **FRUITS** Dry capsules. **LEAVES** Very narrow; greyish white below. **STATUS** Scarce in N England, Wales; locally common in W Ireland.

■ See also Spotted Rock-rose (p.274)

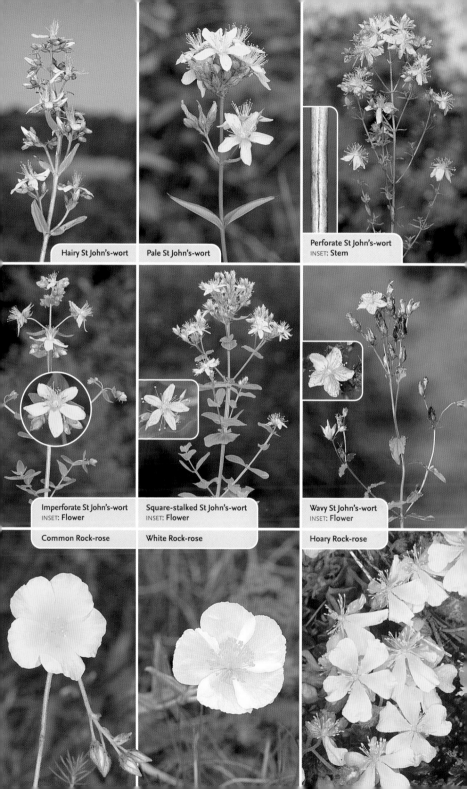

Hairy St John's-wort

Pale St John's-wort

Perforate St John's-wort
INSET: **Stem**

Imperforate St John's-wort
INSET: **Flower**

Square-stalked St John's-wort
INSET: **Flower**

Wavy St John's-wort
INSET: **Flower**

Common Rock-rose

White Rock-rose

Hoary Rock-rose

Sweet Violet *Viola odorata* HEIGHT to 15cm

Fragrant perennial herb of woods and hedgerows, mostly on calcareous soils. FLOWERS 15mm across, violet or white, with blunt sepals (Feb–May). FRUITS Egg-shaped. LEAVES Long-stalked, *rounded in spring*; larger, heart-shaped in autumn. STATUS Widespread and locally common in England and Wales.

Hairy Violet *Viola hirta* HEIGHT to 15cm

Similar to Sweet Violet but unscented and much *more hairy*. Found in dry grassland, mainly on calcareous soils. FLOWERS 15mm across, with pale violet petals and blunt sepals (Mar–May). FRUITS Egg-shaped. LEAVES *Narrow heart-shaped and hairy*. STATUS Widespread and locally common in England and Wales; absent from the north, scarce in Ireland.

Common Dog-violet *Viola riviniana* HEIGHT to 12cm

Familiar perennial herb of woodland rides and grassland. FLOWERS 15–25mm across, bluish violet with a *blunt, pale spur that is notched at the tip*; pointed sepals (Mar–May). FRUITS Egg-shaped. LEAVES Long-stalked, heart-shaped and mainly hairless. STATUS Widespread and locally common throughout.

Early Dog-violet *Viola reichenbachiana* HEIGHT to 12cm

Similar to Common Dog-violet but with subtle differences in the flower and leaf form. Found in woods and hedgerows, mostly on chalk. FLOWERS 15–20mm across with pale violet, narrow petals and a *spur that is darker than the petals and not notched* (Mar–May). FRUITS Egg-shaped. LEAVES *Narrow heart-shaped*. STATUS Locally common.

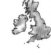

Heath Dog-violet *Viola canina* ✿ HEIGHT to 30cm

Perennial herb that *lacks a basal rosette of leaves*. Found on dry grassland, mainly on sandy soils. FLOWERS 12–18mm across with *pale blue petals* and a short, *greenish-yellow spur* (Apr–June). FRUITS Not inflated. LEAVES *Narrow-oval with a heart-shaped base*. STATUS Widespread but only very locally common.

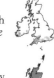

Pale Dog-violet *Viola lactea* ✿✿ HEIGHT to 12cm

Similar to Heath Dog-violet but note differences in flower and leaf form. Found on heathland. FLOWERS 12–18mm across with *very pale petals* and a short, greenish spur (May–June). FRUITS Not inflated. LEAVES *Narrow and wedge-shaped at the base* (not heart-shaped). STATUS Local in SW England, SW Wales and S Ireland.

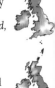

Marsh Violet *Viola palustris* HEIGHT to 15cm

Distinctive, hairless perennial with creeping runners. Found in bogs and marshy places on acid soils. FLOWERS 10–15mm across with *rounded, dark-veined, pale lilac petals* and a blunt, pale spur (Apr–July). FRUITS Egg-shaped. LEAVES *Kidney-shaped*, long-stalked. STATUS Widespread but local; commonest in the north and west.

Wild Pansy *Viola tricolor* HEIGHT to 12cm

Also known as **Heartsease**. Ssp. *tricolor* is an annual of cultivated ground; ssp *curtisii* is a perennial of dry grassland. FLOWERS 15–25mm across; yellow and violet in ssp. *tricolor* but yellow in ssp. *curtisii* (Apr–Aug). FRUITS Egg-shaped. LEAVES Lanceolate with leaf-like stipules. STATUS Widespread and locally common.

ssp. *curtisii*

Mountain Pansy *Viola lutea* ✿ HEIGHT to 30cm

Attractive creeping, almost hairless perennial of upland calcareous grassland. FLOWERS 15–30mm across; may be yellow, bluish violet or both (May–Aug). FRUITS Egg-shaped. LEAVES Lanceolate with palmate stipules at the bases. STATUS Locally common in upland areas of N Wales, N England and Scotland.

■ See also Dwarf Pansy (p.273) and Fen Violet (p.279)

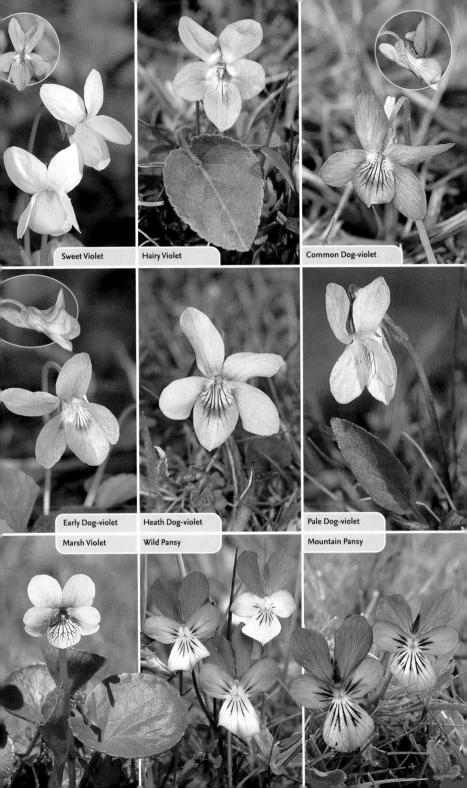

Sweet Violet

Hairy Violet

Common Dog-violet

Early Dog-violet

Heath Dog-violet

Pale Dog-violet

Marsh Violet

Wild Pansy

Mountain Pansy

Field Pansy *Viola arvensis* (Violaceae) **HEIGHT** to 15cm
Variable annual found on arable land and cultivated ground. **FLOWERS** 10–15mm
across, creamy white with an orange flush on the lower petal; sepals at least as
long as petals (Apr–Oct). **FRUITS** Capsules. **LEAVES** With deeply toothed stipules.
STATUS Widespread and common throughout.

Giant-rhubarb *Gunnera tinctoria* (Gunneraceae) ❀❀ **HEIGHT** to 2m
Huge herbaceous perennial. Favours damp ground, often beside water; tolerates
shade. **FLOWERS** Small but in club-like spikes to 1m long (July–Aug). **FRUITS** Spongy.
LEAVES Rhubarb-like, up to 2m across, and rounded with jagged marginal lobes;
on long, spiny stalks. **STATUS** Widely planted and sometimes naturalised.

White Bryony *Bryonia dioica* (Cucurbitaceae) **HEIGHT** to 4m
Climbing perennial whose progress is aided by long, unbranched tendrils. Found
in hedges and woodland margins. **FLOWERS** Greenish, 5-parted and on separate-sex
plants; arising from leaf axils (May–Aug). **FRUITS** Red, shiny berries. **LEAVES**
4–7cm across, divided into 5 lobes. **STATUS** Common in England; scarce elsewhere.

Purple-loosestrife *Lythrum salicaria* (Lythraceae) **HEIGHT** to 1.5m
Upright downy perennial of damp habitats such as river banks and fens. **FLOWERS**
10–15mm across, reddish purple with 6 petals; in tall spikes (June–Aug). **FRUITS**
Capsules. **LEAVES** 4–7cm long, narrow, unstalked and in opposite pairs. **STATUS**
Widespread and locally common, except in the north.

Water-purslane *Lythrum portula* (Lythraceae) **PROSTRATE**
Low-growing, creeping, hairless annual. Found on damp, bare ground and also in
shallow water, mainly on acid soils. **FLOWERS** 1–2mm across, with 6 pinkish petals
that are often absent or fallen; in leaf axils (June–Oct). **FRUITS** Capsules. **LEAVES**
Oval, in opposite pairs. **STATUS** Locally common throughout.

Grass-poly *Lythrum hyssopifolia* (Lythraceae) ❀❀❀ **HEIGHT** to 25cm
Upright, hairless annual that sometimes branches at the base. Favours winter-wet
hollows in arable fields or on disturbed ground. **FLOWERS** 4–5mm across, pink
and 6-parted; in leaf axils up stem (June–Aug). **FRUITS** Capsules. **LEAVES** Narrow
(grass-like), alternate. **STATUS** Rare; in Cambridgeshire, Hampshire and Dorset only.

Sea-heath *Frankenia laevis* (Frankeniaceae) ❀❀ **PROSTRATE**
Branched, mat-forming, woody perennial. Restricted to the drier upper reaches
of saltmarshes. **FLOWERS** 5mm across with 5 pink, crinkly petals (June–Aug).
FRUITS Capsules. **LEAVES** Small, narrow with inrolled margins; densely packed
and opposite on side shoots. **STATUS** Local, from Hampshire to Norfolk only.

Enchanter's-nightshade *Circaea lutetiana* (Onograceae) **HEIGHT** to 65cm
Delicate, slightly downy perennial of woodland and hedgerows. **FLOWERS** Small,
with white petals; in loose spikes above the leaves (June–Aug). **FRUITS** Club-shaped,
bristly. **LEAVES** 10cm long, oval, heart-shaped at the base and gently toothed, with
round stalks. **STATUS** Common and widespread, except in the north.

Upland Enchanter's-nightshade *Circaea × intermedia* (Onograceae)
❀ **HEIGHT** to 45cm
Hairless perennial of shady upland woods and rocky places. **FLOWERS** White, in
loose spikes (June–Aug). **FRUITS** Club-shaped. **LEAVES** 8cm long, oval, heart-shaped
at the base and sharply toothed with slightly winged stalks. **STATUS** Locally common
in upland areas in the west and north. Note: Often occurs in the absence of one of
its parents, **C. alpina**, a rare plant that is similar but smaller, with winged leaf stalks and
flowers in a tight terminal cluster.

■ *See also* Hampshire-purslane (p.275) and Iceland Purslane (p.284)

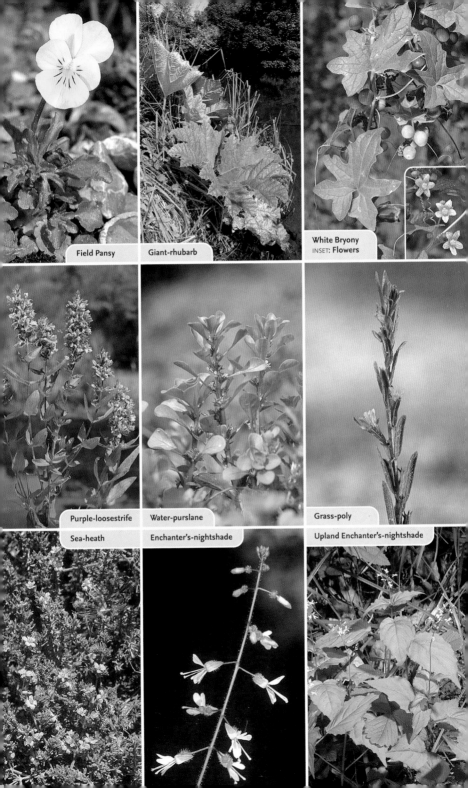

Field Pansy

Giant-rhubarb

White Bryony
INSET: Flowers

Purple-loosestrife

Water-purslane

Grass-poly

Sea-heath

Enchanter's-nightshade

Upland Enchanter's-nightshade

Six-stamened Waterwort *Elatine hexandra* (Elatinaceae) 🌑🌑 **PROSTRATE**
Mat-forming annual that is often tinged red. Found on the bare, shallow and
drying margins of peaty pools and lakes. **FLOWERS** Tiny, comprising 3 pinkish
petals, 3 blunt sepals and 6 stamens (June–Sep). **FRUITS** Capsules. **LEAVES** Spoon-
shaped; in opposite pairs or 4s. **STATUS** Extremely local, mainly SE England.

Rosebay Willowherb *Chamerion angustifolium* (Onograceae) **HEIGHT** to 1.5m
Showy perennial of waste ground, cleared woodland and river banks, on a wide
range of soil types. **FLOWERS** 2–3cm across, with pinkish-purple petals; in tall
spikes (July–Sep). **FRUITS** Pods containing cottony seeds. **LEAVES** Lanceolate,
arranged spirally up the stems. **STATUS** Widespread and common throughout.

Great Willowherb *Epilobium hirsutum* (Onograceae) **HEIGHT** to 2m
Downy perennial with a round stem. Favours damp habitats such as fens
and river banks. **FLOWERS** *25mm across*, pinkish purple with pale centres, and
a 4-lobed stigma; in terminal clusters (July–Aug). **FRUITS** Pods containing
cottony seeds. **LEAVES** *Oval, hairy and clasping*. **STATUS** Common.

Hoary Willowherb *Epilobium parviflorum* (Onograceae) **HEIGHT** to 75cm
Downy perennial. Similar to Great Willowherb but smaller, with *non-clasping
leaves*. Found in damp habitats. **FLOWERS** *12mm across* with pale pink, notched
petals and a 4-lobed stigma (July–Sep). **FRUITS** Pods containing cottony seeds.
LEAVES Broadly oval; upper ones *alternate*. **STATUS** Common, except in the north.

Broad-leaved Willowherb *Epilobium montanum* (Onograceae)
HEIGHT to 80cm
Upright perennial. Similar to Hoary Willowherb but *almost hairless*. Found
in woods and hedges. **FLOWERS** *6–10mm across* (drooping in bud), with pale
pink, notched petals and a 4-lobed stigma (June–Aug). **FRUITS** Pods
containing cottony seeds. **LEAVES** *Oval, rounded at the base*, toothed; stem
leaves *opposite*. **STATUS** Widespread and common.

Spear-leaved Willowherb *Epilobium lanceolatum* (Onograceae) 🌑
HEIGHT to 80cm
Recalls a slender, *grey-green* form of Broad-leaved Willowherb with *alternate
leaves*. Found in shady places. **FLOWERS** *6–8mm across* with a 4-lobed stigma;
white at first, turning pink later (July–Sep). **FRUITS** Pods containing cottony
seeds. **LEAVES** *Narrow, tapering to the base and stalked*. **STATUS** Local,
S England and S Wales only.

American Willowherb *Epilobium ciliatum* (Onograceae) 🌑 **HEIGHT** to 50cm
Upright perennial; *stems have 4 raised lines* and spreading, glandular hairs; on
waste, damp places. **FLOWERS** *8–10mm across* with pink, notched petals and a
club-shaped stigma (July–Sep). **FRUITS** Pods containing cottony seeds. **LEAVES**
Narrow-oval, toothed, short-stalked. **STATUS** Introduced but widely naturalised.

Square-stalked Willowherb *Epilobium tetragonum* (Onograceae) 🌑
HEIGHT to 1m
Upright, downy perennial with *4-ridged stems (sometimes winged)*. Found in
damp woods and on river banks. **FLOWERS** *6–8mm across* (upright in bud),
with pink petals and a club-shaped stigma (July–Aug). **FRUITS** Pods (*6–10cm
long*) containing cottony seeds. **LEAVES** *Narrow, finely toothed*. **STATUS** Common
only in England and Wales.

Short-fruited Willowherb *Epilobium obscurum* (Onograceae)
HEIGHT to 80cm
Upright perennial, similar to Square-stalked Willowherb but with *broader
leaves and shorter fruits*. Favours damp ground. **FLOWERS** 6–8mm across, with
pink petals and a club-shaped stigma (July–Aug). **FRUITS** Pods (*4–6cm long*)
containing cottony seeds. **LEAVES** *Oval with a rounded base*. **STATUS** Common.

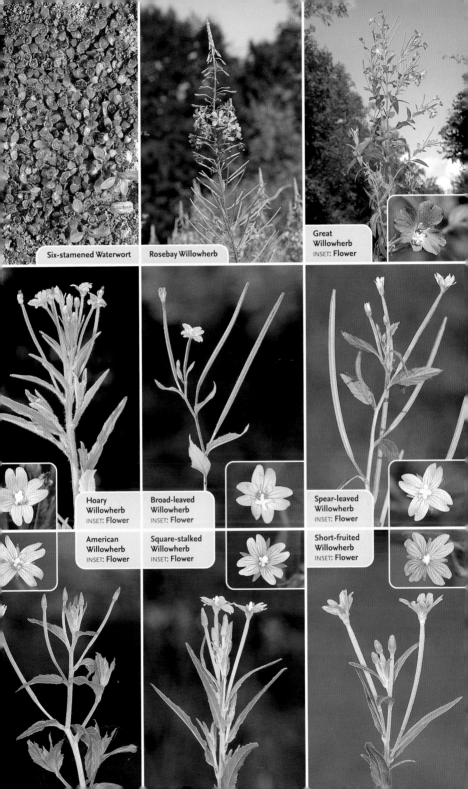

Six-stamened Waterwort

Rosebay Willowherb

Great Willowherb
INSET: **Flower**

Hoary Willowherb
INSET: **Flower**

Broad-leaved Willowherb
INSET: **Flower**

Spear-leaved Willowherb
INSET: **Flower**

American Willowherb
INSET: **Flower**

Square-stalked Willowherb
INSET: **Flower**

Short-fruited Willowherb
INSET: **Flower**

Pale Willowherb *Epilobium roseum* (Onograceae) ✽ **HEIGHT** to 80cm
Similar to Short-fruited Willowherb but with *only faint lines on the stem*. Favours damp ground. **FLOWERS** 4–7mm across, white at first, turning pink later (July–Aug). **FRUITS** Pods containing cottony seeds. **LEAVES** Elliptical with a *wedge-shaped base; stalk to 2cm long*. **STATUS** Locally common in England and Wales; scarce elsewhere.

Marsh Willowherb *Epilobium palustre* (Onograceae) **HEIGHT** to 50cm
Slender, upright perennial with a *round, smooth stem*. Found in damp habitats, mainly on acid soils. **FLOWERS** 4–7mm across and pale pink, with a *club-shaped stigma*; often drooping (July–Aug). **FRUITS** Pods containing cottony seeds. **LEAVES** Narrow, untoothed, unstalked, in opposite pairs. **STATUS** Widespread and locally common.

Alpine Willowherb *Epilobium anagallidifolium* (Onograceae) ✽✽
HEIGHT to 5cm
Creeping, hairless perennial with slender stems. Restricted to damp ground in upland areas. **FLOWERS** 4–5mm across, pink, seldom opening fully; *on drooping stems* (July–Aug). **FRUITS** Long, erect, red pods with cottony seeds. **LEAVES** Ovate, barely toothed, short-stalked. **STATUS** Local in mountains, from N England northwards.

Marsh
Willowherb

Chickweed
Willowherb

Chickweed Willowherb *Epilobium alsinifolium* (Onograceae) ✽✽ **HEIGHT** to 20cm
Branched and usually upright perennial that is almost hairless. Found on damp ground in uplands. **FLOWERS** 8–11mm across, pinkish purple and seldom opening fully; *on drooping stalks* (July–Aug). **FRUITS** Long, green, erect. **LEAVES** Ovate, short-stalked, slightly toothed. **STATUS** Local in mountains from N Wales northwards.

New Zealand Willowherb *Epilobium brunnescens* (Onograceae) ✽✽ **PROSTRATE**
Creeping, mat-forming perennial that roots at the nodes. Found in damp ground in mountains. **FLOWERS** 6–7mm across, with deeply notched pink or white petals; *on long, erect stalks* (July–Aug). **FRUITS** Slender pods. **LEAVES** Circular, opposite. **STATUS** Introduced but now widespread in many mountain regions.

Fuchsia *Fuchsia magellanica* (Onograceae) ✽✽ **HEIGHT** to 1.5m
Deciduous, much-branched shrub. Favours rocky ground and rough slopes, often coastal. **FLOWERS** 2cm long, bell-shaped, with red sepals and violet petals; pendent, on slender stalks (Aug–Oct). **FRUITS** Black berries. **LEAVES** Ovate. **STATUS** Introduced for hedging; naturalised locally, mainly in W Britain and SW Ireland.

Common Evening-primrose *Oenothera biennis* (Onograceae) ✽ **HEIGHT** to 1.5m
Downy biennial of wasteland. **FLOWERS** 4–5cm across, yellow, opening only on dull days or evenings (June–Sep). **FRUITS** Capsules. **LEAVES** Lanceolate with red veins. **STATUS** Introduced and naturalised. *O. lazioviana* (flowers 6–8cm across) and *O. cambrica* (flowers 3–5cm across) also occur; fruits have red, swollen-based hairs.

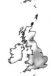

Dogwood *Cornus sanguinea* (Cornaceae) **HEIGHT** to 4m
Deciduous shrub whose deep red twigs stand out in winter. Found in hedgerows and scrub, mainly in calcareous soils. **FLOWERS** White with 4 petals; in flat clusters (May–July). **FRUITS** Berries that ripen black. **LEAVES** Oval, opposite, with 3–5 veins on both sides of midrib. **STATUS** Locally common in England and Wales.

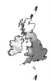

Dwarf Cornel *Cornus suecica* (Cornaceae) ✽✽ **HEIGHT** to 15cm
Creeping perennial of upland moors. **FLOWERS** Small, purplish black; in dense umbels surrounded by 4 white bracts (June–Aug). **FRUITS** Red berries. **LEAVES** Ovate and pointed with 3 main veins on both sides of the midrib. **STATUS** Scattered in N England and locally common in parts of Scotland; absent from Ireland.

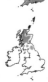

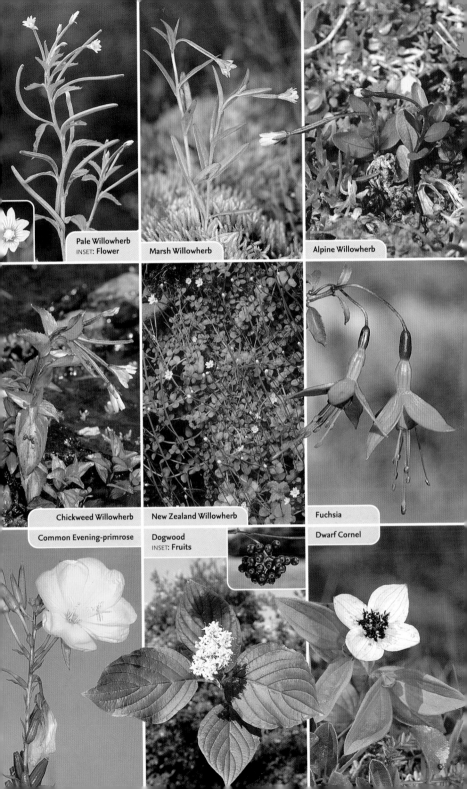

Pale Willowherb
INSET: **Flower**

Marsh Willowherb

Alpine Willowherb

Chickweed Willowherb

New Zealand Willowherb

Fuchsia

Common Evening-primrose

Dogwood
INSET: **Fruits**

Dwarf Cornel

Ivy *Hedera helix* (Araliaceae) HEIGHT to 20m
Evergreen, self-clinging climber that also carpets the ground. Found in woodlands, hedgerows and scrub. FLOWERS Yellowish green, 4-parted; in globular heads (Sep–Nov). FRUITS Berries that ripen purplish black. LEAVES Glossy, dark green and 3- or 5-lobed with paler veins. STATUS Widespread and common.

Marsh Pennywort *Hydrocotyle vulgaris* (Apiaceae) CREEPING
Low-growing perennial and an atypical umbellifer. Found in short, grassy vegetation on damp, mostly acid ground. FLOWERS Tiny, pinkish, hidden by leaves; in small umbels (June–Aug). FRUITS Rounded, ridged. LEAVES Round, dimpled with broad, blunt teeth. STATUS Widespread, but most common in the west.

Sanicle *Sanicula europaea* (Apiaceae) ❀ HEIGHT to 50cm
Slender, hairless perennial of deciduous woodland, mostly on neutral or basic soils and often under Beech. FLOWERS Pinkish, in small umbels on reddish stems (May–Aug). FRUITS Egg-shaped, with hooked bristles. LEAVES With 5–7 toothed lobes; lower leaves long-stalked. STATUS Very locally common throughout.

Sanicle

Sea-holly *Eryngium maritimum* (Apiaceae) ❀ HEIGHT to 60cm
Distinctive, hairless perennial of coastal shingle and sand. FLOWERS Blue, in globular umbels to 4cm long (July–Sep). FRUITS Bristly. LEAVES *Waxy, blue-green, holly-like* with spiny, white margins and white veins. STATUS Widespread on the coasts of England, Wales and Ireland; absent from N and E Scotland.

Astrantia *Astrantia major* (Apiaceae) ❀❀ HEIGHT to 80cm
Upright, hairless perennial. Found in woods and grassland. FLOWERS Small, pale pinkish; in dense umbels, fringed by pale bracts tinged with green and red, the whole 2–3cm across (June–Aug). FRUITS Cylindrical. LEAVES Toothed, deeply pinnately lobed, long-stalked. STATUS Introduced and naturalised locally.

Shepherd's-needle *Scandix pecten-veneris* (Apiaceae) ❀❀ HEIGHT to 50cm
Hairless annual that is diagnostically distinctive in fruit. Found in arable fields. FLOWERS Small, white; in small umbels (May–July). FRUITS *Needle-like, 6–8cm long, much of which is a flattened 'beak'.* LEAVES 2–3 times pinnate. STATUS Widespread in S and E England but declining here and elsewhere.

Rough
Chervil

Rough Chervil *Chaerophyllum temulum* (Apiaceae) HEIGHT to 1m
Biennial with *solid, ridged, bristly, purple-spotted stems.* Similar to both Cow Parsley and Upright Hedge-parsley. Favours hedges and verges. FLOWERS White, in umbels up to 6cm across (June–July). FRUITS Elongate, tapering, ridged. LEAVES 2–3 times pinnate, hairy, dark green. STATUS Common in England and Wales.

Cow Parsley *Anthriscus sylvestris* (Apiaceae) HEIGHT to 1m
Downy, herbaceous perennial with *hollow, unspotted stems.* Found in meadows and woodland margins, and on verges. FLOWERS White, in umbels up to 6cm across; bracts absent (Apr–June). FRUITS Elongate, ridged. LEAVES 2–3 times pinnate, only slightly hairy, fresh green. STATUS Widespread and common.

Bur Chervil *Anthriscus caucalis* (Apiaceae) ❀❀ HEIGHT to 50cm
Delicate annual with hairless, hollow stems, flushed purple at the base. Found on sandy ground, often coastal. FLOWERS White, in umbels 2–4cm across; bracts absent (May–June). FRUITS Egg-shaped, with hooked bristles. LEAVES Finely divided, feathery, hairy below. STATUS Widespread but local.

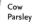

Cow
Parsley

■ *See also* Field Eryngo (p.271)

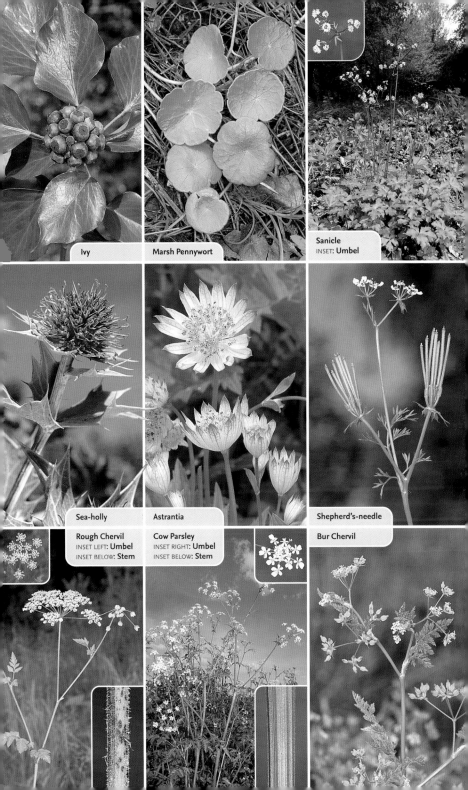

Ivy

Marsh Pennywort

Sanicle
INSET: **Umbel**

Sea-holly

Astrantia

Shepherd's-needle

Rough Chervil
INSET LEFT: **Umbel**
INSET BELOW: **Stem**

Cow Parsley
INSET RIGHT: **Umbel**
INSET BELOW: **Stem**

Bur Chervil

Alexanders *Smyrnium olusatrum* ✤ HEIGHT to 1.25m

Stout, sometimes clump-forming, hairless biennial. Favours waste ground, road-side verges and hedgerows, mainly on calcareous soils. FLOWERS Yellowish, in umbels 4–6cm across, with 7–15 rays (Mar–June). FRUITS Globular, ridged, black when ripe. LEAVES Dark green, shiny and 3 times trifoliate. STATUS Introduced but widely naturalised, mainly on S and SE coasts of England and Ireland.

Pignut *Conopodium majus* HEIGHT to 25cm

Delicate, upright perennial that is seldom branched and which has smooth, hollow stems. Found in open woodland and grassland, mainly on dry, acid soils. FLOWERS White, in umbels 3–6cm across (Apr–June). FRUITS Narrow, egg-shaped, with erect styles. LEAVES Finely divided basal leaves that soon wither; narrow-lobed ones on stem. STATUS Locally common throughout.

Pignut

Sweet Cicely *Myrrhis odorata* ✤ HEIGHT to 1.5m

Upright, downy perennial with hollow stems. Whole plant *smells of aniseed when bruised*. Favours grassland and damp ground, often near habitation. FLOWERS White, with unequal petals, in umbels to 5cm across (May–June). FRUITS Elongated, ridged. LEAVES *Fern-like*, to 30cm long and 2 or 3 times pinnate. STATUS Introduced and naturalised, mainly in N England and Scotland.

Upright Hedge-parsley *Torilis japonica* HEIGHT to 1m

Slender annual with *solid, unspotted, roughly hairy stems*. Found in hedges and woodland margins. FLOWERS White (or tinged pink), in terminal, long-stalked *umbels 2–4cm across, with 5–12 rays* (July–Aug). FRUITS Egg-shaped, with hooked, purple bristles. LEAVES 1 – 3 times pinnate, hairy. STATUS Widespread and common.

Spreading Hedge-parsley *Torilis arvensis* ✤✤ HEIGHT to 40cm

Wiry, branched, spreading annual; recalls the previous species. Found in arable fields on chalky soils. FLOWERS White, in long-stalked *umbels 2–4cm across, with 3–5 rays*; bracts absent (July–Sep). FRUITS Egg-shaped; spines curved but lacking hooks. LEAVES Once or twice pinnate. STATUS Mainly SE England; declining.

Upright
Hedge-parsley

Spreading
Hedge-parsley

Knotted Hedge-parsley *Torilis nodosa* ✤✤ HEIGHT to 50cm

Roughly hairy, tough annual with solid, ridged stems; often prostrate. Found in arable fields and on sunny banks; often coastal. FLOWERS Whitish, in umbels *1cm across, arising from leaf axils* (May–July). FRUITS Egg-shaped with warts and spines. LEAVES Once or twice pinnate. STATUS Local, mainly S and E England.

Hogweed *Heracleum sphondylium* HEIGHT to 2m

Robust, roughly hairy perennial with hollow, ridged stems. Found in meadows and open woodlands and on roadside verges. FLOWERS Off-white, with unequal petals; in umbels with 40 or so rays, and up to 20cm across (May–Aug). FRUITS Elliptical, hairless, flattened. LEAVES To 60cm long, broad, hairy, pinnate, the lobes usually rather ovate. STATUS Widespread and common throughout.

Hogweed

Giant Hogweed *Heracleum mantegazzianum* ✤✤ HEIGHT to 4m
Huge, impressive biennial or perennial whose size alone makes it unmistakable. Stems are hollow, ridged and purple-spotted. Whole plant causes blisters if touched in sunlight. Favours damp ground and often found beside rivers. FLOWERS White, in umbels to 50cm across (June–July). FRUITS Flattened, narrowly oval. LEAVES Pinnate, up to 1m long. STATUS Introduced and naturalised locally.

■ *See also* Bladderseed (p.271)

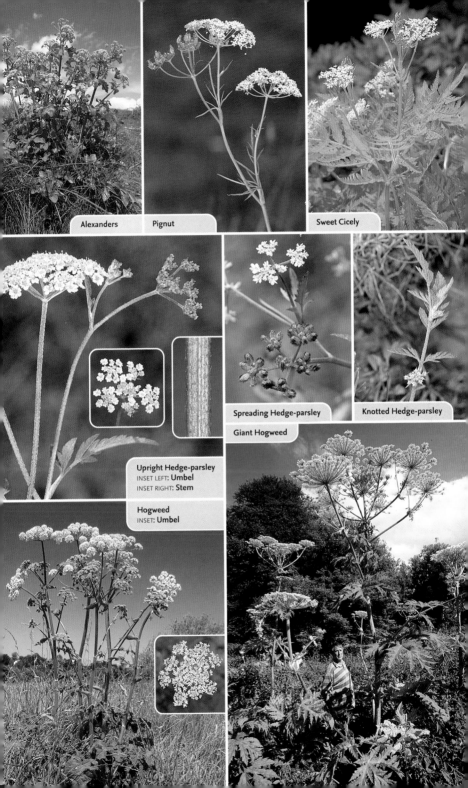

Alexanders

Pignut

Sweet Cicely

Spreading Hedge-parsley

Knotted Hedge-parsley

Giant Hogweed

Upright Hedge-parsley
INSET LEFT: **Umbel**
INSET RIGHT: **Stem**

Hogweed
INSET: **Umbel**

Cowbane *Cicuta virosa* ✿✿ **HEIGHT** to 1m
Robust, upright, hairless perennial with hollow, ridged stems. Found in damp habitats, including fens and marshes, and sometimes partly aquatic. Extremely poisonous. **FLOWERS** White, in domed umbels 11–13cm across; bracts absent (July–Aug). **FRUITS** Globular, ridged, with prominent styles. **LEAVES** Dark green, 2–3 times pinnate, divided into narrow leaflets. **STATUS** Scattered across the region but extremely local and generally scarce.

Hemlock *Conium maculatum* **HEIGHT** to 2m
Highly poisonous, hairless biennial with *hollow, purple-blotched stems* and an unpleasant smell when bruised. Found on damp, wayside ground, motorway verges and riversides. **FLOWERS** White, in umbels 2–5cm across (June–July). **FRUITS** Globular with wavy ridges. **LEAVES** Up to 4 times pinnately divided into fine leaflets. **STATUS** Widespread and locally common, except in the far north.

Wild Angelica *Angelica sylvestris* **HEIGHT** to 2m
Robust, almost hairless perennial with hollow, purplish stems. Found in damp meadows and woodlands. **FLOWERS** White (sometimes tinged pink), in robust, domed umbels to 15cm across (June–July). **FRUITS** Oval, flattened, 4-winged. **LEAVES** 2 or 3 times pinnate; lower leaves up to 60cm long, upper leaves smaller, with bases forming inflated sheaths. **STATUS** Widespread and common throughout.

Burnet-saxifrage *Pimpinella saxifraga* **HEIGHT** to 70cm
Downy, branched perennial of dry, calcareous grassland. **FLOWERS** White, in loose, open umbels (June–Sep). **FRUITS** Egg-shaped, ridged. **LEAVES** Once pinnate, with oval leaflets at base of plant; stem leaves finely divided into narrow leaflets. **STATUS** Widespread and locally common, but absent from NW Scotland.

Greater Burnet-saxifrage *Pimpinella major* ✿
HEIGHT to 1m
Branched perennial with hollow, ridged, hairless stems. Found in shady and grassy places. **FLOWERS** White, in umbels 3–6cm across (June–Sep). **FRUITS** Egg-shaped, ridged. **LEAVES** Usually once pinnate, with toothed, oval lobes. **STATUS** Widespread but distinctly local; commonest in central England.

Burnet-saxifrage

Greater
Burnet-saxifrage

Ground-elder *Aegopodium podagraria* **HEIGHT** to 1m
Creeping, patch-forming, hairless perennial. Favours damp and disturbed ground: a persistent garden weed. **FLOWERS** White, in compact umbels 2–6cm across with 10–20 rays (May–July). **FRUITS** Egg-shaped, ridged. **LEAVES** Fresh green, roughly triangular in outline and twice trifoliate. **STATUS** Doubtfully native; widely introduced and translocated (inadvertently) by gardeners and now widespread.

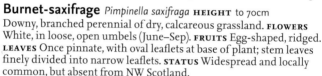

Ground-elder

Greater Water-parsnip *Sium latifolium* ✿✿ **HEIGHT** to 2m
Hairless perennial with hollow, ridged stems. Found in fens, on river banks. **FLOWERS** White, in terminal, long-stalked umbels 6–10cm across (July–Aug). **FRUITS** Egg-shaped, ridged. **LEAVES** Pinnate, with 4–8 pairs of narrow, toothed leaflets plus a terminal one. **STATUS** Local, mainly SE England; commonest in E Anglia.

Greater
Water-parsnip

Lesser Water-parsnip *Berula erecta* **HEIGHT** to 70cm
Spreading, sometimes patch-forming perennial. Favours damp ground and shallow water margins. **FLOWERS** White, in short-stalked umbels 3–6cm across, arising opposite leaves on stem (July–Sep). **FRUITS** Spherical, ridged. **LEAVES** Pinnate, with 7–14 pairs of oval, jagged-toothed leaflets. **STATUS** Widespread and locally common.

■ *See also* Milk-parsley (p.279) and Cambridge Milk-parsley (p.279)

Hemlock

Hemlock
TOP: Umbel
BOTTOM: Stem

Wild Angelica

Cowbane

Burnet-saxifrage
INSET TOP: Leaf
INSET BOTTOM: Umbel

Greater Burnet-saxifrage

Ground-elder

Greater Water-parsnip

Lesser Water-parsnip

Scots Lovage *Ligusticum scoticum* ✿✿ HEIGHT to 80cm

Robust, hairless perennial; forms clumps. Stems ribbed, purplish, and hollow towards the base. Found on coastal habitats. **FLOWERS** White, in flat-topped umbels 4–6cm across, on long, reddish stalks (June–Aug). **FRUITS** Oval, flattened, with 4 wings. **LEAVES** Bright green, shiny and 2 times trifoliate with oval leaflets and inflated, sheathing stalks. **STATUS** Locally common on northern coasts.

Wild Parsnip *Pastinaca sativa* ssp. *sativa* HEIGHT to 1m

Upright, downy perennial with hollow, ridged stems; smells when bruised. Grows in dry, calcareous grassland. **FLOWERS** Yellowish, in open, bractless umbels 3–9cm across (June–Sep). **FRUITS** Oval, flattened, winged. **LEAVES** Pinnate with oval, lobed and toothed leaflets. **STATUS** Widespread and locally common only in S Britain. **Garden Parsnip** *P. s. hortensis*, the familiar vegetable, is sometimes naturalised.

Hemlock Water-dropwort *Oenanthe crocata* ✿ HEIGHT to 1.25m

Distinctive, poisonous perennial. Stems hollow and grooved, and plant smells of parsley. Found in damp meadows and ditches. **FLOWERS** White, in domed umbels 5–10cm across, with 10–40 rays and numerous bracts (June–Aug). **FRUITS** Cylindrical, with long styles. **LEAVES** 2–4 times pinnately divided with toothed, tapering lobes. **STATUS** Widespread but locally common only in S and W Britain.

Tubular Water-dropwort *Oenanthe fistulosa* ✿ HEIGHT to 50cm

Upright, delicate, hairless perennial with slender, inflated, hollow stems. Favours damp ground and shallow water. **FLOWERS** Pinkish white, in open umbels 2–4cm across, with 2–4 rays (July–Sep). **FRUITS** Roughly cylindrical but angular; in umbels that become globular as they ripen. **LEAVES** With inflated stalks; leaflets of lower leaves oval, those of *upper ones tubular.* **STATUS** Local.

Parsley Water-dropwort *Oenanthe lachenalii* ✿✿ HEIGHT to 1m

Upright, hairless perennial with solid, ridged stems. Found in damp, often brackish meadows. **FLOWERS** White, in terminal umbels 2–6cm across, with 6–15 rays (June–Sep). **FRUITS** *Egg-shaped, ribbed and lacking swollen, corky bases (see next species).* **LEAVES** 2 or 3 times pinnate with narrow to oval, flat leaflets, the whole recalling young, fresh parsley leaves. **STATUS** Local, mainly coastal.

Corky-fruited Water-dropwort *Oenanthe pimpinelloides* ✿✿ HEIGHT to 1m

Upright, hairless perennial with solid, ridged stems. Favours damp, grassy places, often coastal and particularly on clay soils. **FLOWERS** White, in terminal, flat-topped umbels 2–6cm across, with 6–15 rays (May–Aug). **FRUITS** *Cylindrical, with swollen, corky bases.* **LEAVES** Once or twice pinnate, with narrow-oval to wedge-shaped leaflets. **STATUS** Scarce and local, in S England only.

Fruit

Leaf

Corky-fruited
Water-dropwort

Fine-leaved Water-dropwort *Oenanthe aquatica* ✿✿ HEIGHT to 1.3m

Bushy biennial with shiny, hollow, grooved stems. Grows in margins of still and slow-flowing waters. **FLOWERS** White, in flat-topped umbels, 2–5cm across, both terminal and arising opposite leaf stalks (June–Sep). **FRUITS** Ovoid. **LEAVES** Delicate-looking; submerged ones 3 or 4 times pinnate, with fine lobes; aerial leaves 3 times pinnate, with ovate segments. **STATUS** Extremely local. **River Water-dropwort** *O. fluviatilis* is similar but mainly submerged, with narrow, pinnate leaves. Flowers in white umbels but often absent (June–Sep). Favours flowing water. Rare, mainly in the south.

Rock-samphire *Crithmum maritimum* ✿ HEIGHT to 40cm

Branched, hairless perennial of coastal rocky habitats. **FLOWERS** Greenish yellow, in umbels 3–6cm across, with 8–30 rays and many bracts (June–Sep). **FRUITS** Egg-shaped, ridged, corky. **LEAVES** Divided into narrow, fleshy lobes, triangular in cross-section. **STATUS** Locally common.

Fine-leaved
Water-dropwort

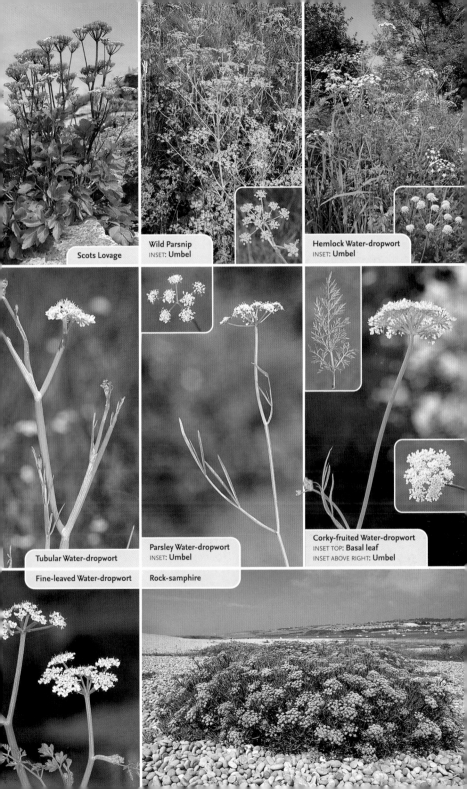

Scots Lovage

Wild Parsnip
INSET: Umbel

Hemlock Water-dropwort
INSET: Umbel

Tubular Water-dropwort

Parsley Water-dropwort
INSET: Umbel

Corky-fruited Water-dropwort
INSET TOP: Basal leaf
INSET ABOVE RIGHT: Umbel

Fine-leaved Water-dropwort

Rock-samphire

Fool's-parsley *Aethusa cynapium* HEIGHT to 50cm

Delicate, hairless annual with slender, ribbed stems. Found in gardens and arable fields. FLOWERS White, in umbels 2–3cm across, the *secondary umbels with a 'beard' of long upper bracts* (June–Aug). FRUITS Egg-shaped, ridged. LEAVES Twice pinnate, flat, triangular in outline. STATUS Commonest in the south.

Fennel *Foeniculum vulgare* HEIGHT to 2m

Grey-green, strong-smelling, hairless perennial with solid young stems and hollow older ones. Favours grassy places, mainly near the sea. FLOWERS Yellow, in open umbels 4–8cm across (July–Oct). FRUITS Narrow, egg-shaped, ridged. LEAVES Feathery, comprising thread-like leaflets. STATUS Locally common in the south.

Pepper-saxifrage *Silaum silaus* ✿ HEIGHT to 1m

Slender, hairless perennial with solid, ridged stems. Found in meadows on damp, heavy soils. FLOWERS Yellowish, in long-stalked umbels 2–6cm across (July–Sep). FRUITS Egg-shaped, ridged. LEAVES 2 to 4 times pinnate, with narrow, pointed leaflets. STATUS Locally common in England but scarce or absent elsewhere.

Spignel *Meum athamanticum* ✿✿ HEIGHT to 60cm

Aromatic, hairless, hollow-stemmed perennial of upland grassland. Fibrous remains of previous year's leaf stalks crown rootstock. FLOWERS Creamy white, in frothy-looking umbels 3–6cm across (June–July). FRUITS Egg-shaped, ridged. LEAVES 3–4 times pinnate, with bristle-like lobes. STATUS Local, from N Wales to Scotland.

Wild Carrot *Daucus carota*

ssp. *carota* HEIGHT to 75cm

Upright or spreading hairy perennial with solid, ridged stems. Found in rough grassland, mostly on chalky soils or near the sea. FLOWERS White (pinkish in bud), in long-stalked umbels to 7cm across, the *central flower red*; note the divided bracts beneath (June–Sep). FRUITS Oval, with spiny ridges; fruiting umbels concave. LEAVES 2 or 3 times pinnate, with narrow leaflets. STATUS Widespread and locally common, except in the north.

Fennel

Pepper-saxifrage

Wild Carrot

Spignel

Sea Carrot *Daucus carota* ssp. *gummifer* HEIGHT to 75cm

Similar to Wild Carrot but with more fleshy leaves and umbels that are flat or convex (not concave) in fruit. FLOWERS Structurally similar to Wild Carrot (June–Sep). FRUITS Oval, with spiny ridges; fruiting umbels flat or convex. LEAVES 2 or 3 times pinnate, with narrow leaflets. More fleshy than Wild Carrot. STATUS Found on cliffs, rocky slopes and dunes by the sea, mainly in the south-west.

Honewort *Trinia glauca* ✿✿✿ HEIGHT to 15cm

Compact, hairless, grey-green, waxy perennial. Found in short, dry grassland on limestone soils. FLOWERS White, on separate-sex plants; male umbels 1cm, female 3cm across (May–June). FRUITS Egg-shaped, ridged. LEAVES 2 or 3 times pinnate, with narrow lobes. STATUS Rare; S Devon and N Somerset only.

Slender Hare's-ear *Bupleurum tenuissimum* ✿✿ HEIGHT to 50cm

Slender, easily overlooked annual. Entirely restricted to coastal grassland and upper reaches of saltmarshes. FLOWERS Yellow, in tiny umbels 3–4mm across, surrounded by bracts, and arising from leaf axils (July–Sep). FRUITS Globular. LEAVES Narrow, pointed. STATUS Local; coastal S and E England only.

■ *See also* Small Hare's-ear (p.271) and Moon Carrot (p.277)

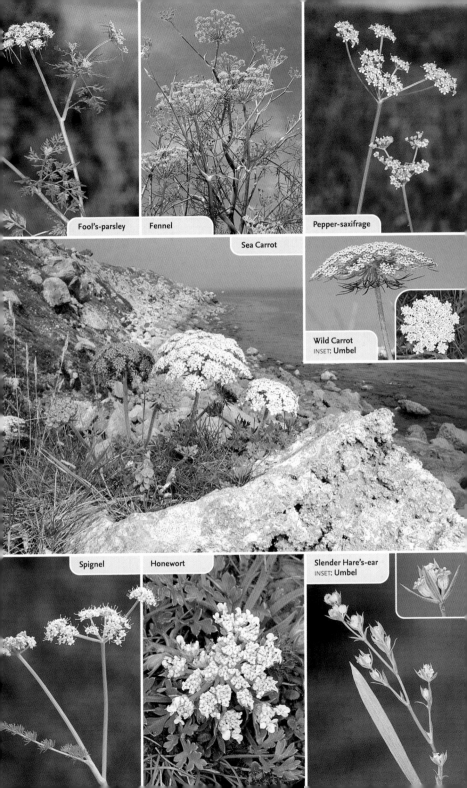

Fool's-parsley

Fennel

Pepper-saxifrage

Sea Carrot

Wild Carrot
INSET: **Umbel**

Spignel

Honewort

Slender Hare's-ear
INSET: **Umbel**

Wild Celery *Apium graveolens* ✿ HEIGHT to 1m

Upright, hairless biennial with a characteristic strong smell of celery. Stems are solid and grooved. Favours rough, often saline, grassland and its distribution is mainly coastal. FLOWERS White, in short-stalked or unstalked umbels 3–6cm across (June–Aug). FRUITS Globular. LEAVES Shiny, pinnate; basal leaves once or twice pinnate with toothed and lobed, diamond-shaped lobes; stem leaves appearing trifoliate. STATUS Absent from Scotland and commonest in coastal S England.

Fool's-water-cress *Apium nodiflorum* HEIGHT to 20cm

Creeping perennial whose leaves bear a passing resemblance to Watercress (p.58). Could also be confused with Lesser Water-parsnip (p.124). Roots at nodes of lower stems; upright stems are hollow. Found in ditches and wet hollows. FLOWERS White, in open umbels (July–Aug). FRUITS Egg-shaped, ridged. LEAVES Shiny; pinnate, with oval, toothed leaflets. STATUS Widespread and locally common.

Fool's-water-cress

Lesser Marshwort *Apium inundatum* ✿ CREEPING

Creeping, prostrate, hairless perennial with smooth stems. Found in damp ground, often on the margins of ponds and marshes, and sometimes growing submerged. FLOWERS White, in small stalked umbels with 2–4 rays (June–July). FRUITS Narrow ovoid. LEAVES Pinnate, with narrow, hair-like leaflets, not unlike those of some water-crowfoot species (p.48–52). STATUS Widespread but rather local.

Corn Parsley *Petroselinum segetum* ✿✿ HEIGHT to 60cm

Slender, rather wiry, hairless, dark grey-green perennial that *smells of parsley*. Found in grassy places and hedges, usually near the sea. FLOWERS White, in open umbels 3–5cm across, which are open and irregular, with rays of unequal length (Aug–Sep). FRUITS Egg-shaped. LEAVES Pinnate, with ovate, toothed leaflets. STATUS Local and mainly coastal in S England and S Wales only.

Corn Parsley

Garden Parsley *Petroselinum crispum* ✿✿ HEIGHT to 40cm

Hairless biennial that is bright green at first but turns yellow with age. Familiar as a kitchen herb. Found in grassy places and on disturbed ground. FLOWERS Greenish yellow, in open umbels 2–3cm across (June–Aug). FRUITS Globular. LEAVES Shiny, roughly triangular and 3 times pinnate; cultivars have variably crinkled leaflets. STATUS Widely grown in gardens and naturalised occasionally.

Garden Parsley

Stone Parsley *Sison amomum* ✿ HEIGHT to 1m

Upright, bushy perennial with an *unpleasant smell* (nutmeg and petrol) when bruised. Found in grassy places on clay soils. FLOWERS White, in open umbels, 1–4cm across, with unequal rays (July–Aug). FRUITS Globular. LEAVES Fresh green; lower ones have oval leaflets, upper ones have narrow leaflets. STATUS Local, in the south.

Whorled Caraway *Carum verticillatum* ✿✿ HEIGHT to 1m

Upright, hairless perennial with solid stems. Found in damp grassland on acid soils. FLOWERS White, in long-stalked umbels, 2–5cm across, with numerous bracts (June–Aug). FRUITS Egg-shaped, ridged. LEAVES Comprising *thread-like leaflets that appear to be borne in whorls*. STATUS Local, mainly in the west.

Stone Parsley

Hog's Fennel *Peucedanum officinale* ✿✿✿ HEIGHT to 1.5m

Hairless, dark green perennial with solid stems. Restricted to coastal grassland on clay soils. FLOWERS Deep yellow, in open umbels, 15–20cm across (July–Sep). FRUITS Narrow-ovate. LEAVES 4- to 6-trifoliate with flattened, narrow segments. STATUS Restricted to a couple of locations on the Thames Estuary.

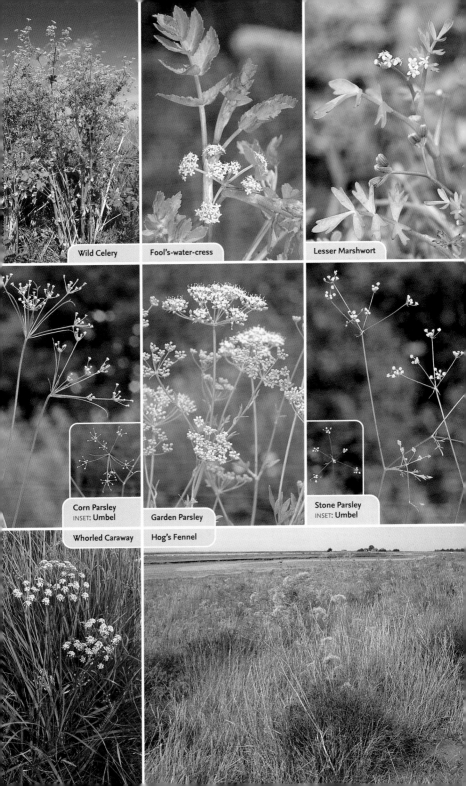

Wild Celery

Fool's-water-cress

Lesser Marshwort

Corn Parsley
INSET: Umbel

Garden Parsley

Stone Parsley
INSET: Umbel

Whorled Caraway

Hog's Fennel

Primrose *Primula vulgaris* HEIGHT to 20cm

Familiar herbaceous perennial, found in hedgerows, woodlands and shady meadows. FLOWERS 2–3cm across, 5-lobed, pale yellow, usually with deep yellow centres; solitary, on long hairy stalks that arise from the centre of the leaf rosette (Feb–May). FRUITS Capsules. LEAVES Oval, tapering, crinkly, up to 12cm long; they form a basal rosette. STATUS Widespread and common throughout.

Primrose

Cowslip *Primula veris* HEIGHT to 25cm

Elegant, downy perennial of dry, unimproved grassland, often on calcareous soils. FLOWERS 8–15mm across, fragrant, bell-shaped, stalked, orange-yellow; in rather 1-sided umbels of 10–30 flowers (Apr–May). FRUITS Capsules. LEAVES Tapering, wrinkled, hairy, forming a basal rosette. STATUS Widespread and locally common, except in Scotland.

Cowslip

Oxlip *Primula elatior* ✿✿ HEIGHT to 20cm

Attractive perennial of open woodland, including coppiced sites, usually on clay soils. FLOWERS 15–25mm across, pale yellow, 5-lobed, resembling small Primrose flowers; in 1-sided umbels of 10–20 flowers (Mar–May). FRUITS Capsules. LEAVES Oval, long-stalked, crinkly, ending abruptly at the base and not tapering; form a basal rosette. STATUS Locally common only in parts of E Anglia.

False Oxlip *Primula veris × vulgaris* ✿ HEIGHT to 20cm

Naturally occurring hybrid between Primrose and Cowslip that superficially resembles Oxlip. Found in hedgerows, woodlands and meadows, where both parents occur. FLOWERS 15–20mm across, yellow and 5-lobed; in umbels that are not 1-sided (Mar–May). FRUITS Capsules. LEAVES Oval, crinkly, tapering; forming a basal rosette. STATUS Widespread but always local and far less numerous than parent plants.

Oxlip False Oxlip

Bird's-eye Primrose *Primula farinosa* ✿✿ HEIGHT to 12cm

Charming perennial, associated with damp, bare grassland, and invariably found on limestone soils. FLOWERS 12–17mm across, 5-lobed and pink with a yellow central 'eye'; in terminal umbels on upright, mealy stems (June–July). FRUITS Capsules. LEAVES Spoon-shaped, mealy white on the underside, forming a basal rosette. STATUS Local and restricted to a few locations in N England.

Yellow Loosestrife *Lysimachia vulgaris* ✿ HEIGHT to 1m

Softly hairy perennial of damp grassland, and often found beside rivers and in fens. FLOWERS 15–20mm across, yellow, with 5 pointed lobes; in terminal heads (June–Aug). FRUITS Capsules. LEAVES Narrow, ovate, in whorls of 3 or 4; often adorned with black dots. STATUS Widespread and locally common throughout.

Creeping-Jenny *Lysimachia nummularia* ✿ CREEPING

Low-growing, hairless perennial found on damp, grassy ground. FLOWERS 15–25mm across, yellow, bell-shaped with 5 pointed lobes; on stalks arising from leaf axils (June–Aug). FRUITS Capsules. LEAVES Rounded or heart-shaped; in opposite pairs. STATUS Locally common in England; scarce or absent elsewhere.

Yellow Pimpernel *Lysimachia nemorum* CREEPING

Evergreen, hairless perennial similar to Creeping-Jenny but more delicate. Found in damp, shady places, especially in woodlands. FLOWERS 10–15mm across, yellow, star-shaped with 5 lobes; on slender stalks arising from leaf axils (May–Aug). FRUITS Capsules. LEAVES Oval or heart-shaped, in opposite pairs along creeping stems. STATUS Widespread and common throughout.

■ *See also* Scottish Primrose (p.285)

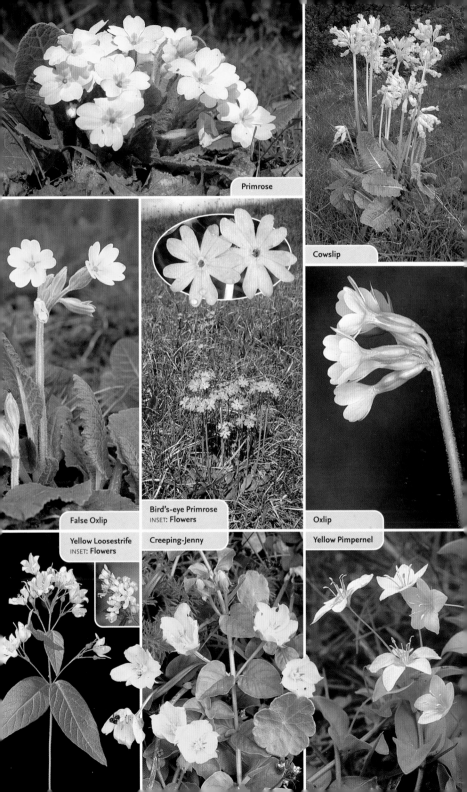

Primrose

Cowslip

False Oxlip

Bird's-eye Primrose
INSET: Flowers

Oxlip

Yellow Loosestrife
INSET: Flowers

Creeping-Jenny

Yellow Pimpernel

Sea-milkwort *Glaux maritima* ✤ HEIGHT to 10cm
Low-growing, generally creeping, hairless perennial found on the upper reaches of saltmarshes and on sea walls. **FLOWERS** 5–6mm across, comprising 5 pink, petal-like sepals; on upright shoots (May–Sep). **FRUITS** Dark brown capsules. **LEAVES** Ovate, succulent, in opposite pairs along the trailing stems. **STATUS** Widespread and locally common on coasts throughout the region.

Scarlet Pimpernel *Anagallis arvensis* ssp. *arvensis* CREEPING
Low-growing, hairless annual of cultivated and disturbed ground. **FLOWERS** 10–15mm across with 5 scarlet or pinkish-orange (sometimes blue) *petals fringed with hairs*; on slender stalks, and opening wide only in bright sunshine (June–Aug). **FRUITS** Capsules. **LEAVES** Oval, usually in pairs. **STATUS** Widespread and generally common throughout the region, except in Scotland.

Blue Pimpernel *Anagallis arvensis* ssp. *foemina* ✤ CREEPING
Low-growing, hairless annual of cultivated and disturbed ground, mainly on chalky soils. Superficially very similar to blue forms of Scarlet Pimpernel. **FLOWERS** 10–15mm across with 5 blue *petals not fringed with hairs*; on slender stalks, and opening wide only in bright sunshine (June–Aug). **FRUITS** Capsules. **LEAVES** Narrow, lanceolate. **STATUS** Widespread but commonest in the south.

Bog Pimpernel

Chaffweed

Bog Pimpernel *Anagallis tenella* ✤ CREEPING
Delicate, attractive hairless perennial; has trailing stems and sometimes forms mats. Found on damp ground, such as bogs and dune slacks, mainly on acid soils. **FLOWERS** To 1cm long, pink, funnel-shaped with 5 lobes; on slender, upright stalks (June–Aug). **FRUITS** Capsules. **LEAVES** Rounded, short-stalked, in opposite pairs. **STATUS** Widespread and locally common in the west but scarce in the east.

Chaffweed *Anagallis minima* ✤✤ HEIGHT to 2cm
Tiny, insignificant, hairless annual that is easily over-looked. Found in short grass on damp, sandy ground. **FLOWERS** Minute, pale pink, borne at the bases of the stem leaves (June–Aug). **FRUITS** Spherical and pinkish, like miniature apples. **LEAVES** Oval and, uniquely among British species, with a *black line around the margin of the undersurface*. **STATUS** Widespread but extremely local.

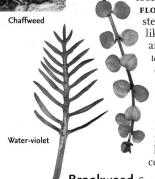

Water-violet

Water-violet *Hottonia palustris* ✤✤ AQUATIC
Attractive, rather delicate perennial of still or slow-flowing waters. **FLOWERS** 15–20mm across, 5-lobed, pale lilac with a yellow central 'eye'; in spikes on tall, hairless stems rising clear of the water (May–June). **FRUITS** Capsules. **LEAVES** Feathery, divided into narrow lobes; seen both floating and submerged. **STATUS** Very locally common in S and E England but scarce or absent elsewhere.

Brookweed *Samolus valerandi* ✤ HEIGHT to 12cm
Hairless, pale green perennial. Found on damp ground, usually on saline or calcareous soils. **FLOWERS** 2–3mm across with 5 white petals, joined to halfway; in terminal clusters (June–Aug). **FRUITS** Spherical capsules. **LEAVES** Spoon-shaped; appearing mainly as a basal rosette. **STATUS** Widespread but local and mainly coastal.

Chickweed-wintergreen *Trientalis europaea* ✤✤ HEIGHT to 20cm
Spreading, delicate perennial of mature, northern conifer forests. **FLOWERS** 12–18mm across, star-shaped with 7 white petals; 1 or 2 borne on long, slender stalks (June–July). **FRUITS** Capsules. **LEAVES** Ovate; mainly in a whorl near the top of the stem. **STATUS** Very locally common in Scotland and scarce in N England.

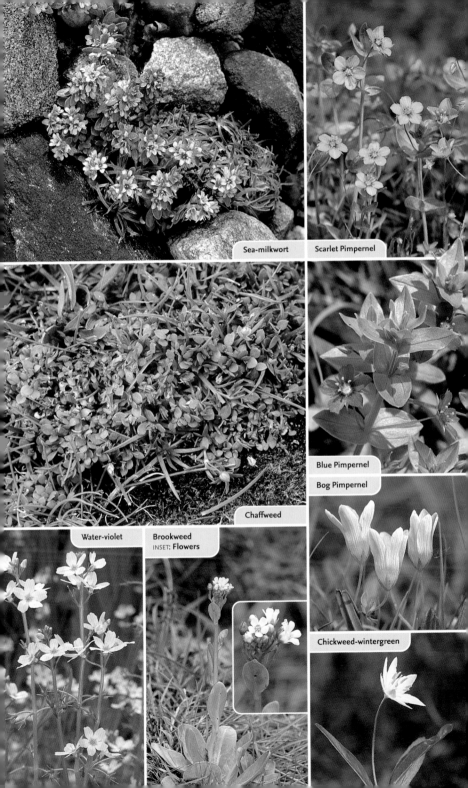

Sea-milkwort

Scarlet Pimpernel

Blue Pimpernel

Bog Pimpernel

Chaffweed

Water-violet

Brookweed
INSET: **Flowers**

Chickweed-wintergreen

Heather *Calluna vulgaris* HEIGHT to 50cm

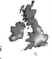

Dense, evergreen undershrub also known as **Ling**. A characteristic plant of acid soils on heath and moors, on all but the wettest terrain. Also occurs in mature conifer woodland. FLOWERS 4–5mm long, bell-shaped, usually pink but sometimes white; in spikes (Aug–Sep). FRUITS Capsules. LEAVES Short, narrow, *in 4 rows along the stem.* STATUS Widespread and locally abundant throughout the region. In many heathland and moorland areas it is the dominant plant.

Bell Heather *Erica cinerea* HEIGHT to 50cm

Hairless, evergreen undershrub of acid soils, typically favouring drier locations than Heather or Cross-leaved Heath. FLOWERS 5–6mm long, bell-shaped, purplish red; in groups along the stems that sometimes appear like elongated spikes (June–Sep). FRUITS Capsules. LEAVES Narrow, dark green, *in whorls of 3 up the wiry stems.* STATUS Widespread and locally common, especially in the north and west; it sometimes becomes the dominant plant on dry heaths and moors.

Cross-leaved Heath *Erica tetralix* HEIGHT to 30cm

Downy, grey-green undershrub that favours damp, acid soils. It is the characteristic plant of the waterlogged margins of heathland and moorland bogs. FLOWERS 6–7mm long, rather globular and pink; in rather compact, terminal 1-sided clusters (June–Oct). FRUITS Downy capsules. LEAVES Narrow, fringed with hairs and *in whorls of 4 along the stems.* STATUS Widespread and locally common throughout the region, but always in wetter locations than Ling or Bell Heather.

Dorset Heath *Erica ciliaris* ❀❀ HEIGHT to 50cm

Clump-forming, evergreen undershrub that favours damp, acid soils on heathlands. FLOWERS 8–10mm long, elongate egg-shaped, pinkish purple, with projecting styles; the flowers opening in succession from the bottom so the spikes taper towards the top (July–Sep). FRUITS Hairless capsules. LEAVES Narrow with bristly margins; *in whorls of 3.* STATUS Local, restricted to SW England and W Ireland; locally common on Dorset heaths. Note that this species hybridises with Cross-leaved Heath, the result having flowers like *E. ciliaris* and leaves like *E. tetralix.*

Rhododendron *Rhododendron ponticum* HEIGHT to 5m

A popular, evergreen ornamental shrub that is naturalised in some areas. Favours acid, damp soils. FLOWERS 4–6cm long, bell-shaped, pinkish red; in clusters (May–June). FRUITS Dry capsules containing numerous flat seeds. LEAVES Shiny, leathery, elliptical, dark green. STATUS Often controlled because it is invasive and detrimental to native flora.

Trailing Azalea *Loiseleuria procumbens* ❀❀ CREEPING

Attractive, low-growing perennial undershrub that forms prostrate mats on acid soils and stony ground on mountain plateaux. FLOWERS 5mm across, bell-shaped, deeply lobed, pink; either solitary or in clusters (May–June). FRUITS Capsules. LEAVES Thick, opposite and oblong with downrolled margins. STATUS Found mainly in the Scottish Highlands and locally common only in the Cairngorms.

St Dabeoc's Heath *Daboecia cantabrica* ❀❀ HEIGHT to 60cm

Hairy, evergreen, rather straggly undershrub. Found on dry heaths on acid soils. FLOWERS 10–14mm long, elongate egg-shaped, pinkish purple, nodding; in open, terminal spikes (June–Oct). FRUITS Capsules. LEAVES Narrow-ovate, with downrolled margins; dark green and hairy above but white below. STATUS Restricted to heaths in W Ireland but locally common in places.

■ *See also* Cornish Heath (p.272), Blue Heath (p.284) and Irish Heath (p.286)

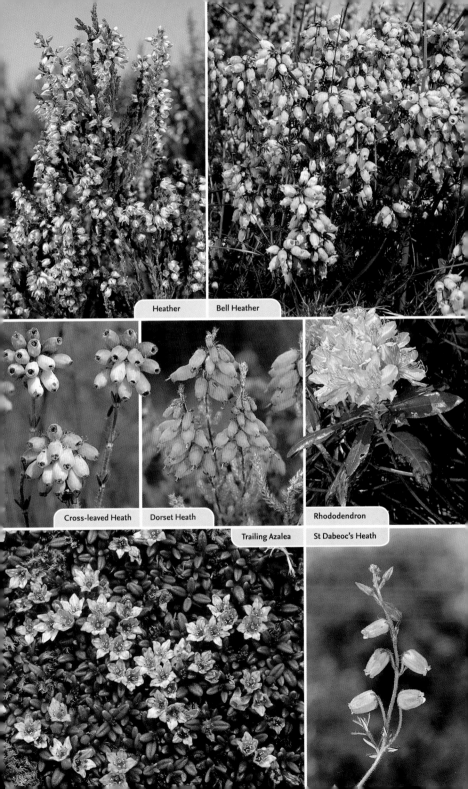

Heather Bell Heather

Cross-leaved Heath Dorset Heath Rhododendron

Trailing Azalea St Dabeoc's Heath

Bog-rosemary *Andromeda polifolia* (Ericaceae) ❀❀ HEIGHT to 40cm

Hairless, evergreen undershrub found in acid bogs, often growing alongside *Sphagnum* moss. FLOWERS 8–10mm long, pink, urn-shaped; pendent on short stalks, in small, terminal clusters (May–Sep). FRUITS Capsules. LEAVES Narrow, bluish green above, whitish below; alternate, untoothed. STATUS Local and declining, from Wales and central England to S Scotland; also in Ireland.

Bilberry *Vaccinium myrtillus* (Ericaceae) HEIGHT to 75cm

Hairless, deciduous undershrub with 3-angled green twigs. Found on acid soils, on heathland and in open woodland. FLOWERS 5–6mm long, greenish pink, globular urn-shaped; pendent, on short stalks (Apr–June). FRUITS Familiar and delicious black berries. LEAVES Bright green, oval, finely toothed. STATUS Widespread and common across much of the region; least numerous in the east.

Bog Bilberry *Vaccinium uliginosum* (Ericaceae) ❀❀ HEIGHT to 70cm

Rather straggly, deciduous undershrub with round, brown twigs. Found on damp moorland and mountain ledges. FLOWERS 6mm long, globular urn-shaped, pale pink; in clusters (May–June). FRUITS Globular, bluish-black berries. LEAVES Ovate, bluish green, untoothed. STATUS Local, in N England and Scotland.

Bearberry *Arctostaphylos uva-ursi* (Ericaceae) ❀ PROSTRATE

Low-growing, mat-forming evergreen undershrub. Found on dry moorland and mountain slopes. FLOWERS 5–6mm long, urn-shaped, pink; in clusters on short stalks (May–Aug). FRUITS Shiny, bright red berries 7–9mm across. LEAVES Oval, untoothed, leathery; dark green and shiny above, paler below. STATUS Locally common in Scotland but rare elsewhere within its range.

Arctic Bearberry *Arctostaphylos alpinus* (Ericaceae) ❀❀ PROSTRATE

Mat-forming deciduous undershrub, the stems often bearing the withered remains of the previous year's leaves. Found on acid moorland. FLOWERS 4–5mm long, urn-shaped, white; in small clusters (May–Aug). FRUITS Black berries up to 1cm across. LEAVES Wrinkled and toothed; turning red in autumn. STATUS N Scotland only.

Cowberry *Vaccinium vitis-idaea* (Ericaceae) ❀ HEIGHT to 20cm

Straggly evergreen undershrub, with round twigs that are downy when young. Found on moors and in woodland on acid soils. FLOWERS 5–6mm long, bell-shaped, pink; in drooping terminal clusters (May–June). FRUITS Shiny, bright red berries, up to 1cm across. LEAVES Leathery, oval, untoothed; dark green above, paler below. STATUS Locally common from N Wales northwards; also in Ireland.

Cranberry *Vaccinium oxycoccos* (Ericaceae) ❀❀ HEIGHT to 12cm

Creeping evergreen undershrub with slender, trailing, wiry stems. Associated with permanently inundated peat bogs. FLOWERS 8–10mm, distinctive, recalling miniature *Fuchsia* flowers; pink with reflexed petals and protruding stamens (May–July). FRUITS Bright red berries. LEAVES Dark green, narrow, with inrolled margins. STATUS Locally common only in N Wales, N England and E Ireland.

Crowberry *Empetrum nigrum* (Empetraceae) ❀ HEIGHT to 10cm

Mat-forming, Heather-like evergreen undershrub with stems that are reddish when young. Found on upland moors on damp, acid ground. FLOWERS Tiny, pinkish, with 6 petals; arising at base of leaves (May–June). FRUITS Shiny berries, 5–7mm across, green at first but ripening black in late summer. LEAVES Narrow, shiny, dark green, with inrolled margins. STATUS Locally common only in N Britain.

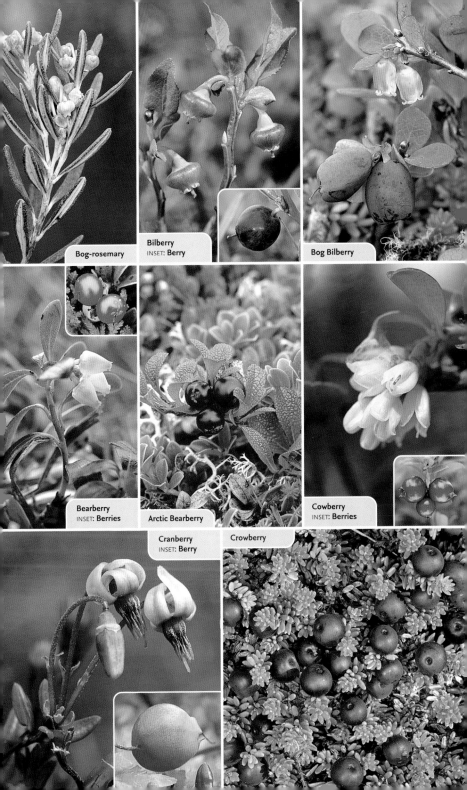

Bog-rosemary

Bilberry
INSET: **Berry**

Bog Bilberry

Bearberry
INSET: **Berries**

Arctic Bearberry

Cowberry
INSET: **Berries**

Cranberry
INSET: **Berry**

Crowberry

Common Wintergreen *Pyrola minor* (Pyrolaceae) ✿✿ **HEIGHT** to 20cm

Hairless, evergreen perennial of open, upland woodlands and moors, often found on calcareous soils. **FLOWERS** 5–6mm across, pinkish white, rounded, rather bell-shaped, with a *straight style that does not protrude beyond the petals*; on upright stalks (June–Aug). **FRUITS** Capsules. **LEAVES** Oval, toothed, stalked; forming a basal rosette. **STATUS** Local and generally scarce, least so in N England but declining even there. **Intermediate Wintergreen** (*P. media*) is similar but has more elongate leaves and a protruding style; local and scarce, mainly in E Scotland.

Round-leaved Wintergreen *Pyrola rotundifolia* (Pyrolaceae) ✿✿

HEIGHT to 15cm

Low-growing perennial of damp, calcareous ground including fens and coastal dune slacks. **FLOWERS** 8–12mm across, white, bell-shaped; *style S-shaped, protruding beyond petals* (May–Aug). **FRUITS** Capsules. **LEAVES** Rounded, long-stalked; forming a basal rosette. **STATUS** Local and declining across its range.

Serrated Wintergreen *Orthilia secunda* (Pyrolaceae) ✿✿ **HEIGHT** to 15cm

Low-growing perennial of open, mature pine forests and mountains. **FLOWERS** 5–6mm across, greenish white; pendent, short-stalked, on 1-sided stalks (July–Aug). **FRUITS** Capsules. **LEAVES** Oval, toothed, pale green. **STATUS** Local and scarce, from N England northwards, but least so in the Scottish Highlands.

Yellow Bird's-nest *Monotropa hypopitys* (Monotropaceae) ✿✿ **HEIGHT** to 10cm

Bizarre plant of Beech and conifer woodland, also found in dune slacks. Whole plant lacks chlorophyll and looks waxy yellow; food is obtained from soil leaf mould. **FLOWERS** 10–15mm long, bell-shaped; in nodding spikes (June–Sep). **FRUITS** Capsules. **LEAVES** Scale-like. **STATUS** Widespread but extremely local.

Thrift *Armeria maritima* (Plumbaginaceae) **HEIGHT** to 20cm

Attractive cushion-forming perennial that often carpets suitable coastal cliffs. Sometimes also grows in saltmarshes, and on a few mountain tops. **FLOWERS** Pink, in dense, globular heads 15–25mm across, on slender stalks (Apr–July). **FRUITS** Capsules. **LEAVES** Dark green, long, narrow. **STATUS** Widespread and locally abundant; mainly coastal.

Common Sea-lavender *Limonium vulgare* (Plumbaginaceae) ✿

HEIGHT to 30cm

Distinctive, hairless perennial that is woody at the base. Entirely restricted to saltmarshes and tolerates tidal inundation. **FLOWERS** 6–7mm long, pinkish lilac, in branched, flat-topped heads on arching sprays (July–Sep). **FRUITS** Capsules. **LEAVES** Spoon-shaped with long stalks. **STATUS** Widespread and locally common in S and SE England but scarce or absent elsewhere.

Lax-flowered Sea-lavender *Limonium humile* (Plumbaginaceae) ✿✿ **HEIGHT** to 25cm

Similar to Common Sea-lavender but with subtle differences in appearance of flower heads and leaves. Restricted to saltmarshes. **FLOWERS** 6–7mm long, pinkish lilac, in *open, lax clusters with well-spaced flowers*; sprays branching below the middle (July–Sep). **FRUITS** Capsules. **LEAVES** Narrow, long-stalked. **STATUS** Local in England, Wales and S Scotland; widespread and fairly common on Irish coasts.

Common Sea-lavender

Lax-flowered Sea-lavender

Rock Sea-lavender *Limonium binervosum* (Plumbaginaceae) ✿✿ **HEIGHT** to 30cm

Hairless perennial of coastal cliffs and rocks; occasionally on stabilised shingle beaches. **FLOWERS** 6–7mm long, pinkish lilac, in small, well-spaced clusters on sprays that branch from below the middle (July–Sep). **FRUITS** Capsules. **LEAVES** Narrow, spoon-shaped, with winged stalks. **STATUS** Locally common on coasts.

■ *See also* Portland (p.271) and Matted Sea-lavender (p.279), Jersey Thrift (p.274) and One-flowered Wintergreen (p.284)

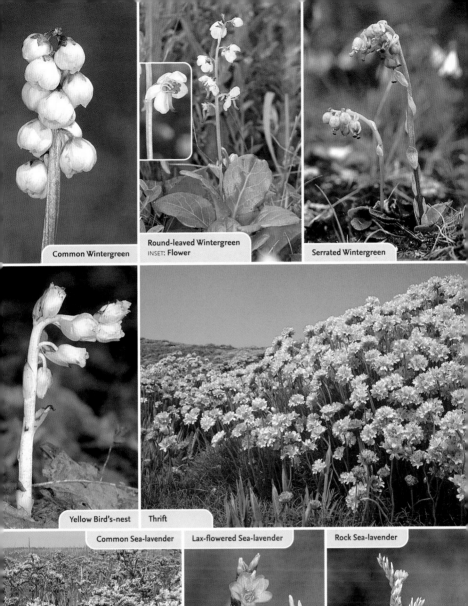

Common Wintergreen

Round-leaved Wintergreen
INSET: **Flower**

Serrated Wintergreen

Yellow Bird's-nest Thrift

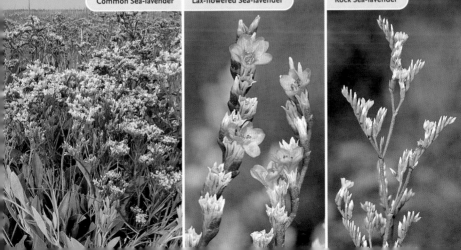

Common Sea-lavender Lax-flowered Sea-lavender Rock Sea-lavender

Wild Privet *Ligustrum vulgare* (Oleaceae) **HEIGHT** to 10m
Much-branched, semi-evergreen shrub that has downy young twigs. Found in hedgerows and areas of scrub, mainly on chalk and limestone soils. **FLOWERS** 4–5mm across, creamy white, fragrant, 4-petalled; in terminal spikes (May–June). **FRUITS** Shiny, globular, poisonous, ripening black in the autumn; in clusters. **LEAVES** Shiny, untoothed, oval, opposite. **STATUS** Widespread and locally common in S and central England and Wales but generally scarce elsewhere.

Yellow Centaury *Cicendia filiformis* (Gentianaceae) ✿✿ **HEIGHT** to 15cm
Slender, very delicate annual or biennial that is extremely easy to overlook when not in flower. Found on damp, sandy ground, usually growing in short turf, and often near the sea. **FLOWERS** 3–5mm across with 4 petal-like corolla lobes that open only in full sunshine (July–Aug). **FRUITS** Capsules. **LEAVES** Tiny, narrow, in opposite pairs. **STATUS** Extremely local and restricted to S and SW Britain and SW Ireland; perhaps easiest to find in the New Forest.

Common Centaury *Centaurium erythraea* (Gentianaceae) **HEIGHT** to 25cm
Variable, hairless annual found in dry, grassy places, including verges, chalk downland and sand dunes. **FLOWERS** 10–15mm across, unstalked, pink, with 5 petal-like lobes that open fully only in sunshine; in *terminal clusters and on side shoots* (June–Sep). **FRUITS** Capsules. **LEAVES** Grey-green, *oval*, those on the stem narrower than the basal ones (*10–20mm across*), which form a rosette; all leaves have 3–7 veins. **STATUS** Widespread and common, except in Scotland. Dwarf form var. *capitatum* (so-called **Dumpy Centaury**) occurs on coasts of England and Wales.

Seaside Centaury *Centaurium littorale* (Gentianaceae) ✿✿ **HEIGHT** to 15cm
Similar to Common Centaury but more compact, with subtle differences in the leaves and flowers. Associated with sandy, coastal ground and mainly northern. **FLOWERS** 10–16mm across, unstalked, pink, with 5 petal-like lobes; in *dense, flat-topped clusters* (June–Aug). **FRUITS** Capsules. **LEAVES** Grey-green; basal leaves *narrow and 4–5mm wide*, forming a rosette; *stem leaves narrower still and parallel-sided*. **STATUS** Locally common on coasts of N and NW Britain.

Lesser Centaury *Centaurium pulchellum* (Gentianaceae) ✿ **HEIGHT** to 15cm
Slender annual that usually branches from near the base. Rather similar to Common Centaury but *lacking a basal rosette of leaves*. **FLOWERS** 5–8mm across, short-stalked and dark pink; in open clusters (June–Sep). **FRUITS** Capsules. **LEAVES** Narrowly ovate, 3–7 veined, appearing only on the stems. **STATUS** Widespread but local in England and Wales only; mainly coastal and most frequent in the south.

Perennial Centaury *Centaurium scilloides* (Gentianaceae) ✿✿✿ **HEIGHT** to 25cm
Perennial with creeping stems and upright flowering stalks. Found in short turf and restricted to coastal cliffs. **FLOWERS** 15–20mm across, stalked, pink; in *few-flowered clusters* (July–Aug). **FRUITS** Capsules. **LEAVES** *Rounded and stalked on the creeping stems but narrower and unstalked on upright stems*. **STATUS** Rare; restricted to cliffs in Pembrokeshire; it may have disappeared from N Cornwall.

Yellow-wort *Blackstonia perfoliata* (Gentianaceae) ✿✿ **HEIGHT** to 30cm
Distinctive upright, grey-green annual of short, calcareous grassland. **FLOWERS** 10–15mm across with 6–8 bright yellow petal lobes that open only in bright sunshine (June–Oct). **FRUITS** Capsules. **LEAVES** Ovate and waxy; stem leaves in opposite pairs that are fused at the base around the stem; basal leaves forming a rosette. **STATUS** Locally common in England and Wales, mainly in the south.

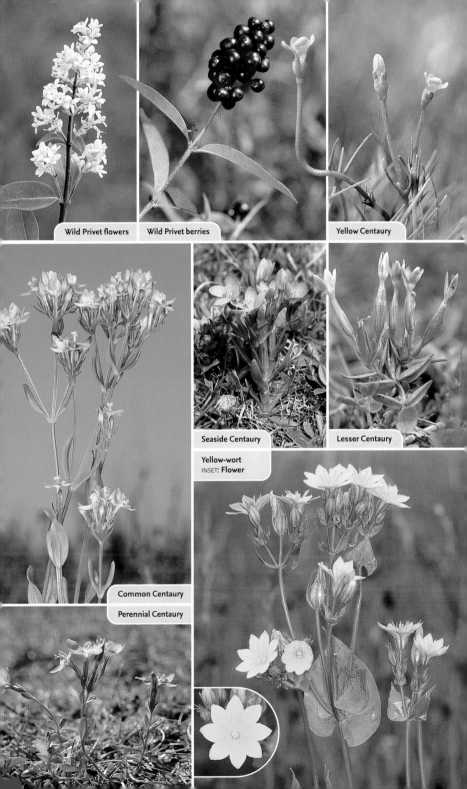

Wild Privet flowers Wild Privet berries

Yellow Centaury

Seaside Centaury

Lesser Centaury

Yellow-wort
INSET: Flower

Common Centaury

Perennial Centaury

Marsh Gentian *Gentiana pneumonanthe* (Gentianaceae) ✿✿ **HEIGHT** to 30cm
Scarce, attractive hairless perennial of bogs and damp, grassy heaths on acid soils.
FLOWERS 25–45mm long, trumpet-shaped, bright blue, the outside of the corolla
tube being marked with 5 green stripes; in terminal clusters (July–Oct). **FRUITS**
Capsules. **LEAVES** Narrow, blunt, 1-veined, borne up the stem in opposite pairs.
STATUS Local, with scattered sites in England and Wales.

Spring Gentian *Gentiana verna* (Gentianaceae) ✿✿✿ **HEIGHT** to 7cm
Stunningly attractive perennial of limestone grassland. **FLOWERS** 20–25mm across,
5-lobed and bright blue; on upright stems (May–June). **FRUITS** Capsules. **LEAVES**
Oval, bright green; forming a basal rosette and in opposite pairs on the stem.
STATUS Restricted to a few locations in Upper Teesdale (N England) and the
Burren (W Ireland), but sometimes locally common there.

Autumn Gentian *Gentianella amarella* (Gentianaceae) **HEIGHT** to 25cm
Variable hairless biennial, often tinged purple. Found in grassy areas, mostly on
calcareous soil and sand dunes. **FLOWERS** 1cm across, purple, with *4 or 5 corolla
lobes and equal calyx lobes*; in upright spikes (July–Oct). **FRUITS** Capsules. **LEAVES**
Forming a basal rosette in the first year but withering before the flower stem
appears in the second year. **STATUS** Widespread and locally common.

Field Gentian *Gentianella campestris* (Gentianaceae) ✿ **HEIGHT** to 10cm
Biennial, similar to Autumn Gentian but separable with care by studying the
flowers. Found in grassland on neutral or acid soils. **FLOWERS** 10–12mm across,
bluish purple, sometimes creamy white; note the *4 corolla lobes and unequal calyx
lobes, one pair much larger than the other* (July–Oct). **FRUITS** Capsules. **LEAVES**
Narrow ovate. **STATUS** Locally common in N England and Scotland; scarce or
absent elsewhere.

Lesser Periwinkle *Vinca minor* (Apocynaceae) ✿ **HEIGHT** to 1m
Woody, trailing evergreen perennial; scrambles through or over other vegetation
in woods and shady hedges. **FLOWERS** 25–30mm across with 5 bluish-violet lobes
that are *obliquely truncated* on the outer margin; on slender stalks with narrow,
hairless calyx lobes (Feb–May). **FRUITS** Capsules. **LEAVES** Ovate, shiny, dark
green, in opposite pairs. **STATUS** Widely naturalised; possibly native in S England.

Greater Periwinkle *Vinca major* (Apocynaceae) ✿ **HEIGHT** to 1m
Woody, trailing evergreen perennial of woods and hedges. **FLOWERS** 4–5cm across
with 5 bluish-violet lobes that are *acutely truncated* on the outer margin; on slender
stalks, the calyx lobes having hairy margins (Mar–May). **FRUITS** Capsules.
LEAVES Ovate, shiny, dark green, stalked, in opposite pairs. **STATUS** Naturalised.

Field Madder *Sherardia arvensis* (Rubiaceae) ✿ **CREEPING**
Low-growing, hairy annual with square stems. Found on arable and disturbed
land. **FLOWERS** 3–5mm across, pinkish, with 4 corolla lobes; in small heads
(May–Sep). **FRUITS** Nutlets. **LEAVES** Narrow, oval and arranged in whorls of 4–6
along the stems. **STATUS** Widespread; rather common in the south but becoming
scarce further north.

Bogbean *Menyanthes trifoliata* (Menyanthaceae) ✿ **HEIGHT** to 15cm
Distinctive, creeping aquatic perennial found in shallow water as well as damp peaty
soil in marshes, fens and bogs. **FLOWERS** 15mm across, star-shaped, pinkish white
with 5 fringed petal lobes; in spikes up to 25cm long (Mar–June). **FRUITS** Capsules.
LEAVES Trifoliate; *emergent ones with the texture and appearance of Broad Bean
leaves.* **STATUS** Widespread and locally common throughout.

■ *See also* Early Gentian (p.275), Chiltern Gentian (p.280) and Alpine Gentian (p.283)

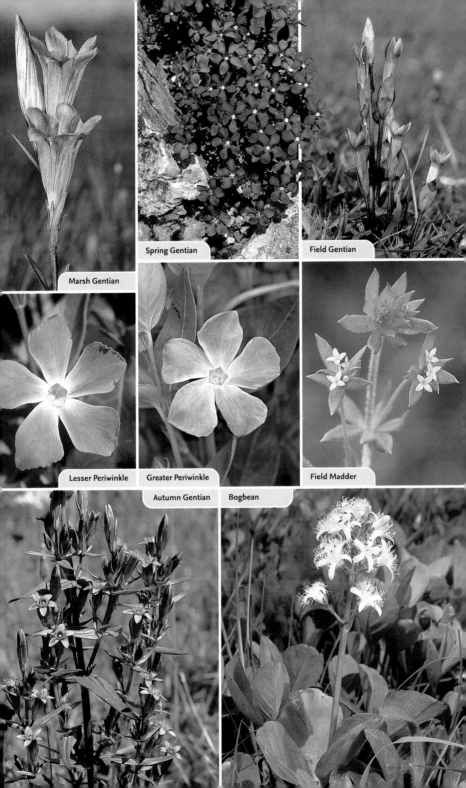

Marsh Gentian

Spring Gentian

Field Gentian

Lesser Periwinkle

Greater Periwinkle

Field Madder

Autumn Gentian

Bogbean

Squinancywort *Asperula cynanchica* ✿ HEIGHT to 15cm

Hairless perennial that is typically rather prostrate; note the 4-angled stems. Found in dry grassland, mainly on chalk or limestone soils. FLOWERS 3–4mm across, pink, with 4 petals, star-shaped; in dense clusters (June–Sep). FRUITS Warty nutlets. LEAVES Narrow, variable in length, in whorls of 4. STATUS Locally common in S England only; scarce or absent elsewhere.

Woodruff *Galium odoratum* ✿ HEIGHT to 25cm

Upright, hairless, square-stemmed perennial. Found in shady woodlands, mostly on calcareous soils; spreads and forms carpets in suitable locations. *Whole plant smells of hay.* FLOWERS 3–4mm across, white, with 4 petals; in clusters (May–June). FRUITS Nutlets with hooked bristles. LEAVES Lanceolate, in whorls of 6–8; leaf margins bristly. STATUS Locally common, except in the north.

Lady's Bedstraw *Galium verum* HEIGHT to 30cm

Attractive, branched perennial and the only true bedstraw with yellow flowers (but note Crosswort, p. 148). Stems square; whole plant smells of hay. Found in dry grassland. FLOWERS 2–3mm across, yellow, with 4 petals; in dense clusters (June–Sep). FRUITS Smooth nutlets that ripen black. LEAVES Narrow with down-rolled margins; in whorls of 8–12. Leaves blacken when dry. STATUS Widespread and common.

Hedge Bedstraw *Galium mollugo* HEIGHT to 1.5m

Scrambling perennial with smooth, square stems. Found in hedgerows and dry, grassy places, typically on base-rich soils. FLOWERS 3mm across, white, with 4 petals; in large, frothy clusters (June–Sep). FRUITS Wrinkled, hairless nutlets. LEAVES *Oval, 1-veined, bristle-tipped and with forward-pointing bristles on the margins.* STATUS Widespread and fairly common, except in the north; absent from Ireland.

Heath Bedstraw *Galium saxatile* HEIGHT to 50cm

Spreading, rather weak-stemmed perennial that is sometimes almost prostrate and mat-forming. *Whole plant blackens when dry.* Found on heaths and grassland on acid soils. FLOWERS 3mm across, white, 4-petalled, with a sickly smell; in clusters (June–Aug). FRUITS Hairless, warty nutlets. LEAVES *Narrow-ovate, bristle-tipped, with forward-pointing marginal bristles.* STATUS Widespread and locally common.

Fen Bedstraw *Galium uliginosum* ✿ HEIGHT to 70cm

Straggly, slender perennial with *rough stems that have backward-pointing bristles on the edges.* Found in damp, grassy places, mainly on calcareous soils. FLOWERS 2–3mm across, white, with 4 petals; in open, few-flowered clusters (June–Aug). FRUITS Wrinkled, brown nutlets. LEAVES *Narrow, spine-tipped and with backward-pointing marginal bristles; in whorls of 6–8.* STATUS Widespread but local.

Common Marsh-bedstraw *Galium palustre* HEIGHT to 70cm

Delicate, straggling perennial with *rather rough stems.* Grows in damp, grassy places. FLOWERS 3–4mm across, white, with 4 petals; in open clusters (June–Aug). FRUITS Wrinkled nutlets. LEAVES *Narrow, widest towards the tip and not bristle-tipped; in whorls of 4–6.* STATUS Widespread and common throughout.

Slender Marsh-bedstraw *Galium constrictum* ✿✿ HEIGHT to 60cm

Similar to Common Marsh-bedstraw but *more slender and with smooth stems.* Grows on marshy ground beside ponds. FLOWERS 2–3mm across, white, with 4 petals; in few-flowered clusters (May–Aug). FRUITS Warty nutlets. LEAVES *Narrow, not bristle-tipped but with forward-pointing marginal bristles.* STATUS Local, restricted to a few locations in England and W Ireland; easiest to locate in the New Forest.

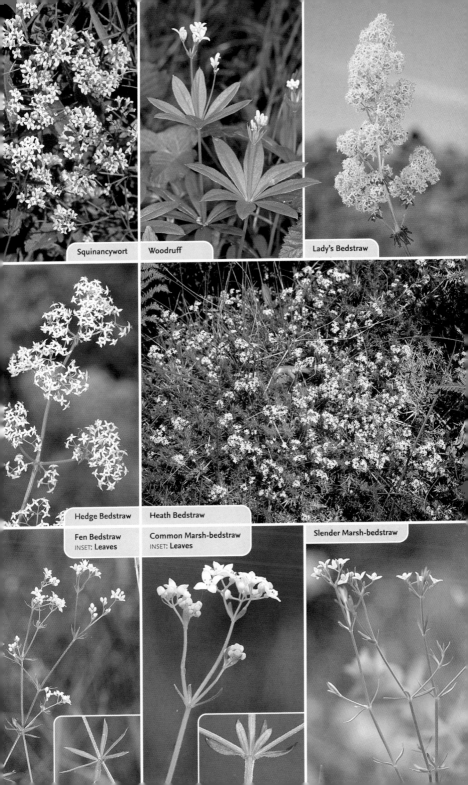

Squinancywort Woodruff Lady's Bedstraw

Hedge Bedstraw Heath Bedstraw

Fen Bedstraw
INSET: **Leaves**

Common Marsh-bedstraw
INSET: **Leaves**

Slender Marsh-bedstraw

Limestone Bedstraw *Galium sterneri* (Rubiaceae) ❀ HEIGHT to 30cm
Spreading, mat-forming perennial that turns greenish black when dry. Similar to Heath Bedstraw but grows only on base-rich grassland, never on acid soils. FLOWERS 3mm across, greenish white, with 4 petals; in domed clusters (May–July). FRUITS Hairless, warty nutlets. LEAVES *Narrow-oblong, bristle-tipped, with backward-pointing marginal bristles.* STATUS Locally common in the north only.

Northern Bedstraw *Galium boreale* (Rubiaceae) ❀❀ HEIGHT to 60cm
Upright, rather robust (by bedstraw standards) perennial; the region's *only white-flowered bedstraw with 3-veined leaves*. Found in grassy and rocky upland places. FLOWERS 4mm across, white, with 4 petals; in branched, terminal clusters (June–Aug). FRUITS Brown nutlets with hooked bristles. LEAVES *Blunt, leathery, dark green, widest at the middle.* STATUS Widespread in N Britain and N Ireland.

Wall Bedstraw *Galium parisiense* (Rubiaceae) ❀❀ HEIGHT to 40cm
Delicate annual with *square stems that have backward-pointing bristles on the angles.* Grows on old walls, rarely on dunes. FLOWERS 2mm across, greenish white, with 4 petals; in small, open clusters (June–July). FRUITS Warty, hairless nutlets. LEAVES *Narrow with forward-pointing marginal bristles.* STATUS Local and rare.

Cleavers *Galium aparine* (Rubiaceae) HEIGHT to 1.5m
Sprawling annual of hedgerows and disturbed ground. Stems are square and rough; backward-pointing bristles on the edges help secure the plant's scrambling progress through vegetation. FLOWERS 2mm across, greenish white, with 4 petals; in clusters arising from leaf axils (May–Sep). FRUITS Nutlets with hooked bristles. LEAVES With backward-pointing marginal bristles. STATUS Common and widespread.

Cleavers

Crosswort *Cruciata laevipes* (Rubiaceae) HEIGHT to 50cm
Attractive and distinctive perennial with hairy, square stems. Grows in hedgerows, roadside verges and grassy woodlands, mainly on calcareous soils. FLOWERS 2–3mm across, yellow, with 4 petals; in dense clusters arising from leaf axils (Apr–June). FRUITS Smooth black nutlets. LEAVES Oval, 3-veined, hairy; in whorls of 4. STATUS Widespread, commonest in N and E England.

Wild Madder *Rubia peregrina* (Rubiaceae) ❀ HEIGHT to 1m
Straggly, bedstraw-like perennial; 4-angled stems have backward-pointing bristles on the angles. Grows in hedgerows and scrub. FLOWERS 4–6mm across, yellowish green, 5-lobed; in small clusters arising from leaf axils (June–Aug). FRUITS Black, spherical berries. LEAVES Dark green, shiny, leathery, with prickles on the margins and midrib below. STATUS Local, mainly coastal and in the south.

Wild Madder fruits

Jacob's-ladder *Polemonium caeruleum* (Polemoniaceae) ❀❀ HEIGHT to 1m
Attractive, upright perennial of grassy places and scree slopes in limestone areas. FLOWERS 2–3cm across, bright blue with 5 petal-like corolla lobes; in spikes (June–July). FRUITS Capsules. LEAVES Alternate and pinnate with 6–12 pairs of leaflets. STATUS Locally native in N England; naturalised elsewhere.

Common Dodder *Cuscuta epithymum* (Cuscutaceae) ❀ CLIMBING
Bizarre parasitic, leafless plant that lacks chlorophyll and gains its nutrition from host plants, which include Heather, clovers and other herbaceous plants. Found in grassy places and on heaths, the slender, red stems twining through the vegetation. FLOWERS 3–4mm across, pink, in dense clusters (July–Sep). FRUITS Capsules. LEAVES Absent. STATUS Locally common in the south; scarce elsewhere. **Greater Dodder** *C. europaea* is similar but more robust. Scarce and local, growing on Common Nettle.

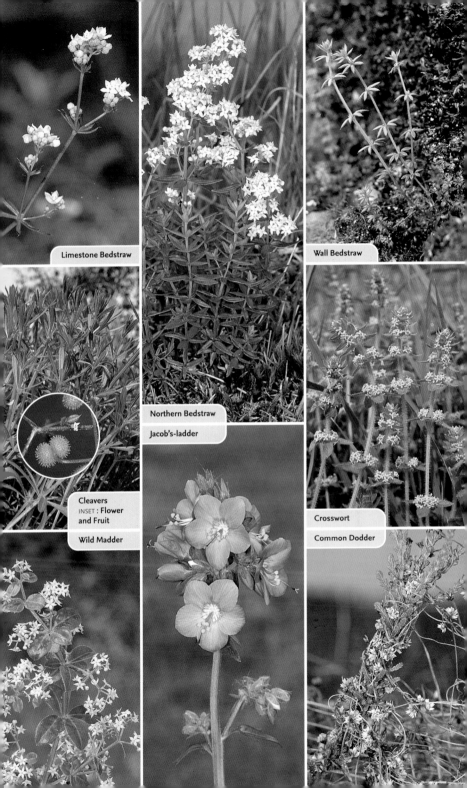

Limestone Bedstraw

Wall Bedstraw

Northern Bedstraw

Jacob's-ladder

Cleavers
INSET : Flower and Fruit

Wild Madder

Crosswort

Common Dodder

Large Bindweed *Calystegia silvatica* (Convolvulaceae) ❀ **CLIMBING**, to 2–4m
Vigorous, hairless perennial similar to Hedge Bindweed; subtle differences in flower structure allow separation. Grows on disturbed ground and roadside verges, twining around other plants to assist its progress. **FLOWERS** 6–7cm across, white, funnel-shaped (June–Sep); *the 2 epicalyx bracts overlap one another and conceal the sepals*. **FRUITS** Capsules. **LEAVES** Arrow-shaped, to 12cm long. **STATUS** Naturalised, mainly in the south where it is locally common.

Hedge Bindweed *Calystegia sepium* (Convolvulaceae) **CLIMBING**, to 2–3m
Vigorous, hairless perennial that twines around other plants to assist its progress. Found in hedgerows, woodland margins and on disturbed ground, by late summer often swamping the plants on and through which it grows. **FLOWERS** 3–4cm across, white, funnel-shaped (June–Sep); *the 2 epicalyx bracts, which surround the sepals, do not overlap one another*. **FRUITS** Capsules. **LEAVES** Arrow-shaped, to 12cm long. **STATUS** Widespread and common in the south but scarce in the north.

Sea Bindweed *Calystegia soldanella* (Convolvulaceae) ❀❀ **CREEPING**
Prostrate perennial that grows on sand dunes, and occasionally on stabilised shingle. **FLOWERS** 3–5cm across, funnel-shaped, pink with 5 white stripes; on slender stalks (June–Aug). **FRUITS** Capsules. **LEAVES** Kidney-shaped, fleshy, to 4cm long, long-stalked. **STATUS** Widespread on coasts but locally common only in the south.

Field Bindweed *Convolvulus arvensis* (Convolvulaceae) **CREEPING OR CLIMBING**, to 3m
Familiar perennial that grows in disturbed ground and arable land; a persistent garden weed. Twines around other plants to assist its progress. **FLOWERS** 15–30mm across, funnel-shaped, either white or pink with broad, white stripes (June–Sep). **FRUITS** Capsules. **LEAVES** Arrow-shaped, 2–5cm long, long-stalked. **STATUS** Widespread and common throughout the region, except in N Scotland.

Common Comfrey *Symphytum officinale* (Boraginaceae)
HEIGHT to 1m
Roughly hairy perennial with strikingly winged stems. Grows in damp ground beside rivers and ditches. **FLOWERS** 12–18mm long, tubular to bell-shaped; colour varies but usually white, pink or purple, in curved clusters (May–June). **FRUITS** Shiny nutlets. **LEAVES** Oval, hairy, the upper ones clasping, and *the stalk running down the main stem*. **STATUS** Widespread; common only in central and S England. **Rough Comfrey** *S. asperum* is similar, but stems are *not* winged. Naturalised.

Common Comfrey

Tuberous Comfrey *Symphytum tuberosum* (Boraginaceae) ❀❀
HEIGHT to 1.3m
Similar to Common Comfrey, but note flower colour and unbranched habit. Grows in shady places. **FLOWERS** 12–18mm long, creamy yellow (June–July). **FRUITS** Rough nutlets. **LEAVES** Oval; *middle leaves longest*. **STATUS** Local, mainly in the north.

Russian Comfrey *Symphytum* × *uplandicum* (Boraginaceae) ❀ **HEIGHT** to 1m
Hybrid between Common and Rough comfrey, found in hedgerows and on verges. Note the *slightly winged stems*. **FLOWERS** 12–18mm long, usually bluish purple, in curved clusters (May–Aug). **FRUITS** Nutlets. **LEAVES** Oval; *stalks of upper ones run a short distance down stem*. **STATUS** Widely naturalised. Note that various other hybrid garden escape comfreys are naturalised locally, e.g. *Symphytum* 'Hidcote Blue'.

Bugloss *Anchusa arvensis* (Boraginaceae) **HEIGHT** to 50cm
Roughly hairy annual, found on disturbed and often sandy soils. **FLOWERS** 5–6mm across, blue; in clusters (May–Sep). **FRUITS** Egg-shaped nutlets. **LEAVES** Narrow, with wavy margins; lower ones stalked, upper ones clasping the stem. **STATUS** Widespread and locally common in E England; becoming scarcer elsewhere.

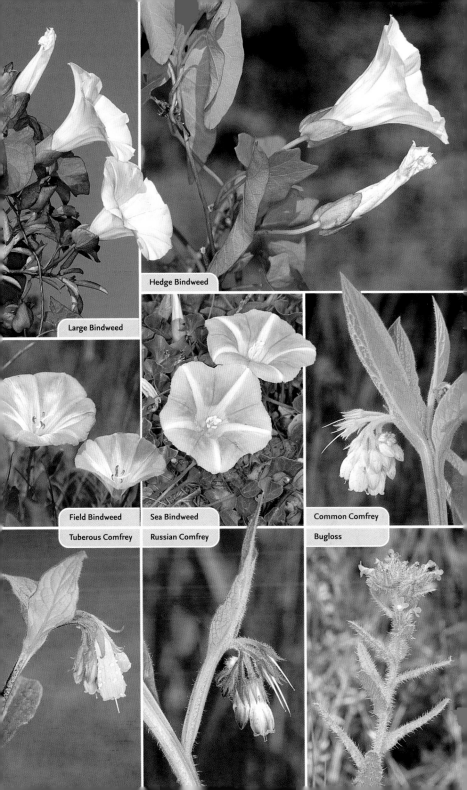

Hedge Bindweed

Large Bindweed

Field Bindweed

Sea Bindweed

Common Comfrey

Tuberous Comfrey

Russian Comfrey

Bugloss

Borage *Borago officinalis* ❀ HEIGHT to 30cm
Robust, bristly annual. Found growing on disturbed ground and sometimes on roadside verges. FLOWERS 20–25mm across, the 5 blue petal-like corolla lobes alternating with purplish calyx teeth; note also the projecting column of anthers (May–July). FRUITS Nutlets. LEAVES Oval; lower ones stalked, upper ones clasping the stem. STATUS Cultivated in gardens; sometimes naturalised as an escape.

Hound's-tongue *Cynoglossum officinale* ❀ HEIGHT to 75cm
Upright, downy biennial that *smells strongly of mice*. Grows in dry, grassy places, often on chalky soil and near the coast. FLOWERS 5–7mm across, maroon, 5-lobed; in branched clusters (June–Aug). FRUITS Comprising groups of 4 flattened, oval nutlets covered in hooked bristles. LEAVES Narrow, hairy; lower ones stalked. STATUS Widespread, but most common in S and E England.

Fruit

Common Gromwell *Lithospermum officinale* ❀ HEIGHT to 50cm
Upright, downy perennial that grows along woodland margins and in scrub, usually on calcareous soils. FLOWERS 3–4mm across, creamy white, 5-lobed; in clusters (June–July). FRUITS *Shiny white nutlets whose texture resembles glazed china.* LEAVES Narrow, unstalked, pointed, with strongly marked side veins. STATUS Locally common in S England and S Wales but scarce or absent elsewhere.

Field Gromwell *Lithospermum arvense* ❀❀ HEIGHT to 40cm
Upright, downy perennial that grows in arable fields and on dry, disturbed ground. FLOWERS 3–4mm across, 5-lobed, white; in clusters (May–Aug). FRUITS *Warty, brown nutlets.* LEAVES Strap-shaped, blunter than those of Common Gromwell, and without prominent side veins. STATUS Local, mainly in S and E England.

Purple Gromwell *Lithospermum purpureocaeruleum* ❀❀ HEIGHT to 20cm
Downy, unbranched perennial with creeping stems that root at the tip and upright flowering stems. Grows in woodland and scrub on calcareous soils. FLOWERS 12–15mm across, funnel-shaped, pink at first, soon turning deep blue; in terminal clusters (Apr–June). FRUITS Shiny white nutlets. LEAVES Narrow lanceolate, dark green, pointed. STATUS Local and scarce in S England and Wales only.

Narrow-leaved Lungwort *Pulmonaria longifolia* ❀❀ HEIGHT to 25cm
Softly hairy perennial that grows in woodland and scrub, usually on heavy soils. FLOWERS 8mm across, somewhat bell-shaped, pink at first but soon turning blue; in terminal clusters (Apr–May). FRUITS Narrowly egg-shaped nutlets. LEAVES Green with white spots; *basal ones narrowly ovate and tapering gradually to the base,* stem leaves unstalked and clasping. STATUS Locally common and restricted to parts of the New Forest, Isle of Wight and E Dorset.

Lungwort *Pulmonaria officinalis* ❀ HEIGHT to 30cm
Roughly hairy perennial of verges and waysides. FLOWERS 1cm across, bell-shaped, pink at first, turning blue; in terminal clusters (Feb–May). FRUITS Egg-shaped nutlets. LEAVES Oval, green with white spots; *basal ones tapering abruptly to winged stalks;* stem leaves unstalked and clasping. STATUS Naturalised locally.

Narrow-leaved Lungwort

Lungwort

Green Alkanet *Pentaglottis sempervirens* ❀ HEIGHT to 60cm
Upright, bristly perennial found in shady hedgerows and on roadside verges. FLOWERS 8–10mm across, blue with a white centre; in clusters arising from upper leaf axils (Apr–June). FRUITS Rough nutlets. LEAVES Oval, pointed, net-veined; lower leaves stalked, upper ones unstalked. STATUS Naturalised locally.

■ See also Green Hound's-tongue (p.280)

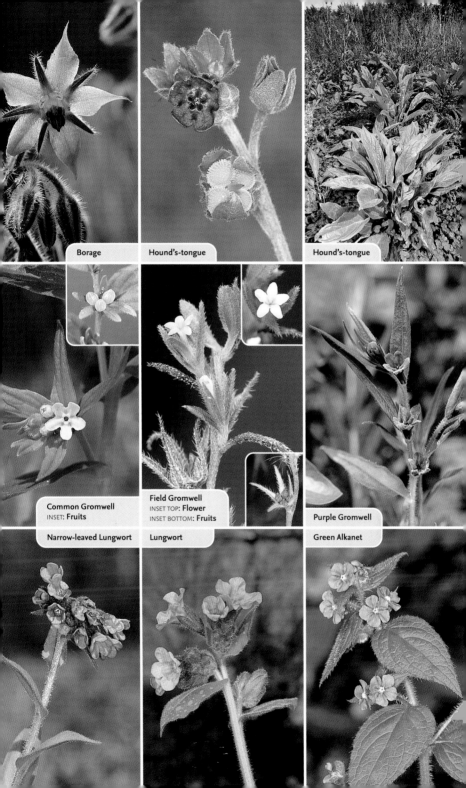

Borage

Hound's-tongue

Hound's-tongue

Common Gromwell
INSET: **Fruits**

Field Gromwell
INSET TOP: **Flower**
INSET BOTTOM: **Fruits**

Purple Gromwell

Narrow-leaved Lungwort

Lungwort

Green Alkanet

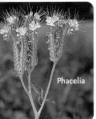

Phacelia

Viper's-bugloss *Echium vulgare* HEIGHT to 80cm
Upright biennial covered in reddish bristles. Grows in dry grassland, mainly on sandy and calcareous soils, often near the coast. FLOWERS 15–20mm long, funnel-shaped, bright blue with protruding purplish stamens; in tall spikes (May–Sep). FRUITS Rough nutlets. LEAVES Narrow and pointed; basal leaves stalked. STATUS Widespread and common in England and Wales; scarce elsewhere. **Phacelia** *Phacelia tanacetifolia* (Hydrophyllaceae) (to 80cm) is unrelated but superficially similar. Alien, sometimes sown as a supposed conservation plant, and naturalised occasionally.

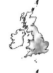

Early Forget-me-not *Myosotis ramosissima* HEIGHT to 10cm
Downy annual of arable fields, bare grassy places and open woodland. FLOWERS 2–3mm across, 5-lobed, sky-blue; in clusters (Apr–June). Corolla tube shorter than calyx tube. FRUITS Nutlets. LEAVES Ovate, basal ones forming a rosette. STATUS Widespread and common in most parts, except the far north.

Field Forget-me-not *Myosotis arvensis* HEIGHT to 25cm
Variable downy, branching annual. Grows in dry grassland, disturbed soil and arable land and verges. FLOWERS 5mm across, with 5 blue lobes, the corolla tube shorter than the calyx; in forked clusters (Apr–June). FRUITS Nutlets. Fruit stalks longer than calyx, which is coated in spreading, hooked hairs. LEAVES Oblong, the basal ones forming a rosette. STATUS Widespread and common, except in the north.

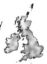

Changing Forget-me-not *Mysotis discolor* HEIGHT to 20cm
Branched, downy annual. Grows in bare, dry and often disturbed ground, especially on sandy soil. FLOWERS 2–3mm across, 5-lobed, yellowish at first but soon changing to blue, the mature corolla tube being longer than the calyx; in clusters (May–Sep). FRUITS Nutlets. Fruit stalks shorter than calyx. LEAVES Oblong. STATUS Widespread and locally common throughout.

Water Forget-me-not *Myosotis scorpioides* HEIGHT to 12cm
Creeping perennial with upright flowering stems. All stems are angular and covered in close-pressed hairs. Grows in watery habitats on neutral and basic soils. FLOWERS 8–10mm across, 5-lobed; sky-blue with a yellow 'eye'; in curved clusters (June–Sep). FRUITS Nutlets. Fruit stalks longer than calyx. LEAVES Narrow, oblong, unstalked. STATUS Widespread and locally common throughout.

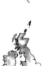

Creeping Forget-me-not *Myosotis secunda* HEIGHT to 12cm
Creeping perennial with hairs spreading on its upright stems, but appressed on the flower stalks. Grows in watery ground on acid soils including bogs. FLOWERS 6–8mm across, blue with 5 slightly notched lobes, the calyx divided more than halfway into teeth; in clusters (June–Aug). FRUITS Nutlets. Fruit stalks much longer than calyx. LEAVES Oblong. STATUS Common in W and N Britain and Ireland; scarce or absent elsewhere.

Tufted Forget-me-not *Myosotis laxa* HEIGHT to 12cm
Branched perennial that lacks runners. Grows in damp ground. Note the appressed hairs on the stems, leaves and calyx. FLOWERS 3–4mm across with rounded blue lobes, the calyx having pointed teeth; in clusters (May–Aug). FRUITS Nutlets. Fruit stalks 2–3 times calyx length. LEAVES Oblong. STATUS Common and widespread.

Wood Forget-me-not *Myosotis sylvatica* ✿ HEIGHT to 50cm
Much branched, leafy, hairy perennial of damp soils in shady woodland rides and margins. Note the spreading hairs on the stem and leaves. FLOWERS 6–10mm across, 5-lobed, pale blue, the calyx with hooked hairs; in curved clusters (Apr–July). FRUITS Brown nutlets. Fruit stalks twice the calyx length. LEAVES Oblong. STATUS Locally common in SE and E England; scarce or absent elsewhere.

■ See also Purple Viper's Bugloss (p.274), Alpine Forget-me-not (p.282) and Oysterplant (p.285)

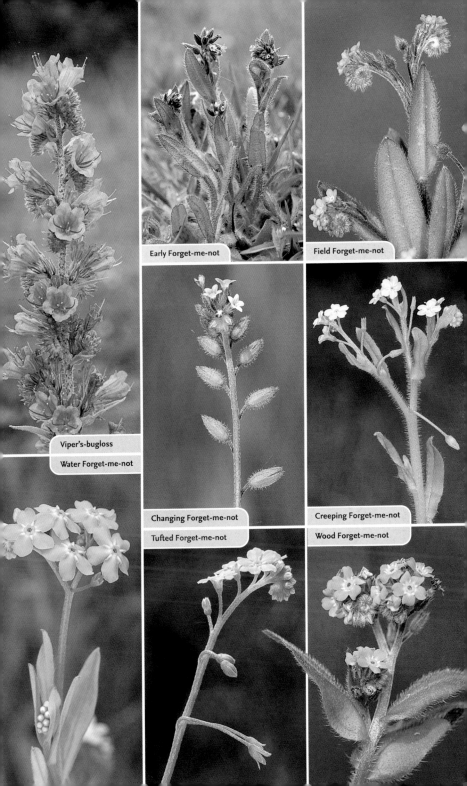

Early Forget-me-not

Field Forget-me-not

Viper's-bugloss

Water Forget-me-not

Changing Forget-me-not

Creeping Forget-me-not

Tufted Forget-me-not

Wood Forget-me-not

Vervain *Verbena officinalis* (Verbenaceae) ❀ HEIGHT to 70cm
Upright, roughly hairy perennial with stiff, square stems. Grows in dry, grassy places, especially on chalk and limestone. FLOWERS 4–5mm across, pinkish lilac with 2 lips; on slender spikes (June–Sep). The flowers are extremely attractive to insects. FRUITS Comprising a cluster of nutlets. LEAVES Pinnately lobed, lanceolate. STATUS Widespread and common in England and Wales; scarce elsewhere.

Vervain

Bugle *Ajuga reptans* (Lamiaceae) HEIGHT to 20cm
Familiar upright perennial with stems hairy on 2 opposite sides only. Grows in woods and grassy places, usually on damp, heavy soils. Leafy, creeping runners root at intervals. FLOWERS 15mm long, bluish violet, the lower lip with pale veins (Apr–May). FRUITS Nutlets. LEAVES Ovate; lower leaves stalked, upper ones unstalked, in opposite pairs. STATUS Widespread and commonest in the south.

Pyramidal Bugle *Ajuga pyramidalis* (Lamiaceae) ❀❀❀ HEIGHT to 15cm
Upright perennial; stems are hairy all round. Plant usually forms a rather conical outline. Grows on limestone rocks. FLOWERS 15mm long, blue with protruding stamens, and shorter than the purplish bracts (Apr–May). FRUITS Nutlets. LEAVES Oval, stalked. STATUS Rare, in N England, N Scotland and W Ireland only.

Ground-pine *Ajuga chamaepitys* (Lamiaceae) ❀❀ HEIGHT to 20cm
Distinctive, unusual hairy annual. Grows on dry, bare and disturbed ground, including cultivated land, on calcareous soils. FLOWERS 8–15mm long, mainly yellow, with small purple markings; borne at leaf nodes (May–Aug). FRUITS Nutlets. LEAVES Withering early at the base; stem leaves diagnostically deeply divided into 3 narrow lobes that smell of pine when rubbed. STATUS Rare, S England only.

Skullcap *Scutellaria galericulata* (Lamiaceae) HEIGHT to 40cm
Creeping, square-stemmed downy or hairless perennial with upright flowering stalks. Grows in damp ground, in marshes and on river banks. FLOWERS 10–15mm long, bluish violet; in pairs on upright, leafy stems, mainly towards the top (June–Sep). FRUITS Nutlets. LEAVES Oval, stalked, toothed. STATUS Widespread and locally common throughout much of the region, except Ireland and N Scotland.

Lesser Skullcap *Scutellaria minor* (Lamiaceae) ❀ HEIGHT to 15cm
Creeping, square-stemmed, hairless perennial with upright flowering stalks. Grows in damp, grassy places on acid soils. FLOWERS 6–10mm long, pink, with 2 lips, the lower one marked with purplish spots; on leafy, upright stems, mainly towards the top (July–Oct). FRUITS Nutlets. LEAVES Lanceolate to oval and typically almost untoothed. STATUS Widespread and locally common, mainly in the south.

Selfheal *Prunella vulgaris* (Lamiaceae) HEIGHT to 20cm
Creeping, downy perennial with leafy runners that root at intervals and upright flowering stems. Grows in grassy places and woodland rides, on calcareous and neutral soils. FLOWERS 10–15mm long, bluish violet; in dense, cylindrical and terminal heads adorned with purplish bracts and calyx teeth (Apr–June). FRUITS Nutlets. LEAVES Paired, oval. STATUS Widespread, but commonest in the south.

Wood Sage *Teucrium scorodonia* (Lamiaceae) HEIGHT to 40cm
Downy perennial of woodland rides, heaths and coastal cliffs, mainly on acid soils. FLOWERS 5–6mm long, yellowish, with the upper lip (as seen in other Lamiaceae) absent; in leafless spikes (June–Sep). FRUITS Nutlets. LEAVES Oval, heart-shaped at the base, wrinkled. STATUS Widespread and locally common.

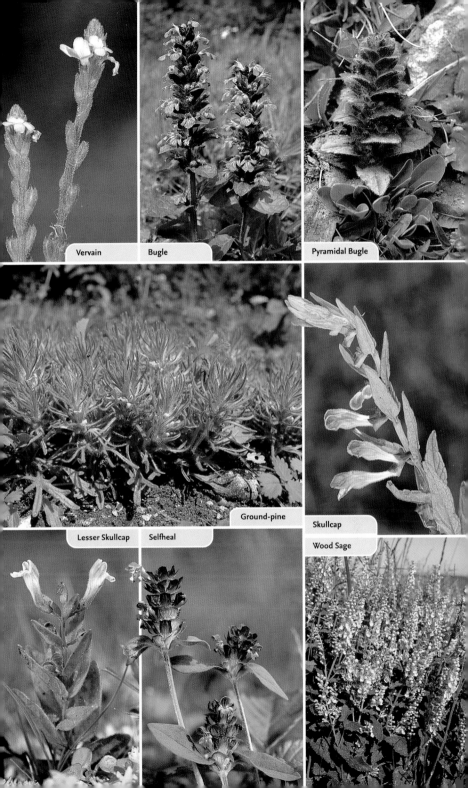

Vervain

Bugle

Pyramidal Bugle

Ground-pine

Skullcap

Lesser Skullcap Selfheal

Wood Sage

Cut-leaved Germander *Teucrium botrys* ✿✿✿ HEIGHT to 25cm
Upright, branched, downy annual or biennial. Grows on bare ground, in short grassland often on previously disturbed soil, and in arable fields, on chalk and limestone soils. FLOWERS 7–9mm long with no upper lip but a deep pink lower lip; in small clusters up leafy stems (July–Sep). FRUITS Nutlets. LEAVES Almost triangular but deeply cut, the lower ones almost pinnately so. STATUS Rare and restricted to a few locations in S England, from the Cotswolds to Kent.

Water Germander *Teucrium scordium* ✿✿✿ HEIGHT to 35cm
Downy, spreading perennial with creeping runners and upright flowering stems. Grows in damp, grassy places, typically on calcareous soils and sometimes in dune slacks. FLOWERS 8–10mm long with no upper lip but a pinkish-purple lower lip; in whorls up leafy stems (July–Sep). FRUITS Nutlets. LEAVES Oblong, toothed, unstalked. STATUS Rare, restricted to a few sites in S England and W Ireland.

Ground-ivy

White Dead-nettle

Ground-ivy *Glechoma hederacea* HEIGHT to 15cm
Softly hairy, strongly smelling perennial with creeping stems that root at regular intervals and upright flowering stems. Grows in woodlands, hedgerows and grassland, and on bare ground; tolerant of both shady and exposed locations. FLOWERS 15–20mm long, bluish violet; in open whorls arising from leaf axils. FRUITS Nutlets. LEAVES Kidney-shaped to rounded, toothed, long-stalked. STATUS Widespread and generally common.

White Dead-nettle *Lamium album* HEIGHT to 40cm
Downy, slightly aromatic, patch-forming perennial with square stems. Grows on roadside verges and disturbed ground in grassland and woodland margins. FLOWERS 25–30mm long, white, with a hairy upper lip and toothed lower lip; in whorls (Mar–Nov). FRUITS Nutlets. LEAVES Ovate to triangular with a heart-shaped base, toothed and stalked. Superficially similar to those of Common Nettle (p. 22) but lacking stinging hairs. STATUS Widespread.

Red Dead-nettle *Lamium purpureum* HEIGHT to 30cm
Branched, spreading, downy annual, pungently aromatic when crushed; acquires a purplish tinge. Grows on disturbed ground and cultivated soils. FLOWERS 12–18mm long, purplish pink, with a hooded upper lip and the lower lip toothed at the base and twice the length of the calyx; in whorls on upright stems (Mar–Oct). FRUITS Nutlets. LEAVES Heart-shaped to oval, round-toothed, stalked. STATUS Widespread and common throughout most of the region. **Cut-leaved Dead-nettle** *L. hybridum* is similar but less downy, with deeply cut leaves. Local on arable ground.

Henbit Dead-nettle *Lamium amplexicaule* HEIGHT to 20cm
A trailing, branched, often rather straggly annual. Grows on cultivated soil and disturbed ground, typically in dry locations. FLOWERS 15–20mm long, pinkish purple with a hairy lip and long corolla tube; in widely spaced whorls. Only a few flowers in a given whorl open at any one time, some remaining small and closed (Mar–Nov). FRUITS Nutlets. LEAVES Rounded, blunt-toothed, the upper ones almost unstalked. STATUS Widespread but only locally common and least so in the north. **Northern Dead-nettle** *L. confertum* is similar but bracts do not clasp stem; coastal cultivated ground, Scotland.

Common Hemp-nettle *Galeopsis tetrahit* HEIGHT to 50cm
Upright, branched, hairy-stemmed annual with stems that are swollen at the nodes. Grows in arable fields and on verges and disturbed ground. FLOWERS 15–20mm long, pinkish, the corolla tube similar in length to the bristly, toothed and persisting calyx; in whorls (July–Sep). FRUITS Nutlets. LEAVES Ovate, toothed, stalked. STATUS Widespread and locally common throughout.

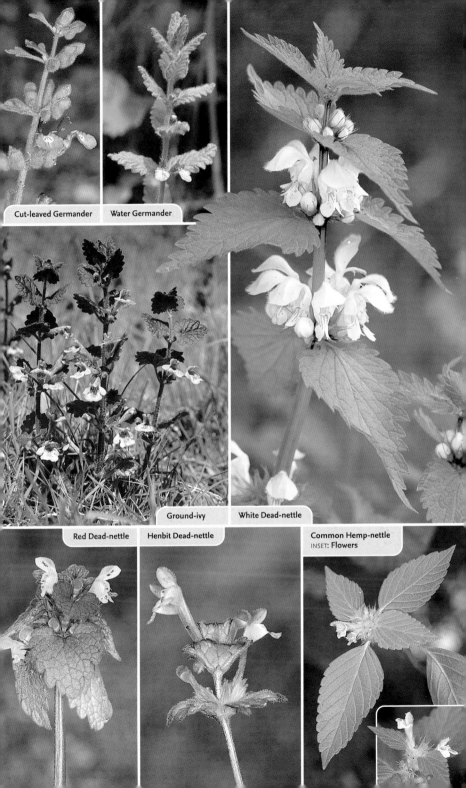

Cut-leaved Germander

Water Germander

Ground-ivy

White Dead-nettle

Red Dead-nettle

Henbit Dead-nettle

Common Hemp-nettle
INSET: Flowers

Large-flowered Hemp-nettle *Galeopsis speciosa* ❀ HEIGHT to 50cm

Attractive, branched, bristly hairy annual with a robust appearance. Grows in cultivated land and on disturbed ground, mainly on peaty soils. FLOWERS 25–35mm long, yellow with purple on the lower lip; corolla tube twice the length of the calyx; in whorls (July–Sep). FRUITS Nutlets. LEAVES Ovate, toothed, stalked. STATUS Widespread and fairly common in the north; rather scarce in the south.

Red Hemp-nettle *Galeopsis angustifolia* ❀❀ HEIGHT to 30cm

Branched, downy annual with stems that are not swollen at the nodes. Grows in arable fields, on disturbed ground and on shingle usually near the coast. FLOWERS 15–25mm long, reddish pink with a hooded upper lip and a 2-lobed lower lip, the corolla tube twice as long as the calyx; in terminal heads (July–Sep). FRUITS Nutlets. LEAVES Narrow, only slightly toothed. STATUS Widespread but local, and encountered mainly in SE England.

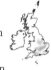

Cat-mint *Nepeta cataria* ❀❀ HEIGHT to 50cm

Upright, greyish, downy perennial. The whole plant has a minty smell that cats find alluring. Grows in dry, grassy places, including verges and hedgerows, often on chalky soils. FLOWERS 8–12mm long, white with purple spots; in whorls and clustered, terminal heads (July–Sep). FRUITS Nutlets. LEAVES Heart-shaped, toothed, stalked, downy below and woolly above. STATUS Widespread but local in S England and S Wales; sometimes naturalised as a garden escape elsewhere.

Bastard Balm *Melittis melissophyllum* ❀❀ HEIGHT to 60cm

Attractive, hairy, strong-smelling perennial that grows along woodland rides and in shady hedgerows and areas of scrub. FLOWERS 25–40mm long, fragrant, mainly white variably adorned with pink or purple, the corolla tube longer than the calyx; in whorls (May–July). FRUITS Nutlets. LEAVES Ovate, toothed, stalked. STATUS Local and rather scarce in S England (mainly the south-west) and S Wales; scarce or absent elsewhere.

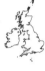

Yellow Archangel *Lamiastrum galeobdolon* HEIGHT to 45cm

Attractive, hairy perennial with long, leafy runners and upright flowering stems. Grows in woodland rides and hedgerows, mainly on basic soils. FLOWERS 17–20mm long, rich yellow adorned with reddish streaks, the lip divided into 3 equal lobes; in whorls (Apr–June). FRUITS Nutlets. LEAVES Oval to triangular, toothed and similar to those of Common Nettle (p.22) or White Dead-nettle (p.158). STATUS Locally common in England and Wales but scarce or absent elsewhere. Note, the subspecies *argentatum* has variegated leaves, is popular in gardens and is sometimes naturalised.

ssp. *argentatum*

Black Horehound *Ballota nigra* HEIGHT to 50cm

Straggly, bushy, hairy perennial that has a pungent and unpleasant smell when bruised. Grows on disturbed ground and roadside verges. FLOWERS 12–18mm long, pinkish purple with a concave upper lip; in whorls with striking calyx teeth (June–Sep). FRUITS Nutlets. LEAVES Stalked, ovate or heart-shaped. STATUS Locally common in England and Wales but scarce or absent elsewhere.

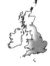

Motherwort *Leonurus cardiaca* ❀❀ HEIGHT to 1m

Upright, unbranched, variably downy perennial with a pungent smell and a historical association with midwifery. Grows on verges and in shady hedgerows and waste ground, usually close to habitation. FLOWERS 10–15mm long, pink or white, the upper lip hairy; in whorls with striking calyx teeth (July–Sep). FRUITS Nutlets. LEAVES Long-stalked; upper ones deeply palmately lobed; lower ones toothed. STATUS Naturalised in a few scattered locations across the region.

Motherwort

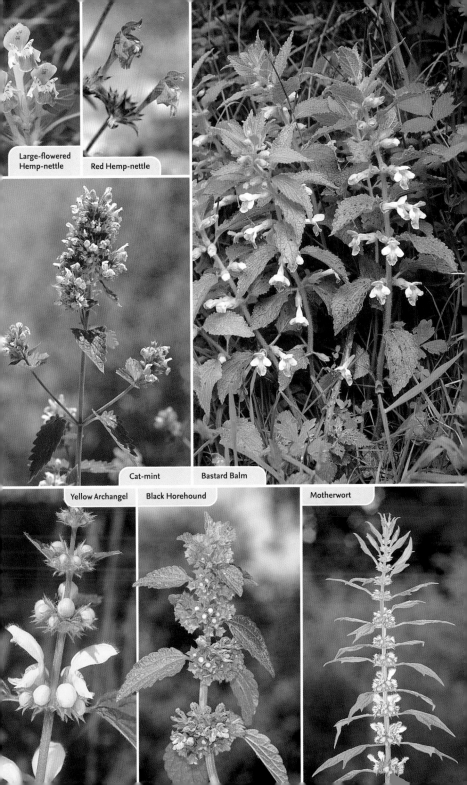

Large-flowered Hemp-nettle

Red Hemp-nettle

Cat-mint

Bastard Balm

Yellow Archangel

Black Horehound

Motherwort

Betony *Stachys officinalis* HEIGHT to 50cm

Upright, unbranched, downy or hairless perennial. Grows along woodland rides and in grassy waysides and hedgerows, typically on sandy or chalky soils. FLOWERS 12–18mm long, reddish purple; in showy, dense terminal heads, reminiscent of marsh-orchid spikes (June–Sep). FRUITS Nutlets. LEAVES Stalked, oblong, typically heart-shaped at the base but narrower up the stem. STATUS Widespread and fairly common in England and Wales but scarce or absent elsewhere.

Marsh Woundwort *Stachys palustris* HEIGHT to 1m

Robust, non-smelling perennial with creeping stems and unbranched flowering stalks. Grows in damp ground in marshes, and beside ditches and rivers; occasionally found along the margins of damp arable fields. FLOWERS 12–15mm long, pinkish purple with white markings; in elegant, open spikes (June–Sep). FRUITS Nutlets. LEAVES Toothed, narrow-oblong, often heart-shaped at the base and mostly unstalked. STATUS Widespread and locally common throughout.

Betony

Field Woundwort *Stachys arvensis* ✿ HEIGHT to 25cm

Variable, creeping or upright, slightly hairy annual. Grows in arable fields and on disturbed ground, mainly on sandy, acid soils. FLOWERS 15–20mm long, pinkish with purple markings; in open, leafy spikes (Apr–Oct). FRUITS Nutlets. LEAVES Oval, bluntly toothed, rather short-stalked. STATUS Widespread and locally common in the south and west but scarce or absent elsewhere.

Hedge Woundwort *Stachys sylvatica* HEIGHT to 75cm

Roughly hairy perennial with creeping stems, upright flower stalks, and an unpleasant smell to the whole plant when bruised. Grows in hedgerows, wayside ground and verges, often on disturbed soil. FLOWERS 12–18mm long, reddish purple with white markings on the lower lip; in open, terminal spikes (June–Oct). FRUITS Nutlets. LEAVES Ovate, toothed, long-stalked, the lower ones rather heart-shaped. STATUS Widespread and common throughout much of the region.

Limestone Woundwort *Stachys alpina* ✿✿✿ HEIGHT to 80cm

Creeping, patch-forming, softly hairy perennial with upright flowering stems. Superficially similar to Hedge Woundwort but not scented when bruised. Grows in open woodland and on rocky ground on limestone. FLOWERS 15–22mm long, often with creamy-yellow markings; in whorls in open, leafy spikes (June–Aug). FRUITS Nutlets. LEAVES Stalked, heart-shaped with rounded teeth. STATUS Rare; restricted to protected sites in Gloucestershire and N Wales.

Wild Clary *Salvia verbenaca* ✿✿ HEIGHT to 80cm

Upright, downy, almost unbranched perennial. Upper parts of the flowering stem, including the bracts and calyces, often tinged purple. Grows in dry grassland, typically on calcareous soils and often near the coast. FLOWERS 8–15mm long, bluish violet, the calyx sticky and coated with long, white hairs; in whorls in rather compact spikes (May–Aug). FRUITS Nutlets. LEAVES Oval with jagged teeth; mainly basal. STATUS Widespread but local in S and E England only.

Meadow Clary *Salvia pratensis* ✿✿ HEIGHT to 1m

Wild
Clary

Attractive downy, slightly aromatic, upright perennial. Grows in dry grassland on chalk and limestone soils. FLOWERS 2–3cm long, bluish violet, the calyx downy but lacking long white hairs; in whorls on upright and showy spikes (June–July). FRUITS Nutlets. LEAVES Narrow, heart-shaped at the base, bluntly toothed, wrinkled; basal leaves stalked, upper leaves increasingly stalkless up the stem. STATUS Rare; restricted to a few sites in S England.

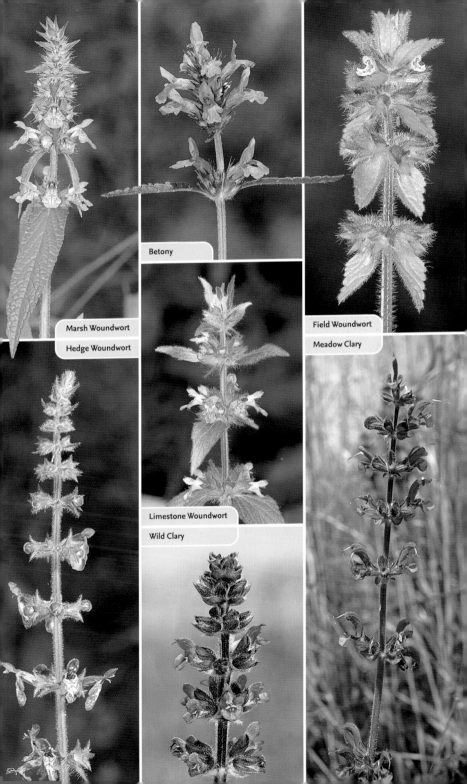

Marsh Woundwort

Betony

Field Woundwort

Hedge Woundwort

Meadow Clary

Limestone Woundwort

Wild Clary

Water Mint *Mentha aquatica* **HEIGHT** to 50cm
Variable, hairy, stiff- and reddish-stemmed perennial that smells strongly of mint. Found on damp ground, sometimes growing in shallow standing water. **FLOWERS** 3–4mm long, lilac-pink; in dense terminal heads up to 2cm long, and a few sub-terminal whorls (July–Oct). Popular with insects. **FRUITS** Nutlets. **LEAVES** Oval, toothed. **STATUS** Widespread and common throughout.

Corn Mint *Mentha arvensis* **HEIGHT** to 30cm
Upright but rather straggly, hairy perennial that grows in damp arable land, and on paths and disturbed ground. Has a strong and rather pungent smell of mint. **FLOWERS** 3–4mm long, lilac; in dense whorls at intervals along the stem and not terminally (May–Oct). **FRUITS** Nutlets. **LEAVES** Toothed, oval, short-stalked. **STATUS** Widespread and generally common.

Round-leaved Mint *Mentha suaveolens* ✿✿ **HEIGHT** to 70cm
Extremely aromatic perennial that smells distinctly of apples. Has both creeping and upright stems, and the whole plant, especially the undersides of the leaves, has a thick coat of woolly hairs.

Round-leaved Mint

Grows in damp, grassy places. **FLOWERS** 3–4mm long, lilac; in dense spikes (July–Sep). **FRUITS** Nutlets. **LEAVES** Oval to rounded, hairy and wrinkled. **STATUS** Native in the west, but also escapes from cultivation.

Spear Mint

Spear Mint *Mentha spicata* ✿✿ **HEIGHT** to 75cm
Almost hairless perennial that is the most popular cultivated culinary mint. Grows in damp ground; outside the garden context, it is found in meadows and on verges. **FLOWERS** 3–4mm long, pinkish lilac; in tall, whorled terminal spikes (July–Oct). **FRUITS** Nutlets. **LEAVES** Narrow-ovate, toothed, almost unstalked. **STATUS** Popular as a garden plant but also naturalised locally across the region.

Peppermint

Peppermint *Mentha × piperata* ✿✿ **HEIGHT** to 1m
Robust perennial, a hybrid between Spear Mint and Water Mint. Has a strong peppermint smell. Grows in damp ground. **FLOWERS** 3–4mm long, pinkish lilac; in terminal spikes with a few whorls below (July–Sep). **FRUITS** Nutlets. **LEAVES** Narrow-ovate, stalked. **STATUS** A popular culinary herb that is naturalised locally.

Common Calamint *Clinopodium ascendens* ✿✿ **HEIGHT** to 50cm
Upright, hairy and tufted perennial that branches from the base and smells of mint. Grows in dry grassland, hedgerows and verges, often on chalk or limestone soils. **FLOWERS** 3–4cm long, pinkish lilac with darker spots on the lower lip; in clustered heads comprising dense whorls (June–Sep). **LEAVES** Rounded, long-stalked. **STATUS** Very locally common in the south but scarce or absent elsewhere.

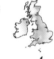

Lesser Calamint *Clinopodium calamintha* ✿✿ **HEIGHT** to 50cm
Tufted, greyish perennial. Similar to Common Calamint but downier and more branched. Grows in dry grassland and verges,

Common Calamint

mostly on sandy or chalky soils. **FLOWERS** 10–15mm long, pale pinkish mauve and almost unspotted; in whorls (July–Sep). After flowering, the calyx tube has hairs projecting from the mouth. **FRUITS** Nutlets. **LEAVES** Oval, almost untoothed. **STATUS** Local, restricted to S and E England.

Basil Thyme *Clinopodium acinos* ✿✿ **HEIGHT** to 20cm
Downy annual with both creeping and upright stems. Grows in dry, grassy habitats on calcareous soils. **FLOWERS** 7–10mm long, bluish violet with a white patch on the lower lip; in few-flowered whorls along much of the stems' length (May–Aug). **FRUITS** Nutlets. **LEAVES** Oval, stalked, only slightly toothed. **STATUS** Widespread but only locally common in S and E England; scarce or absent elsewhere.

■ *See also Pennyroyal (p.275) and Wood Calamint (p.275)*

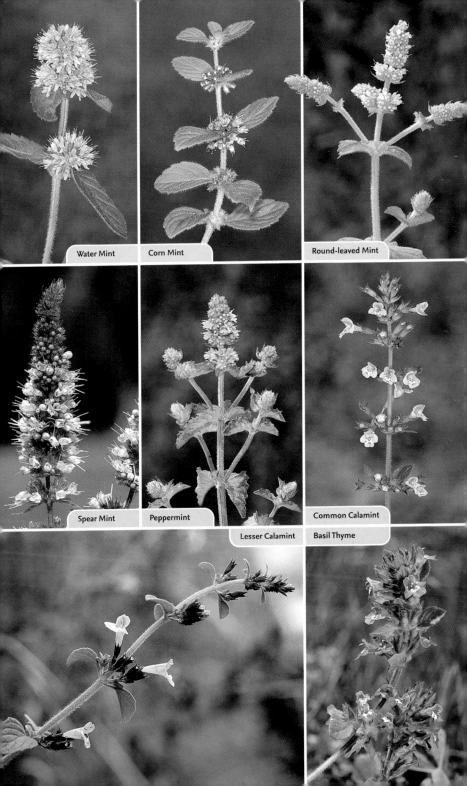

Water Mint

Corn Mint

Round-leaved Mint

Spear Mint

Peppermint

Common Calamint

Lesser Calamint

Basil Thyme

Wild Basil *Clinopodium vulgare* (Lamiaceae) **HEIGHT** to 35cm
Upright, hairy, usually unbranched perennial that grows in dry,
grassy places, mostly on chalk or limestone soils. The whole plant
is pleasantly aromatic. **FLOWERS** 15–22mm long, pinkish purple;
in whorls that have bristly purple bracts coated in woolly hairs,
arising from the axils of the upper leaves (July–Sep). **FRUITS** Nutlets.
LEAVES Ovate, toothed, stalked. **STATUS** Locally common in S and
E England but scarce or absent elsewhere in the region.

Wild
Basil

Gipsywort *Lycopus europaeus* (Lamiaceae) **HEIGHT** to 75cm
Hairy, usually somewhat branched, superficially mint-like perennial.
Grows in damp ground and beside fresh water, favouring ditches and
pond margins. **FLOWERS** 5mm long, whitish with small purplish
spots; in compact whorls arising from the axils of the upper leaves
(July–Sep). **FRUITS** Nutlets. **LEAVES** Yellowish green, deeply cut or
pinnately divided into lobes. **STATUS** Widespread and common in central
and S England but scarce or absent elsewhere.

White Horehound *Marrubium vulgare* (Lamiaceae)
❀❀ **HEIGHT** to 50cm
Robust, upright, aromatic perennial coated with downy white
hairs. Grows on dry, often disturbed, ground, mainly on chalky
soil and near the coast. **FLOWERS** 12–15mm long, white; in many-
flowered whorls, only a few flowers appearing at any one time (June–
Oct). **FRUITS** Nutlets. **LEAVES** Oval, toothed, wrinkled. **STATUS** Local, mainly
near the S coast of England; occasional elsewhere.

Gipsywort

Wild Marjoram *Origanum vulgare* (Lamiaceae) **HEIGHT** to 50cm
Downy, tufted perennial. The plant (mainly the leaves) has a pleasantly
aromatic smell, familiar to lovers of culinary herbs. The stems
are often reddish. Grows in dry grassland on calcareous soils.
FLOWERS Maroon in bud but 6–8mm long and pinkish purple
when flowering; in dense, terminal clusters that also include purplish
bracts (July–Sep). **FRUITS** Nutlets. **LEAVES** Oval, pointed, in opposite pairs.
STATUS Widespread and locally common in the south but scarce elsewhere.

Wild
Marjoram

Wild Thyme *Thymus polytrichus* (Lamiaceae) **HEIGHT** to 5cm
Creeping, mat-forming perennial with slender, woody runners. The whole plant
is faintly aromatic, smelling of culinary thyme. Grows on dry grassland and
heaths, and coastal cliffs and dunes. **FLOWERS** 3–4mm long, pinkish purple; in
dense, terminal heads with dark purplish calyx tubes, and on 4-angled stems that
are hairy on 2 opposite sides (June–Sep). **FRUITS** Nutlets. **LEAVES** Ovate, short-
stalked, in opposite pairs. **STATUS** Widespread and common throughout.

Large Thyme *Thymus pulegioides* (Lamiaceae) ❀ **HEIGHT** to 15cm
Rather tufted, sometimes mat-forming perennial that lacks woody runners. The
whole plant is strongly aromatic, smelling of culinary thyme. Grows on chalk
downland and dry heaths. **FLOWERS** 4–6mm long, pinkish purple; in whorls and
terminal heads, all with purplish bracts, and on stems that have rows of hairs
down the 4 angles and downy hairs on 2 opposite sides (June–Aug). **FRUITS**
Nutlets. **LEAVES** Ovate, short-stalked, opposite. **STATUS** Common in the south but
scarce or absent elsewhere.

Butterfly-bush *Buddleja davidii* (Buddlejaceae) **HEIGHT** to 4m
Robust shrubby perennial with long, arching branches. Grows on waste and
disturbed ground. **FLOWERS** 3–4mm across, 4-lobed, pinkish purple; in long
spikes that are extremely attractive to butterflies (June–Sep). **FRUITS** Capsules
with winged seeds. **LEAVES** Long, narrow, darker above than below. **STATUS**
Popular as a garden plant but also widely naturalised, often on coasts or railway
embankments.

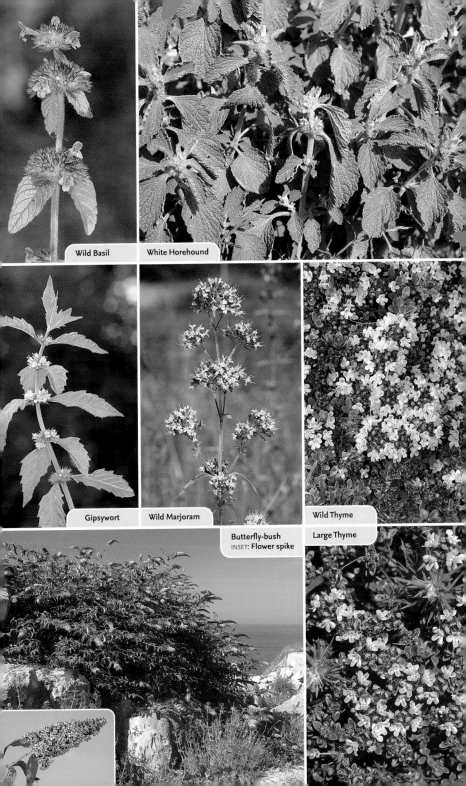

Wild Basil

White Horehound

Gipsywort

Wild Marjoram

Wild Thyme

Butterfly-bush
INSET: **Flower spike**

Large Thyme

Deadly Nightshade *Atropa belladonna* (Solanaceae) ✤ **HEIGHT** to 1m
Branched, often downy perennial. Grows in scrub and on disturbed ground on calcareous soils. **FLOWERS** 25–30mm across, purplish, bell-shaped; pendent, on stalks that arise from the leaf axils (June–Aug). **FRUITS** Globular black berries 15–20mm across. As common name suggests, these are poisonous. **LEAVES** Broadly oval, pointed, stalked. **STATUS** Locally common only in S and E England.

Henbane *Hyoscyamus niger* (Solanaceae) ✤ **HEIGHT** to 75cm
Branched, stickily hairy annual or biennial with a strong, unpleasant smell. Grows on disturbed ground, often on sandy soils. The whole plant is poisonous. **FLOWERS** 2–3cm across, funnel-shaped, creamy yellow with a purplish centre and purple veins; in leafy, 1-sided terminal spikes (June–Aug). **FRUITS** Capsules. **LEAVES** Oval, pointed, the lower ones with teeth, the upper ones clasping the stem. **STATUS** Locally common in S and E England but scarce or absent elsewhere.

Fruit

Thorn-apple *Datura stramonium* (Solanaceae) ✤✤ **HEIGHT** to 1m
Distinctive, almost unmistakable branched annual. Grows on cultivated and disturbed ground. The whole plant is poisonous. **FLOWERS** 7–10cm across, white, trumpet-shaped with 5 lobes (June–Oct). **FRUITS** Distinctive green capsules, up to 5cm long, with strong spines. **LEAVES** Long-stalked, up to 20cm long, ovate to triangular with toothed lobes. **STATUS** Widely naturalised but its occurrence is unpredictable and annual success is weather dependent; best in warm summers.

Duke of Argyll's Teaplant *Lycium barbarum* (Solanaceae) ✤ **HEIGHT** to 1.5m
Deciduous perennial with spiny, greyish-white, woody stems. Grows on disturbed ground and in hedgerows, often near the coast. **FLOWERS** 8–10mm long, purplish, 5-lobed, with projecting yellow anthers; arising from leaf axils in groups of 1–3 (June–Sep). **FRUITS** Egg-shaped red berries. **LEAVES** Lanceolate, grey-green. **STATUS** Introduced from China and naturalised, especially near the sea.

Bittersweet *Solanum dulcamara* (Solanaceae) **HEIGHT** to 1.5m
Downy, scrambling perennial that is woody at the base, hence the alternative name **Woody Nightshade**. Grows in hedgerows and scrub, and often on stabilised shingle beaches. **FLOWERS** 10–15mm across, with 5 purple, petal-like corolla lobes and projecting yellow anthers; in hanging clusters on purple stems (May–Sep). **FRUITS** Poisonous, egg-shaped red berries, up to 1cm long. **LEAVES** Oval, pointed. **STATUS** Widespread and common throughout, except in the north and in Ireland.

Black Nightshade *Solanum nigrum* (Solanaceae) ✤ **HEIGHT** to 60cm
Straggly annual; usually hairless, *stems sometimes blackish*. Grows in disturbed soils. **FLOWERS** 7–10mm across, with white corolla lobes and projecting yellow anthers; in pendent clusters of 5–10 (July–Sep). **FRUITS** Spherical berries, green at first but *ripening black*, and *not partly concealed by sepals*. **LEAVES** Oval, toothed. **STATUS** Locally common in the south only. **Green Nightshade** *S. physalifolium* (Solanaceae) is similar but berries remain *green when ripe* and are *partly concealed by sepals*.

Round-leaved Fluellen *Kickxia spuria* (Scrophulariaceae) ✤ **PROSTRATE**
Creeping, softly hairy, slightly sticky annual. Grows in cultivated soils, particularly margins of arable fields. **FLOWERS** 8–15mm long, mainly yellow but with a purple upper lip and a *curved spur*; on slender stalks arising from the leaf axils (July–Oct). **FRUITS** Capsules. **LEAVES** *Oval or slightly rounded*. **STATUS** Locally common only in S England.

Sharp-leaved Fluellen *Kickxia elatine* (Scrophulariaceae) ✤ **PROSTRATE**
Creeping, hairy, branching annual. Grows in cultivated soils and on disturbed ground. **FLOWERS** 8–12mm long, yellow with a purple upper lip and a *straight spur*; on slender stalks arising from leaf axils (July–Oct). **FRUITS** Capsules. **LEAVES** *Triangular to arrow-shaped*. **STATUS** Local, mainly S and E England.

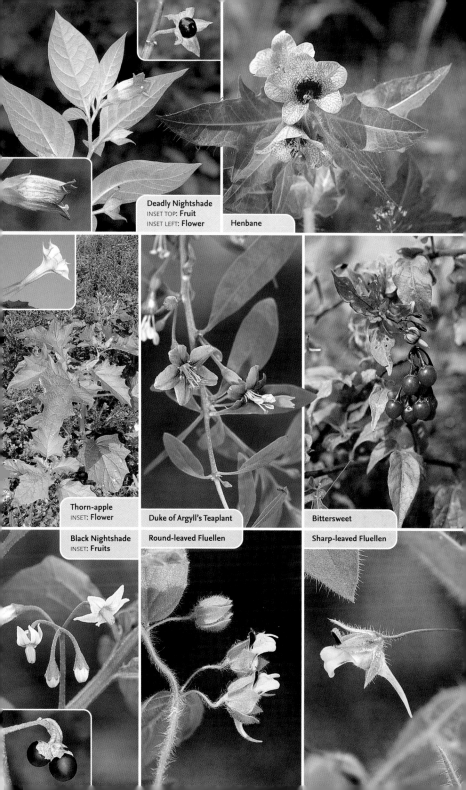

Deadly Nightshade
INSET TOP: **Fruit**
INSET LEFT: **Flower**

Henbane

Thorn-apple
INSET: **Flower**

Duke of Argyll's Teaplant

Bittersweet

Black Nightshade
INSET: **Fruits**

Round-leaved Fluellen

Sharp-leaved Fluellen

Great Mullein *Verbascum thapsus* HEIGHT to 2m

Robust, upright biennial that is covered in a thick coating of white, woolly hairs. Grows in dry, grassy places, on roadside verges and on waste ground. **FLOWERS** 15–35mm across, 5-lobed, yellow, with *whitish hairs on the upper 3 stamens only*; in tall, dense spikes, sometimes with side branches (June–Aug). **FRUITS** Egg-shaped capsules. **LEAVES** Ovate, woolly; forming a basal rosette in the first year from which tall, leafy stalks arise in the second. **STATUS** Widespread and locally common.

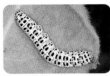

LEFT: **Great Mullein** branched in response to Rabbit damage
ABOVE: **Mullein Moth** larva

Hoary Mullein *Verbascum pulverulentum* ✤✤✤ HEIGHT to 2m

Upright biennial, covered in white, woolly hairs that easily rub off the leaves. Grows in dry calcareous grassland. **FLOWERS** 15–35mm across, 5-lobed, yellow, with *whitish hairs on all stamens*; in branched spikes (July–Sep). **FRUITS** Egg-shaped capsules. **LEAVES** Ovate; woolly on both sides. **STATUS** Local, E Anglia only.

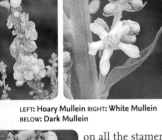

White Mullein *Verbascum lychnitis* ✤✤ HEIGHT to 1.5m

Upright biennial. Stems rounded below but angled and downy above. Grows in dry, grassy places, mainly on calcareous soils. **FLOWERS** 15–20mm across, 5-lobed, white with whitish hairs on all the stamens; in branched spikes (July–Aug). **FRUITS** Egg-shaped capsules. **LEAVES** Ovate, shiny dark green above, downy below. **STATUS** Local and rather scarce in S England; scarce or absent elsewhere.

LEFT: **Hoary Mullein** RIGHT: **White Mullein**
BELOW: **Dark Mullein**

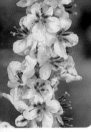

Dark Mullein *Verbascum nigrum* ✤ HEIGHT to 1m

Upright, ridge-stemmed biennial; stems purplish and usually unbranched. Grows on roadside verges and disturbed ground, on calcareous and sandy soils. **FLOWERS** 1–2cm across, yellow, the stamens coated in purple hairs; in elongated spikes (June–Aug). **FRUITS** Capsules. **LEAVES** Dark green, oval, the lower ones long-stalked, the upper ones almost unstalked. **STATUS** Locally common in S and E England only.

Moth Mullein *Verbascum blattaria* ✤✤ HEIGHT to 1.3m

Upright slender biennial or short-lived perennial with angled stems that are *stickily hairy above*. Grows on waste ground and in damp, grassy places. **FLOWERS** 2–3cm across, usually yellow but sometimes pinkish white, the stamens coated in purplish hairs; *solitary and in open spikes; flower stalks longer than calyx* (June–Sep). **FRUITS** Capsules. **LEAVES** Shiny, dark green, hairless. **STATUS** Occasional, S and E England only.

Twiggy Mullein

Twiggy Mullein *Verbascum virgatum* ✤✤ HEIGHT to 1.5m

Slender, glandular-hairy biennial of dry grassy places. **FLOWERS** 1–2cm across, yellow, in groups of 1–5; flower stalks shorter than calyx (June–Sep). **FRUITS** Capsules. **LEAVES** Heart-shaped at the base, the upper ones slightly clasping. **STATUS** Rare; restricted as a native to Devon, Cornwall and the Scilly Isles; occasional elsewhere.

Mudwort *Limosella aquatica* ✤✤ HEIGHT to 10cm

Hairless, rosette-forming annual with creeping runners. Grows on muddy margins of drying ponds. **FLOWERS** 3–5mm across, bell-shaped, with 5 pinkish-white lobes; on slender stalks arising from leaf axils (June–Oct). **FRUITS** Capsules. **LEAVES** Narrow-ovate and long-stalked. **STATUS** Rare, mainly in the south.

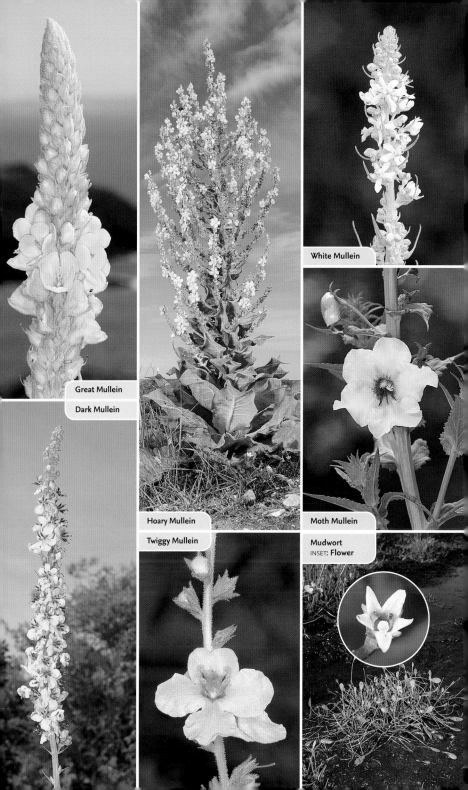

Great Mullein

Dark Mullein

Hoary Mullein

Twiggy Mullein

White Mullein

Moth Mullein

Mudwort
INSET: Flower

Common Figwort

Common Figwort *Scrophularia nodosa* HEIGHT to 70cm
Upright, hairless perennial with stems that are solid and square but *not winged*. Grows in damp woodland and shady places. FLOWERS 1cm long, greenish with a maroon upper lip, and narrow white borders to the sepal lobes; in open spikes (June–Sep). FRUITS Greenish capsules, like miniature figs. LEAVES Oval, pointed, with sharp teeth. STATUS Widespread and common, except in N Scotland.

Water Figwort
LEFT: Leaf ABOVE: Fruit

Water Figwort *Scrophularia auriculata* HEIGHT to 70cm
Upright, hairless perennial with stems that are square with *prominent wings*. Grows in damp ground, in woodlands and beside fresh water. FLOWERS 1cm long, greenish with a maroon upper lip, and broad white borders to the sepal lobes; in open spikes (June–Sep). FRUITS Greenish capsules, like miniature figs. LEAVES Oval but blunt-tipped, with rounded teeth; on winged stalks. STATUS Widespread and common.

Balm-leaved Figwort *Scrophularia scorodonia* ❁❁ HEIGHT to 70cm
Upright, branched, *downy grey* perennial with stems that are square and angled. Grows in woodland and on damp flushes on rocky cliffs. FLOWERS 1cm long, greenish with a maroon upper lip; in open spikes (June–Sep). FRUITS Greenish capsules, like miniature figs. LEAVES Oval, toothed, *wrinkled*, with downy hairs on both surfaces. STATUS Locally common in SW England only.

Balm-leaved Figwort

Yellow Figwort *Scrophularia vernalis* ❁❁ HEIGHT to 50cm
Upright, downy perennial of verges, rough ground and woodland rides. FLOWERS 8–10mm long, yellow; in small clusters on stalks arising from upper leaf axils (Apr–June). FRUITS Greenish capsules, like small figs. LEAVES Oval, pointed, wrinkled; rather nettle-like. STATUS Naturalised.

Common Toadflax *Linaria vulgaris* HEIGHT to 75cm
Greyish-green, hairless perennial of dry grassland and occasionally arable field margins. FLOWERS 15–25mm long, yellow with orange centres and long spurs; in tall, cylindrical spikes (June–Oct). FRUITS Capsules. LEAVES Narrow, linear and borne up the stems. STATUS Widespread and locally common; scarce in Ireland.

Pale Toadflax *Linaria repens* ❁❁ HEIGHT to 75cm
Greyish-green perennial with a creeping rhizome and numerous upright, leafy stems. Grows in dry, grassy places and on disturbed ground. FLOWERS 7–14mm long, lilac with dark veins; in terminal spikes (June–Sep). FRUITS Capsules. LEAVES Narrow, appearing in whorls on the lower part of the stem. STATUS Occurs as an escape from cultivation but also possibly native in England and Wales.

Weasel's-snout *Misopates orontium* ❁❁ HEIGHT to 25cm
Attractive and distinctive downy annual, usually unbranched. Grows in arable fields and on disturbed ground, usually favouring sandy soils. FLOWERS 10–15mm long, pinkish purple, toadflax-like in shape but without a spur; arising from leaf axils towards the top of the stem (July–Oct). FRUITS Capsules. LEAVES Narrow, linear. STATUS Scarce and declining, found mainly in S and E England.

Small Toadflax *Chaenorhinum minus* ❁ HEIGHT to 25cm
Upright, downy, slightly sticky annual. Grows on dry, disturbed ground including arable fields and railway tracks, favouring calcareous soils. FLOWERS 6–8mm long, pinkish lilac with a yellow patch and short spur; on long stalks arising from leaf axils (May–Oct). FRUITS Capsules. LEAVES Narrow. STATUS Fairly common.

■ *See also* Sand Toadflax (p.271)

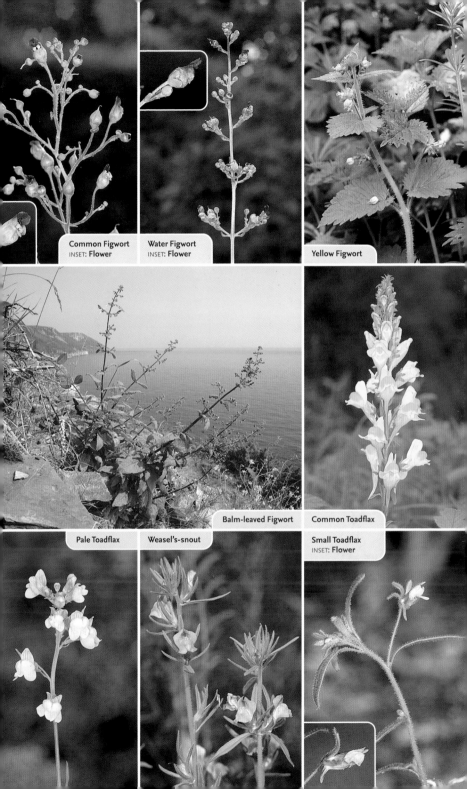

Common Figwort
INSET: **Flower**

Water Figwort
INSET: **Flower**

Yellow Figwort

Balm-leaved Figwort

Common Toadflax

Pale Toadflax

Weasel's-snout

Small Toadflax
INSET: **Flower**

Ivy-leaved Toadflax *Cymbalaria muralis* TRAILING

Hairless perennial with trailing, purplish stems. Grows on rocks and walls. FLOWERS 10–12mm across, lilac with yellow and white at the centre, and a curved spur; on long stalks (Apr–Nov). FRUITS Capsules, on long stalks that become recurved with maturity, forcing the fruit into nooks and crannies. LEAVES Long-stalked, ivy-shaped, 5-lobed. STATUS Originally a garden plant but now widely naturalised throughout much of the region, except N Scotland.

Thyme-leaved Speedwell *Veronica serpyllifolia* HEIGHT to 20cm

Delicate, often downy perennial, with creeping stems that root at intervals, and typically hairless, upright flowering stems. Grows on bare and disturbed ground including short grassland, cultivated land and woodland clearings. FLOWERS 5–7mm across, the corolla 4-lobed and pale blue or white; on short stalks in loose spikes (Apr–Oct). FRUITS Flattened, rather oval capsules. LEAVES *Thyme-like, small, oval, untoothed.* STATUS Widespread and common throughout.

Wall Speedwell *Veronica arvensis* HEIGHT to 20cm

Upright, softly hairy annual that grows in dry, bare locations including banks, old walls and heathland tracks. FLOWERS *2–4mm across,* the corolla 4-lobed and blue; in dense, leafy spikes, the *flowers partly obscured by leaf-like bracts* (Mar–Oct). FRUITS Flattened, hairy, heart-shaped capsules with a projecting style. LEAVES Oval and toothed; lower ones short-stalked, upper ones unstalked. STATUS Widespread and common throughout.

Rock Speedwell *Veronica fruticans* ❀❀❀ HEIGHT to 20cm

Attractive and distinctive perennial with stems that are woody and hairless at the base. Grows on rock ledges, at high altitudes in mountains. FLOWERS 10–15mm across, the corolla 4-lobed and *deep blue with a reddish centre*; in open, few-flowered terminal clusters (July–Sep). FRUITS Flattened, elliptical, hairy capsules with a long projecting style. LEAVES Oval, unstalked, slightly toothed. STATUS Rare; restricted to a few locations in the Scottish Highlands.

Wood Speedwell *Veronica montana* HEIGHT to 20cm

Delicate perennial, similar to Germander Speedwell; creeping stems root at the nodes, and upright *flowering stems are hairy all round.* Grows on damp ground in woodland. FLOWERS 7–9mm across, the corolla 4-lobed and lilac; on slender stalks in open spikes (Apr–July). FRUITS Flattened, heart-shaped capsules. LEAVES Oval, toothed, hairy, distinctly stalked. STATUS Widespread and locally common.

Marsh Speedwell *Veronica scutellata* ❀ HEIGHT to 20cm

Delicate, downy or hairless perennial with both creeping and upright stems. Grows in damp, often boggy ground, especially on acid soils. FLOWERS 6–7mm across, the corolla 4-lobed and pale pink or white, with dark lines; on stalks in open spikes (June–Aug). FRUITS Flattened, notched capsules broader than they are tall. LEAVES *Narrow, lanceolate, 2–4cm long.* STATUS Locally common throughout.

Germander Speedwell *Veronica chamaedrys* HEIGHT to 20cm

Delicate and attractive perennial with creeping stems that root at the nodes, and upright *flowering stems that have 2 lines of hairs.* Grows in grassy places, in meadows and open woodlands, and on verges. FLOWERS 10–12mm across, the corolla 4-lobed and blue with a white centre; on slender stalks in open, terminal spikes (Apr–June). FRUITS Flattened, hairy, heart-shaped capsules. LEAVES Oval, toothed, hairy, short-stalked. STATUS Widespread and common throughout.

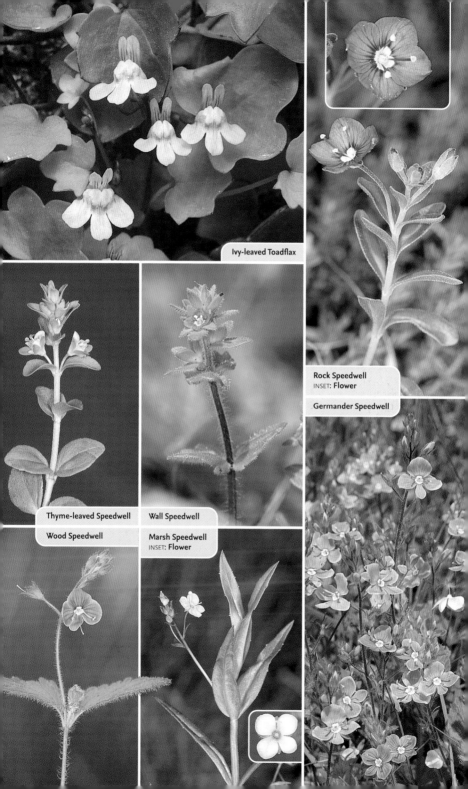

Ivy-leaved Toadflax

Rock Speedwell
INSET: **Flower**

Germander Speedwell

Thyme-leaved Speedwell

Wall Speedwell

Wood Speedwell

Marsh Speedwell
INSET: **Flower**

Heath Speedwell *Veronica officinalis* HEIGHT to 10cm
Delicate, mat-forming, hairy perennial. Stems creeping, root at nodes and are hairy all round. Grows in grassland, woodland and on heaths. FLOWERS 6–8mm across, the corolla 4-lobed and *lilac-blue with darker veins*; in *cylindrical and often conical spikes* (May–Aug). FRUITS Flattened, heart-shaped capsules. LEAVES Oval, toothed, unstalked, hairy on both sides. STATUS Widespread and common.

Blue Water-speedwell *Veronica anagallis-aquatica* HEIGHT to 25cm
Hairless perennial with creeping stems that root at the nodes, and upright flowering stems. Grows in damp ground, in woodlands and marshes, and also around the margins of shallow ponds. FLOWERS 5–6mm across, the corolla 4-lobed and *pale blue*; in dense spikes that comprise pairs of flowers on stalks arising from leaf axils, the *stalks as long as the bracts* (June–Aug). FRUITS Flattened, rounded, notched capsules. LEAVES Narrow-oval, pointed, toothed, up to 12cm long. STATUS Locally common.

Pink Water-speedwell *Veronica catenata* HEIGHT to 20cm
Hairless perennial, similar to Blue Water-speedwell (they hybridise), but smaller and *often tinged purple*. Hybrid is often commoner than the parents. Grows in damp ground and around pond margins. FLOWERS 5–6mm across, the corolla 4-lobed and *pink*; in rather open spikes comprising paired flowers arising from leaf axils, their *stalks shorter than the bracts* (June–Aug). FRUITS Flattened, rounded, notched capsules. LEAVES Narrow-oval, pointed, toothed. STATUS Locally common.

Brooklime *Veronica beccabunga* HEIGHT to 30cm
Straggly, hairless perennial with creeping stems that root at the nodes, and upright flowering stems. Grows in shallow standing water and damp ground. FLOWERS 7–8mm across, the corolla 4-lobed and blue; in pairs arising from leaf axils (May–Sep). FRUITS Flattened, rounded capsules. LEAVES *Oval*, fleshy, short-stalked. STATUS Widespread and locally common throughout.

Common Field-speedwell *Veronica persica* PROSTRATE
Straggling, hairy, branched annual with reddish stems. Grows on bare soil, cultivated arable fields and disturbed ground. FLOWERS 6–8mm across, the corolla 4-lobed and mainly *pale blue, but with white on the lower lip*; solitary and on rather long, slender stalks arising from leaf axils (Jan–Dec). FRUITS Broad, flattened capsules, with keeled lobes. LEAVES *Pale green*, oval, toothed and in pairs. STATUS Probably not native but now widespread and common.

Fruit

Grey Field-speedwell *Veronica polita* PROSTRATE
Straggling, hairy, branched perennial. Similar to Common Field-speedwell; note differences in flower and leaf colour. Grows in cultivated ground, often on chalky soil. FLOWERS 8–12mm across, the corolla 4-lobed and *entirely blue*; solitary and on stalks arising from leaf axils (Mar–Nov). FRUITS Flattened, broad capsules with rounded lobes. LEAVES *Grey-green*, oval, deeply toothed, paired. STATUS Widespread and fairly common.

Green Field-speedwell *Veronica agrestis* ✿ PROSTRATE
Similar to both Common and Field-speedwells but separable with care. Favours bare and disturbed ground, often on acid soils. FLOWERS 3–5mm across, the corolla 4-lobed and *extremeley pale with a white lower lip* (Jan–Dec). FRUITS with rounded lobes. LEAVES Fresh green, oval, toothed and in pairs. STATUS Widespread but rather scarce and declining.

Fruit

Slender Speedwell *Veronica filiformis* ✿✿ PROSTRATE
Mat-forming, downy perennial with creeping stems. Grows in short grassland, sometimes on lawns. FLOWERS 8–10mm across, the corolla 4-lobed and bluish with a white lip; on *relatively long, slender stalks arising from leaf axils* (Apr–July). FRUITS Seldom produced. LEAVES 5–10mm across, rounded to kidney-shaped, blunt-toothed and short-stalked. STATUS Introduced; now locally common in the south.

■ See also Spiked Speedwell (p.278), Breckland Speedwell (p.278) and Fingered Speedwell (p.278)

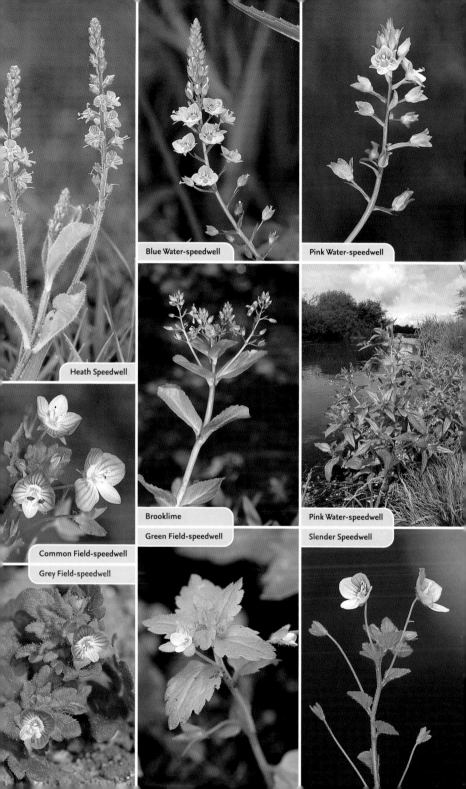

Heath Speedwell

Blue Water-speedwell

Pink Water-speedwell

Brooklime

Pink Water-speedwell

Green Field-speedwell

Slender Speedwell

Common Field-speedwell

Grey Field-speedwell

Ivy-leaved Speedwell *Veronica hederifolia* PROSTRATE

Creeping, hairy, much-branched annual that grows on bare ground and in cultivated fields. FLOWERS 4–5mm across, the corolla 4-lobed and pale lilac-blue; on short stalks arising from leaf axils (Mar–Aug). FRUITS Flattened, broadly rounded, hairless capsules. LEAVES 10–12mm across, *kidney-shaped to rounded, deeply lobed, often rather Ivy-like.* STATUS Widespread and common, least so in the north.

Alpine Speedwell *Veronica alpina* ✿✿ PROSTRATE

Perennial with wiry, downy, creeping stems that root at the nodes, and short, upright flowering stems. Grows in areas of short grass and rocks in mountains. FLOWERS 7–8mm across, the corolla 4-lobed and blue; on short stalks, in crowded spikes (July–Aug). FRUITS Flattened, oval, slightly notched capsules. LEAVES Oval, blunt-toothed. STATUS Scarce, restricted to Scottish Highlands.

Cornish Moneywort *Sibthorpia europaea* ✿✿ PROSTRATE

Intriguing and distinctive, hairy, mat-forming perennial with slender, creeping stems that root at the nodes. Grows on damp, shady banks in woodlands and beside streams. FLOWERS Tiny, the corolla with 2 yellow lobes and 3 pink ones; solitary, on short, slender stalks (July–Oct). FRUITS Capsules. LEAVES 2cm across, long-stalked and kidney-shaped with 5–7 lobes. STATUS Very locally common, but scattered and restricted to SW England, Sussex, S Wales and SW Ireland.

Monkeyflower *Mimulus guttatus* ✿ HEIGHT to 50cm

Attractive, distinctive perennial, the upper parts of which are downy. Grows in damp soil, typically beside streams and rivers. FLOWERS 25–45mm across and showy, the corolla yellow marked with small red spots, and a 3-lobed lower lip and 2-lobed upper lip; in open, terminal clusters (June–Sep). FRUITS Capsules. LEAVES Oval, in opposite pairs; upper ones unstalked and clasping. STATUS N American species, introduced and now widely naturalised across the region.

Blood-drop-emlets *Mimulus luteus* ✿✿ HEIGHT to 50cm

Showy, distinctive perennial. Similar to Monkeyflower but with *strikingly marked flowers.* Grows in damp soil, typically beside streams and rivers. FLOWERS 25–45mm across, the corolla yellow but with *large red blotches on the throat*, and a 3-lobed lower lip and 2-lobed upper lip; in open, terminal clusters (June–Sep). FRUITS Capsules. LEAVES Oval, in opposite pairs, the upper ones clasping the stem. STATUS Introduced from N America but naturalised, mainly in the north.

Fairy Foxglove *Erinus alpinus* ✿✿ HEIGHT to 30cm

Charming hairy perennial that is tufted but unbranched. Grows on rocky banks and old stone walls. FLOWERS 10–15mm across, the corolla pinkish purple with 5 lobes; in elongated, terminal spikes (May–Sep). FRUITS Capsules. LEAVES Narrow-ovate, toothed, appearing mainly as a basal rosette. STATUS A familiar garden rockery plant that is naturalised locally in N England and Scotland.

ABOVE: **Rosette**
RIGHT: **Flower**

Foxglove *Digitalis purpurea*
HEIGHT to 1.5m

Familiar greyish, downy biennial or short-lived perennial. Grows in woodlands and on moors and sea cliffs, thriving best on acid soils and appearing in good quantity on recently cleared ground. FLOWERS 4–5cm long, the corolla pinkish purple (sometimes white forms are found) with darker spots in the throat; in tall, elegant terminal spikes (June–Sep). FRUITS Green capsules. LEAVES 20–30cm long, downy, oval, wrinkled; forming a rosette in the first year from which the flowering spike appears in the second. STATUS Widespread and common throughout.

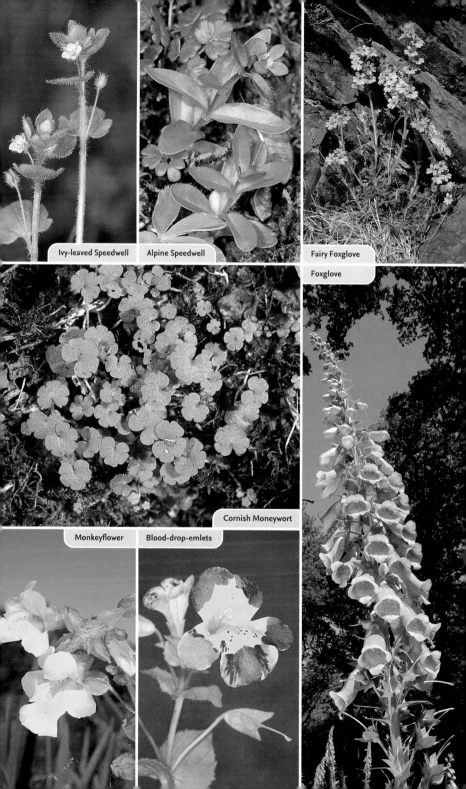

Ivy-leaved Speedwell

Alpine Speedwell

Fairy Foxglove

Foxglove

Cornish Moneywort

Monkeyflower

Blood-drop-emlets

Eyebright *Euphrasia officinalis* agg. **HEIGHT** to 25cm

Branched or unbranched annual, semi-parasitic on roots of other plants and sometimes tinged reddish. The plant's appearance is extremely variable and 30 or so species are recognised. However, an expert eye and considerable experience are needed to discern the differences. Given the limited space available in this book, here all Eyebrights are considered as a single aggregate species. All grow in undisturbed grassy places. **FLOWERS** 5–10mm long (depending on the 'species' involved), the corolla 2-lipped (the lower lip 3-lobed) and whitish (sometimes tinged pink) with purple veins and a yellow throat; in leafy spikes (May–Sep). **FRUITS** Capsules. **LEAVES** Oval but sharply toothed, sometimes tinged bronze. **STATUS** Widespread and locally common but declining.

Red Bartsia *Odontites vernus* **HEIGHT** to 40cm

Straggly, branched, downy annual with stems often tinged reddish. Semi-parasitic on the roots of other plants. Grows on disturbed ground, tracks and verges, and in arable field margins. **FLOWERS** 8–10mm long, the corolla pinkish purple and 2-lipped, the lower lip 3-lobed; in 1-sided, elongated, slightly curved spikes (June–Sep). **FRUITS** Capsules. **LEAVES** Narrow, toothed, unstalked, in opposite pairs. **STATUS** Widespread and common throughout.

Yellow Bartsia *Parentucellia viscosa* ✿✿ **HEIGHT** to 40cm

Stickily hairy, unbranched annual that is semi-parasitic on the roots of other plants. Grows in damp, grassy places, mostly near the sea and often in dune slacks. **FLOWERS** 15–35mm long, the corolla bright yellow and 2-lipped, the lower lip 3-lobed; in leafy spikes (June–Sep). **FRUITS** Capsules. **LEAVES** Lanceolate, unstalked. **STATUS** Very locally common near coasts of S and SW England and W Ireland.

Alpine Bartsia *Bartsia alpina* ✿✿✿ **HEIGHT** to 25cm

Upright, downy, unbranched perennial; semi-parasitic on the roots of other plants. Grows in damp grassland on upland, limestone soils. **FLOWERS** 15–20mm long, the corolla purple and 2-lipped (upper longer than lower); in spikes (July–Aug). **FRUITS** Capsules. **LEAVES** Oval, unstalked, untoothed, the upper ones tinged purple. **STATUS** Rare, restricted to a few sites in N England and the Scottish Highlands.

Common Cow-wheat *Melampyrum pratense* **HEIGHT** to 35cm

Variable but typically straggly annual that is semi-parasitic on the roots of other plants. Grows on heaths and along woodland rides, and found mainly on acid soils. **FLOWERS** 10–18mm long, the corolla pale yellow and flattened laterally, 2-lipped but with the *mouth almost closed*; in pairs, arising from axils of toothed, leaf-like bracts in spikes (May–Sep). **FRUITS** Capsules. **LEAVES** Narrow, shiny, in opposite pairs. **STATUS** Widespread and locally common throughout.

Common Cow-wheat

Small Cow-wheat *Melampyrum sylvaticum* ✿✿ **HEIGHT** to 25cm

Variable, straggly annual; semi-parasitic on roots of other plants. Grows in upland birch or pine woodlands. **FLOWERS** 8–10mm long, the corolla deep yellow and 2-lipped, the *mouth opening widely* and the lower lip curved down; in pairs arising from the axils of leaf-like bracts that are barely toothed (June–Aug). **FRUITS** Capsules. **LEAVES** Narrow-oval. **STATUS** Very local in Scotland and N Ireland.

Crested Cow-wheat *Melampyrum cristatum* ✿✿✿ **HEIGHT** to 50cm

Upright, downy annual that is semi-parasitic on the roots of other plants. Grows on verges and along grassy woodland rides. **FLOWERS** 12–16mm long, the corolla yellow and purple, and 2-lipped; in *4-sided spikes* with triangular, toothed bracts tinged purple at the base (June–Sep). **FRUITS** Capsules. **LEAVES** Lanceolate, unstalked, in opposite pairs. **STATUS** Rare and local, confined to E England.

■ *See also* Arctic Eyebright (p.285)

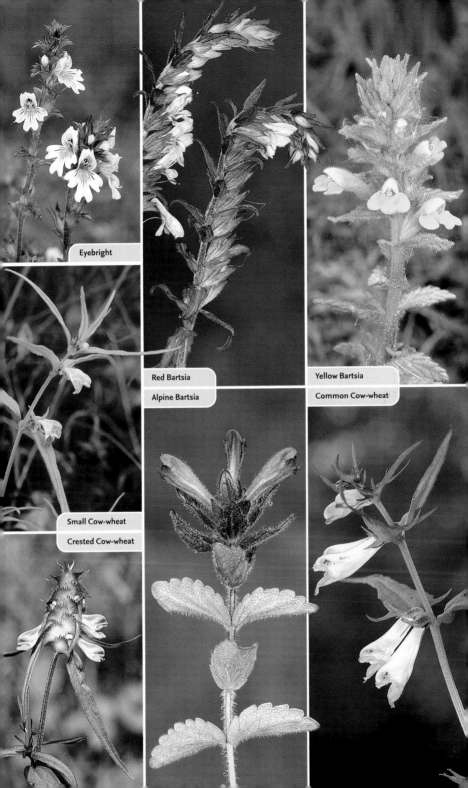

Eyebright

Red Bartsia

Alpine Bartsia

Yellow Bartsia

Common Cow-wheat

Small Cow-wheat

Crested Cow-wheat

Field Cow-wheat *Melampyrum arvense* (Scrophulariaceae) ✿✿✿ HEIGHT to 50cm

Upright, downy, unbranched annual that is semi-parasitic on the roots of other plants. Superficially similar to Crested Cow-wheat but grows in arable fields and grassland. FLOWERS 20–25mm long, the corolla yellow and pink, and 2-lobed; in *cylindrical spikes* with numerous toothed bracts, tinged reddish purple (June–Sep). FRUITS Capsules. LEAVES Lanceolate, unstalked, in opposite pairs. STATUS Rare, restricted to a few locations in S England.

Yellow-rattle *Rhinanthus minor* (Scrophulariaceae) HEIGHT to 45cm

Variable, upright, almost hairless annual that is semi-parasitic on the roots of other plants. The stems are stiff, 4-angled and often marked with dark spots and streaks. Grows in undisturbed meadows and stabilised dunes. FLOWERS 10–20mm long, the corolla yellow, 2-lipped and somewhat tubular and *straight*, the 2 teeth on the upper lip are 1mm *long*; in spikes with triangular, toothed, leaf-like *green bracts* (May–Sep). FRUITS Inflated capsules inside which the ripe seeds do indeed rattle. LEAVES Oblong with rounded teeth. STATUS Widespread and common.

Greater Yellow-rattle *Rhinanthus angustifolius* (Scrophulariaceae) ✿✿✿ HEIGHT to 60cm

Upright, semi-parasitic annual. Similar to Yellow-rattle but branched, and with subtle differences in flower structure. Grows in undisturbed grassland. FLOWERS 15–20mm long, the corolla yellow, 2-lipped with a *concave dorsal surface*; the 2 teeth on the upper lip are 2mm *long*; in spikes with triangular, toothed, *yellowish-green bracts* (May–Sep). FRUITS Inflated capsules. LEAVES Oblong with rounded teeth. STATUS Rare, restricted to a few scattered sites from S England to Scotland.

Lousewort *Pedicularis sylvatica* (Scrophulariaceae) HEIGHT to 20cm

Spreading, hairless perennial with *numerous branching stems*. Semi-parasitic on the roots of other plants. Grows on damp heaths and moors, and in bogs, usually on acid soils. FLOWERS 20–25mm long, the corolla *pale pink* and 2-lipped; the *upper lip with 2 teeth*; in few-flowered leafy spikes (Apr–July). FRUITS Inflated capsules. LEAVES Feathery, divided into toothed leaflets. STATUS Widespread and locally common throughout the region in suitable habitats.

Marsh Lousewort *Pedicularis palustris* (Scrophulariaceae) ✿ HEIGHT to 60cm

Upright, hairless perennial with a *single branching stem*. Semi-parasitic on the roots of other plants. Grows on marshes and bogs, not exclusively favouring acid soils, hence its occurrence in some fens. FLOWERS 20–25mm long, the corolla pinkish purple and 2-lipped, the *upper lip with 4 teeth*; in open, leafy spikes (May–Sep). FRUITS Inflated capsules. LEAVES Feathery, deeply divided into toothed lobes. STATUS Widespread and locally common, least so in E England.

Toothwort *Lathraea squamaria* (Orobanchaceae) ✿ HEIGHT to 25cm

Bizarre perennial that is entirely parasitic on the roots of woody shrubs, especially Hazel. Grows in woodlands, invariably on base-rich soils. FLOWERS 15–18mm long, tubular, pinkish lilac to creamy white; in 1-sided spikes (Apr–May). FRUITS Capsules, contained within the dead flower. LEAVES Creamy white, scale-like, alternate, clasping; not true leaves. STATUS Widespread but only locally common; absent from N Scotland and W Ireland.

Purple Toothwort *Lathraea clandestina* (Orobanchaceae) ✿✿ SUBTERRANEAN

Distinctive perennial. Entirely parasitic on the roots of trees such as poplars, willows and Alders, and grows in damp woodland. The main visible signs of the plant above ground are the flowers; sometimes these form large patches. FLOWERS 4–5cm long, the corolla purple and held erect (Mar–May). FRUITS Capsules. LEAVES Purplish, scale-like, close to the ground; not true leaves. STATUS Introduced and naturalised locally.

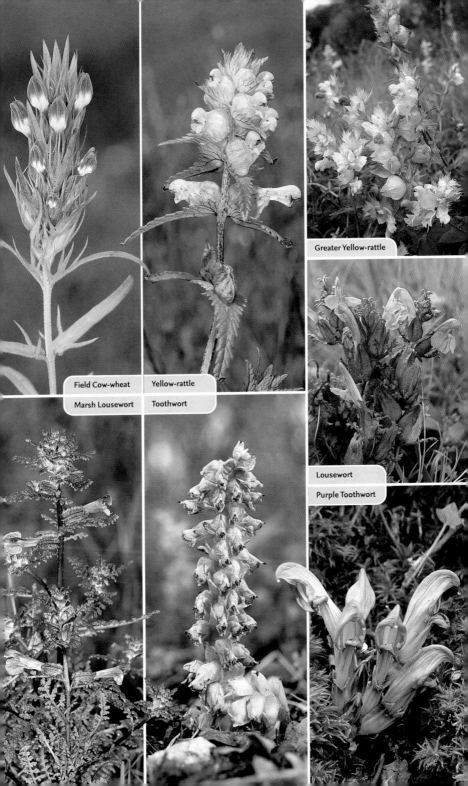

Field Cow-wheat

Yellow-rattle

Greater Yellow-rattle

Marsh Lousewort

Toothwort

Lousewort

Purple Toothwort

Common Broomrape *Orobanche minor* (Orobanchaceae) ❀
HEIGHT to 40cm
Upright, unbranched annual that usually has a purplish-tinged stem. Whole plant lacks chlorophyll and is entirely parasitic on the roots of Pea family members, notably clovers, and other herbaceous plants. Found in grassy places and scrub, and on verges. **FLOWERS** 10–18mm long, the corolla pinkish yellow with purple veins, tubular with smoothly curved dorsal surface, and 2-lipped; in open, upright spikes (June–Sep). **FRUITS** Egg-shaped capsules, concealed by the dead flowers. **LEAVES** Brownish, scale-like; not true leaves. **STATUS** Locally common in central and S England, Wales and S Ireland. Note var. *maritima* is found on coastal dunes, parasitising mainly Sea Carrot and Sea Holly.

Knapweed Broomrape *Orobanche elatior* (Orobanchaceae) ❀❀ **HEIGHT** to 70cm
Imposing plant with a relatively thick stem that is yellowish brown and slightly swollen at the base. Parasitic on the roots of knapweeds, and other Daisy family members. Grows in calcareous grassland. **FLOWERS** 18–25mm long, the corolla yellow tinged purple and the filaments *hairy at the base*; in upright, swollen, rather club-like spikes (June–July). **FRUITS** Egg-shaped capsules, concealed by the dead flowers. **LEAVES** Brownish, scale-like; not true leaves. **STATUS** Locally common in S and E England only.

Greater Broomrape *Orobanche rapum-genistae* (Orobanchaceae) ❀❀
HEIGHT to 80cm
Impressive plant and the tallest of its kind in the region. Stems are yellowish and distinctly swollen at the base. Parasitic on the roots of Broom and Gorse. Found on grassy banks and heaths. **FLOWERS** 20–25mm long, the corolla yellow tinged purple and the filaments *hairless at the base*; in upright spikes (May–July). **FRUITS** Egg-shaped capsules, concealed by the dead flowers. **LEAVES** Brownish, scale-like; not true leaves. **STATUS** Widespread but scarce, occurring mainly in England and Wales.

Ivy Broomrape *Orobanche hederae* (Orobanchaceae) ❀❀ **HEIGHT** to 60cm
Upright plant with a downy, purple-tinged stem that is swollen at the base. A yellow form also occurs. Parasitic on Ivy and found mainly on calcareous soils. **FLOWERS** 12–20mm long, the corolla creamy white with purple veins, with a tube that is mainly straight but swollen at the base; in spikes (May–July). **FRUITS** Egg-shaped capsules, concealed by the dead flowers. **LEAVES** Brownish, scale-like; not true leaves. **STATUS** Local, mainly in S and W Britain.

Thyme Broomrape *Orobanche alba* (Orobanchaceae) ❀❀ **HEIGHT** to 25cm
Attractive, upright, rather stout plant that is tinged reddish. Parasitic on the roots of thymes and related plants. **FLOWERS** 15–20mm long, *fragrant*, the corolla reddish; in comparatively short spikes (May–Aug). **FRUITS** Egg-shaped capsules, concealed by the dead flowers. **LEAVES** Brownish, scale-like; not true leaves. **STATUS** Scarce and local, restricted to coastal grassland in SW England, W Scotland and Ireland.

Moschatel *Adoxa moschatellina* (Adoxaceae) ❀ **HEIGHT** to 10cm
Hairless perennial that sometimes forms carpets. Grows in damp, shady woodlands and hedgerows, mainly on heavy soils; sometimes also found in mountains. **FLOWERS** 6–8mm across, yellowish green; in long-stalked heads of 5 flowers, 4 of which face outwards, the fifth facing upwards (Apr–May). **FRUITS** Spongy drupes. **LEAVES** Pale green and fleshy; basal leaves long-stalked and twice 3-lobed, stem leaves 3-lobed and in opposite pairs. **STATUS** Locally common in England and Wales.

Red Valerian *Centranthus ruber* (Valerianaceae) **HEIGHT** to 75cm
Upright, branched, hairless, greyish-green perennial. Grows on broken, rocky ground, chalk cliffs and old walls. **FLOWERS** 8–10mm long, the corolla reddish or pink (sometimes white); in dense terminal heads (May–Sep). **FRUITS** With a feathery pappus. **LEAVES** Ovate, untoothed, in opposite pairs. **STATUS** Introduced and widely naturalised but most frequent in coastal districts.

Red Valerian, white form

■ *See also* Bedstraw Broomrape (p.276)

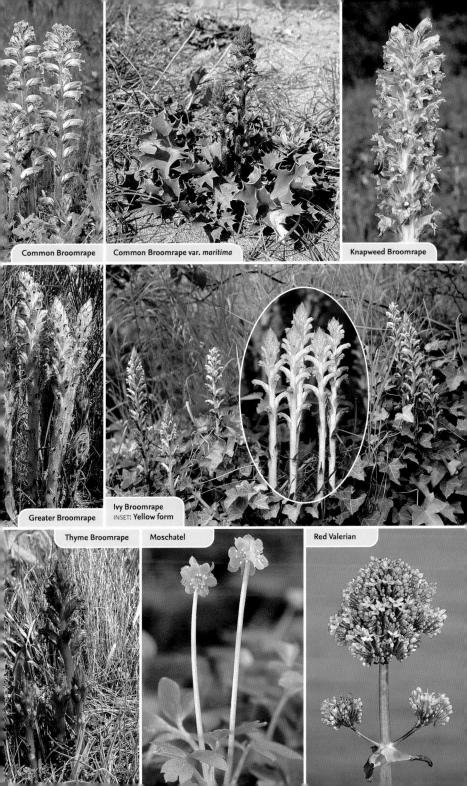

Common Broomrape

Common Broomrape var. *maritima*

Knapweed Broomrape

Greater Broomrape

Ivy Broomrape
INSET: **Yellow form**

Thyme Broomrape

Moschatel

Red Valerian

Common Valerian *Valeriana officinalis* (Valerianaceae) ❀ **HEIGHT** to 1.5m
Upright, usually unbranched perennial. Grows in grassy wayside places, beside
rivers and in woodland; favours both dry and damp soil, growing tallest in
damp places. **FLOWERS** 3–5mm long, the corolla funnel-shaped, 5-lobed, pale
pink; in dense, terminal umbels 4–7cm across (June–Aug). **FRUITS** Oblong, with
a feathery pappus. **LEAVES** Lanceolate, toothed, in opposite pairs. **STATUS**
Widespread and locally common.

Marsh Valerian *Valeriana dioica* (Valerianaceae) ❀ **HEIGHT** to 30cm
Slender perennial with creeping runners and upright flowering stems. Grows in
damp grassland and fens. **FLOWERS** Pale pink, on separate-sex plants: males 5mm
across, in terminal heads 4cm across; females 2mm across, in heads 1–2cm across
(May–June). **FRUITS** Oblong, with a feathery pappus. **LEAVES** Ovate, opposite; basal
ones long-stalked. **STATUS** Locally common.

Common Cornsalad *Valerianella locusta* (Valerianaceae) ❀ **HEIGHT** to 30cm
Branched, almost hairless annual. Grows in dry, grassy and bare places including
arable land, old walls and dunes. **FLOWERS** 1–2mm across, the corolla pinkish
lilac and 5-lobed; in flat-topped terminal clusters 1–2cm across (Apr–Aug).
FRUITS *Flattened, rather ovate.* **LEAVES** Spoon-shaped towards the base of the
plant, oblong higher up. **STATUS** Widespread across the region but only locally
common.

Broad-fruited Cornsalad *Valerianella rimosa* (Valerianaceae) ❀❀ **HEIGHT** to 30cm
Branched annual. Similar to Common Cornsalad but less leafy and with different-
shaped fruits. Grows in arable fields. **FLOWERS** 1–2mm across, the corolla lilac and
5-lobed; in few-flowered clusters (July–Aug). **FRUITS** *Egg-shaped, not flattened,
grooved on 1 side.* **LEAVES** Oblong or spoon-shaped. **STATUS** Restricted to S England.

Narrow-fruited Cornsalad *Valerianella dentata* (Valerianaceae) ❀❀
HEIGHT to 30cm
Similar to Broad-fruited Cornsalad but straggly and with different-shaped fruits.
Grows in arable fields on chalky soils. **FLOWERS** 1–2mm across, the corolla lilac
and 5-lobed; in few-flowered clusters (June–July). **FRUITS** *Narrow-ovoid, flat on one
side, round on the other.* **LEAVES** Spoon-shaped to oblong. **STATUS** SE England only.

Common Butterwort *Pinguicula vulgaris* (Lentibulariaceae) **HEIGHT** to 15cm
Stickily hairy carnivorous perennial that grows in bogs and damp flushes.
FLOWERS 12–14mm across, the corolla *violet* with a white throat, funnel-shaped
with *spreading lobes to the lower lip*, and a 4–7mm-long spur; on slender stems (May–
Aug). **FRUITS** Capsules. **LEAVES** Yellow-green, sticky and able to trap and digest
insects; borne as a basal rosette. **STATUS** Widespread and locally common in the
north and west.

Large-flowered Butterwort *Pinguicula grandiflora* (Lentibulariaceae)
❀❀ **HEIGHT** to 20cm
Stickily hairy carnivorous perennial that grows in bogs and damp flushes
among rocks. **FLOWERS** 25–30mm across, the corolla *violet* with a purple-streaked
white throat, a 10–12mm-long spur and overlapping lobes to the lower lip; on
slender stems (May–July). **FRUITS** Capsules. **LEAVES** Yellow-green, sticky, borne as a
basal rosette. **STATUS** Native to SW Ireland but introduced to Devon and Cornwall.

Pale Butterwort *Pinguicula lusitanica* (Lentibulariaceae) ❀❀ **HEIGHT** to 10cm
Charming, delicate, stickily hairy carnivorous perennial of damp heaths and bogs.
FLOWERS 7–9mm across, the corolla *pale pinkish lilac* with a short spur; on slender
stems arising from a basal rosette of leaves (July–Sep). **FRUITS** Capsules. **LEAVES**
Yellowish green (sometimes bronzed) with inrolled margins, sticky and able to
trap and digest insects. **STATUS** Restricted to SW and NW Britain and Ireland.

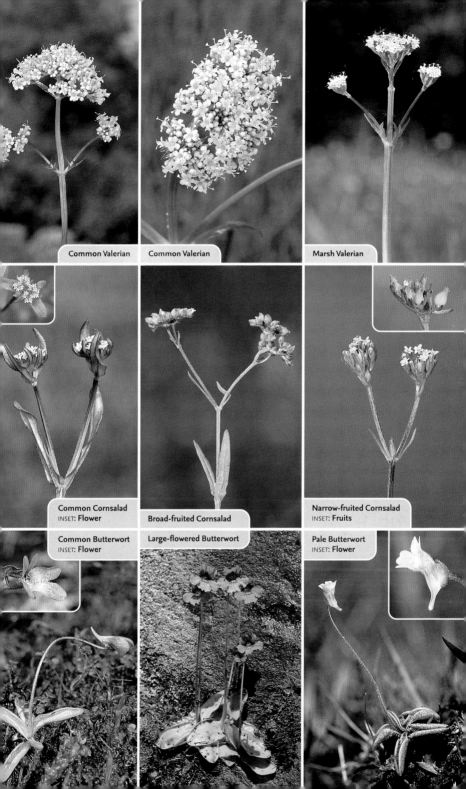

Common Valerian

Common Valerian

Marsh Valerian

Common Cornsalad
INSET: Flower

Broad-fruited Cornsalad

Narrow-fruited Cornsalad
INSET: Fruits

Common Butterwort
INSET: Flower

Large-flowered Butterwort

Pale Butterwort
INSET: Flower

Greater Plantain *Plantago major* (Plantaginaceae) **HEIGHT** to 20cm
Persistent, *usually hairless* perennial of lawns, disturbed grassland and
arable land. **FLOWERS** 3mm across, the corolla pale yellow and anthers
purple when young, turning yellow later; on slender spikes, 10–12cm
long (June–Oct). **FRUITS** Capsules. **LEAVES** Broad, oval, to 25cm long,
with 3–9 veins and a *distinct, narrow stalk*; in basal rosettes. **STATUS**
Widespread and extremely common throughout.

Hoary Plantain *Plantago media* (Plantaginaceae) **HEIGHT** to 25cm
Persistent, *downy* perennial of lawns and trampled grassland, mainly on calcareous
soils. **FLOWERS** 2mm across, the corolla whitish and the anthers lilac; on slender
spikes up to 20cm long (May–Aug). **FRUITS** Capsules. **LEAVES** Greyish, narrowly
ovate, *tapering gradually to broad stalks*; in basal rosettes. **STATUS** Widespread and
common in England, but scarce or absent elsewhere.

Buck's-horn Plantain *Plantago coronopus* (Plantaginaceae) **HEIGHT** to 15cm
Downy, greyish-green perennial of grassland, disturbed ground and rocky
sites, mainly near the sea. **FLOWERS** 2mm across, with a brownish corolla
and yellow stamens; in slender spikes, 2–4cm long (May–July). **FRUITS**
Capsules. **LEAVES** 20cm long, 1-veined, *pinnately divided*; in dense basal
rosettes. **STATUS** Widespread and common around the coasts of Britain and
Ireland; also occurs inland in SE England.

Sea Plantain *Plantago maritima* (Plantaginaceae) **HEIGHT** to 15cm
Characteristic coastal perennial, tolerant of salt spray and occasional immersion
in sea water. Grows mainly in saltmarshes but also on coastal cliffs. **FLOWERS**
3mm across, with a brownish corolla and yellow stamens; in slender spikes,
2–6cm long (June–Aug). **FRUITS** Capsules. **LEAVES** Narrow, *strap-like, untoothed*,
with *3–5 faint veins*; in dense basal rosettes. **STATUS** Widespread and common
around coasts.

Ribwort Plantain *Plantago lanceolata* (Plantaginaceae) **HEIGHT** to 15cm
Persistent perennial that grows on disturbed grassland, cultivated ground
and tracks. **FLOWERS** 4mm across, with a brownish corolla and white sta-
mens; in compact heads, 2cm long, on *furrowed stalks up to 40cm long*
(Apr–Oct). **FRUITS** Capsules. **LEAVES** *Lanceolate*, up to 20cm long with *3–5 dis-
tinct veins*; in spreading basal rosettes. **STATUS** Widespread and common
throughout.

Shoreweed *Littorella uniflora* (Plantaginaceae) ✤ **CREEPING**
Aquatic perennial that grows on the margins of ponds and lakes with acid, nutri-
ent-poor waters. Has creeping runners and sometimes forms patches. **FLOWERS**
Greenish; males, with long stamens, on stalks while females are stalkless and basal.
FRUITS Capsules. **LEAVES** 7–10cm long, semicircular in cross-section, narrow,
spongy; in tufted, radiating rosettes. **STATUS** Local, mainly in the north and west.

Sea Arrowgrass *Triglochin maritimum* (Juncaginaceae) ✤ **HEIGHT** to 50cm
Plantain-like tufted perennial that *grows in saltmarshes*. **FLOWERS** 3–4mm across, 3-
petalled, green, edged with purple; in a long, narrow spike, which itself is long-
stalked (May–Sep). **FRUITS** *Egg-shaped, with 6 segments*. **LEAVES** Long, narrow, *not
furrowed*. **STATUS** Widespread and locally common around all coasts.

Marsh Arrowgrass *Triglochin palustre* (Juncaginaceae) ✤ **HEIGHT** to 50cm
Differs from Sea Arrowgrass in leaf and fruit structure. *Grows in freshwater habitats*,
notably marshy meadows. **FLOWERS** 2–3mm across, 3-petalled, green, edged with
purple; in slender, long-stalked spikes (June–Aug). **FRUITS** *Club-shaped, with 3
segments*. **LEAVES** Long, narrow, *furrowed*. **STATUS** Locally common.

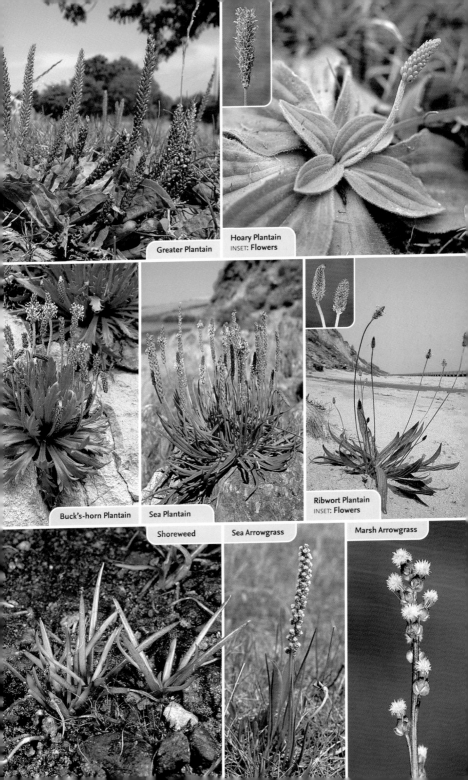

Greater Plantain

Hoary Plantain
INSET: **Flowers**

Buck's-horn Plantain

Sea Plantain

Ribwort Plantain
INSET: **Flowers**

Shoreweed

Sea Arrowgrass

Marsh Arrowgrass

Honeysuckle *Lonicera periclymenum* (Caprifoliaceae) **HEIGHT** to 5m
Familiar woody climber that twines clockwise up other shrubs and trees. Grows in woodland, scrub and hedgerows. **FLOWERS** 3–5cm long, scented, the corolla trumpet-shaped, 2-lipped and creamy yellow to white; in whorled heads (June–Aug). **FRUITS** Red berries, in clusters. **LEAVES** Grey-green, oval, in opposite pairs. **STATUS** Widespread and common throughout.

Elder

Elder *Sambucus nigra* (Caprifoliaceae) **HEIGHT** to 10m
Deciduous shrub or small tree with spreading, outcurved main branches and corky bark. Grows in woodland, scrub and hedgerows, thriving best on chalky and nitrogen-enriched soils. **FLOWERS** 5mm across, creamy white, with a heady scent; in flat-topped clusters, 10–20cm across (June–July). **FRUITS** Blackish-purple berries, in clusters. **LEAVES** Unpleasant smelling, divided into 5–7 leaflets. **STATUS** Widespread and common.

Dwarf Elder

Dwarf Elder *Sambucus ebulus* (Caprifoliaceae) ❀ **HEIGHT** to 2m
Unpleasant-smelling deciduous shrub or small tree with grooved stems. Grows in hedgerows and scrub, and on roadside verges. **FLOWERS** 3–5mm across, pinkish white; in flat-topped clusters, 8–15cm across (June–Aug). **FRUITS** Black, poisonous berries, in clusters. **LEAVES** Divided into 7–13 narrow leaflets. **STATUS** Widespread but patchily distributed and mainly in the south.

Guelder-rose

Guelder-rose *Viburnum opulus* (Caprifoliaceae) **HEIGHT** to 4m
Branched, deciduous shrub with hairless, angled twigs and scaly buds. Grows in hedgerows and scrub, mainly on heavy soils. **FLOWERS** White, in flat-topped clusters comprising outer flowers 15–20mm across and inner ones 4–7mm across (June–July). **FRUITS** Red berries, in clusters. **LEAVES** Divided into 5 irregularly toothed lobes. **STATUS** Widespread and common, except in the north.

Wayfaring-tree *Viburnum lantana* (Caprifoliaceae) ❀ **HEIGHT** to 6m
Deciduous shrub with downy, rounded twigs, and buds without scales. Grows in hedgerows and scrub, usually on calcareous soils. **FLOWERS** 5–7mm across, creamy white; in flat-topped clusters 6–10cm across (May–June). **FRUITS** Berries that ripen from red to black, but not all simultaneously. **LEAVES** Ovate, finely toothed, wrinkled, dark green above, downy white below. **STATUS** Locally common in SE England only.

Wayfaring-tree

Twinflower *Linnaea borealis* (Caprifoliaceae) ❀❀ **HEIGHT** to 7cm
Charming, delicate, creeping evergreen perennial. Sometimes mat-forming. Grows on the woodland floor in mature and undisturbed Scottish pine forests. **FLOWERS** 5–9mm long, the corolla pink and bell-shaped; in pairs on upright, slender stalks (June–Aug). **FRUITS** Dry, papery. **LEAVES** Oval to rounded, in pairs on wiry stems. **STATUS** Rare and restricted to a few locations in NE Scotland.

Small Scabious *Scabiosa columbaria* (Dipsacaceae) ❀ **HEIGHT** to 65cm
Upright, branching perennial of calcareous grassland. **FLOWERS** Bluish violet, in compact heads 2–3cm across; outer flowers larger than inner ones (June–Sep). **FRUITS** Dry, papery. **LEAVES** Pinnately lobed basal leaves in a rosette, and narrow-lobed stem leaves. **STATUS** Locally common in England and Wales.

Field Scabious *Knautia arvensis* (Dipsacaceae) **HEIGHT** to 75cm
Robust, hairy biennial or perennial of dry grassland. **FLOWERS** Bluish violet, in heads 3–4cm across; outer flowers larger than inner ones (June–Oct). **FRUITS** Dry, papery. **LEAVES** Lobed basal leaves in a rosette, and less divided stem leaves. **STATUS** Widespread and common, except N Scotland.

Field Scabious

■ *See also* Fly Honeysuckle (p.277)

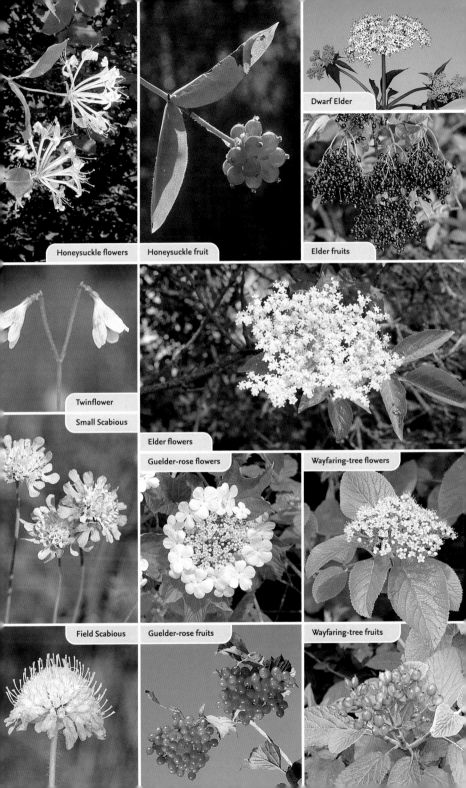

Honeysuckle flowers

Honeysuckle fruit

Dwarf Elder

Elder fruits

Twinflower

Small Scabious

Elder flowers

Guelder-rose flowers

Wayfaring-tree flowers

Field Scabious

Guelder-rose fruits

Wayfaring-tree fruits

Devil's-bit Scabious
Succisa pratensis (Dipsacaceae) **HEIGHT** to 75cm
Upright perennial with hairy or hairless stems. Grows in damp grassland, woodland rides and marshes. **FLOWERS** Pinkish lilac to violet-blue with *projecting anthers* (like tiny mallets); in dense, domed terminal heads, 15–25mm across, on long, slender stalks (June–Oct). **FRUITS** Dry, papery. **LEAVES** Spoon-shaped at the base of the plant, and narrow on the stem. **STATUS** Widespread and common throughout.

Wild Teasel
Dipsacus fullonum (Dipsacaceae) **HEIGHT** to 2m
Biennial of damp and disturbed grassland on heavy soils. Stems are angled, with sharp prickles on the angles. **FLOWERS** Pinkish purple, in egg-shaped heads 6–8cm long, with numerous spiny bracts; on tall stems (July–Aug). **FRUITS** Dry, papery; borne in the dry flower heads, and popular with Goldfinches. **LEAVES** Spine-coated, appearing as rosettes in the first year; in the second year these die back and stem leaves are opposite and joined at the base, the resulting cup collecting water. **STATUS** Widespread and common in the south; scarce or absent elsewhere.

Wild Teasel seed head

Small Teasel

Small Teasel
Dipsacus pilosus (Dipsacaceae) ❀❀ **HEIGHT** to 1.25m
Upright biennial with stems that are hairy towards the top of the plant. Grows along woodland margins and on banks. **FLOWERS** White, in spherical to egg-shaped heads 15–20mm across, with spiny bracts; on tall stems (July–Sep). **FRUITS** Dry, papery; borne in the dry flower heads. **LEAVES** Oval, those at the base long-stalked and forming a rosette; stem leaves sometimes with 2 basal lobes but not joined around the stem. **STATUS** Local, in England and Wales only.

Round-headed Rampion
Phyteuma orbiculare (Campanulaceae) ❀❀ **HEIGHT** to 50cm
Distinctive, hairless, unbranched perennial; grows in chalk grassland. **FLOWERS** Bluish violet, in rounded heads 15–25mm across, on long, slender stems (June–Aug). **FRUITS** Dry capsules. **LEAVES** Oval at the base of the plant, narrow and unstalked on the stem. **STATUS** Local, restricted to a few locations in S England; an indicator of undisturbed sites but absent from many seemingly suitable locations.

Sheep's-bit
Jasione montana (Campanulaceae) ❀ **HEIGHT** to 30cm
Attractive, spreading, downy biennial that grows in dry grassland, and on coastal cliffs, heaths and dunes, favouring acid soils and absent from calcareous locations. **FLOWERS** Sky-blue, in rounded heads, 20–35mm across, on slender stalks (May–Sep). *Anthers not projecting* (cf. Devil's-bit Scabious). **FRUITS** Dry capsules. **LEAVES** Wavy-edged, hairy at the base, forming a rosette, but narrow on the stem. **STATUS** Widespread but local, and commonest in the west and near the sea.

Clustered Bellflower
Campanula glomerata (Campanulaceae) ❀ **HEIGHT** to 25cm
Upright, robust, hairy perennial that grows on grassland and verges, on calcareous soils. **FLOWERS** 15–25mm long, the corolla violet-blue and bell-shaped, with blunt teeth; mainly in terminal clusters (June–Oct). **FRUITS** Dry capsules. **LEAVES** Long-stalked and heart-shaped at the base of the plant but narrower and clasping on the stem. **STATUS** Locally common in S and E England but scarce or absent elsewhere.

Harebell
Campanula rotundifolia (Campanulaceae) **HEIGHT** to 40cm
Attractive delicate, hairless perennial with wiry stems. Grows in dry, grassy places, on both calcareous and acid soils. **FLOWERS** 15mm long, the corolla blue and bell-shaped with sharp, triangular teeth; nodding, on slender stalks (July–Oct). **FRUITS** Dry capsules. **LEAVES** Rounded ones at the base of the plant, which soon wither, and narrower stem leaves that persist during flowering. **STATUS** Widespread and common, except in the south-west.

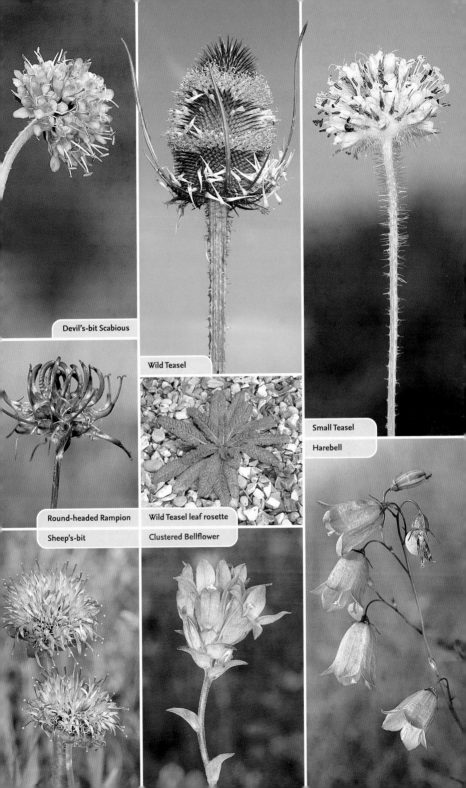

Devil's-bit Scabious

Wild Teasel

Small Teasel

Harebell

Round-headed Rampion

Sheep's-bit

Wild Teasel leaf rosette

Clustered Bellflower

Nettle-leaved Bellflower *Campanula trachelium* ✿ HEIGHT to 75cm

Roughly hairy perennial with *sharply angled stems*. Grows in hedgerows and scrub, mainly on calcareous soils. FLOWERS 3–4cm long, the corolla bluish violet and bell-shaped with flared, triangular lobes; in leafy spikes (July–Aug). FRUITS Dry capsules. LEAVES Stalked and heart-shaped at base of plant; stem leaves short-stalked, oval, toothed, *nettle-like*. STATUS Locally common only in S and E England.

Giant Bellflower *Campanula latifolia* ✿ HEIGHT to 1m

Upright perennial. Recalls Nettle-leaved Bellflower but larger, *downy or hairless* and with *bluntly angled stems*; flowers are larger. Grows in shady woods and hedgerows. FLOWERS 4–5.5cm long, the corolla pale blue (sometimes white) and bell-shaped, with triangular lobes; in tall, leafy spikes (July–Aug). FRUITS Dry capsules. LEAVES Ovate to lanceolate, toothed; lower ones have winged stalks. STATUS Widespread and locally common only in central and N England.

Peach-leaved Bellflower *Campanula persicifolia* ✿✿ HEIGHT to 70cm

Upright, hairless perennial of meadows and hedgerows. FLOWERS 3–4cm long, the corolla blue and bell-shaped but expanded, rather rounded and open, with short lobes; in open spikes on slender stalks (June–Aug). FRUITS Dry capsules. LEAVES Narrowly ovate with rounded teeth at the base of the plant; stem leaves narrow, with rounded teeth. STATUS Introduced as a garden plant, naturalised locally.

Spreading Bellflower *Campanula patula* HEIGHT to 60cm

Delicate and slender perennial of dry, grassy places. FLOWERS 20–25mm long, bell-shaped and bluish purple; on slender stalks (July–Sep). FRUITS Dry capsules. LEAVES Spoon-shaped basal leaves and narrow stem ones. STATUS Local and declining.

Rampion Bellflower *Campanula rapunculus* HEIGHT to 1m

Upright biennial of grassy places and roadside verges. FLOWERS 1–2cm long, bell-shaped and pale blue, usually on short stalks and held erect (June–Aug). FRUITS Dry capsules. LEAVES Narrow, the basal ones slightly toothed. STATUS Naturalised in a few sites.

Ivy-leaved Bellflower *Wahlenbergia hederacea* ✿✿ CREEPING

Delicate, trailing, hairless perennial of damp ground on moors and heaths. FLOWERS 5–10mm long, the corolla pale blue and narrowly bell-shaped with flared, triangular lobes at the mouth; on long, slender stalks (July–Aug). FRUITS Dry capsules. LEAVES 5–10mm across, pale green, rounded to kidney-shaped with lobes, like tiny Ivy leaves; on slender stalks. STATUS Locally common in SW.

Venus's-looking-glass *Legousia hybrida* ✿✿ HEIGHT to 40cm

Hairy perennial of arable fields, typically on calcareous soils. FLOWERS 5–10mm across; purple colour revealed only when 5-lobed corolla *opens flat in bright sunshine*; closes tight (and looks pale) at other times (May–Aug). FRUITS Long, narrow, tapering capsules. LEAVES Oblong, wavy; upper ones stalkless, lower ones short-stalked. STATUS Local in S and E England (formerly much more common).

Water Lobelia *Lobelia dortmanna* ✿✿ AQUATIC

Hairless perennial with slender, hollow, leafless stems. Grows in acid waters of upland and western lakes with gravelly bottoms. FLOWERS 15–20mm long, the corolla lilac and 2-lipped, the upper lip with 2 narrow lobes, the lower one with 3 narrow lobes; in spikes on slender stalks (July–Sep). FRUITS Capsules. LEAVES Narrow, fleshy; in rosettes on lake beds. STATUS Locally common in north and west.

Heath Lobelia *Lobelia urens* ✿✿✿ HEIGHT to 50cm

Upright, hairless perennial of damp, grassy heaths. FLOWERS 10–15mm long, the corolla bluish purple and 2-lipped, with 2 narrow upper lobes and 3 narrow lower lobes; in open spikes (July–Aug). FRUITS Capsules. LEAVES Dark green, oval at the base of the plant, narrow on the stem. STATUS Scarce, mainly Sussex to Devon.

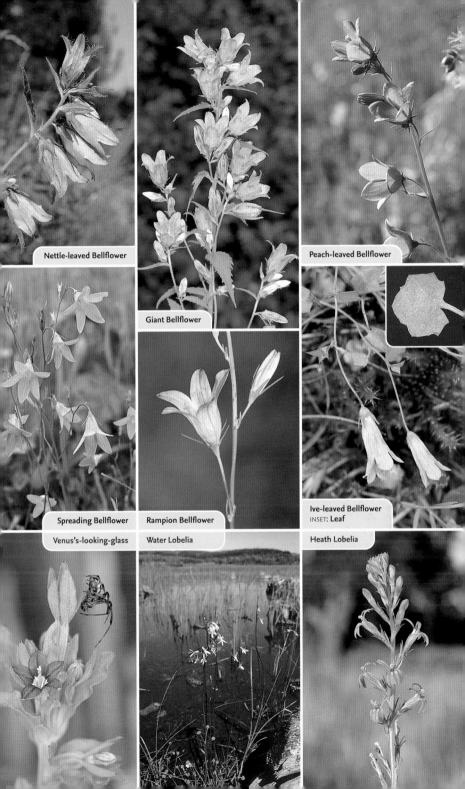

Nettle-leaved Bellflower

Giant Bellflower

Peach-leaved Bellflower

Spreading Bellflower

Rampion Bellflower

Ive-leaved Bellflower
INSET: Leaf

Venus's-looking-glass

Water Lobelia

Heath Lobelia

Daisy *Bellis perennis* HEIGHT to 10cm

Familiar downy perennial found in lawns and other areas of short grass. FLOWERS In solitary heads, 15–25mm across, on slender stems; comprising yellow disc florets and white (often faintly crimson-tipped) ray florets (Mar–Oct). FRUITS Achenes. LEAVES Spoon-shaped, forming prostrate rosettes from which flower stalks arise. STATUS Widespread and common throughout.

Daisy

Oxeye Daisy *Leucanthemum vulgare* HEIGHT to 60cm

Downy or hairless perennial of dry, grassy meadows and verges, often on disturbed ground. FLOWERS In solitary heads, 30–50mm across, with yellow disc florets and white ray florets (May–Sep). *No scales between disc florets.* FRUITS Achenes. LEAVES Dark green, toothed; lower leaves spoon-shaped, stalked and forming a rosette, stem leaves pinnately lobed. STATUS Widespread and common throughout.

Wild Chamomile *Chamaemelum nobile* ❀❀
HEIGHT to 25cm

Creeping, downy, *greyish* perennial that is *pleasantly aromatic.* Grows in short grassland on sandy soils. FLOWERS In solitary heads, 18–24mm across, with yellow disc florets and white ray florets (June–Aug). *Scales present between disc florets.* FRUITS Achenes. LEAVES Feathery, pinnately divided into fine, bristle-tipped lobes, *hairless below.* STATUS Local.

ABOVE: Wild Chamomile 'lawn'
LEFT: Oxeye Daisy

Stinking Chamomile *Anthemis cotula* ❀ HEIGHT to 50cm

Similar to Scented Mayweed but *hairless* and *unpleasantly scented.* Grows in disturbed ground. FLOWERS In solitary heads, 20–35mm across, with yellow disc florets and white ray florets (July–Sep). *Scales present between disc florets.* FRUITS Achenes. LEAVES Feathery, much divided. STATUS Common only in the south.

Corn Chamomile *Anthemis arvensis* ❀ HEIGHT to 50cm

Pleasantly aromatic annual with *downy* stems. Grows on cultivated, calcareous ground. FLOWERS In solitary heads with yellow disc florets and white ray florets (June–July). *Scales present between disc florets.* FRUITS Achenes. LEAVES Much divided; lobes *broader* than in other mayweeds, *downy below.* STATUS Local.

Scentless Mayweed *Tripleurospermum inodorum* HEIGHT to 75cm

Scentless, hairless, often rather straggly perennial of disturbed and cultivated ground. FLOWERS In clusters of solitary, long-stalked heads, 20–40mm across, comprising yellow disc florets and white ray florets (Apr–Oct). *No scales between disc florets. Receptacle domed and solid.* FRUITS Achenes *tipped with black oil glands.* LEAVES Feathery, much divided. STATUS Widespread and common.

Scentless Mayweed

Sea Mayweed *Tripleurospermum maritimum* ❀ HEIGHT to 60cm

Similar to Scentless Mayweed but more branched and spreading; grows mainly on coastal shingle and sand. FLOWERS In clusters of solitary, long-stalked heads, 20–40mm across, with yellow disc florets and white ray florets (Apr–Oct). *No scales between disc florets. Receptacle domed and solid.* FRUITS Achenes. LEAVES Much divided into cylindrical, *fleshy* segments. STATUS Widespread around coasts.

Scented Mayweed *Matricaria recutita* ❀ HEIGHT to 60cm

Similar to Scentless Mayweed but *scented and aromatic.* Grows on disturbed ground. FLOWERS In clusters of solitary, long-stalked heads, 20–30mm across, with yellow disc florets and white ray florets (June–Aug). *No scales between disc florets.* Receptacle *hollow and conical.* FRUITS Achenes *without black oil glands.* LEAVES Feathery, much divided. STATUS Widespread and common only in the south.

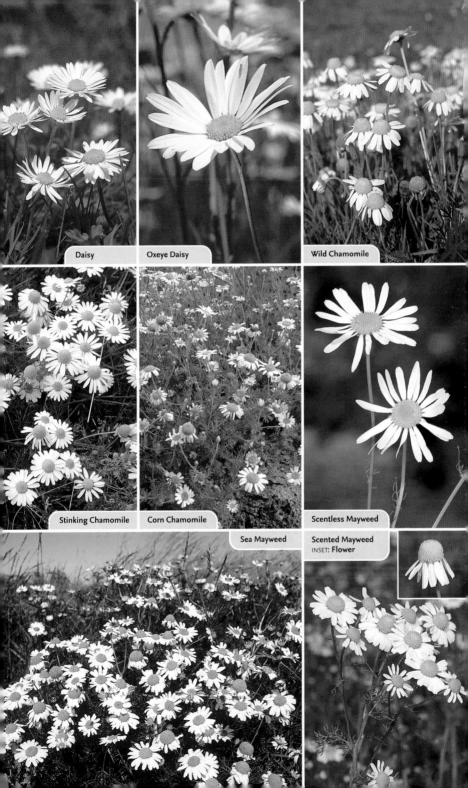

Daisy

Oxeye Daisy

Wild Chamomile

Stinking Chamomile

Corn Chamomile

Scentless Mayweed

Sea Mayweed

Scented Mayweed
INSET: **Flower**

Pineapple Mayweed *Matricaria discoidea* **HEIGHT** to 12cm

Bright green, hairless perennial that *smells strongly of pineapple when crushed*. Grows on disturbed ground, paths and tracks. **FLOWERS** Comprising yellowish-green disc florets only (no ray florets), in rounded to conical heads 8–12mm long, the receptacles of which are hollow (May–Nov). **FRUITS** Achenes. **LEAVES** Finely divided, feathery. **STATUS** Widespread and common throughout.

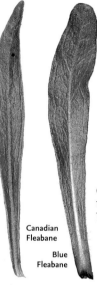

Canadian Fleabane *Conyza canadensis* **HEIGHT** to 1m

Upright, hairy annual of disturbed and bare ground; often seen beside roads. **FLOWERS** In heads 5–8cm long, with pinkish or white florets; in dense and much-branched inflorescences (Jul–Oct). **FRUITS** Achenes. **LEAVES** Narrow. **STATUS** Introduced and increasing.

Blue Fleabane *Erigeron acer* ✿ **HEIGHT** to 30cm

Roughly hairy annual or biennial; stems are stiff and tinged reddish. Grows in dry, grassy places and on coastal shingle and dunes. **FLOWERS** In heads 12–18mm across, the bluish-purple ray florets mainly concealing the yellow disc florets; in clusters (June–Aug). **FRUITS** Achenes. **LEAVES** Spoon-shaped and stalked at base of plant; narrow and unstalked on stem. **STATUS** Widespread only in England and Wales.

Common Cudweed *Filago vulgaris* ✿ **HEIGHT** to 25cm

Upright, greyish annual with a *white-woolly* coating. Plant branches towards the top. Grows in dry, grassy places, often on sandy soil. **FLOWERS** In rounded, woolly clusters 10–12mm across, of 20–35 heads, *not overtopped by leaves*; each head with yellow florets and *yellowish-tipped, straight bract tips* (July–Aug). **FRUITS** Achenes. **LEAVES** Narrow, woolly, *wavy*. **STATUS** Locally common in the south.

Canadian
Fleabane

Blue
Fleabane

Broad-leaved Cudweed *Filago pyramidata* ✿✿✿ **HEIGHT** to 25cm

Similar to Common Cudweed but always branches from the base. Grows in arable fields on chalky or sandy soils. **FLOWERS** In woolly clusters, 7–12mm across, of 10–20 heads, *overtopped by leaves*; each head with *outcurved yellow-tipped bracts* (July–Aug). **FRUITS** Achenes. **LEAVES** *Ovate*, sharp-pointed. **STATUS** Rare, S England only.

Red-tipped Cudweed *Filago lutescens* ✿✿✿ **HEIGHT** to 25cm

Similar to Common Cudweed but plant has a *yellow-woolly* coating. Grows on disturbed, sandy soils. **FLOWERS** In rounded, woolly clusters, 8–10mm across, of 10–20 heads; each head with *red-tipped bracts* (July–Aug). **FRUITS** Achenes. **LEAVES** Sharp-pointed, *not wavy*. **STATUS** Rare; restricted to a few sites in SE England.

Small Cudweed *Filago minima* ✿✿ **HEIGHT** to 20cm

Slender, greyish, woolly annual that branches above the middle of the plant. Grows on grassy heaths, on sandy, acid soils. **FLOWERS** In clusters of 3–6 conical or ovoid heads 3–4mm long, with bracts woolly only at the base, and tipped yellow (July–Sep). **FRUITS** Achenes. **LEAVES** Narrow, woolly. **STATUS** Very locally common in England and Wales; scarce or absent elsewhere.

Marsh Cudweed *Gnaphalium uliginosum* **HEIGHT** to 20cm

Greyish-green, woolly, branched annual that grows in damp, disturbed ground and on tracks. **FLOWERS** In unstalked heads 3–4mm long, comprising yellow disc florets and brown bracts; in clusters (July–Oct). **FRUITS** Achenes. **LEAVES** Narrow, woolly on both sides, the top ones surrounding, sometimes overtopping, the flower heads. **STATUS** Widespread and common throughout.

■ *See also* Jersey Cudweed (p.274) and Cottonweed (p.286)

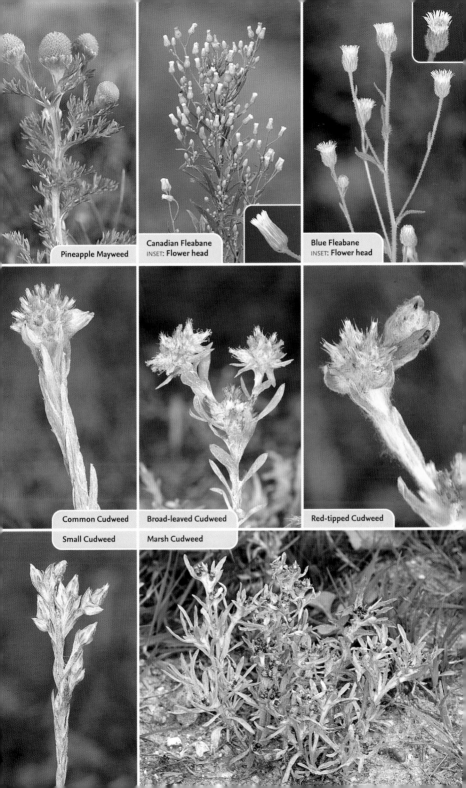

Pineapple Mayweed

Canadian Fleabane
INSET: **Flower head**

Blue Fleabane
INSET: **Flower head**

Common Cudweed

Broad-leaved Cudweed

Red-tipped Cudweed

Small Cudweed

Marsh Cudweed

Dwarf Cudweed *Gnaphalium supinum* ❀❀ HEIGHT to 10cm
Tufted, compact, greyish-green perennial that grows on damp ground in mountains, typically on acid soils. FLOWERS In small, compact, brown heads, fringed by bracts; heads in clusters (July–Aug). FRUITS Achenes. LEAVES *Narrow*, woolly on both sides, the upper ones surrounding the flower heads. STATUS Very locally common only in the Scottish Highlands.

Heath Cudweed *Gnaphalium sylvaticum* ❀ HEIGHT to 50cm
Greyish perennial with rather prostrate, leafy non-flowering stalks and upright, leafy flowering stems. Grows in dry, grassy places on heaths and along woodland rides. FLOWERS In heads 5–7mm long, with yellow-brown florets and brown-tipped bracts; in clusters or leafy spikes (July–Sep). FRUITS Achenes. LEAVES Green and hairless above but white-woolly below. STATUS Locally common.

Mountain Everlasting *Antennaria dioica* ❀ HEIGHT to 20cm
Downy perennial with rooting runners and leaf rosettes from which flower stems arise. Grows on upland heaths and moors. FLOWERS In compact, woolly, separate-sex heads, in umbel-like clusters; male heads 6mm across with white-tipped bracts, female heads 12mm across with pink-tipped bracts (June–Aug). FRUITS Achenes. LEAVES Green and hairless above, downy below. STATUS Locally common in upland and northern regions.

Ploughman's-spikenard *Inula conyzae* ❀ HEIGHT to 1m
Upright, downy biennial or perennial; stems often tinged red. Grows in dry grassland on calcareous soils. FLOWERS In ovoid heads 8–10mm long, comprising yellow florets, and purplish and green bracts; in clusters (July–Sep). FRUITS Achenes. LEAVES Oval basal leaves, recalling those of Foxglove, and narrower stem leaves. STATUS Locally common only in England and Wales.

Golden-samphire *Inula crithmoides* ❀❀ HEIGHT to 75cm
Attractive tufted, upright perennial that grows on saltmarshes, coastal shingle and sea cliffs. FLOWERS In heads 15–30mm across with spreading, yellow ray florets and orange-yellow central disc florets; in terminal clusters (July–Sep). FRUITS Achenes. LEAVES Bright green, narrow, fleshy. STATUS Widespread and locally common only around the coasts of SW Britain and Ireland.

Common Fleabane *Pulicaria dysenterica* HEIGHT to 50cm
Creeping perennial with upright, branched, woolly flowering stems. Grows in damp meadows and ditches on heavy soils. FLOWERS In heads 15–30mm across, with spreading yellow ray florets and deeper yellow, central disc florets; in open clusters (July–Sep). FRUITS Achenes with a hairy pappus. LEAVES Heart-shaped, clasping the stem; basal leaves soon wither. STATUS Common, except in Scotland.

Common Fleabane

Trifid Bur-marigold

Trifid Bur-marigold *Bidens tripartita* ❀ HEIGHT to 60cm
Branched, almost hairless annual with reddish stems. Grows in damp ground and shallow water. FLOWERS In heads 10–25mm across, with yellow disc florets (no ray florets) and 5–8 leaf-like bracts below (July–Oct). FRUITS Oblong, flattened, with 1 barbed bristle. LEAVES Stem leaves *stalked, 3-lobed.* STATUS Local in south.

Nodding Bur-marigold *Bidens cernua* ❀
HEIGHT to 70cm
Recalls Trifid Bur-marigold but has *hairy* stems. Grows in damp ground and shallow water. FLOWERS In *nodding* heads 15–30mm across with yellow disc florets and 5–8 leaf-like bracts below (July–Oct). FRUITS Narrow, flattened, with 3–4 barbed bristles. LEAVES Stem leaves lanceolate, *unstalked, undivided.* STATUS Locally common in the south.

Nodding Bur-marigold

■ *See also* Small Fleabane (p.275) and Alpine Fleabane (p.283)

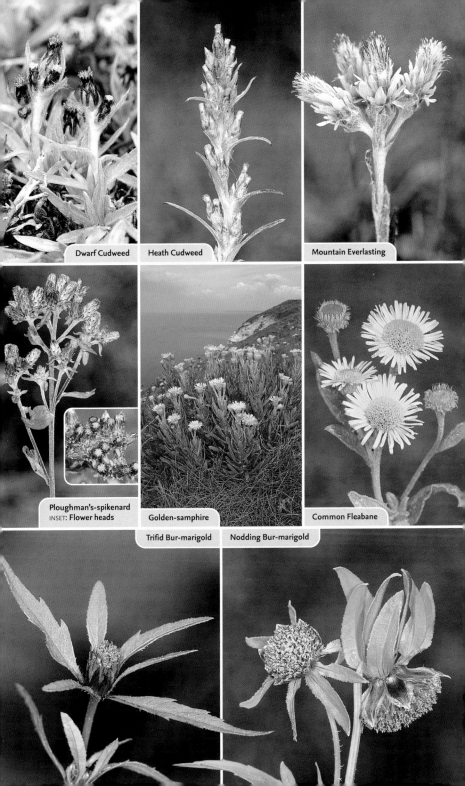

Dwarf Cudweed

Heath Cudweed

Mountain Everlasting

Ploughman's-spikenard
INSET: **Flower heads**

Golden-samphire

Common Fleabane

Trifid Bur-marigold

Nodding Bur-marigold

Goldenrod *Solidago virgaurea* HEIGHT to 75cm

Upright but variable perennial that is sometimes slightly downy. Grows in woods and grassland, and on rocky banks, and is tolerant of a wide range of soil types. **FLOWERS** Yellow; individual heads 5–10mm across, comprising ray and disc florets; in branched spikes (June–Sep). **FRUITS** 1-seeded with pappus hairs. **LEAVES** Stalked and spoon-shaped at the base of the plant, stem leaves narrow and unstalked. **STATUS** Widespread and locally common throughout.

Goldenrod

Canadian Goldenrod *Solidago canadensis* ✤ HEIGHT to 2m

Variable upright, downy perennial that grows in damp wayside ground, hedgerows and rough grassland. **FLOWERS** Yellow; individual heads in crowded, arching, 1-sided sprays in branching clusters (July–Oct). **FRUITS** 1-seeded with pappus hairs. **LEAVES** Oval, toothed, 3-veined. **STATUS** Introduced; now a familiar garden plant that is naturalised locally as an escape.

Gallant-soldier *Galinsoga parviflora* ✤✤ HEIGHT to 75cm

Upright, much branched, hairless annual that grows on waste ground and in cultivated fields. **FLOWERS** In untidy-looking heads 3–5mm across, with yellow disc florets and 4–5 white rays; in much branched inflorescences (May–Oct). **FRUITS** With long hairs. **LEAVES** Ovate, toothed, stalked, in opposite pairs. **STATUS** Introduced from S America and now naturalised, mainly in S and SE England.

Sneezewort *Achillea ptarmica* ✤ HEIGHT to 60cm

Upright, branched or unbranched perennial with stiff, angular stems, the upper parts of which are downy. Grows in damp situations in meadows, woodland rides and clearings, almost always on acid soils. **FLOWERS** In heads 1–2cm across, comprising greenish-yellow disc florets and white ray florets; heads carried in open clusters (July–Sep). **FRUITS** Achenes. **LEAVES** Narrow, undivided, untoothed, stalkless. **STATUS** Locally common throughout.

Yarrow *Achillea millefolium* HEIGHT to 50cm

Upright, downy perennial with creeping stems and upright, unbranched, furrowed flowering stalks. The whole plant is strongly aromatic. Grows in meadows, verges and hedgerows, and on waste ground. **FLOWERS** In heads 4–6mm across, comprising yellowish disc florets and pinkish-white ray florets; heads arranged in flat-topped clusters (June–Nov). **FRUITS** Achenes. **LEAVES** Dark green, finely divided, feathery. **STATUS** Widespread and common throughout.

Elecampane *Inula helenium* HEIGHT to 2m

Impressive, hairy perennial of verges and grassy habitats, often on damp ground. **FLOWERS** Yellow in heads 6–8cm across (July–Aug). **FRUITS** Achenes. **LEAVES** Up to 40cm long, ovate. **STATUS** Naturalised locally.

Corn Marigold *Chrysanthemum segetum* ✤ HEIGHT to 50cm

Attractive hairless, upright annual that grows in arable fields and cultivated ground, usually on acid, sandy soils. **FLOWERS** In heads 30–45mm across, with orange-yellow disc florets and yellow ray florets; heads solitary (June–Oct). **FRUITS** Achenes. **LEAVES** Narrow, deeply lobed or toothed, slightly fleshy; upper leaves clasping the stem. **STATUS** Possibly introduced to the region but now widespread, although range and abundance is decreasing.

Tansy *Tanacetum vulgare* HEIGHT to 75cm

Robust, upright perennial that is strongly aromatic. Grows on roadside verges, and in hedgerows and disturbed ground. **FLOWERS** In golden-yellow, button-like heads 7–12mm across, comprising disc florets only; in flat-topped, umbel-like clusters up to 12cm across, comprising up to 70 heads (July–Oct). **FRUITS** Achenes. **LEAVES** Yellowish green, pinnately divided with deeply cut lobes. **STATUS** Common and widespread throughout.

 ■ *See also* Goldilocks Aster (p.271)

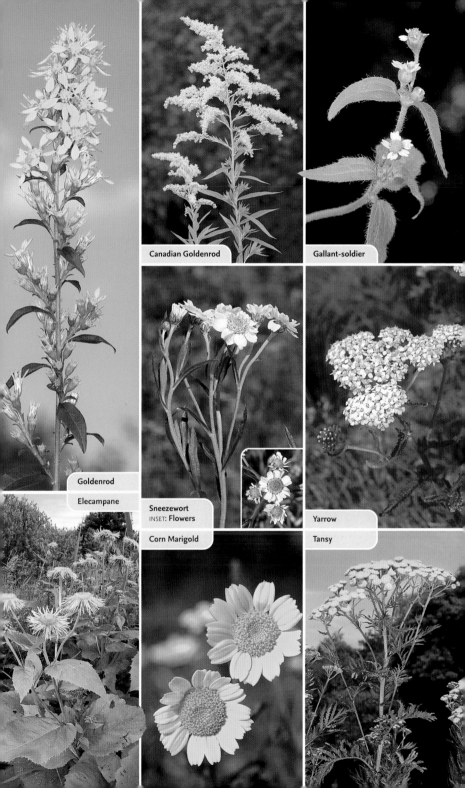

Canadian Goldenrod

Gallant-soldier

Goldenrod

Elecampane

Sneezewort
INSET: Flowers

Corn Marigold

Yarrow

Tansy

Feverfew *Tanacetum parthenium* ✤ HEIGHT to 50cm

Upright, much branched, downy perennial that is strongly aromatic. Grows in disturbed ground, and on verges, waysides and old walls. **FLOWERS** In daisy-like heads, 1–2cm across, that comprise yellow disc and white ray florets; in loose clusters (July–Aug). **FRUITS** Achenes. **LEAVES** Yellowish green, pinnately divided; lower leaves stalked, upper ones unstalked. **STATUS** Introduced as a garden plant and widely naturalised, often near habitation.

Sea Aster *Aster tripolium* HEIGHT to 75cm

Attractive branched, hairless, salt-tolerant perennial that grows in saltmarshes and on sea cliffs. **FLOWERS** Comprising umbel-like clusters of flower heads, each 1–2cm across and consisting of yellow disc florets and bluish-lilac ray florets (July–Sep). **FRUITS** Achenes. **LEAVES** Fleshy, narrow, with a prominent midrib. **STATUS** Locally common around the coasts of Britain and Ireland. Beware confusion with garden escape Michelmas-daisies (*Aster* sp.).

Michelmas-daisy

Sea Aster

Hemp-agrimony *Eupatorium cannabinum* HEIGHT to 1.5m

Tall, upright, downy perennial of damp grassland and also in scrub on chalk. **FLOWERS** Dull pinkish lilac; in heads 2–5mm across, comprising 5–6 florets, in dense, terminal clusters 3–7cm across (July–Sep). **FRUITS** 1-seeded with pappus hairs. **LEAVES** Trifoliate, in opposite pairs up the stem. **STATUS** Common, except in the north.

Butterbur *Petasites hybridus* ✤ HEIGHT to 50cm

Patch-forming perennial with creeping rhizomes. Grows in damp ground, often beside rivers. **FLOWERS** In pinkish-red heads on separate-sex plants (male flower heads 7–12mm across, females 3–6mm across), carried on robust spikes, up to 40cm tall, (Mar–May), going over as leaves appear. **FRUITS** Achenes. **LEAVES** Heart-shaped, up to 1m across, and most evident in summer. **STATUS** Locally common.

Winter Heliotrope *Petasites fragrans* ✤ HEIGHT to 20cm

Creeping, patch-forming perennial that grows in damp or shady wayside places and hedgerows. **FLOWERS** Vanilla-scented, in pinkish-lilac heads 10–12mm across, carried in spikes 20–25cm long (Dec–Mar). **FRUITS** Achenes. **LEAVES** Rounded, 20cm across, long-stalked, present all year. **STATUS** A naturalised garden escape.

Mugwort *Artemisia vulgaris* HEIGHT to 1.25m

Upright aromatic plant, branched above. The stems are ribbed, reddish and downy. Grows on roadside verges, disturbed land and waste ground. **FLOWERS** In reddish heads 2–3mm across, arranged in tall, branched spikes (July–Sep). **FRUITS** Achenes. **LEAVES** Pinnate, dark green and hairless above, but silvery downy below; lower leaves stalked, upper ones unstalked. **STATUS** Widespread and common.

Wormwood *Artemisia absinthium* ✤ HEIGHT to 80cm

Aromatic, upright perennial with silkily hairy stems. Grows in disturbed coastal grassland and on roadside verges. **FLOWERS** In yellowish heads 3–5mm across, bell-shaped, nodding, carried in tall, branched spikes (July–Sep). **FRUITS** Achenes. **LEAVES** Pinnately divided into deeply cut lobes that are silvery hairy on both sides. **STATUS** Locally common in England and Wales, but scarce or absent elsewhere.

Sea Wormwood *Seriphidium maritimum* HEIGHT to 65cm

Aromatic, branched perennial; upright and spreading stems have woody bases. Grows in saltmarshes and on sea walls, tolerating salt spray and occasional inundation. **FLOWERS** In egg-shaped, slightly nodding, yellow heads 1–2mm across, carried in dense, branched, leafy spikes (Aug–Oct). **FRUITS** Achenes. **LEAVES** Pinnately divided, downy on both sides. **STATUS** Local, on coasts of England and Wales.

■ *See also* Field Wormwood (p.278)

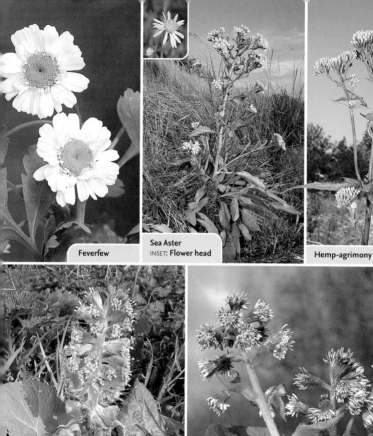

Feverfew

Sea Aster
INSET: Flower head

Hemp-agrimony

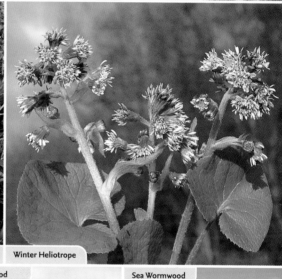

Butterbur

Winter Heliotrope

Mugwort

Wormwood

Sea Wormwood

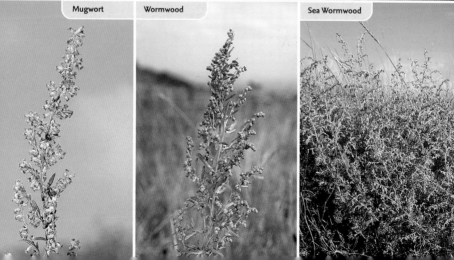

Common Ragwort *Senecio jacobaea* HEIGHT to 1m

Hairless, poisonous biennial or short-lived perennial. Grows in grassland; thrives in grazed areas (animals avoid eating the living plant). Food plant of Cinnabar Moth larvae. FLOWERS Yellow, in heads 15–25mm across, carried in *dense, flat-topped clusters* (June–Nov). FRUITS Those of disc florets downy; ray floret fruits hairless. LEAVES Pinnate with a *blunt end lobe*. STATUS Common and widespread.

Common Ragwort

Hoary Ragwort

Hoary Ragwort *Senecio erucifolius* HEIGHT to 1.5m

Perennial, similar to Common Ragwort but with downy stems and undersides to leaves. Found in neutral and basic grassland. FLOWERS Pale yellow heads 15–20mm across; in clusters (July–Aug). FRUITS Downy. LEAVES Divided; lobes pointed and narrower than Common Ragwort. STATUS Locally common in England and Wales.

Oxford Ragwort *Senecio squalidus* ❀ HEIGHT to 50cm

Annual or perennial that is much branched from the base, typically forming a straggly, spreading plant. Grows in disturbed ground and characteristic of railway tracks, verges and waste ground. FLOWERS Yellow, in heads 15–25mm across, carried in clusters (May–Dec). Note the *black-tipped bracts*. FRUITS Downy. LEAVES Pinnate with a *pointed end lobe*. STATUS Widely naturalised.

Marsh Ragwort *Senecio aquaticus* HEIGHT to 80cm

Poisonous biennial or perennial that grows in damp grassy places and marshes. FLOWERS Yellow, in heads 20–30mm across, carried in *open* clusters that are fewer-flowered than Common Ragwort and *not flat-topped* (July–Aug). FRUITS Downy. LEAVES Either undivided or with a larger end lobe than those of Common Ragwort. STATUS Widespread and locally common in suitable habitats.

Silver Ragwort *Senecio cineraria* ❀❀ HEIGHT to 80cm

Bushy, woody, silvery-grey perennial. Grows on coastal cliffs and walls. FLOWERS Yellow, in heads 15–25mm across, with silvery-woolly stalks and bracts; in clusters (June–Aug). FRUITS Downy. LEAVES Pinnate, green, downy above but white-woolly below. STATUS Introduced, often planted around car parks and other formal sites; naturalised on coasts of SW England.

Groundsel *Senecio vulgaris* HEIGHT to 40cm

Branched annual plant of cultivated and disturbed ground; familiar garden weed. FLOWERS *Cylindrical* heads, 10mm long, of yellow *disc florets only*, with *black-tipped* greenish bracts; carried in clusters (Jan–Dec). FRUITS Very hairy. LEAVES Pinnately lobed; lower leaves stalked, upper ones clasping the stem. STATUS Widespread and common throughout.

Heath Groundsel *Senecio sylvaticus* HEIGHT to 70cm

Recalls Groundsel but taller and more robust. Grows on sandy soils on heaths. FLOWERS *Stickily hairy, conical* heads, 10mm long, of yellow disc florets, recurved ray florets and bracts that are *not black-tipped*; heads in open clusters (June–Sep). FRUITS Hairy. LEAVES Deeply pinnately divided. STATUS Locally common.

Sticky Groundsel *Senecio viscosus* ❀ HEIGHT to 60cm

Like Heath Groundsel but *whole plant is stickily hairy and pungent*. In dry, bare places, often coastal. FLOWERS Conical heads, 12mm long, of yellow disc florets, recurved ray florets and bracts that are *not black-tipped*; in open clusters (July–Sep). FRUITS *Hairless*. LEAVES Pinnate. STATUS Locally common.

Field Fleawort *Tephroseris integrifolia* ❀❀ HEIGHT to 65cm

Slender, unbranched, downy perennial of calcareous grassland. FLOWERS In heads 15–25mm across, with orange-yellow disc florets and yellow ray florets; in few-flowered clusters (May–July). FRUITS Hairy. LEAVES Oval, toothed at the base, forming a rosette; stem leaves few, narrow, clasping. STATUS Local.

■ *See also Fen Ragwort (p.279)*

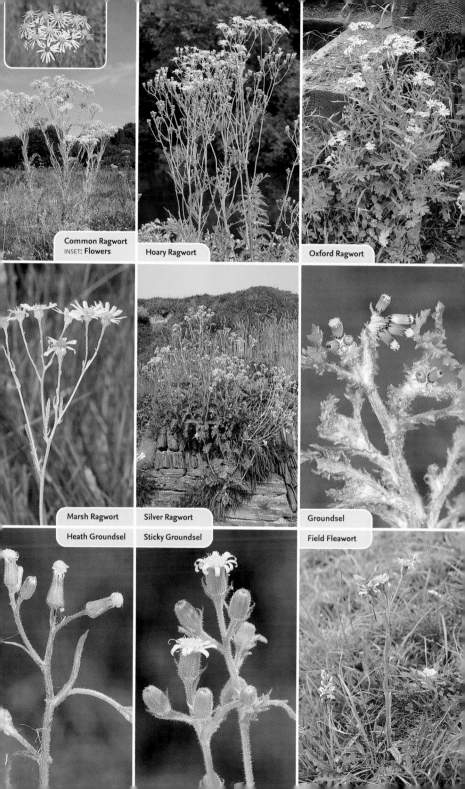

Common Ragwort
INSET: **Flowers**

Hoary Ragwort

Oxford Ragwort

Marsh Ragwort

Silver Ragwort

Groundsel

Heath Groundsel

Sticky Groundsel

Field Fleawort

Colt's-foot *Tussilago farfara* HEIGHT to 15cm
Creeping perennial with runners and upright flowering stalks that are leafless, purplish and woolly, with overlapping, fleshy bracts. Grows in bare and disturbed ground, particularly on clay. FLOWERS In heads 15–35mm across, with orange-yellow disc florets and yellow ray florets; heads solitary, terminal (Feb–Apr). FRUITS A 'clock' of hairy seeds. LEAVES Rounded, heart-shaped, 10–20cm across, appearing after flowering. STATUS Widespread and common.

Leopard's-bane *Doronicum pardalianches* ✿✿ HEIGHT to 70cm
Upright downy or hairy perennial that grows on roadside verges and in woodland rides. FLOWERS In heads 3–5cm across, comprising orange-yellow disc florets and bright yellow ray florets; carried in branched inflorescences of 2–5 heads (May–June). FRUITS Achenes. LEAVES Heart-shaped, toothed; stalked at the base of the plant, with stem leaves increasingly unstalked up the plant. STATUS Introduced as a garden plant, and naturalised locally across the region.

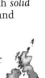

Greater Burdock *Arctium lappa* HEIGHT to 1m
Branched, downy biennial of hedgerows, woodland rides, verges and waste ground. FLOWERS In egg-shaped heads 20–40mm *across*, with purplish florets not projecting beyond the greenish-yellow, hooked, spiny bracts; carried in few-flowered inflorescences (July–Sep). FRUITS Burs, with hooked spines (flower bracts) that cling to animal fur and aid dispersal. LEAVES Heart-shaped, with *solid stalks*; basal leaves *as long as wide*. STATUS Locally common in England and Wales; scarce elsewhere.

Lesser Burdock *Arctium minus* HEIGHT to 50cm
Robust, downy biennial of waste ground, verges and hedgerows. Similar to Greater Burdock but note differences in flowers and leaves. FLOWERS In egg-shaped heads, *15–20mm across*, with purplish florets projecting beyond the greenish-yellow, hooked, spiny bracts; in open spikes (July–Sep). FRUITS Burs. LEAVES Heart-shaped, with hollow stalks; basal leaves *longer than wide*. STATUS Widespread and common.

Musk Thistle *Carduus nutans* HEIGHT to 1m
Upright, elegant biennial. The stems are cottony, mainly with spiny wings although *stalks below flowers are spine-free*. Grows in dry, grassy areas including verges and dunes. FLOWERS In rayless heads 3–5cm across, with reddish-purple florets and purplish spiny bracts; heads solitary, *nodding* (June–Aug). FRUITS With unbranched hairs. LEAVES Pinnately lobed, spiny. STATUS Locally common only in England and Wales; scarce or absent elsewhere.

Welted Thistle *Carduus crispus* HEIGHT to 1.3m
Upright, much branched biennial with cottony stems that have spiny wings along almost their entire length, *except for a very short section just below the flower heads*. Grows in grassland, scrub, verges and open woodland. FLOWERS In cylindrical or egg-shaped heads 2–3cm long, with reddish-purple florets and woolly green bracts; heads in clusters (June–Aug). FRUITS With unbranched hairs. LEAVES Oblong, deeply pinnate, 3-lobed, spiny at base of plant; upper leaves narrower and stalkless. STATUS Common throughout, except in Ireland and N Scotland.

Slender Thistle *Carduus tenuiflorus* ✿ HEIGHT to 1m
Upright, greyish biennial. Similar to Welted Thistle but *stems are spiny-winged right up to the flower heads* and *extremely cottony*. Grows in dry grassland, often near the sea. FLOWERS In egg-shaped heads 5–10mm across, with pinkish-red florets; in dense, terminal clusters (June–Aug). FRUITS With unbranched hairs. LEAVES Pinnate, spiny, cottony below. STATUS Locally common around coasts, except in the north.

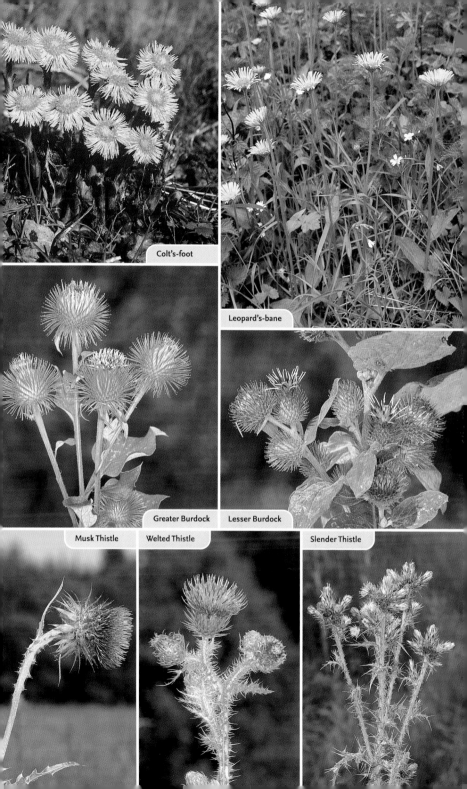

Colt's-foot

Leopard's-bane

Greater Burdock

Lesser Burdock

Musk Thistle

Welted Thistle

Slender Thistle

Carline Thistle *Carlina vulgaris* ✿ HEIGHT to 60cm

Upright, branched or unbranched biennial, with stiff spines. Grows in dry calcareous grassland. FLOWERS In golden-brown, rayless heads 15–40mm across, surrounded by spreading, straw-coloured bracts; in clusters (July–Sep). Dead flower heads persist. FRUITS With feathery pappus hairs. LEAVES Oblong with wavy margins and spiny lobes; lower leaves downy. STATUS Locally common.

Creeping Thistle

Creeping Thistle *Cirsium arvense* HEIGHT to 1m

Creeping perennial with upright, unwinged, mostly spineless flowering stems. Grows in disturbed ground and grassy areas. FLOWERS In heads 10–15mm across, with *pinkish-lilac florets* and darker bracts; heads in clusters (June–Sep). FRUITS With feathery pappus hairs. LEAVES Pinnately lobed, spiny, the upper leaves clasping. STATUS Widespread and common throughout.

Spear Thistle *Cirsium vulgare* HEIGHT to 1m

Upright biennial with stems that are downy and spiny-winged between the leaves. Grows in grassland and on disturbed ground. FLOWERS In heads 2–4cm across, comprising purple florets topping a basal ball coated with spiny bracts; heads solitary or in small clusters (July–Sep). FRUITS With feathery pappus hairs. LEAVES Pinnately lobed, spiny. STATUS Widespread and common throughout.

Spear Thistle

Meadow Thistle

Melancholy Thistle *Cirsium heterophyllum* ✿ HEIGHT to 1m

Upright, unbranched perennial with stems that are grooved, cottony, spineless and unwinged. FLOWERS In heads 3–5cm across, with reddish-purple florets; heads usually solitary or in small clusters (June–Aug). FRUITS With feathery pappus hairs. LEAVES Oval, toothed, barely spiny; *green and hairless above* but coated with *white felt underneath.* STATUS Locally common only in N England and Scotland.

Meadow Thistle *Cirsium dissectum* HEIGHT to 75cm

Creeping perennial that produces upright long, slender flowering stems that are unwinged, downy and ridged. FLOWERS In heads 20–25mm across, with reddish-purple florets and darker bracts; heads *solitary* (June–July). FRUITS With feathery pappus hairs. LEAVES Oval, toothed, green and hairy above but white cottony below. STATUS Locally common in S and central England, Wales and Ireland.

Dwarf Thistle *Cirsium acaule* HEIGHT to 5cm

Creeping, flattened perennial with a characteristic rosette of extremely spiny leaves. Grows in short grassland on calcareous soils. FLOWERS In heads 3–5cm across, with reddish-purple florets; heads *usually stalkless* (June–Sep). FRUITS With feathery pappus hairs. LEAVES Pinnate with wavy, spiny lobes. STATUS Locally common only in S and E England and S Wales; scarce or absent elsewhere.

Woolly Thistle *Cirsium eriophorum* ✿✿ HEIGHT to 1.5m

Upright biennial of calcareous grassland. Stems are *furrowed, cottony and unwinged.* FLOWERS In heads 6–7cm across, comprising reddish-purple florets topping a ball coated with *cottony bracts*; heads solitary (July–Sep). FRUITS With feathery pappus hairs. LEAVES Pinnate, spiny, cottony below. STATUS Local, mainly in the south.

Marsh Thistle *Cirsium palustre* HEIGHT to 1.5m

Upright, branched biennial, often tinged reddish. *Stems have continuous spiny wings.* Grows in damp grassland. FLOWERS In heads 10–15mm across, with dark reddish-purple florets; heads in clusters (July–Sep). FRUITS With feathery pappus hairs. LEAVES Pinnately lobed, spiny. STATUS Widespread and common.

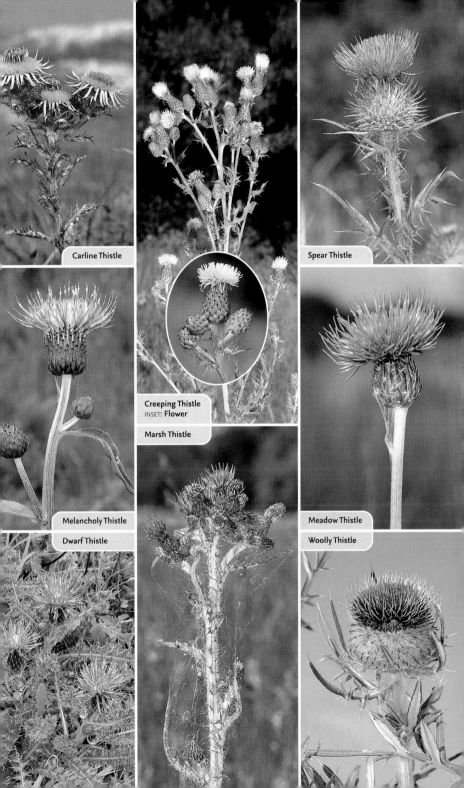

Carline Thistle

Creeping Thistle
INSET: **Flower**

Marsh Thistle

Spear Thistle

Melancholy Thistle

Dwarf Thistle

Meadow Thistle

Woolly Thistle

Saw-wort *Serratula tinctoria* ❀ **HEIGHT** to 75cm

Slender, hairless, *spineless* perennial with grooved, rather stiff stems. Grows in damp meadows and along woodland rides. **FLOWERS** In heads 15–20mm long, comprising pinkish-purple florets and close-pressed *purplish bracts*; heads carried in open, terminal clusters (July–Oct). **FRUITS** With unbranched pappus hairs. **LEAVES** Varying from undivided to deeply lobed, but edges always saw-toothed. **STATUS** Locally common only in SW England; scarce or absent elsewhere.

Cotton Thistle *Onopordum acanthium* ❀❀ **HEIGHT** to 2.5m

Tall biennial with winged, spiny stems coated in *cottony down*. Grows on disturbed ground. **FLOWERS** In heads 30–35mm across, with reddish-purple florets and a globular base covered in spine-tipped bracts; in clusters (July–Sep). **FRUITS** With unbranched pappus hairs. **LEAVES** Oblong with wavy, spiny lobes; cottony on both surfaces. **STATUS** Probably introduced; local in S and E England.

Common Knapweed *Centaurea nigra* **HEIGHT** to 1m

Downy or hairy perennial that branches towards the top of the plant. The stems are stiff and grooved and are often swollen beneath the base of the flowers. Grows in a wide range of grassy places. **FLOWERS** In heads 2–4cm across, with reddish-purple florets and a swollen, hard base covered in brown bracts; heads usually solitary (June–Sep). **FRUITS** Lacking pappus hairs. **LEAVES** Narrow, those near the base of the plant slightly lobed. **STATUS** Widespread and common throughout.

Greater Knapweed *Centaurea scabiosa* ❀ **HEIGHT** to 1m

Elegant perennial of dry, mainly calcareous, grassland. Stems are stiff, downy, grooved and swollen towards the base. **FLOWERS** In heads 3–5cm across, with reddish-purple disc florets (outer ones elongated, spreading, ray-like) and a swollen base coated with brown bracts; heads solitary (June–Sep). **FRUITS** Hairless achenes. **LEAVES** Oblong, deeply pinnate. **STATUS** Locally common in S and E England.

Cornflower *Centaurea cyanus* ❀❀ **HEIGHT** to 90cm

Creeping perennial with upright flowering stems that are winged below leaf stalks and swollen beneath flower heads. Grows in arable fields and on disturbed ground. **FLOWERS** In heads 15–30mm across, with bluish outer florets and reddish-purple inner florets (June–Aug). **FRUITS** Hairless. **LEAVES** Narrow; basal ones may be lobed. **STATUS** Formerly a common arable 'weed', before modern agricultural herbicides; now virtually extinct on farmland, seen mainly where seed is deliberately scattered.

Chicory *Cichorium intybus* ❀ **HEIGHT** to 1m

Branched perennial with stiff, grooved stems. Grows in bare, grassy places and typically on calcareous soils; often seen on roadside verges. **FLOWERS** In heads 3–4cm across, with sky-blue florets; opening only in the morning and in sunny weather (June–Sep). **FRUITS** Achenes. **LEAVES** Stalked and lobed at base of plant; upper ones narrow and clasping. **STATUS** Locally common only in S England.

Goat's-beard *Tragopogon pratensis* **HEIGHT** to 60cm

Upright annual or perennial of grassy places. **FLOWERS** In heads 3–4cm across, with yellow florets and long, narrow bracts; flowers close by midday and remain closed on dull mornings (May–Aug). **FRUITS** White 'clocks' 8–10cm across. **LEAVES** Narrow, grass-like, clasping or sheathing at the base. **STATUS** Locally common only in England and Wales; scarce or absent elsewhere.

Salsify *Tragopogon porrifolius* ❀❀ **HEIGHT** to 70cm

Upright annual or perennial of grassy places and disturbed ground, usually near the sea. Similar to Goat's-beard but flower colour entirely different. **FLOWERS** In heads 3–4cm across, with reddish-purple florets and 8 long, narrow bracts; closing by midday and remaining closed on dull mornings (June–July). **FRUITS** White 'clocks'. **LEAVES** Narrow, grass-like, clasping or sheathing at the base. **STATUS** Introduced and formerly cultivated; now occasionally naturalised, mainly in the south.

■ *See also Red Star-thistle (p.277)*

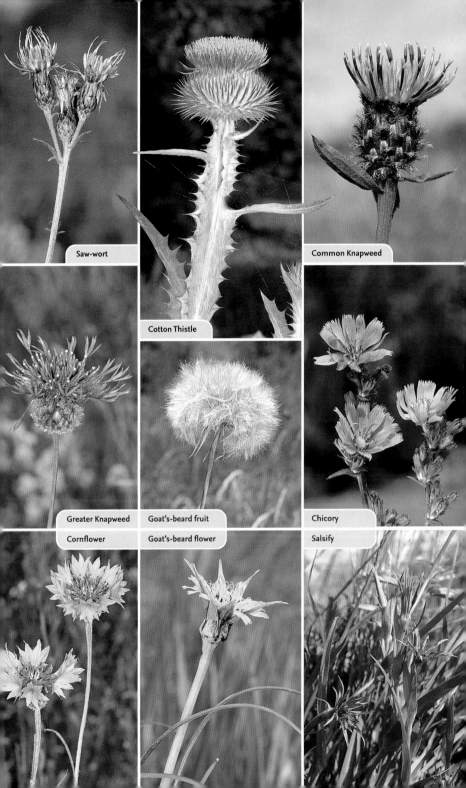

Saw-wort

Cotton Thistle

Common Knapweed

Greater Knapweed

Goat's-beard fruit

Chicory

Cornflower

Goat's-beard flower

Salsify

Smooth Sow-thistle *Sonchus oleraceus* HEIGHT to 1m

Upright, hairless annual or biennial that grows in disturbed and cultivated ground. Broken stems exude a milky sap. FLOWERS In heads 20–25mm across, with pale yellow florets; heads in umbel-like clusters (May–Oct). FRUITS Wrinkled, with feathered pappus hairs forming a 'clock'. LEAVES *Matt*, pinnate with triangular lobes, spiny margins and clasping *pointed auricles* at the base. STATUS Widespread and common throughout.

Perennial Sow-thistle *Sonchus arvensis* HEIGHT to 2m

Impressive perennial that grows in damp, grassy places and on disturbed ground. Broken stems exude a milky sap. FLOWERS In heads 4–5cm across, with yellow florets; heads in branched, umbel-like clusters (July–Sep). FRUITS Ribbed, flattened, with feathery pappus hairs forming a 'clock'. LEAVES Narrow, *shiny*, dark green above and greyish below, with pinnate lobes and soft marginal spines; clasping, *rounded auricles* at base. STATUS Widespread and common throughout.

Marsh Sow-thistle *Sonchus palustris* ❀❀❀ HEIGHT to 2.5m

Tall perennial of marshes and upper reaches of saltmarshes. FLOWERS In heads 3–4cm across, with yellow florets; heads in branched, umbel-like clusters (July–Sep). FRUITS With feathery pappus hairs forming a 'clock'. LEAVES Pinnate with sharp lobes. STATUS Local and scarce.

Perennial
Sow-thistle

Marsh
Sow-thistle

Prickly Sow-thistle *Sonchus asper* HEIGHT to 1m

Upright, mainly hairless annual or biennial that grows in cultivated land and on waste ground. Broken stems exude a milky sap. FLOWERS In heads 20–25mm across, with rich yellow florets; heads in umbel-like clusters (June–Oct). FRUITS Elliptical, with pappus hairs forming a 'clock'. LEAVES Glossy green above with *wavy, crinkly, sharp-spined margins*, and *rounded auricles* clasping at the base. STATUS Widespread and common throughout.

Prickly Lettuce *Lactuca serriola* ❀ HEIGHT to 1.75m

Fruit

Upright, stiff biennial, the upper part branched. Broken stems exude a milky sap. Grows on disturbed and waste ground, verges and railways. FLOWERS In heads 11–13mm across, with yellow florets; in open, branched inflorescences (July–Sep). FRUITS Brown, with unbranched pappus hairs. LEAVES Grey-green with *pointed clasping bases*, often held *stiffly erect*; margins and lower midrib have weak spines; lower leaves may have narrow lobes. STATUS Common only in the south.

Great Lettuce *Lactuca virosa* ❀ HEIGHT to 2m

Fruit

Similar to Prickly Lettuce but taller; note differences in leaves. Stems are often tinged purple, and exude a milky sap when broken. FLOWERS In heads 9–11mm across, with yellow florets; in open, branched inflorescences (July–Sep). FRUITS Blackish maroon, with unbranched pappus hairs. LEAVES Dark green, *spreading*, with *rounded, clasping bases*; lower leaves may have broad lobes. STATUS Common only in the south.

Wall Lettuce *Mycelis muralis* ❀ HEIGHT to 1m

Upright, hairless perennial. Stems are often tinged purple and exude a milky sap when broken. Grows on shady banks and walls, usually on chalky soils. FLOWERS In heads 7–10mm across, with 5 yellow ray florets; in open clusters (June–Sep). FRUITS With unbranched hairs. LEAVES Pinnate, the end lobe triangular; upper leaves clasping. STATUS Widespread but only locally common.

Wall Lettuce

■ *See also* Least Lettuce (p.276)

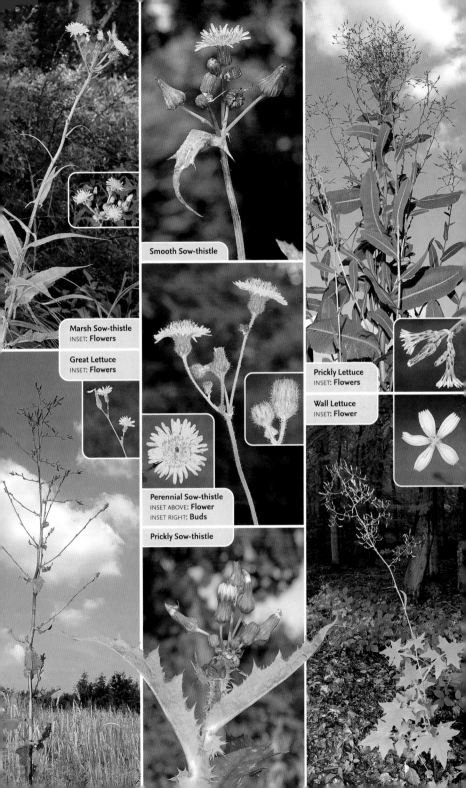

Smooth Sow-thistle

Marsh Sow-thistle
INSET: **Flowers**

Great Lettuce
INSET: **Flowers**

Prickly Lettuce
INSET: **Flowers**

Wall Lettuce
INSET: **Flower**

Perennial Sow-thistle
INSET ABOVE: **Flower**
INSET RIGHT: **Buds**

Prickly Sow-thistle

Common Dandelion *Taraxacum officinale* agg. **HEIGHT** to 35cm

Extremely variable perennial. Experts recognise several sub-groups (sections), containing numerous so-called microspecies; however, for simplicity's sake, here they are treated together as a single species. All grow in a wide variety of grassy places. **FLOWERS** In heads 3–5cm across, with yellow florets; heads solitary, on hollow stems that yield a milky sap if broken (Mar–Oct). **FRUITS** With a hairy pappus, arranged as a white 'clock'. **LEAVES** Spoon-shaped, sharply lobed; in a basal rosette. **STATUS** Widespread and common throughout.

Mouse-ear Hawkweed *Pilosella officinarum* **HEIGHT** to 25cm

Variable, hairy perennial. Plant has creeping runners and often forms mats. Stems produce a milky latex when broken. Grows in a wide range of dry, grassy places, from meadows to heaths. **FLOWERS** In heads 2–3cm across, with *pale yellow florets* that have a red stripe below; heads solitary on *leafless* stems (May–Oct). **FRUITS** With unbranched hairs. **LEAVES** Spoon-shaped, green and hairy above, downy white below; in a basal rosette. **STATUS** Widespread and common throughout.

Fox-and-cubs *Pilosella aurantiaca* ✿✿ **HEIGHT** to 40cm

Variable, spreading perennial, similar in many respects to Mouse-ear Hawkweed, except for the flower colour. Note that the stems are *leafy* and coated in *blackish hairs*. Grows in grassy places, and on verges and banks. **FLOWERS** In heads 2–3cm across, with *reddish-orange florets*; in clusters (June–July). **FRUITS** With unbranched hairs. **LEAVES** Lanceolate, hairy, in a basal rosette. **STATUS** Introduced; a familiar garden plant but widely naturalised as well.

Hawkweeds *Hieracium* agg. ✿ **HEIGHT** to 80cm

Complex group of variable upright perennials, with stems hairy towards the base. Separating the species is best left to experts. Found in dry grassy places, along woodland rides, on verges and banks, and on heaths. **FLOWERS** In heads 2–3cm across, with yellow florets; on hairy stalks, in clusters (July–Sep). **FRUITS** With unbranched hairs. **LEAVES** Ovate, toothed but not pinnately lobed; basal leaves in a rosette, stem leaves unstalked. **STATUS** Widespread and locally common throughout.

Typical *Hieracium* leaves

Bristly Oxtongue *Picris echioides* **HEIGHT** to 80cm

Branched, upright annual or biennial. Stems are covered in stiff bristles. Grows in dry grassland and disturbed ground. **FLOWERS** In heads 20–25mm across, with pale yellow florets; in open clusters (June–Oct). **FRUITS** With feathery hairs. **LEAVES** Oblong, the upper ones clasping; covered in *swollen-based bristles and pale spots*. **STATUS** Locally common in S Britain but scarce elsewhere.

Hawkweed Oxtongue *Picris hieracioides* ✿ **HEIGHT** to 70cm

Branched perennial with stems that are bristly and sometimes tinged reddish towards the base. Grows in rough grassland, often near the coast. **FLOWERS** In heads 20–25mm across (July–Sep). **FRUITS** With feathery hairs. **LEAVES** Like those of Bristly Oxtongue but narrow-oblong, toothed, covered in bristles that are *not swollen-based*. **STATUS** Locally common only in SE England; scarce or absent elsewhere.

Nipplewort *Lapsana communis* **HEIGHT** to 1m

Upright, much branched annual with stiff stems that do not produce latex when broken. Grows in cultivated and disturbed ground, and often in gardens. **FLOWERS** In heads 1–2cm across, with yellow florets; carried in open clusters (July–Oct). Flower buds nipple-like. **FRUITS** Hairless. **LEAVES** Oval to lanceolate, toothed, short-stalked. **STATUS** Widespread and common throughout.

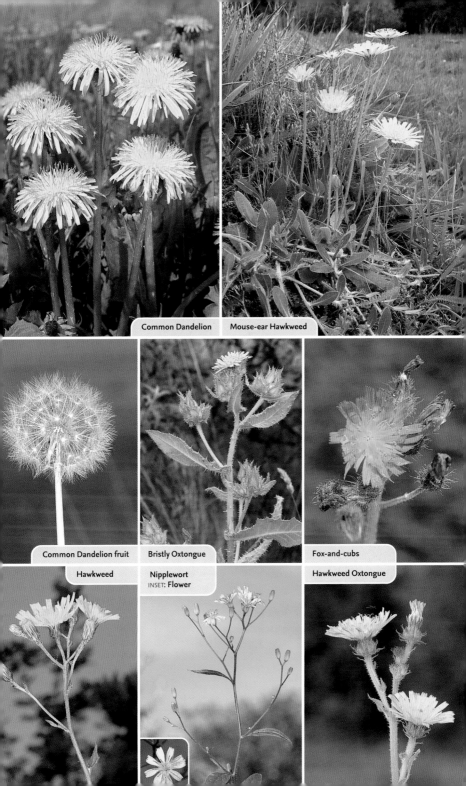

Common Dandelion Mouse-ear Hawkweed

Common Dandelion fruit Bristly Oxtongue Fox-and-cubs

Hawkweed Nipplewort Hawkweed Oxtongue
INSET: Flower

Rough Hawkbit *Leontodon hispidus* HEIGHT to 35cm

Perennial, coated in *rough white hairs*. Grows in dry grassland, mostly on calcareous soils. FLOWERS In heads 25–30mm across, with golden-yellow florets; heads solitary, on slender stalks coated with branched hairs (June–Oct). Rough scales present between the florets. FRUITS Forming a white 'clock'. LEAVES Wavy-lobed, *very hairy*, in a basal rosette. STATUS Locally common, except in N Scotland.

Autumn Hawkbit *Leontodon autumnalis* HEIGHT to 25cm

Variable hairless or slightly hairy perennial of dry, grassy places, mostly on acid soils. FLOWERS In heads 15–25mm across, with yellow florets; the involucre tapering gradually to the stem, which bears *numerous scale-like bracts below the head* (June–Oct). Flowering stems branch 2 or 3 times. FRUITS Forming a white clock. LEAVES Oblong, deeply pinnately lobed. STATUS Common.

Lesser Hawkbit *Leontodon saxatilis* HEIGHT to 25cm

Perennial with similarities to both Autumn and Rough hawkbits. Stems are hairless above but bristly below. Grows in dry, grassy places. FLOWERS In heads 20–25mm across, with yellow florets. Heads solitary, drooping in bud; scale-like bracts absent from flower stalk (June–Oct). FRUITS Forming a white 'clock'. LEAVES Pinnately lobed, sparsely hairy. STATUS Common and widespread, except in the north.

Cat's-ear *Hypochaeris radicata* HEIGHT to 50cm

Tufted perennial with hairless stems. Grows in dry grassland. FLOWERS In heads 25–40mm across, with *yellow florets much longer than bristly, purple-tipped bracts*; flower stalks *slightly swollen beneath solitary heads* (June–Sep). Scales present between florets. FRUITS Beaked, with some feathery hairs. LEAVES Oblong, bristly, wavy-edged, in a basal rosette. STATUS Common.

Smooth Cat's-ear *Hypochaeris glabra* ✿✿✿ HEIGHT to 20cm

Upright, usually hairless annual of dry grassland, mainly on sandy soils. FLOWERS In heads 10–15mm across, with *yellow florets not much longer than the bracts*; flower stalks hardly swollen beneath the heads (June–Oct). Scales present between florets. FRUITS With some feathery hairs. LEAVES Oblong, *shiny, almost hairless*, in a basal rosette. STATUS Locally common only in S and E England.

Spotted Cat's-ear *Hypochaeris maculata* ✿✿ HEIGHT to 30cm

Rather distinctive perennial that grows in dry grassland and on broken, rocky slopes, mainly on calcareous soils. FLOWERS In heads 3–5cm across, with lemon-yellow florets and blackish bracts; heads solitary, on bristly stalks (June–Aug). Scales present between florets. FRUITS With feathery hairs. LEAVES Ovate, wavy-edged, bristly, marked with *reddish-purple spots*. STATUS Rare and local.

Smooth Hawk's-beard *Crepis capillaris* HEIGHT to 80cm

Hairless, branched annual or biennial of dry, grassy places. FLOWERS In heads 15–25mm across, with yellow florets and 2 rows of bracts, the outer ones spreading; heads in branched clusters (June–Oct). FRUITS With a pappus of unbranched hairs. LEAVES Pinnate, *upper ones with clasping, arrow-shaped bases*. STATUS Common.

Rough Hawk's-beard *Crepis biennis* ✿ HEIGHT to 1.2m

Branched, roughly hairy plant of grassland, verges and waste ground. FLOWERS In heads 25–30mm across, with yellow florets (June–Sep). FRUITS With a pappus of unbranched hairs. LEAVES Pinnate, with a large end lobe. STATUS Local, mainly SE England.

Beaked Hawk's-beard *Crepis vesicaria* ✿ HEIGHT to 1.2m

Branched, downy plant of grassland, verges and waste ground. FLOWERS In heads 15–25mm across, with orange-yellow florets, outer ones striped red (June–Sep). FRUITS With a pappus of unbranched hairs. LEAVES Irregularly pinnate, with a large end lobe. STATUS Introduced but common in S England.

■ *See also Stinking Hawk's-beard (p.276)*

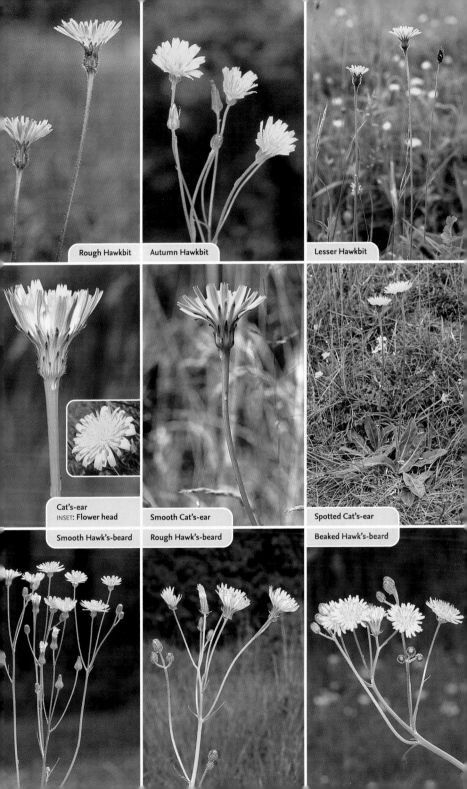

Rough Hawkbit

Autumn Hawkbit

Lesser Hawkbit

Cat's-ear
INSET: **Flower head**

Smooth Cat's-ear

Spotted Cat's-ear

Smooth Hawk's-beard

Rough Hawk's-beard

Beaked Hawk's-beard

Bog Asphodel *Narthecium ossifragum* ❀ HEIGHT to 20cm

Tufted, hairless perennial that grows in boggy heaths and moors. The whole plant turns orange-brown in fruit and persists into early winter at least. FLOWERS 12–15mm across, yellow, star-like, with woolly orange anthers; in spikes (June–Aug). FRUITS Splitting capsules. LEAVES Narrow, iris-like, basal; in a flat fan. STATUS Widespread in the north and west, much more local in the south and east.

Scottish Asphodel *Tofieldia pusilla* ❀❀ HEIGHT to 20cm

Upright, delicate, hairless perennial that is easy to overlook. Grows in damp ground and bogs, mainly in mountain regions. FLOWERS 2–3mm across, greenish white with 3 blunt lobes; in dense, rounded spikes on slender stems (June–Aug). FRUITS Capsules. LEAVES Iris-like, in a flat, basal fan. STATUS Restricted to Scottish Highlands (where it is fairly widespread) and Upper Teesdale.

Meadow Saffron *Colchicum autumnale* ❀❀ HEIGHT to 10cm

Bulbous perennial. Flowers appear in autumn, long after the leaves have withered. Can be confused with Autumn Crocus (p. 228). Grows in undisturbed meadows and woodland rides. FLOWERS Pinkish purple, 6-lobed, with orange anthers and 6 stamens; on slender stalks (in fact the extended perianth tube) (Aug–Oct). FRUITS Capsules. LEAVES Long, ovate, appearing in spring. STATUS Local, central England.

Martagon Lily *Lilium martagon* ❀❀ HEIGHT to 1.8m

Upright bulbous perennial that grows in woodland and scrub. FLOWERS 4–5cm across, reddish purple with darker spots, the perianth segments extremely recurved; pendent, in open spikes (June–July). FRUITS Capsules. LEAVES Ovate, glossy dark green, in whorls. STATUS A familiar garden plant that is naturalised occasionally, but possibly native in a few locations in S Britain.

Pyrenean Lily *Lilium pyrenaicum* ❀❀❀ HEIGHT to 1.5m

Upright bulbous perennial that grows on banks and in hedgerows. FLOWERS 4–5cm across, yellow with dark spots, the perianth segments extremely recurved; in spikes (May–July). FRUITS Capsules. LEAVES Narrow, alternate up the stem. STATUS A familiar garden plant that has become naturalised in a few locations in SW England, Wales and W Ireland.

Yellow Star-of-Bethlehem *Gagea lutea* ❀❀ HEIGHT to 15cm

Delicate perennial that grows in damp woodland, often on calcareous or heavy soils. Easily overlooked when not in flower. FLOWERS 2cm across, yellow, star-like; in umbel-like clusters of 1–7 (Mar–May). FRUITS 3-sided capsules. LEAVES Comprising a single, narrow basal leaf with a hooded tip and 3 distinctly ridged veins. STATUS Local and generally scarce; least uncommon in central England.

Star-of-Bethlehem *Ornithogalum angustifolium* ❀❀ HEIGHT to 25cm

Bulbous perennial of dry grassland. FLOWERS 3–4cm across, star-like (opening only in sunshine), the 6 white petals with a green stripe on the back; in umbel-like clusters (May–June). FRUITS Capsules with 6 ridges. LEAVES Narrow with a white stripe down the centre. STATUS Possibly native in E England; naturalised elsewhere.

Spiked Star-of-Bethlehem *Ornithogalum pyrenaicum* ❀❀❀ HEIGHT to 80cm

Upright perennial of open woodland. Also known as **Bath Asparagus**. Grows in scrub and open woodland. FLOWERS 2cm across, greenish white; in tall, drooping-tipped spikes (May–July). FRUITS Capsules. LEAVES Grey-green, narrow, basal; soon withering. STATUS Very local, mainly from Bath east along M4 corridor.

■ *See also* Grape-hyacinth (p.278), Early Star-of-Bethlehem (p.281), Snowdon Lily (p.281), Rannoch-rush (p.284) and Pipewort (p.286).

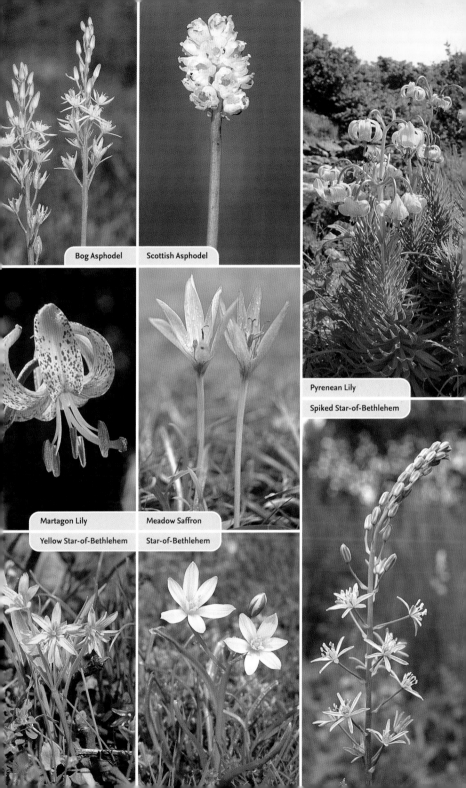

Bog Asphodel

Scottish Asphodel

Pyrenean Lily

Spiked Star-of-Bethlehem

Martagon Lily

Meadow Saffron

Yellow Star-of-Bethlehem

Star-of-Bethlehem

Wild Tulip *Tulipa sylvestris* ✿✿✿ **HEIGHT** to 40cm

Attractive bulbous perennial that grows in meadows and along grassy woodland rides. **FLOWERS** 3–4cm across (when fully open), fragrant, with yellow petals sometimes tinged green below; solitary, on slender stems (May–June). **FRUITS** Capsules. **LEAVES** Grey-green, narrow, up to 25cm long. **STATUS** Introduced and now widely, but locally, naturalised, mainly in S England.

Bluebell *Hyacinthoides non-scripta* **HEIGHT** to 50cm

Attractive hairless, bulbous perennial that grows in woodland and also on coastal cliffs. In wooded areas where the management regime suits its needs (sympathetically coppiced Hazel is ideal) it forms extensive and continuous carpets on the woodland floor. **FLOWERS** Bell-shaped, with 6 *recurved lobes* at the mouth, bluish purple (very occasionally pink or white); in 1-*sided* drooping-tipped spikes (Apr–June). **FRUITS** Capsules. **LEAVES** Long, *15mm wide*, glossy green and all basal. **STATUS** Widespread throughout, and sometimes locally abundant.

Spanish Bluebell *Hyacinthoides hispanica* ✿ **HEIGHT** to 40cm

Bulbous perennial that grows in woods and hedges. Similar to Bluebell but separable by studying leaf size and flower structure. **FLOWERS** Bell-shaped, bluish purple, the 6 lobes *not recurved* at the mouth; in spikes that are *not 1-sided* (May–June). **FRUITS** Capsules. **LEAVES** Basal, long and up to *35mm wide*. **STATUS** Garden plant that is naturalised locally. The hybrid *H. non-scripta* x *H. hispanica* is more popular in gardens, and more widely naturalised, than Spanish Bluebell. Confusingly, plants show a spectrum of characters intermediate between the two parents.

Spring Squill *Scilla verna* ✿ **HEIGHT** to 5cm

Compact, resilient, hairless perennial that grows in dry, short coastal grassland, typically in sight of the sea. **FLOWERS** 10–15mm across, bell-shaped, *lilac-blue*; in upright terminal clusters on a short stalk, each flower having a *bluish-purple bract* (Apr–June). **FRUITS** Capsules. **LEAVES** Wiry, curly, basal, 4–6 in number; *appearing in early spring*, before the flowers. **STATUS** Locally common on the coasts of W Britain and E Ireland; scarce or absent elsewhere.

Autumn Squill *Scilla autumnalis* ✿✿ **HEIGHT** to 7cm

Similar to Spring Squill but separable by flowering time and subtle difference in appearance of the flowers. Confined to coastal grassland. **FLOWERS** 10–15mm across, bell-shaped, *bluish purple*; in compact terminal clusters on a slender stalk, the *flowers lacking an accompanying bract* (July–Sep). **FRUITS** Capsules. **LEAVES** Wiry, basal, *appearing in autumn*. **STATUS** Coasts of SW England only.

Ramsons *Allium ursinum* **HEIGHT** to 35cm

Bulbous perennial that smells strongly of garlic. Grows in damp woodland, mainly on calcareous soils; where conditions suit its needs it often spreads, forming extensive carpets. **FLOWERS** 15–20mm across, white, bell-shaped; in spherical, terminal clusters on slender, 3-sided, leafless stalks (Apr–May). **FRUITS** Capsules. **LEAVES** Ovate, to 7cm wide and 25cm long, all basal. **STATUS** Widespread throughout much of the region, and locally abundant.

Wild Leek *Allium ampeloprasum* ✿✿✿ **HEIGHT** to 2m

Robust bulbous perennial with a rounded stem. Grows in grassy places near the sea. **FLOWERS** 6–8mm long, purplish with yellow anthers; in spherical heads, 9cm across (June–Aug) Note **Babington's Leek** (var. *babingtonii*) has more open heads than var. *ampeloprasum*. Numerous bulbils may be present. **FRUITS** Capsules. **LEAVES** Flat, narrow, up to 50cm long, and waxy with finely toothed margins. **STATUS** Rare and restricted to coastal districts in SW Britain and W Ireland.

■ *See also* Round-headed Leek (p.271)

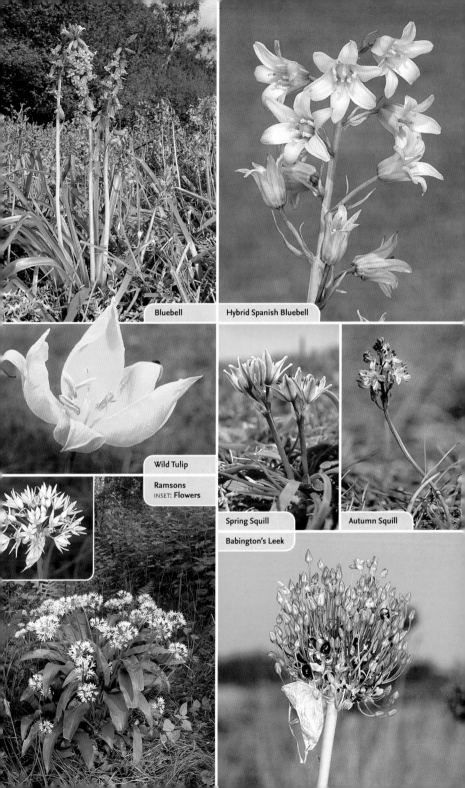

Bluebell

Hybrid Spanish Bluebell

Wild Tulip

Ramsons
INSET: Flowers

Spring Squill

Autumn Squill

Babington's Leek

Sand Leek *Allium scorodoprasum* ✿✿ HEIGHT to 1m

Upright bulbous perennial. Grows in dry grassland on sandy soils. FLOWERS Ovoid, stalked, purplish, stamens not projecting; in rounded umbels 3–4cm across, with purple bulbils and 2 papery bracts (July–Aug). FRUITS Capsules. LEAVES Narrow, keeled, rough-edged. STATUS Local, mainly N England and S Scotland.

Three-cornered Garlic *Allium triquetrum* ✿✿ HEIGHT to 45cm

Bulbous perennial that smells strongly of garlic when bruised. Grows in hedges and disturbed ground. FLOWERS 2cm long, bell-shaped, white with narrow green stripes; in drooping umbels on 3-sided stems (Mar–June). FRUITS Capsules. LEAVES Narrow, keeled; 3 per plant. STATUS Introduced and naturalised locally in the south-west.

Few-flowered Leek *Allium paradoxum* ✿✿✿ HEIGHT to 45cm

Bulbous perennial that grows in woodland and hedgerows. FLOWERS 2cm long, ovoid to bell-shaped, whitish; stalked, in few-flowered (often only 1) umbels with numerous bulbils (Apr–May). FRUITS Capsules. LEAVES Narrow; 1 per plant. STATUS Introduced and naturalised locally in a few locations, mainly in the north.

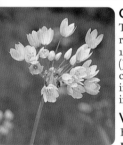

Chives *Allium schoenoprasum* ✿✿ HEIGHT to 40cm

Tufted, bulbous perennial of damp, grassy places on limestone rocks. FLOWERS Purplish, in heads 2–4cm across, comprising 10–30 flowers and 2 papery bracts; stamens not projecting (June–Sep). FRUITS Capsules. LEAVES Green, hollow, cylindrical. STATUS Widely cultivated; local native plant, mainly in the west. **Rosy Garlic** *A. roseum* is taller with stalked, pink flowers in heads 4–5cm across (May–June). Naturalised locally in south.

Rosy Garlic

Wild Onion *Allium vineale* HEIGHT to 60cm

Bulbous perennial of dry grassland and roadside verges. FLOWERS Pink or white, long-stalked, in umbels along with greenish-red bulbils and a papery bract; proportion of flowers to bulbils varies considerably (June–July). FRUITS Capsules. LEAVES Grey-green, hollow, semicircular in cross-section. STATUS Common in the south.

Field Garlic *Allium oleraceum* ✿✿ HEIGHT to 1m

Perennial of dry, grassy places. FLOWERS Whitish, bell-shaped, with stamens not protruding; long-stalked, in open heads with bulbils and 2 long bracts, the longest 15–20cm long (July–Aug). FRUITS Capsules. LEAVES Slender, semicircular or rounded, channelled in cross-section. STATUS Widespread but local. **Keeled Garlic** (*A. carinatum*) is similar but with pink flowers and protruding stamens. Naturalised locally.

Lily-of-the-valley *Convallaria majalis* ✿✿ HEIGHT to 20cm

Creeping perennial of dry woodland, usually on calcareous soils. FLOWERS Bell-shaped, white; in 1-sided spikes, the flowers stalked and nodding (May–June). FRUITS Red berries. LEAVES Oval and basal; 2 or 3 per plant. STATUS Locally native in England and Wales; sometimes naturalised as a garden escape.

Angular Solomon's-seal *Polygonatum odoratum* ✿✿ HEIGHT to 50cm

Creeping perennial with *angled*, arching stems. Grows on rocky ground, mainly on limestone, sometimes in limestone pavements. FLOWERS Bell-shaped, *not waisted*, white; in clusters of 1–2, arising from leaf axils (May–June). FRUITS Blackish berries. LEAVES Ovate, alternate. STATUS Local, mainly in N and NW England.

Common Solomon's-seal *Polygonatum multiflorum* ✿ HEIGHT to 60cm

Creeping perennial with *rounded*, arching stems. Grows in dry woodland, often on calcareous soils. FLOWERS Bell-shaped, waisted in the middle, white; in clusters of 1–3, arising from leaf axils (May–June). FRUITS Bluish-black berries. LEAVES Ovate, alternate. STATUS Locally common only in S England.

Sand Leek

Three-cornered Garlic

Few-flowered Leek

Chives

Wild Onion
INSET: Sprouting bulbils

Keeled Garlic

Lily-of-the-valley

Angular Solomon's-seal

Common Solomon's-seal

May Lily *Maianthemum bifolium* ✿✿✿ HEIGHT to 20cm

Attractive perennial with a creeping rhizome and upright stalks bearing a single pair of leaves and the flower spike. Grows in mature woodlands, often on acid soils. FLOWERS 2–5mm across, white, 4-parted; in spikes 3–4cm long (May–June). FRUITS Red berries, produced only rarely. LEAVES Heart-shaped, shiny, the lower one long-stalked. STATUS Local, N and E England only.

Herb-Paris *Paris quadrifolia* ✿✿ HEIGHT to 35cm

Unusual, distinctive perennial that grows in undisturbed damp woodland, often on calcareous soils. FLOWERS Curious, comprising narrow greenish-yellow petals and sepals, topped by a dark, purplish ovary and yellow stamens; solitary, terminal (May–June). FRUITS Black berries. LEAVES Broad, oval, in whorls of 4. STATUS Widespread throughout much of the region but always extremely local.

Asparagus

Asparagus *Asparagus officinalis* ✿✿ HEIGHT to 1.5m

Branched, hairless perennial that is either upright or prostrate. Young shoots are the familiar vegetable. Grows in free-draining grassy places. FLOWERS 4–6mm long, greenish, bell-shaped; in leaf axils, with separate-sex plants (June–Sep). FRUITS Red berries. LEAVES Reduced to tiny bracts; what appear to be leaves are in fact slender, branched stems. STATUS **Garden Asparagus** (ssp. *officinalis*) is locally naturalised; prostrate **Wild Asparagus** (ssp. *prostratus*) grows on sea cliffs in the south-west.

Butcher's-broom *Ruscus aculeatus* ✿ HEIGHT to 1m

Branched, evergreen perennial of shady woods, often on calcareous soils. FLOWERS Tiny, solitary; on upper surface of leaf-like structures (Jan–Apr). FRUITS Red berries. LEAVES Minute; oval, spine-tipped leaf-like structures are flattened branches. STATUS Locally common native in the south; naturalised elsewhere.

Fritillary *Fritillaria meleagris* ✿✿ HEIGHT to 30cm

Perennial of undisturbed water meadows. FLOWERS 3–5cm long, nodding, bell-shaped, usually pinkish purple with dark chequerboard markings (sometimes pure white); on slender stems (Apr–May). FRUITS Capsules. LEAVES Grey-green, narrow, grass-like. STATUS Very locally abundant in S England; naturalised elsewhere.

Wild Daffodil *Narcissus pseudonarcissus* ✿ HEIGHT to 50cm

Bulbous perennial of open woods and meadows that often flourishes after coppicing. FLOWERS 5–6cm across, with 6 pale yellow outer segments and a deep yellow trumpet (Mar–Apr). FRUITS Capsules. LEAVES Grey-green, narrow, all basal. STATUS Locally common native in parts of England and Wales; sometimes naturalised elsewhere.

Fritillary, white form

Snowdrop *Galanthus nivalis* HEIGHT to 25cm

Familiar spring perennial that grows in damp woodland. FLOWERS 15–25mm long, the 3 outer segments pure white, the inner 3 white with a green patch; solitary, nodding (Jan–Mar). FRUITS Capsules. LEAVES Grey-green, narrow, all basal. STATUS Possibly native in S Britain but widely naturalised.

Summer Snowflake *Leucojum aestivum* ✿✿ HEIGHT to 60cm

Perennial of damp, deciduous woodland. FLOWERS 15–20mm long, bell-shaped, mainly white, but with green marks on the 6 pointed segments; nodding, in umbels of 2–5 flowers with a greenish spathe (Apr–June). FRUITS Capsules. LEAVES Bright green, strap-like. STATUS Very local native in S England; naturalised elsewhere. **Spring Snowflake** (*L. vernum*) is similar but with solitary flowers. Rare native, Somerset and Dorset only.

Spring Snowflake

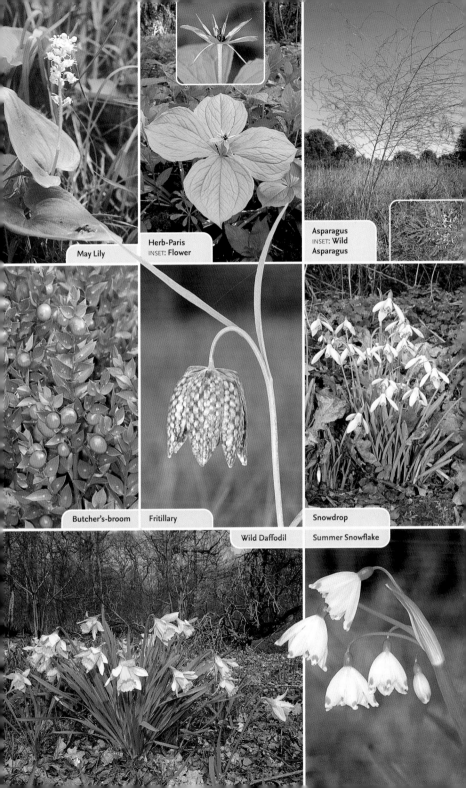

May Lily

Herb-Paris
INSET: Flower

Asparagus
INSET: Wild
Asparagus

Butcher's-broom

Fritillary

Snowdrop

Wild Daffodil

Summer Snowflake

Yellow Iris *Iris pseudacorus* (Iridaceae) **HEIGHT** to 1m
Familiar, robust perennial that grows in pond margins and marshes, and on river banks. **FLOWERS** 8–10cm across, bright yellow with faint purplish veins; in clusters of 2–3 (May–Aug). **FRUITS** Oblong, 3-sided. **LEAVES** Grey-green, sword-shaped, often wrinkled. **STATUS** Widespread and common throughout.

Stinking Iris *Iris foetidissima* (Iridaceae) ✤ **HEIGHT** to 60cm
Tufted perennial of scrub and woodlands, mostly on calcareous soils. **FLOWERS** 7–8cm across, purplish, veined (May–July). **FRUITS** Green, oblong, 3-sided, splitting to reveal orange seeds. **LEAVES** Dark green, sword-shaped, with an unpleasant smell. **STATUS** Locally common only in S England and S Wales.

Spring Crocus *Crocus vernus* (Iridaceae) ✤✤✤ **HEIGHT** to 20cm
Perennial that resembles many garden forms of crocus. Grows in undisturbed grassland. **FLOWERS** 3–4cm across (when open fully), pinkish purple with pale stripes (Mar). **FRUITS** Capsules. **LEAVES** Long, narrow, linear, with a white midrib stripe on the upper surface. **STATUS** Naturalised locally and generally rare.

Stinking Iris fruit

Autumn Crocus *Crocus nudiflorus* (Iridaceae) ✤✤✤ **HEIGHT** to 20cm
Grassland perennial, similar to Spring Crocus but flowering in autumn. Beware confusion with Meadow Saffron (p.220). **FLOWERS** 3–4cm across (when fully open), violet, faintly veined, with 3 stamens (6 in Meadow Saffron) (Sep–Oct). **FRUITS** Capsules. **LEAVES** Narrow with a white midrib stripe. **STATUS** Locally naturalised. **Bieberstein's Crocus** *C. speciosus* is similar but darker veined. Naturalised in the south.

Montbretia *Crocosmia × crocosmiiflora* (Iridaceae) ✤ **HEIGHT** to 70cm
Showy perennial that grows in hedgerows and on roadside verges and disturbed ground. **FLOWERS** Reddish-orange, in 1-sided spikes (July–Aug). **FRUITS** Capsules. **LEAVES** Narrow, linear, flat, superficially iris-like. **STATUS** A cultivated hybrid, naturalised as a garden escape, mainly in the south.

Black Bryony *Tamus communis* (Dioscoreaceae) ✤ **HEIGHT** to 3m
Twining perennial. Similar to White Bryony (p.114), but note different leaf shape and lack of tendrils. Grows in hedgerows and scrub. **FLOWERS** Tiny, yellowish green, 6-petalled; separate-sex plants (May–Aug). **FRUITS** Red berries. **LEAVES** Heart-shaped, glossy, netted. **STATUS** Widespread in England and Wales.

Lords-and-ladies *Arum maculatum* (Araceae) **HEIGHT** to 50cm
Perennial of woods and hedges. **FLOWERS** Comprising a pale green, *purple-margined* spathe, cowl-shaped and part-shrouding the club-shaped, *purplish-brown spadix*; on slender stalks (Apr–May). **FRUITS** Red berries, in a spike. **LEAVES** Arrowhead-shaped, stalked, sometimes dark-spotted; appearing in spring. **STATUS** Commonest in the south.

Fruit
Leaf

Italian Lords-and-ladies *Arum italicum* (Araceae) ✤✤ **HEIGHT** to 50cm
Perennial of shady places. **FLOWERS** Comprising a yellowish spathe *(not purple-margined)*, cowl-shaped (the tip overhanging), and a *yellow spadix* (May–June). **FRUITS** Red berries, in a spike. **LEAVES** Arrowhead-shaped but less pointed than Lords-and-ladies; *some appear in autumn.* **STATUS** Common only in S England; a garden escape elsewhere.

Sweet-flag *Acorus calamus* (Araceae) ✤✤ **HEIGHT** to 1m
Impressive perennial that grows in shallow freshwater margins. **FLOWERS** Comprising a long green spathe and a yellowish-green, cylindrical spadix 7–9cm long that projects at an angle; on long stalks (June–Aug). **FRUITS** None. **LEAVES** Long, narrow, with wavy margins. **STATUS** Introduced and naturalised locally.

■ *See also* Sand Crocus (p.271), Wild Gladiolus (p.275) and Blue-eyed Grass (p.286)

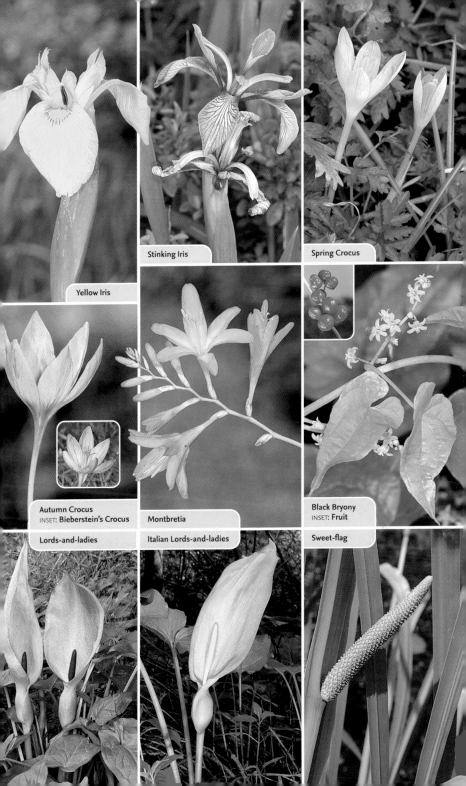

Yellow Iris

Stinking Iris

Spring Crocus

Autumn Crocus
INSET: Bieberstein's Crocus

Montbretia

Black Bryony
INSET: Fruit

Lords-and-ladies

Italian Lords-and-ladies

Sweet-flag

Fly Orchid *Ophrys insectifera* ❀ HEIGHT to 40cm

Slender perennial of dry grassland, open woodland and scrub on calcareous soils. FLOWERS Fancifully insect-like, with greenish sepals and thin, brown, antenna-like upper petals; lower petal 6–7mm across, velvety maroon with a metallic-blue patch, and elongated with 2 side lobes. Up to 14 flowers in an open spike (May–June). FRUITS Egg-shaped. LEAVES Oval, glossy; as a basal rosette and on stem. STATUS Locally common only in England and Wales.

Bee Orchid *Ophrys apifera* ❀ HEIGHT to 30cm

Perennial of dry grassland, mainly on calcareous soils. FLOWERS With pink sepals and green upper petals; lower petal 12mm across, expanded, furry and maroon with variable, pale yellow markings (vaguely bumblebee-like). In spikes (June–July). FRUITS Egg-shaped. LEAVES Green, oval, in a basal rosette, with 2 sheathing leaves on stem. STATUS Locally common only in England, Wales and S Ireland.

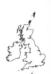

Early Spider-orchid *Ophrys sphegodes* ❀❀ HEIGHT to 35cm

Perennial of dry grassland, on calcareous soils. In grazed areas, the plant is often rather short. FLOWERS Comprising green sepals and yellowish-green upper petals; lower lip 12mm across, expanded, furry, maroon-brown, variably marked with a metallic-blue H-shaped mark. In spikes (Apr–May). FRUITS Egg-shaped. LEAVES Green, seen mainly as a basal rosette. STATUS Local, in S England only.

Early Purple Orchid *Orchis mascula*
HEIGHT to 40cm

Attractive perennial that grows in woodland, scrub and grassland, doing especially well on neutral or calcareous grassland. FLOWERS Pinkish purple, 8–12mm long, with a 3-lobed lower lip and a long spur; in tall spikes (Apr–June). FRUITS Egg-shaped. LEAVES Glossy, dark green with dark spots; these appear first as a rosette, from January onwards, from which the flower stalk arises later in spring. STATUS Widespread and locally common throughout much of the region.

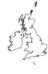

Basal rosette of leaves

Man Orchid *Orchis anthropophorum* ❀❀ HEIGHT to 30cm

Intriguing, distinctive orchid of calcareous grassland and scrub. FLOWERS Fancifully man-like, with a pronounced green hood (comprising sepals and upper petals), an elongated 4-lobed lip (12–15mm long) and a spur; in tall, dense spikes (May–June). FRUITS Forming and swelling at base of flowers. LEAVES Oval, fresh green, forming a basal rosette and sheathing the lower part of the flower stem. STATUS Local, restricted to SE England, where it occurs as isolated colonies.

Lady Orchid *Orchis purpurea* ❀❀ HEIGHT to 75cm

Impressive, attractive perennial that grows in woodland and scrub, mostly on chalk soils. FLOWERS With a dark red hood and a pale pink, red-spotted lip; in a cylindrical spike 10–15cm tall, with flowers opening from the bottom (Apr–June). FRUITS Egg-shaped. LEAVES Broad, oval, forming a basal rosette and loosely sheathing the stem. STATUS Confined to S England and locally common only in Kent.

Burnt Orchid *Neotinea ustulata* ❀❀ HEIGHT to 15cm

Charming perennial of chalk downland. FLOWERS Dark maroon in bud, but with a red-spotted white lip and a red hood when open; in compact, somewhat cylindrical spikes that are fancifully reminiscent of intact cigar ash (May–July). FRUITS Egg-shaped. LEAVES Dull green, forming a basal rosette and also sheathing the stem. STATUS Very locally common only in S England.

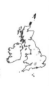

■ *See also* Late Spider Orchid (p.277), Military Orchid (p.280), Monkey Orchid (p.280) and Dense-flowered Orchid (p.286)

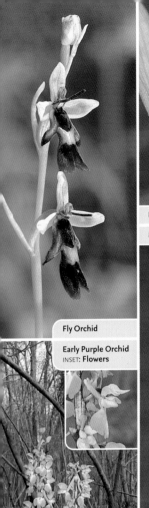

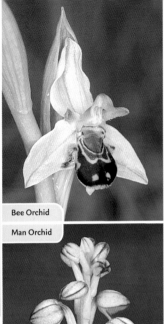

Bee Orchid

Man Orchid

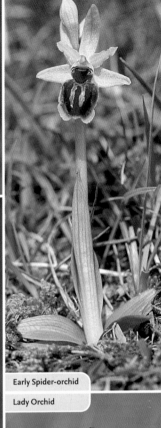

Fly Orchid

Early Purple Orchid
INSET: Flowers

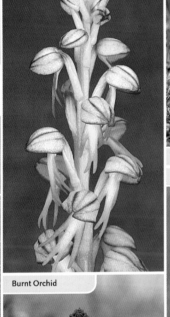

Early Spider-orchid

Lady Orchid

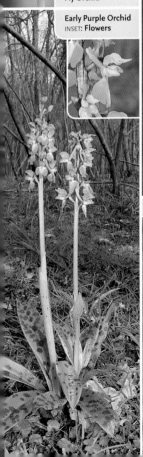

Burnt Orchid

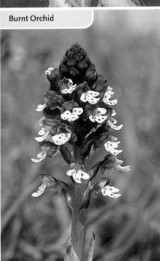

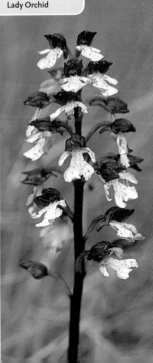

Common Spotted-orchid *Dactylorhiza fuchsii* HEIGHT to 60cm

Orchid of grassland and open woods on calcareous or neutral soils.
FLOWERS Varying in colour from plant to plant, ranging from pale
pink to pinkish purple; darker streaks and spots on lower lip, which
has 3 *even-sized lobes* and is 1cm across; in open spikes (May–Aug).
FRUITS Egg-shaped. LEAVES Green, glossy, dark-spotted; basal rosette
appearing before flower stalk; narrower leaves sheathing lower part of the
stalk. STATUS Locally common. Several regional varieties are recognised.

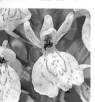

Heath Spotted-orchid *Dactylorhiza maculata* HEIGHT to 50cm

Superficially similar to Common Spotted-orchid but restricted to
damp, mostly acid soils on heaths and moors. FLOWERS Usually
very pale, sometimes almost white, but with darker streaks and
spots; lower lip broad and 3-lobed, with *central lobe smaller than the
outer 2*. In open spikes (May–Aug). FRUITS Egg-shaped. LEAVES
Lanceolate, dark-spotted, those at the base largest and broadest, with
narrower leaves sheathing the stem. STATUS Locally common throughout.

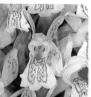

Early Marsh-orchid *Dactylorhiza incarnata* ❀ HEIGHT to 60cm

Orchid of damp meadows, often on calcareous soils but sometimes
on acid ground. FLOWERS Usually flesh-pink, but creamy white or
reddish purple in certain subspecies; *3-lobed lip strongly reflexed
along the mid-line*, hence flower is narrow when viewed from the
front. In spikes (May–June). FRUITS Egg-shaped. LEAVES Yellowish
green, unmarked, narrow-lanceolate, often hooded at the tip. STATUS
Local throughout.

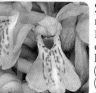

Southern Marsh-orchid *Dactylorhiza praetermissa* ❀

HEIGHT to 70cm
Robust orchid of water meadows, fens and wet dune slacks, mostly
on calcareous soils. FLOWERS Pinkish purple with a broad 3-lobed
lip, 11–14mm long, the lobes shallow and blunt; in tall, dense spikes
(May–June). FRUITS Egg-shaped. LEAVES Glossy dark green, unmarked
(rarely ring-spotted), broadly lanceolate, largest at the base and becoming
narrower and sheathing up the stem. STATUS Common only in the south.

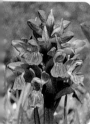

Northern Marsh-orchid *Dactylorhiza purpurella* ❀❀

HEIGHT to 60cm
Northern counterpart of Southern Marsh-orchid. Grows in damp
meadows. FLOWERS Reddish purple, the lip *broadly diamond-shaped
with indistinct lobes* and dark streaks; in spikes (June–July). FRUITS
Egg-shaped. LEAVES Green, *narrow*, including those at the base. STATUS
Mainly N England, N Wales and N Ireland. **Hebridean Marsh-orchid** D. *ebu-
densis* is similar but with deeper-purple flowers and dark-spotted leaves;
restricted to N Uist.

Hebridean Marsh-orchid

Irish Marsh-orchid *Dactylorhiza majalis* ❀❀ HEIGHT to 60cm

Robust orchid of damp meadows, often on calcareous soils. FLOWERS *Magenta*
to pinkish purple, with a broad lip, the side lobes of which are broader than
the prominent central one; in spikes (May–July). FRUITS Egg-shaped. LEAVES
Elliptical, usually dark-spotted; *basal leaves broad*, those on the stem narrower
and sheathing. STATUS Local and mainly coastal in Ireland.

Narrow-leaved Marsh-orchid *Dactylorhiza traunsteinerioides* ❀❀ HEIGHT to 50cm

Delicate orchid of fens and marshes. FLOWERS Pinkish purple, the well-marked lip
3-lobed with the *central lobe longer than side ones*; in short, open, *few-flowered spikes*
(May–June). FRUITS Egg-shaped. LEAVES *Narrow*, lanceolate, keeled, usually
unspotted. STATUS Very local in England, Wales and Ireland.

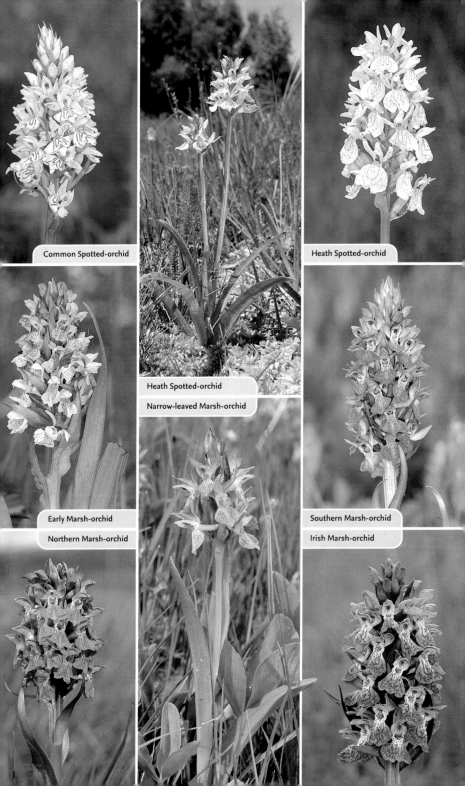

Common Spotted-orchid

Heath Spotted-orchid

Heath Spotted-orchid

Narrow-leaved Marsh-orchid

Early Marsh-orchid

Northern Marsh-orchid

Southern Marsh-orchid

Irish Marsh-orchid

Frog Orchid *Dactylorhiza viridis* ❀ HEIGHT to 20cm

A short, compact orchid, mostly found on calcareous grassland. FLOWERS Fancifully frog-like; the sepals and upper petals forming a greenish hood, the lip 6–8mm long and yellowish brown; in an open spike (June–Aug). FRUITS Forming and swelling at the base of the flowers. LEAVES Broad, oval, forming a basal rosette, with narrower leaves partially sheathing the lower part of the stem. STATUS Widespread and locally common on chalk downs in the south, and on northern upland pastures.

Green-winged Orchid *Anacamptis morio* HEIGHT to 40cm

Perennial of undisturbed grassland. FLOWERS Varying in colour from plant to plant, ranging from pinkish purple to almost white; upper petals, in particular, marked with dark veins and often suffused green, while the lip has a red-dotted, pale central patch. In spikes (Apr–June). FRUITS Egg-shaped. LEAVES Glossy green, unmarked, appearing as a basal rosette, and sheathing the stem. STATUS Locally common in central and S England, S Wales and central Ireland.

ABOVE: **Green-winged Orchid, white form**
BELOW: **Pyramidal Orchid**

Pyramidal Orchid *Anacamptis pyramidalis* ❀ HEIGHT to 30cm

An attractive orchid of dry grassland and usually associated with calcareous soils and stabilised sand dunes. FLOWERS Deep pink, with a 3-lobed lip and a long spur; in dense, conical or domed flower heads (June–Aug). FRUITS Forming and swelling at the base of the flowers. LEAVES Grey-green, lanceolate, usually carried upright, partially sheathing the flower stem. STATUS Locally common in parts of England, Wales and Ireland but commonest in the south-east.

Chalk Fragrant-orchid *Gymnadenia conopsea*
HEIGHT to 40cm

map covers all 3 species

A robust, relatively tall orchid that is associated with calcareous grassland; often occurs in dense colonies. FLOWERS Extremely fragrant, typically pink (although a spike's colour can vary from almost white to deep purple), with a 3-lobed lip and a long spur; in dense, cylindrical spikes to 15cm tall (June–Aug). FRUITS Forming and swelling at the base of the flowers. LEAVES Rather short, mostly at the base of the plant, with a few very narrow leaves up the stem. STATUS Widespread and locally common; most frequent in the south and south-east. **Heath Fragrant-orchid** *G. borealis* is similar but smaller and occurs on heaths; **Marsh Fragrant-orchid** *G. densiflora* is similar but grows in marshes.

Common Twayblade *Neottia ovata* HEIGHT to 50cm

A distinctive orchid of woodlands and grassland, and found on a wide range of soil types. FLOWERS Yellowish green, with a distinct hood and a deeply forked lower lip (10–15mm long); in a loose spike of 20 or more flowers (May–July). FRUITS Forming and swelling at the base of the flowers as they wither. LEAVES A pair of broad, oval basal leaves, up to 16cm long, that appear well before the flowering stem. STATUS Widespread and generally common; sometimes found in sizeable colonies.

Lesser Twayblade *Neottia cordata* ❀ HEIGHT to 20cm

Charming little orchid of moorland and conifer forests. Surprisingly easy to overlook on account of its size, and because it often grows under clumps of Heather (*see* p.136). FLOWERS Small (2–3mm long), reddish, comprising a hood and a forked lip; on a reddish stem, in a loose spike of 5–12 flowers (June–Aug). FRUITS Forming at the base of the flowers, altering the appearance of the reddish flowering spike very little. LEAVES A pair of oval basal leaves, up to 4cm long. STATUS Widespread but distinctly local in the north and north-west. Scarce or absent south of N Wales, the southernmost outpost being on Exmoor.

■ See also Loose-flowered Orchid (p.274), Fen Orchid (p.279) and Lady's-slipper Orchid (p.281)

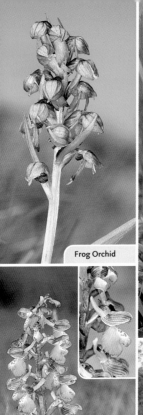

Frog Orchid

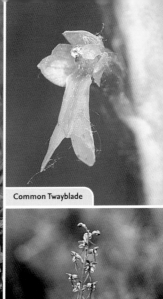

Common Twayblade

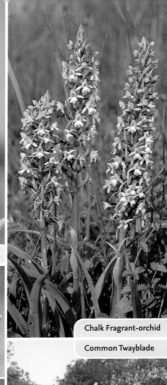

Chalk Fragrant-orchid

Common Twayblade

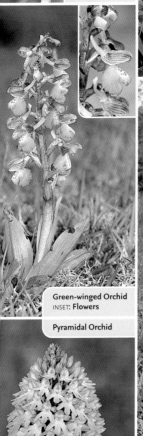

Green-winged Orchid
INSET: Flowers

Pyramidal Orchid

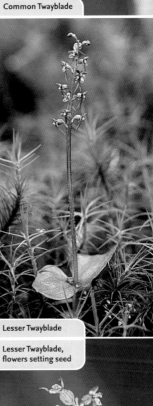

Lesser Twayblade

Lesser Twayblade,
flowers setting seed

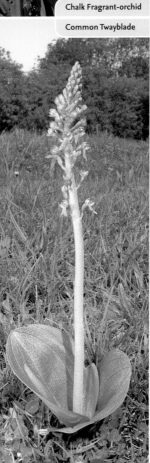

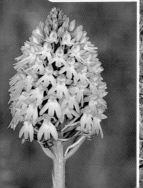

Bird's-nest Orchid *Neottia nidus-avis* ❀ HEIGHT to 35cm

Bizarre-looking orchid that entirely lacks chlorophyll and obtains its nutrition as a parasite of fungal hyphae. It is found in undisturbed woodland, usually under Beech. FLOWERS Brownish, with a hood and a 2-lobed lip, 10mm long; in fairly dense spikes (May–July). FRUITS Forming and swelling at the base of the flowers. LEAVES Reduced to brownish scale-like structures. STATUS Widespread throughout most of the region, except N Scotland, but always local.

Greater Butterfly-orchid *Platanthera chlorantha* ❀

HEIGHT to 50cm
Tall, elegant orchid of undisturbed woodland, scrub and grassland, mostly on calcareous soils. FLOWERS Greenish white with a long, narrow lip, a long spur (15–25mm) and *pollen sacs that form an inverted 'v'*; in open spikes (June–July). FRUITS Forming and swelling at the base of the flowers. LEAVES A single pair at the base of the plant and a few smaller stem leaves. STATUS Widespread but local.

Lesser Butterfly-orchid *Platanthera bifolia* ❀ HEIGHT to 40cm

Attractive orchid of undisturbed grassland, moors and open woodland, on a wide range of soil types. FLOWERS Greenish white with a long, narrow lip, a long spur (25–30mm) and *pollen sacs that are parallel*; in open spikes (May–July). FRUITS Forming and swelling at the base of the flowers. LEAVES A pair of large oval leaves at the base, and much smaller scale-like leaves up the stem. STATUS Widespread but local.

Lizard Orchid *Himantoglossum hircinum* ❀❀❀ HEIGHT to 1m

Extraordinary orchid of scrub, undisturbed grassland and stabilised dunes. Bizarrely, the flowers smell of goats. FLOWERS With a greenish-grey hood, adorned on the inside with reddish streaks, and an extremely long, twisted lip (up to 5cm); in tall spikes (May–July). FRUITS Forming and swelling at the base of the flowers. LEAVES Oval basal leaves that soon wither, and smaller stem leaves that persist. STATUS Regularly seen only in E Kent and Suffolk; very occasionally turns up elsewhere.

White Helleborine *Cephalanthera damasonium* ❀ HEIGHT to 50cm

Attractive orchid of woods and scrub on calcareous soils, often under Beech. FLOWERS 15–20mm long, creamy white, bell-shaped, partially open; each with a leafy bract; in tall spikes (May–July). FRUITS Forming and swelling at the base of the flowers. LEAVES Broad and oval at the base, but becoming smaller up the stem. STATUS Locally common in S England only.

Sword-leaved Helleborine *Cephalanthera longifolia* ❀❀

HEIGHT to 50cm
An elegant orchid of woods and scrub on calcareous soils. Superficially similar to White Helleborine. FLOWERS 20mm long, pure white, bell-shaped, opening more fully than those of White Helleborine; each with a leafy bract; in tall spikes (May–June). FRUITS Forming at the base of the flowers. LEAVES Long, narrow (narrower than White Helleborine), the largest at the base. STATUS Local and scarce, least so in SE England where it occurs in scattered colonies.

Red Helleborine *Cephalanthera rubra* ❀❀❀ HEIGHT to 50cm

An attractive orchid, but often difficult to appreciate because it usually grows in deep shade. Favours woods on calcareous soils, usually Beech. FLOWERS Reddish pink, bell-shaped, open widely at the mouth; in open spikes (June–July). FRUITS Forming and swelling at the base of the flowers. LEAVES Long, narrow. STATUS Rare and local in S England only, but possibly overlooked because of its habitat.

■ *See also Ghost Orchid (p.280)*

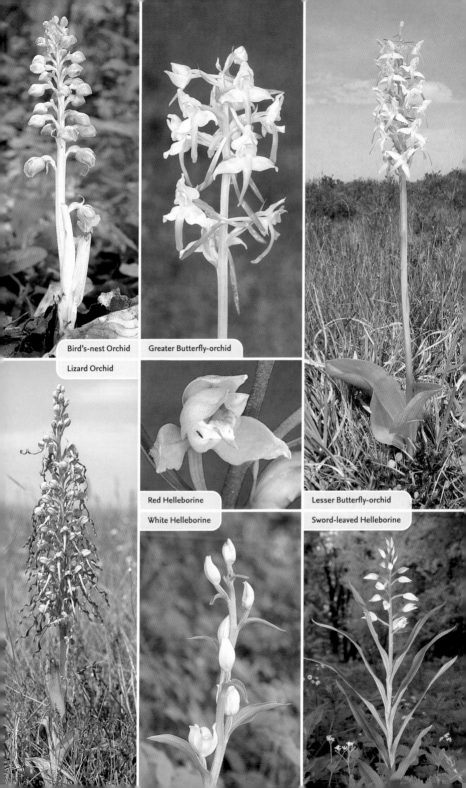

Bird's-nest Orchid

Greater Butterfly-orchid

Lizard Orchid

Red Helleborine

White Helleborine

Lesser Butterfly-orchid

Sword-leaved Helleborine

Marsh Helleborine *Epipactis palustris* ✿ **HEIGHT** to 50cm

Upright, elegant perennial. Grows in marshes, fens and wet dune slacks. **FLOWERS** Comprising reddish- or brownish-green sepals, narrow, whitish upper petals marked with red, and a frilly, whitish lip marked with red streaks towards the base; in open spikes of up to 14 flowers (July–Aug). **FRUITS** Pear-shaped. **LEAVES** Broad, oval towards the base of the plant but narrower up the stem. **STATUS** Very locally common in S England, S Wales and S Ireland; scarce or absent elsewhere.

Broad-leaved Helleborine *Epipactis helleborine* ✿ **HEIGHT** to 75cm

Upright, clump-forming perennial with rather downy stems. Grows in shady woodland and scrub. **FLOWERS** Comprising broad, greenish sepals tinged purple around the margins, broad *upper petals that are strongly purple-tinged*, and a purplish, heart-shaped lip, the tip of which is usually curved under; in dense spikes of up to 100 flowers (July–Sep). **FRUITS** Pear-shaped. **LEAVES** *Broadly oval*, strongly veined. **STATUS** Locally common in most parts, except N Scotland. **Young's Helleborine** var. *youngiana* is yellower; rare, on lead spoil, NW England.

Violet Helleborine *Epipactis purpurata* ✿✿

HEIGHT to 75cm

Upright, clump-forming perennial with *stems strongly violet-tinged*. Similar to Broad-leaved Helleborine. Grows in shady woods, mostly under Beech on chalk soils. **FLOWERS** Comprising rather narrow *sepals and upper petals that are greenish white inside*, and a heart-shaped *whitish lip that is tinged purplish towards the centre*; in spikes (Aug–Sep). **FRUITS** Pear-shaped. **LEAVES** *Narrow, parallel-sided*. **STATUS** Local, mainly S England.

Narrow-lipped Helleborine *Epipactis leptochila* ✿✿ **HEIGHT** to 70cm

Slender, upright perennial. Similar to Broad-leaved Helleborine but separable with care. Grows in shady woods, mainly under Beech on chalk soils. **FLOWERS** Comprising rather narrow, greenish-white sepals and upper petals, and a *narrow heart-shaped lip* that is greenish white, sometimes pink-tinged towards the centre, with a *tip that does not curve under*; in open spikes (June–July). **FRUITS** Pear-shaped. **LEAVES** Narrow-oval. **STATUS** Local, S England only.

Dune Helleborine *Epipactis dunensis* ✿✿✿ **HEIGHT** to 65cm

Upright perennial that is similar to Narrow-lipped Helleborine. Grows in dune slacks. **FLOWERS** Comprising rather narrow, greenish-white sepals and upper petals, and a *broadly heart-shaped lip* that is greenish white, sometimes pink-tinged towards the centre, and *curved under at the tip*; in open spikes, *flowers seldom opening fully* (June–July). **FRUITS** Pear-shaped. **LEAVES** Oval. **STATUS** Rare, restricted to Anglesey and N England. **Lindisfarne Helleborine** *E.sancta* is similar only recently split from *E. dunensis*. Restricted to Holy Island, Northumberland.

Green-flowered Helleborine *Epipactis phyllanthes* ✿✿ **HEIGHT** to 50cm

Slender, upright perennial with rather insignificant-looking flowers. Grows in shady woods on calcareous soils, and sometimes on dunes. **FLOWERS** Comprising *yellowish-green sepals and petals*; flowers pendent, invariably *not opening fully*; in open spikes (July–Sep). **FRUITS** Pear-shaped. **LEAVES** Narrow-ovate, strongly veined. **STATUS** Very local in S England and Wales; scarce or absent elsewhere.

Dark-red Helleborine *Epipactis atrorubens* ✿✿ **HEIGHT** to 60cm

Upright, downy, rather distinctive perennial that grows on limestone soils. **FLOWERS** Comprising rather broad sepals and upper petals, and a broad heart-shaped lip, all of which are *dark reddish purple*; in spikes (June–July). **FRUITS** Pear-shaped, downy. **LEAVES** Oval, tinged purple. **STATUS** Very local and restricted to N England, N Wales, NW Scotland and W Ireland.

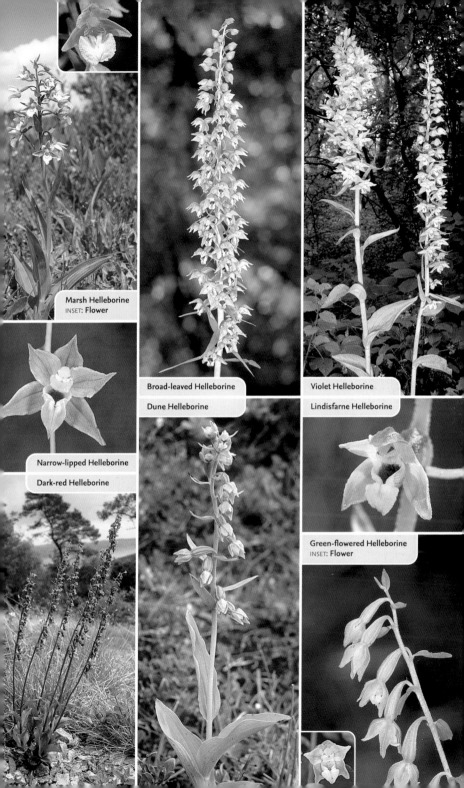

Marsh Helleborine
INSET: Flower

Narrow-lipped Helleborine

Dark-red Helleborine

Broad-leaved Helleborine

Dune Helleborine

Violet Helleborine

Lindisfarne Helleborine

Green-flowered Helleborine
INSET: Flower

Autumn Lady's-tresses *Spiranthes spiralis* HEIGHT to 15cm

Charming little orchid that is easy to overlook until you have got your eye in. Grows in short, dry grassland, both inland and on coastal turf and dunes. FLOWERS Pure white; petals and sepals downy; in a distinct spiral up the grey-green stem (Aug–Sep). FRUITS Egg-shaped, downy. LEAVES Appearing as a basal rosette of oval leaves that wither long before the flower stem appears. STATUS Locally common in S England, Wales and SW Ireland.

Irish Lady's-tresses *Spiranthes romanzoffiana* ❀❀❀ HEIGHT to 25cm

Upright perennial that grows in waterlogged grassland and marshes. FLOWERS Greenish white, in a triple spiral up the stem, creating a rather conical spike (July–Aug). FRUITS Egg-shaped. LEAVES Appearing as a basal rosette of narrowly oval leaves, with more lanceolate ones up the stem. STATUS Rare; restricted to SW and N Ireland, NW Scotland, with an outpost on Dartmoor.

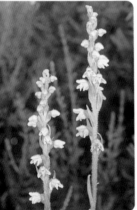

Creeping Lady's-tresses *Goodyera repens* ❀❀ HEIGHT to 25cm

Perennial with both creeping stems and upright flowering stalks. Grows in mature, undisturbed conifer woodland (mainly Scots Pine). FLOWERS White, slightly sticky and not opening fully; arranged in a spiral fashion, in open spikes (July–Aug). FRUITS Egg-shaped. LEAVES Oval, stalked, net-veined evergreen. STATUS Locally common only in Scotland and N England; rare in N Norfolk.

Small-white Orchid *Pseudorchis albida* ❀❀ HEIGHT to 30cm

Slender upright perennial that grows in grassland and on rock ledges, in mountains and upland regions except in the far north. FLOWERS 2–3mm across, greenish white; in cylindrical spikes (May–July). FRUITS Egg-shaped. LEAVES Lanceolate at the base of the plant, becoming narrower up the stem. STATUS Very locally common in Scotland; increasingly scarce, or absent, further south.

Creeping Lady's-tresses

Musk Orchid *Herminium monorchis* ❀❀ HEIGHT to 15cm

Charming, delicate perennial with yellowish-green stems and leaves. Grows in dry, calcareous grassland. FLOWERS Tiny, yellowish, with narrow lobes to the lip and a fragrance of honey; in dainty-looking spikes, 2–4cm long (June–July). FRUITS Egg-shaped. LEAVES Oval at the base of the plant but small and bract-like up the stem. STATUS Locally common only in S England.

Bog Orchid *Hammarbya paludosa* ❀❀ HEIGHT to 8cm

Delicate, slender perennial that grows among *Sphagnum* moss in floating bogs. Stems are bulbous at the base. The whole plant looks yellowish green. FLOWERS Tiny, with a narrowly ovate lip; in spikes up to 5cm long (July–Sep). FRUITS Egg-shaped. LEAVES Rounded-oval, mainly basal. STATUS Widespread but local in Scotland; scarce or absent elsewhere although locally common in the New Forest.

Coralroot Orchid *Corallorhiza trifida* ❀❀ HEIGHT to 25cm

Intriguing creeping perennial that grows in damp, shady woodland and in dune slacks. The plant is yellowish green and saprophytic, feeding on decaying plant matter, and it lacks leaves. FLOWERS Greenish white, the lip often tinged and streaked with red; in open spikes (June–July). FRUITS Egg-shaped. LEAVES Absent. STATUS Widespread and very locally common only in N England and Scotland.

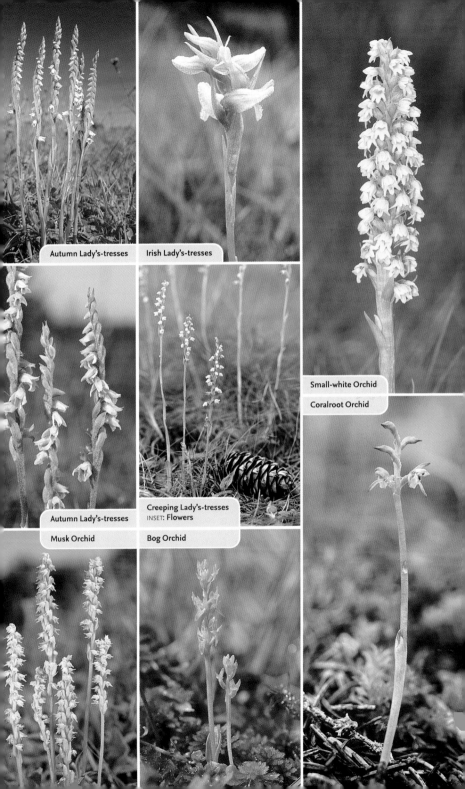

Autumn Lady's-tresses

Irish Lady's-tresses

Small-white Orchid

Coralroot Orchid

Autumn Lady's-tresses

Creeping Lady's-tresses
INSET: Flowers

Musk Orchid

Bog Orchid

Yellow Water-lily *Nuphar lutea* (Nymphaeaceae) AQUATIC

Water plant of still or slow-flowing fresh water to a depth of 5m. Tolerates partial shade and nutrient-rich waters. **FLOWERS** 6cm across, *yellow*, alcohol-scented; on *stalks that rise well above the water surface* (June–Sep). **FRUITS** Flagon-shaped, smooth. **LEAVES** To 40cm across, leathery; unlike White Water-lily, *basal lobes usually touch or overlap*. **STATUS** Widespread and locally common.

White Water-lily *Nymphaea alba* (Nymphaeaceae) AQUATIC

Water plant, conspicuous when its large, floating leaves are visible (they die back in winter). Grows in still or slow-flowing fresh water to a depth of 3m. **FLOWERS** 15–20cm across, fragrant, and comprising 20–25 white or pinkish-white petals that open fully only in bright sunshine; on stalks just above the water surface (June–Aug). **FRUITS** Globular, green, warty. **LEAVES** 10–30cm across, rounded and floating, the upper surface water-repellent. **STATUS** Widespread and locally common.

Fringed Water-lily *Nymphoides peltata* (Menyanthaceae) ✿✿ AQUATIC

Perennial water plant. Recalls Yellow Water-lily but smaller in all respects and with entirely different flowers. Grows in still or slow-flowing water. **FLOWERS** 30–35mm across, comprising *5 fringed petals*; on stalks rising just above the water surface (June–Sep). **FRUITS** Capsules. **LEAVES** 3–8cm across, rounded or kidney-shaped, floating. **STATUS** Locally common in S England and naturalised elsewhere.

Alternate Water-milfoil *Myriophyllum alterniflorum* (Haloragaceae) ✿ AQUATIC

Bushy, submerged water plant that grows in fresh water, favouring acid conditions. **FLOWERS** Inconspicuous, yellow; in leafy spikes with tiny bracts (May–Aug). **FRUITS** Warty, rather ovoid. **LEAVES** Pinnate, feathery, the segments up to 25mm long; in whorls of 3–4 along the stems. **STATUS** Widespread but local.

Spiked Water-milfoil *Myriophyllum spicatum* (Haloragaceae) ✿ AQUATIC

Bushy, submerged water plant with long, trailing stems. Grows in slow-flowing or still fresh water. **FLOWERS** Inconspicuous, greenish, in leafy spikes with undivided bracts (June–Sep). **FRUITS** Rounded, warty. **LEAVES** Pinnate, feathery, the segments up to 3cm long; usually in whorls of 4 along the stems. **STATUS** Widespread and locally common throughout.

Common Water-starwort *Callitriche stagnalis* (Callitrichaceae) AQUATIC

Variable, rather straggly water plant with slender stems. Grows in still and slow-flowing fresh water, and on the drying muddy margins of pools in summer. **FLOWERS** Minute, green, petal-less and borne at the base of the leaves (May–Aug). **FRUITS** Tiny, with 4 segments. **LEAVES** Narrow-oval; those at the water's surface forming a floating rosette. **STATUS** Widespread and common throughout. Several very similar and closely related species are recognised by experts.

Rigid Hornwort *Ceratophyllum demersum* (Ceratophyllaceae) ✿ AQUATIC

Submerged perennial with rather brittle stems; by late summer these acquire a coating of chalk and silt (as do the leaves to a lesser extent). **FLOWERS** Minute, at leaf nodes (July–Sep). **FRUITS** Warty, beaked, with 2 basal spines. **LEAVES** Rigid, toothed, forked 2–3 times; in whorls. **STATUS** Locally common only in England.

Canadian Waterweed *Elodea canadensis* (Hydrocharitaceae) AQUATIC

Submerged perennial with trailing, rather brittle stems. Grows in ponds, lakes and canals. **FLOWERS** Tiny, floating, on slender stalks; seldom flowering (July–Sep). **FRUITS** Capsules. **LEAVES** Narrow, back-curved, in whorls of 3. **STATUS** Introduced from N America but now widely naturalised.

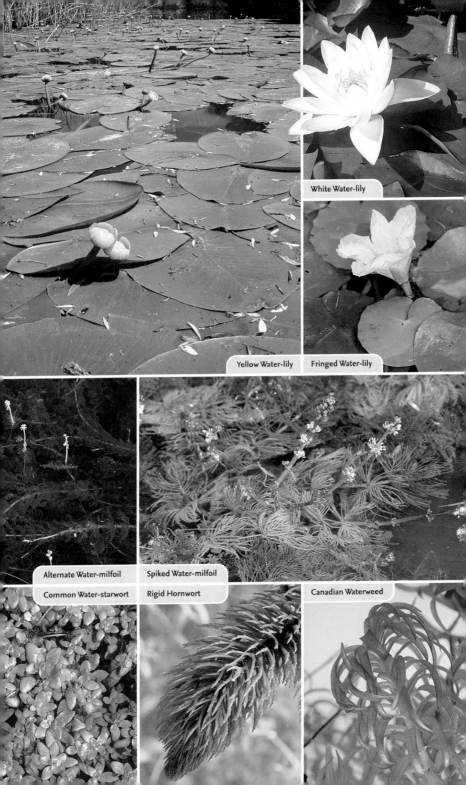

White Water-lily

Yellow Water-lily Fringed Water-lily

Alternate Water-milfoil Spiked Water-milfoil

Common Water-starwort Rigid Hornwort Canadian Waterweed

Frogbit *Hydrocharis morsus-ranae* (Hydrocharitaceae) ❀ AQUATIC

Floating perennial that grows in still waters of canals, ponds and ditches. **FLOWERS** 2cm across, the 3 petals white with a yellow basal spot; on emergent stalks, male and female separate (June–Aug). **FRUITS** Capsules. **LEAVES** 2–3cm across, floating, rounded or kidney-shaped. **STATUS** Local in England; scarce or absent elsewhere.

Water-soldier *Stratiotes aloides* (Hydrocharitaceae) ❀❀ AQUATIC

Submerged perennial for most of the year but floats during summer months. **FLOWERS** 3–4cm across, white, 3-petalled; females solitary, males in clusters of 2–3 (June–Aug). **FRUITS** Capsules. **LEAVES** 30–40cm long, lanceolate, toothed; in a tufted rosette. **STATUS** Local native in E Anglia; scarce introduction elsewhere.

Greater Bladderwort *Utricularia vulgaris* (Lentibulariaceae) ❀❀ AQUATIC

Freshwater plant of still, calcareous waters. Small bladders along submerged stems trap tiny invertebrates. **FLOWERS** 12–18mm long, *deep yellow*; in clusters of 4–10 on emergent stems (June–July). **FRUITS** Capsules. **LEAVES** Finely divided, with bristled teeth. **STATUS** Locally common only in E England and N Ireland.
Bladderwort *U. australis* is very similar but favours acid waters. Local and scarce.

Lesser Bladderwort *Utricularia minor* (Lentibulariaceae) ❀ AQUATIC

Freshwater plant of still, mainly acid waters. Small, flask-shaped bladders along the submerged stems trap tiny invertebrates. **FLOWERS** 6–8mm long, *pale yellow*; in clusters of 2–5 on slender stems (June–July). **FRUITS** Capsules. **LEAVES** Finely divided, untoothed, lacking bristles. **STATUS** Local, mainly in the north and west.

Mare's-tail *Hippuris vulgaris* (Hippuridaceae) ❀ AQUATIC

Grows in streams, ponds and lakes, avoiding acid conditions. Upright, emergent stems are produced from submerged part of plant more readily in still waters. **FLOWERS** Minute, pink, petal-less; produced at the base of the leaves (June–July). **FRUITS** Tiny, greenish nuts. **LEAVES** Narrow; in whorls of 6–12. **STATUS** Local.

Water-plantain *Alisma plantago-aquatica* (Alismataceae)
HEIGHT to 1m

Aquatic and emergent perennial that grows on the margins and in the shallows of ponds and lakes. **FLOWERS** 1cm across, *whitish lilac*, 3-petalled; *in branched whorls* (June–Sep). **FRUITS** Greenish, nut-like. **LEAVES** Oval, long-stalked, with parallel veins. **STATUS** Locally common except W England, W Wales and N Scotland. **Narrow-leaved Water-plantain** *A. lanceolatum* is similar but has narrower, lanceolate leaves.

Water-plantain

Lesser
Water-plantain

Lesser Water-plantain *Baldellia ranunculoides* (Alismataceae)
❀ **HEIGHT** to 25cm

Creeping, spreading perennial that thrives best in still, calcareous waters. **FLOWERS** 12–16mm across, *pale pink*, 3-petalled, *usually solitary* (June–Aug). **FRUITS** Greenish, nut-like, in clusters. **LEAVES** Narrow, long-stalked. **STATUS** Locally common in the south and west; scarce or absent elsewhere.

Floating Water-plantain *Luronium natans* (Alismataceae) ❀❀ AQUATIC

Floating and submerged perennial that roots at the nodes. Grows in acid waters of lakes and canals. **FLOWERS** 12–15mm across, 3-petalled, white with yellow centres; solitary, on long stalks (July–Aug). **FRUITS** Achenes. **LEAVES** Narrow-ovate, floating. **STATUS** Very local, mainly Wales and NW England.

Starfruit *Damasonium alisma* (Alismataceae) ❀❀❀ AQUATIC

Floating and submerged plant. Grows around margins of ponds. **FLOWERS** 5–6mm across, white, 3-petalled; in terminal whorls on emergent stems (June–Aug). **FRUITS** Beaked achenes, arranged in heads like *6-pointed stars*. **LEAVES** Ovate, heart-shaped at the base, long-stalked. **STATUS** Rare and local, SE England only.

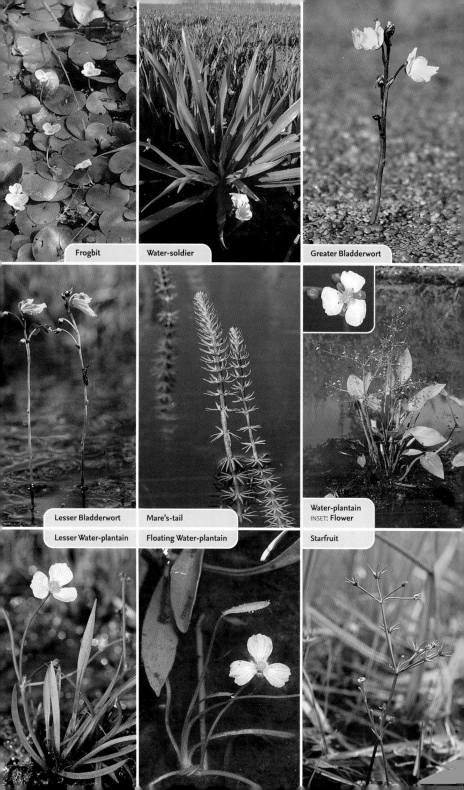

Frogbit

Water-soldier

Greater Bladderwort

Lesser Bladderwort

Mare's-tail

Water-plantain
INSET: **Flower**

Lesser Water-plantain

Floating Water-plantain

Starfruit

Arrowhead *Sagittaria sagittifolia* (Alismataceae) ❀ **HEIGHT** to 80cm
Aquatic perennial of still or slow-flowing fresh water. **FLOWERS** 2cm across, the 3 petals white with a purple basal patch; in whorled spikes (July–Aug). **FRUITS** In globular heads. **LEAVES** Arrow-shaped emergent leaves, oval floating ones and narrow submerged ones. **STATUS** Locally common in the south; scarce or absent elsewhere.

Flowering-rush *Butomus umbellatus* (Butomaceae) ❀❀ **HEIGHT** to 1m
Attractive perennial that grows in the vegetated margins of still or slow-flowing fresh water. **FLOWERS** 25–30mm across, pink; in umbels (July–Aug). **FRUITS** Purple. **LEAVES** Rush-like, 3-angled, very long, arising from the base of the plant. **STATUS** Locally common only in England and Wales.

Common Duckweed *Lemna minor* (Lemnaceae) **AQUATIC**
Surface-floating, freshwater perennial that often forms a carpet over the surface of suitable ponds, lakes and canals by late summer, by vegetative division. **FLOWERS** Minute; seldom present. **FRUITS** Seldom seen. **LEAVES** *5mm across*, round, flat with a *single dangling root*. **STATUS** Widespread and locally common throughout.

Ivy-leaved Duckweed *Lemna trisulca* (Lemnaceae) ❀ **AQUATIC**
Freshwater perennial that floats just below the water's surface in ponds and slow-flowing streams. **FLOWERS** Minute; seldom seen. **FRUITS** Seldom seen. **LEAVES** 10–15mm long, translucent, narrowly ovate; linked in chain-like fashion, the terminal leaves in a trio, like miniature Ivy leaves. **STATUS** Widespread but local.

Fat Duckweed *Lemna gibba* (Lemnaceae) ❀ **AQUATIC**
Floating, freshwater perennial of ponds and ditches. **FLOWERS** Minute and seldom seen. **FRUITS** Seldom seen. **LEAVES** Swollen and spongy, 5–6mm across and 5–6mm deep. **STATUS** Local.

Fat Duckweed, side view

Greater Duckweed *Spirodela polyrhiza* (Lemnaceae) ❀ **AQUATIC**
Surface-floating, freshwater perennial that grows in still or slow-flowing waters of canals, ditches and ponds. **FLOWERS** Minute; seldom seen. **FRUITS** Seldom seen. **LEAVES** To 10mm across, flat, rounded or ovate, with *several dangling roots*. **STATUS** Locally common.

Greater Duckweed underside

Tasselweeds *Ruppia* sp. (Ruppiaceae) ❀❀ **AQUATIC**
Submerged aquatic perennials with slender stems; 2 very similar species occur. Grow in brackish coastal pools and ditches. **FLOWERS** Comprising 2 greenish stamens and no petals; in pairs, arranged in umbels on stalks that rise to the surface (July–Sep). **FRUITS** Swollen, asymmetrical, long-stalked. **LEAVES** Hair-like, 1–3mm wide. **STATUS** Local and declining.

Horned Pondweed *Zannichellia palustris* (Zannichelliaceae) **AQUATIC**
Slender submerged perennial that grows in still or slow-flowing fresh, or slightly brackish, water. **FLOWERS** Minute, greenish, in short-stalked clusters in leaf axils (May–Aug). **FRUITS** With a slender beak. **LEAVES** 1.5mm wide and up to 5cm long, pointed, translucent. **STATUS** Widespread throughout, but local.

Horned Pondweed, fruits

Eelgrasses *Zostera* sp. (Zosteraceae) ❀ **AQUATIC**
Grass-like marine perennials that grow in sand and silt substrates, typically below the low-water mark, hence only seldom exposed to air. **FLOWERS** Small, greenish and borne in branched clusters, enclosed by sheaths (June–Sep). **FRUITS** Spongy. **LEAVES** 5–10mm wide, 30–50cm long and bristle-tipped in **Eelgrass** *Z. marina*; 1–2mm wide, 10–20cm long and rounded-tipped in **Dwarf Eelgrass** *Z. noltei*. **STATUS** Widespread but local.

Eelgrass

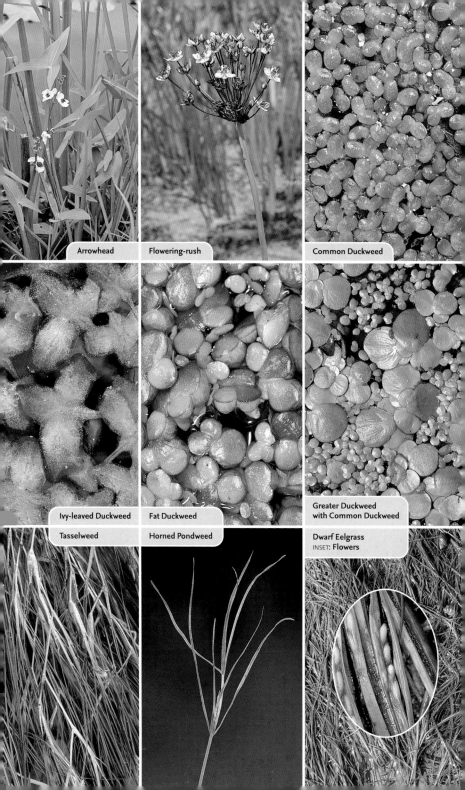

Arrowhead

Flowering-rush

Common Duckweed

Ivy-leaved Duckweed

Fat Duckweed

Greater Duckweed
with Common Duckweed

Tasselweed

Horned Pondweed

Dwarf Eelgrass
INSET: **Flowers**

Opposite-leaved Pondweed

Groenlandia densa **AQUATIC**
Submerged freshwater perennial
of ponds and ditches, as well as
streams with a moderate flow.
FLOWERS Small, greenish, petal-less;
in small submerged clusters (May–Sep).

FRUITS Small clusters of
achenes. **LEAVES**
Narrow-ovate,
pointed-tipped,
in *opposite pairs.*
STATUS Locally
common only in
the south.

Curled Pondweed

Potamogeton crispus **AQUATIC**
Freshwater perennial with
4-angled stems. Grows in still
or slow-flowing water. **FLOWERS**
In small spikes (June–Sep).
FRUITS With a long, curved beak.
LEAVES All submerged and alter-
nate; translucent, up to 9cm
long, narrowly oblong, blunt,
with *crinkly margins.* **STATUS**
Widespread and common
throughout.

Fruit

Slender-leaved Pondweed

Potamogeton filiformis ❀ **AQUATIC**
Perennial of slow-flowing fresh
and brackish water.
FLOWERS In a spike
comprising evenly-spaced
clusters. **FRUITS** Reddish.
LEAVES Extremely slender and all
submerged. **STATUS** Local, mainly
in the north.

Broad-leaved Pondweed

Potamogeton natans **AQUATIC**
Freshwater perennial of still
or slow-flowing water.
FLOWERS Small,
4-parted, greenish; in 8cm-
long spikes, on stalks rising above
the water (May–Sep). **FRUITS**
Round, short-beaked. **LEAVES**
Floating ones oval, up to 12cm
long; *stalk has flexible joint near blade.*
Submerged ones long and narrow. **STATUS**
Widespread and common.

Perfoliate Pondweed

Potamogeton perfoliatus
AQUATIC
Freshwater perennial
that grows in still or
slow-flowing waters.
FLOWERS In small, few-
flowered spikes (June–Sep).
FRUITS Rounded. **LEAVES** All
submerged, dark green,
translucent; oval, tapering,
unstalked, with *heart-
shaped bases that clasp the
stem.* **STATUS** Widespread
and locally common.

Bog Pondweed
Potamogeton polygonifolius
AQUATIC
Freshwater perennial of heath and moorland pools with acid waters.
FLOWERS Greenish, in 4cm-long spikes on long stalks (May–Oct).
FRUITS Round with a tiny beak. **LEAVES**
Floating ones narrow-oval, up to 10cm long, sometimes tinged red, lacking a flexible joint. Submerged ones narrow. **STATUS** Locally common.

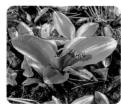

Small Pondweed *Potamogeton berchtoldii* AQUATIC
Freshwater perennial with slightly flattened stems. Grows in still and slow-flowing water. **FLOWERS** In small spikes on short stalks (June–Sep). **FRUITS** Rounded. **LEAVES** All submerged, narrow (50mm long × 1.5–2mm wide), 3-veined, *bristle-tipped; air spaces present* on either side of midrib. **STATUS** Locally common. **Lesser Pondweed** *P. pusillus* is similar but with blunt-tipped leaves; favours still or slow-flowing calcareous fresh water; sometimes also in brackish waters. Locally common.

Flowers

Fen Pondweed *Potamogeton coloratus* ❀❀ AQUATIC
Freshwater perennial of still or slow-flowing calcareous water.
FLOWERS In spikes on short stalks (June–Sep).
FRUITS Greenish.
LEAVES Ovate on stalks shorter than the blade. **STATUS** Local.

Fennel Pondweed
Potamogeton pectinatus
❀ AQUATIC
Variable, much-branched freshwater perennial of slow-flowing or still, acid waters.
FLOWERS In spikes on short stalks (June–Sep). **FRUITS** Greenish.
LEAVES Ovate, long-stalked surface leaves and narrow, unstalked submerged ones. **STATUS** Widespread but local. **Flat-stalked Pondweed** *P. friesii* has narrow, blunt but bristle-tipped leaves. Locally common.

Various-leaved Pondweed
Potamogeton gramineus ❀ AQUATIC
Variable, much branched fresh-water perennial of slow-flowing or still, acid waters. **FLOWERS** In spikes on short stalks (June–Sep). **FRUITS** Greenish. **LEAVES** Ovate, long-stalked surface leaves and narrow, unstalked submerged ones. **STATUS** Local, mainly in N. **Red Pondweed** *P. alpinus* is similar but has short-stalked leaves and a reddish tinge. Local in the north.

Flowers

Branched Bur-reed *Sparganium erectum* (Sparganiaceae) **HEIGHT** to 1m
Upright, hairless, sedge-like perennial. Grows in still or slow-flowing fresh water.
FLOWERS In spherical heads, yellowish male heads separate and above green
female heads (June–Aug). **FRUITS** Beaked; in spherical heads. **LEAVES** Bright
green, linear, keeled, 3-sided. **STATUS** Locally common throughout.

Bulrush *Typha latifolia* (Typhaceae) **HEIGHT** to 2m
Sedge-like plant (aka **Great Reedmace**). Grows in freshwater margins. **FLOWERS**
In spikes, comprising a brown, sausage-like array of female flowers and a narrow,
terminal spire of male flowers, *the two contiguous* (June–Aug). **FRUITS** With cottony
down. **LEAVES** Grey-green, long, 1–2cm wide. **STATUS** Common.

Lesser Bulrush *Typha angustifolia* (Typhaceae) ✿ **HEIGHT** to 2m
Similar to Bulrush (aka **Lesser Reedmace**). Grows in freshwater margins. **FLOWERS**
In spikes, comprising a brown, sausage-like array of *female flowers separated
by a gap from a narrow, terminal spire of male flowers* (June–Aug). **FRUITS** With
cottony down. **LEAVES** Dark green, long, 3–6mm wide. **STATUS** Locally common.

Sea Rush *Juncus maritimus* (Juncaceae) **HEIGHT** to 1m
Upright, stiff perennial that forms clumps in the drier parts of saltmarshes,
and among coastal rocks. **FLOWERS** Pale yellow, in loose clusters below a
sharp-pointed bract (June–July). **FRUITS** Brown, bluntly pointed, of equal
length to sepals. **LEAVES** Sharply pointed. **STATUS** Locally common
on coasts. **Sharp Rush** (*J. acutus*) is similar but larger (to 1.5m) with
spine-tipped bracts and leaves. Rare in coastal dunes in south-west.

Sharp Rush

Toad Rush *Juncus bufonius* (Juncaceae) **HEIGHT** to 40cm
Tufted annual of damp, bare ground. **FLOWERS** Greenish white, in branched
clusters, topped by a sharp spine (May–Sep). **FRUITS** Brown, egg-shaped,
shorter than the sepals. **LEAVES** Narrow, grooved. **STATUS** Widespread and
common. **Three-flowered Rush** *J. triglumis* is short, usually with 3 flowers
per head. Damp, acid ground, Scottish mountains.

Three-flowered Rush

Hard Rush *Juncus inflexus* (Juncaceae) **HEIGHT** to 1.2m
Tufted perennial with stiff, ridged, bluish- or greyish-green stems. Grows
in damp, grassy places but avoids acid soils. **FLOWERS** Brown, in loose
clusters below a long bract (June–Aug). **FRUITS** Brown, egg-shaped
with a tiny point. **LEAVES** Absent. **STATUS** Widespread and common
except in the north. **Slender Rush** (*J. tenuis*) is similar but taller (to 1.5m),
with bracts overtopping flowers. Widespread on damp, bare and acid soils.

Slender Rush

Soft Rush *Juncus effusus* (Juncaceae) **HEIGHT** to 1.5m
Characteristic perennial of overgrazed grassland, mostly on acid soils.
Stems are yellowish green, *glossy and smooth*. **FLOWERS** Pale brown, in loose or open
clusters near the stem tops (June–Aug). **FRUITS** Yellow-brown, egg-shaped,
indented at the tip and shorter than sepals. **LEAVES** Absent. **STATUS** Common.

Compact Rush *Juncus conglomeratus* (Juncaceae) **HEIGHT** to 1m
Perennial of damp, grazed grassland, mainly on acid soils. Similar to compact-flowered
form of Soft Rush but *stems are darker green, ridged, rough and not glossy*.
FLOWERS Brown, in compact clusters (May–July). **FRUITS** Dark brown,
egg-shaped, as long as sepals. **LEAVES** Absent. **STATUS** Common.

Jointed Rush *Juncus articulatus* (Juncaceae) **HEIGHT** to 60cm
Creeping or tufted upright perennial of marshes, and on damp heaths,
moors and dune slacks. **FLOWERS** Brown, in open, branched clusters
(June–Aug). **FRUITS** Brown, egg-shaped, abruptly pointed at the tip.
LEAVES Curved, narrow, flattened with a *transverse joint*. **STATUS** Locally
common. **Sharp-flowered Rush** (*J. acutiflorus*) is similar but has sharply
pointed tepals (mostly blunt in Jointed Rush). Widespread on acid soils.

Sharp-flowered Rush

■ *See also* Dwarf Rush (p.272) and Two-flowered Rush (p.284)

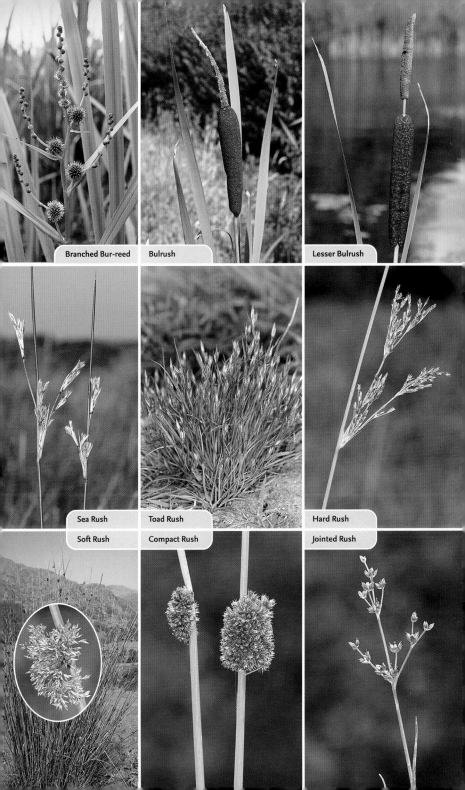

Branched Bur-reed

Bulrush

Lesser Bulrush

Sea Rush

Toad Rush

Hard Rush

Soft Rush

Compact Rush

Jointed Rush

Saltmarsh Rush *Juncus gerardii* (Juncaceae) � **HEIGHT** to 50cm
Characteristic rush of saltmarshes, often covering extensive areas. **FLOWERS** Dark brown, in loose clusters, flanked by leaf-like bracts (June–July). **FRUITS** Brown, egg-shaped, glossy, equal in length to the sepals. **LEAVES** Dark green, arising at base of plant, and on stems. **STATUS** Locally common around coasts.

Heath Rush *Juncus squarrosus* (Juncaceae) ✲ **HEIGHT** to 50cm
Tufted, sometimes mat-forming perennial with stiff stems. Grows on heaths and moors. **FLOWERS** Dark brown with *pale, silvery margins*; in terminal clusters (June–July). **FRUITS** Brown, egg-shaped, blunt with a small point at the tip. **LEAVES** Wiry, grooved; appearing as a *basal rosette*. **STATUS** Locally common.

Field Wood-rush *Luzula campestris* (Juncaceae) **HEIGHT** to 25cm
Tufted perennial of dry grassland, especially on calcareous soils (aka **Good Friday Grass**). **FLOWERS** Brown with yellow anthers; in heads (1 unstalked, several stalked) and arranged in clusters (Apr–May). **FRUITS** Brown, globular. **LEAVES** Grass-like, fringed with long, white hairs. **STATUS** Locally common. Similar **Southern Wood-rush** (*L. forsteri*) has stalks of inflorescence always erect, even in fruit. Shady places in S England only.

Southern Wood-rush

Great Wood-rush *Luzula sylvatica* (Juncaceae) **HEIGHT** to 80cm
Robust tufted perennial of woodlands and rocky, upland terrain, mainly on acid soils. **FLOWERS** Brown, in *heads of 3* in branched, open clusters (June–July). **FRUITS** Brown, egg-shaped. **LEAVES** 5–20mm across, hairy, glossy. **STATUS** Widespread and locally common, mainly in the north and west.

Hairy Wood-rush *Luzula pilosa* (Juncaceae) **HEIGHT** to 30cm
Tufted perennial that grows in woodland and on shady banks. **FLOWERS** Brown, *usually solitary*, arranged in branched, open clusters (Apr–June). **FRUITS** Brown, egg-shaped, narrowing abruptly towards the tip. **LEAVES** 5–10mm wide, yellowish green, hairy, glossy. **STATUS** Widespread and locally common, except in W Ireland.

Heath Wood-rush *Luzula multiflora* (Juncaceae) **HEIGHT** to 30cm
Tufted perennial of heaths and moors on acid soils. **FLOWERS** Brown, in stalked heads of 5–12 flowers, the heads in clusters of 3–10 (May–June). **FRUITS** Brown, globular, shorter than the sepals. **LEAVES** Grass-like, fringed with white hairs. **STATUS** Locally common. Similar **Spiked Wood-rush** *L. spicata* has a nodding inflorescence. Scottish mountains only.

Common Spike-rush *Eleocharis palustris* (Cyperaceae) **HEIGHT** to 50cm
Creeping, hairless perennial with green, leafless stems. Grows in marshes and pond margins. **FLOWERS** Brown, in terminal egg-shaped spikelets of 20–70 flowers (May–July). **FRUITS** Yellowish brown. **LEAVES** Reduced to brownish basal sheaths on stems. **STATUS** Locally common.

Spiked Wood-rush

Sea Club-rush *Bolboschoenus maritimus* (Cyperaceae)
HEIGHT to 1.25m
Creeping, robust perennial of brackish water margins. The stems are rough and triangular in cross-section. **FLOWERS** A tight, terminal cluster of egg-shaped spikelets, flanked by a long, leafy bract (July–Aug). **FRUITS** Dark brown. **LEAVES** Rough, keeled. **STATUS** Locally common. Similar **Floating Club-rush** *Eleogiton fluitans* forms floating and submerged mats in still or slow-flowing, usually acid, waters. Locally common.

Floating Club-rush **Grey Club-rush**

Common Club-rush *Schoenoplectus lacustris* (Cyperaceae) ✲ **HEIGHT** to 3m
Tall, grey-green perennial of river margins and fresh and brackish marshes. **FLOWERS** Stalked, egg-shaped brown spikelets borne in clusters (June–Aug). **FRUITS** Greyish brown. **LEAVES** Narrow and submerged. **STATUS** Locally common. **Grey Club-rush** *S. tabernaemontani* is shorter and more glaucous. Local, often coastal.

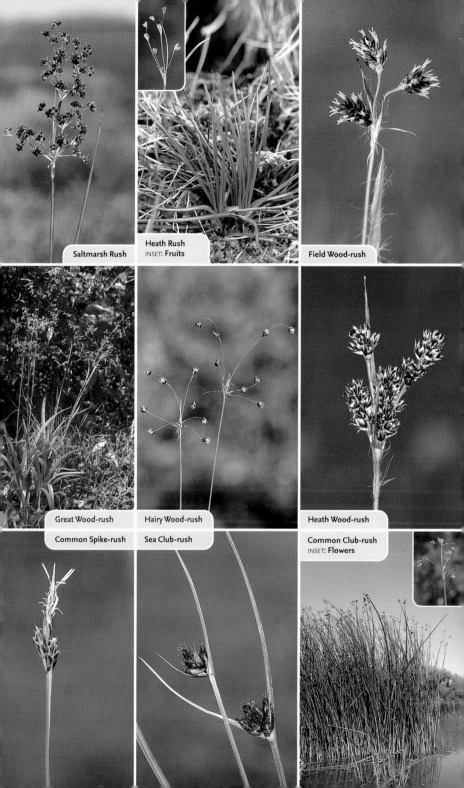

Saltmarsh Rush

Heath Rush
INSET: Fruits

Field Wood-rush

Great Wood-rush

Hairy Wood-rush

Heath Wood-rush

Common Spike-rush

Sea Club-rush

Common Club-rush
INSET: Flowers

Black Bog-rush *Schoenus nigricans* ❀ **HEIGHT** to 50cm
Tufted perennial with rigid, smooth, round stems. Grows in bogs, dune slacks and marshes, usually on base-rich soils. **FLOWERS** Dark brown spikelets, in a terminal head, with a leaf-like bract (May–July). **FRUITS** Whitish. **LEAVES** Long, green, arising at base of plant. **STATUS** Commonest in N and W Britain, and Ireland. Similar **Round-headed Club-rush** *Scirpoides holoschoenus* has globular heads of spikelets. Rare in damp, sandy places, coastal SW Britain only.

Round-headed Club-rush

White Beak-sedge *Rhynchospora alba* ❀ **HEIGHT** to 40cm
Tufted perennial of bogs and wet heaths on acid soils. **FLOWERS** Spikelets that are whitish at first; in flat-topped terminal clusters with a narrow bract (June–Sep). **FRUITS** Similar to flowers. **LEAVES** Pale green, at base of plant and on stem. **STATUS** Very local in S Britain but widespread in Scotland and W Ireland.

Lesser Pond-sedge *Carex acutiformis* **HEIGHT** to 1.2m
Creeping, mat-forming perennial of marshes and the margins of ponds and streams. **FLOWERS** Comprising 2–3 brownish male spikes above 3–4 yellowish-green female spikes; spikes usually unstalked (June–July). **FRUITS** Green, egg-shaped but flattened, narrowing to a beak. **LEAVES** Long, bluish grey, rough. **STATUS** Locally common.

Sand Sedge *Carex arenaria* **HEIGHT** to 35cm
Creeping perennial of sand dunes. Progress of its underground stems can be detected by aerial shoots, which appear in straight lines. **FLOWERS** Pale brown spikes, in a terminal head, male flowers above females (May–July). **FRUITS** Yellowish brown, beaked. **LEAVES** Wiry. **STATUS** Locally common on most suitable coasts.

Curved Sedge *Carex maritima* ❀❀ **HEIGHT** to 12cm
Creeping, distinctive (by sedge standards) perennial of coastal sand. **FLOWERS** Brown, in dense, egg-shaped terminal heads without bracts; on *curved stalks* (June–July). **FRUITS** Beaked, very dark brown. **LEAVES** Curved, with inrolled margins. **STATUS** Local, restricted to Scotland and NE England.

Yellow Sedge *Carex viridula* **HEIGHT** to 40cm
Tufted perennial of damp ground. Several subspecies occur, each with subtly different growing requirements. **FLOWERS** Comprising a terminal, stalked male spike above rounded to egg-shaped clusters of yellowish female flowers (May–June). **FRUITS** Yellow, beaked. **LEAVES** Narrow, curved, longer than stems. **STATUS** Common.

Glaucous Sedge *Carex flacca* **HEIGHT** to 50cm
Common grassland sedge, often on calcareous soils. Stems are 3-sided. **FLOWERS** Comprising 1–3 brown male spikes above 2–5 brown female spikes (Apr–May). **FRUITS** Greenish, flattened, with only a tiny beak. **LEAVES** Pale green, stiff. **STATUS** Widespread and locally common throughout.

Oval Sedge *Carex ovalis* **HEIGHT** to 60cm
Tufted sedge with 3-sided stems that are rough at the top. Grows in rough grassland, mainly on acid soils. **FLOWERS** Yellowish brown, in compact, rather egg-shaped terminal clusters (June–July). **FRUITS** Brownish, beaked. **LEAVES** Green, rough-edged. **STATUS** Widespread and locally common.

Remote Sedge *Carex remota* **HEIGHT** to 60cm
Slender, rather distinctive sedge of damp, shady places. **FLOWERS** In extended inflorescences, 10–20cm long, with widely spaced spikes and long, leafy bracts (June–Aug). **FRUITS** Greenish, egg-shaped, flattened, with a short beak. **LEAVES** Pale green, narrow, rough-edged. **STATUS** Widespread and locally common.

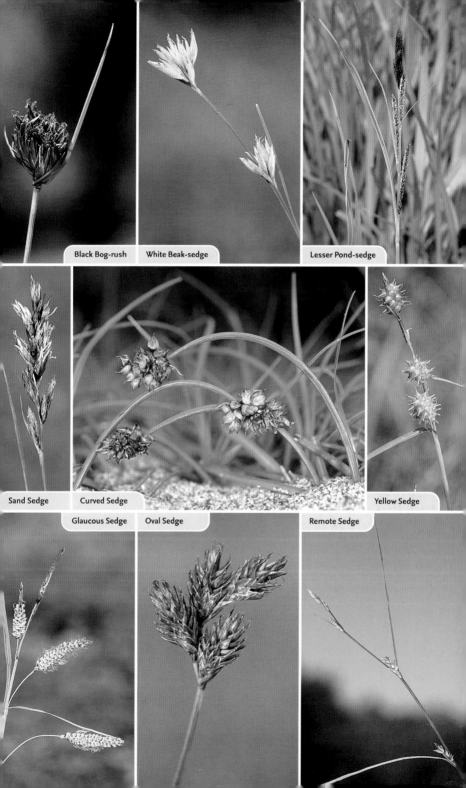

Black Bog-rush White Beak-sedge Lesser Pond-sedge

Sand Sedge Curved Sedge Yellow Sedge

Glaucous Sedge Oval Sedge Remote Sedge

Hairy Sedge *Carex hirta* HEIGHT to 70cm

Distinctive sedge, recognised by its very hairy leaves. Grows in damp grassland. FLOWERS In inflorescences of 2–3 brown male spikes above 2–3 yellowish female spikes (Apr–June). FRUITS Green, beaked, ridged. LEAVES Long, grey-green, covered in long, white hairs. STATUS Widespread and locally common.

Carnation Sedge *Carex panicea* HEIGHT to 30cm

Greyish tufted perennial that grows in damp ground, avoiding acid soils. FLOWERS In inflorescences that comprise a single, terminal male spike above 1–3 female spikes (May–June). FRUITS Greenish, pear-shaped, not beaked. LEAVES Greyish green, rough. STATUS Widespread and locally common.

Common Sedge *Carex nigra* HEIGHT to 50cm

Variable creeping sedge of damp grassland and marshes. Stems are 3-angled and rough at the top. FLOWERS In inflorescences of 1–2 thin male spikes above 1–4 female spikes with black glumes (May–June). FRUITS Short-beaked, green grading to blackish. LEAVES Long, narrow, appearing in tufts. STATUS Widespread and common. Similar **Pale Sedge** *C. pallescens* has pale female spikelets clustered near top of stem. Damp grassland, commonest in the north.

Pale Sedge

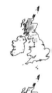

Stiff Sedge *Carex bigelowii* ✿ HEIGHT to 30cm

Creeping perennial with *stiff*, sharply 3-sided stems. Grows on mountains and upland moors. FLOWERS In inflorescences comprising 1 male spike above 2–3 female spikes (June–July). FRUITS Short-beaked, green grading to brown. LEAVES Ridged, curved with inrolled margins. STATUS Locally common only in Scotland.

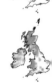

Rock Sedge *Carex rupestris* ✿✿ HEIGHT to 20cm

Delicate, creeping, mat-forming perennial of dry mountain ledges on base-rich rocks. FLOWERS Brown, in slender, terminal spikes, male flowers above females (June–July). FRUITS Yellow, flask-shaped. LEAVES Wiry, curly. STATUS Local and scarce, restricted to a few suitable sites in Scotland.

Flea Sedge *Carex pulicaris* HEIGHT to 25cm

Intriguing tufted sedge with rounded stems. Grows in damp ground, usually on calcareous ground. FLOWERS Reddish brown, in inflorescences comprising a single spike with male flowers above females (June–July). FRUITS Shiny, brown, fancifully flea-like. LEAVES Dark green, thread-like. STATUS Locally common.

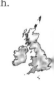

False Fox-sedge *Carex otrubae* HEIGHT to 80cm

Tufted perennial of damp, grassy ground, growing mainly on heavy soils. Stems robust, rough, 3-sided. FLOWERS Greenish brown, in a dense head with long bracts (June–July). FRUITS Smooth, beaked, ribbed. LEAVES Stiff, upright, 5–10mm wide. STATUS Widespread but locally common only in S England. Similar **White Sedge** (*C. curta*) has pale spikelets in compact heads. Acid heaths and moors, mainly in the north.

Greater Tussock-sedge *Carex paniculata* ✿ HEIGHT to 1m

Distinctive, coarsely hairy perennial of marshes and fens, recognised throughout the year by the large tussocks that it forms. FLOWERS Brown, in a dense, terminal spike 5–15cm long (May–June). FRUITS Ribbed, with a winged beak. LEAVES Narrow, to 1.2m long. STATUS Widespread and locally common, mainly in the south.

White Sedge

Pendulous Sedge *Carex pendula* HEIGHT to 1.5m

Clump-forming sedge of damp woodlands on heavy soils. Stems are tall, arching and 3-sided. FLOWERS In inflorescences comprising 1–2 male spikes above 4–5 long, drooping, unstalked female spikes (June–July). FRUITS Flattened, greyish, short-beaked. LEAVES Long, yellowish, up to 2cm wide. STATUS Locally common.

Hairy Sedge

Carnation Sedge

Common Sedge

Stiff Sedge

Rock Sedge

Flea Sedge

False Fox-sedge

Greater Tussock-sedge

Pendulous Sedge

Wood-sedge *Carex sylvatica* (Cyperaceae) HEIGHT to 50cm
Elegant tufted sedge with smooth, 3-sided, arched stems. Grows in damp woods. FLOWERS In nodding inflorescences comprising 1 terminal male spike and 3–4 slender, long-stalked female spikes (May–June). FRUITS Green, 3-sided, beaked. LEAVES Pale green, 3–6mm across, drooping. STATUS Locally common.

Pill Sedge *Carex pilulifera* (Cyperaceae) HEIGHT to 25cm
Tufted sedge with 3-sided stems. Grows on heaths and dry grassland with acid soils. FLOWERS In inflorescences comprising 1 male spike above 2–4 egg-shaped female spikes (May–June). FRUITS Green, rounded, downy, ribbed. LEAVES Yellowish green, narrow, wiry, flaccid. STATUS Widespread but local, except in north and west.

Great Fen-sedge *Cladium mariscus* (Cyperaceae) ✤ HEIGHT to 2.5m
Imposing plant of fens and lake margins. Sometimes forms dense stands, and still cut commercially in E Anglia. FLOWERS Glossy reddish-brown spikelets, in branched clusters (July–Aug). FRUITS Shiny, dark brown. LEAVES Long, saw-edged, often bent at an angle. STATUS Locally common in E Anglia and W Ireland.

Deergrass *Trichophorum cespitosum* (Cyperaceae) HEIGHT to 20cm
Tufted perennial with round, smooth stems. Sometimes forms small tussocks and grows in boggy moorland terrain, on acid soils. FLOWERS A single, egg-shaped, terminal brown spikelet (May–June). FRUITS Brown, matt. LEAVES A *single strap-like leaf* near the base. STATUS Locally very common, mainly in the north and west.

Common Cottongrass *Eriophorum angustifolium* (Cyperaceae) HEIGHT to 75cm
Upright perennial, distinctive when in fruit. Grows in very boggy ground with peaty, acid soils. FLOWERS In inflorescences of drooping, stalked spikelets (Apr–May). FRUITS Dark brown with cottony hairs; fruiting heads resemble balls of cotton wool. LEAVES Dark green, narrow. STATUS Locally common throughout.

Hare's-tail Cottongrass *Eriophorum vaginatum* (Cyperaceae) HEIGHT to 50cm
Tussock-forming perennial of moors and heaths on acid, peaty soil. FLOWERS A terminal spikelet emerging from an inflated sheath (Apr–May). FRUITS Yellowish brown with cottony hairs. LEAVES Very narrow. STATUS Widespread and locally common in N and W Britain, and Ireland.

Common Reed *Phragmites australis* (Poaceae) HEIGHT to 2m
Familiar, robust perennial of damp ground, marshes and freshwater margins. Often forms vast stands. Plant turns brown and persists through winter. FLOWERS Spikelets, purplish brown then fading; in branched, 1-sided terminal clusters (Aug–Sep). FRUITS Brown. LEAVES Broad and long. STATUS Widespread and common.

Purple Moor-grass *Molinia caerulea* (Poaceae) HEIGHT to 80cm
Tussock-forming perennial, usually associated with damp ground on acid heaths and grassy moors. FLOWERS Purplish-green spikelets, borne in long, branched spike-like heads (July–Sep). FRUITS Small, dry nutlets. LEAVES Grey-green, 3–5mm wide, with purplish leaf sheaths. STATUS Widespread and locally common.

Black Bent *Agrostis gigantea* (Poaceae) ✤ HEIGHT to 1.5m
Widespread creeping perennial of waste ground, verges and arable fields. FLOWERS Comprising numerous 1-flowered purplish-brown spikelets borne in branching clusters (July–Aug). FRUITS Small, dry nutlets. LEAVES Dark green, to 6mm across, with long ligules. STATUS Commonest in central and S England.

Purple Moor-grass

Wood-sedge

Pill Sedge

Great Fen-sedge

Deergrass

Common Cottongrass

Hare's-tail Cottongrass

Common Reed

Purple Moor-grass

Black Bent

Bristle Bent *Agrostis curtisii* ✱ HEIGHT to 50cm
Tufted perennial of heaths and moors. FLOWERS Comprising yellow-green spikelets borne in tall, dense, spike-like heads (June–July). FRUITS Small, dry nutlets. LEAVES Grey-green, narrow, bristle-like, with pointed ligules. STATUS Locally common in SW Britain but scarce or absent elsewhere.

Creeping Bent *Agrostis stolonifera* HEIGHT to 1m
Hairless perennial with creeping runners and upright stems; meadows and waste ground. FLOWERS Comprising yellow-green spikelets borne in dense, tall, branched, whorled heads (June–Aug). FRUITS Small, dry nutlets. LEAVES Narrow, with *bluntly pointed ligules*. STATUS Widespread and common, especially in the south.

Common Bent *Agrostis capillaris* HEIGHT to 70cm
Creeping perennial that grows in grassland, mainly on acid soils. FLOWERS Greenish-brown spikelets borne in heads with *spreading*, whorled branches (June–Aug). FRUITS Small, dry nutlets. LEAVES Narrow, with *blunt ligules*. STATUS Widespread and locally common throughout. **Velvet Bent** *A. canina* is similar but flower heads *not obviously whorled or spreading* (June–Aug). Leaves narrow, with *long, pointed ligules*. Widespread and locally common.

Loose Silky-bent *Apera spica-venti* ✱ HEIGHT to 1m
Distinctive annual of dry, often sandy, ground. FLOWERS In a pyramidal-shaped inflorescence, the spikelets with very long awns (June–July). FRUITS Dry nutlets. LEAVES Flat and up to 1cm wide. STATUS Local, mainly S and E England.

False Brome *Brachypodium sylvaticum* HEIGHT to 1m
Tufted, softly hairy perennial that grows in shady woods and hedgerows. FLOWERS In unbranched, slightly nodding heads with long spikelets that are short-stalked (July–Aug). FRUITS Small, dry nutlets. LEAVES Long, 10–12mm wide, hairy. STATUS Widespread and common throughout. **Tor Grass** *B. pinnatum* is similar but more upright and hairless. Chalk grassland.

Curved Hard-grass

Italian Rye-grass *Lolium multiflorum* HEIGHT to 90cm
Tufted annual or biennial with rough stems and leaves. Often sown to provide grazing. FLOWERS In unbranched heads, the spikelets brown with long awns (May–Aug). FRUITS Small, dry nutlets. LEAVES Often *rolled when young*. STATUS Widespread and common, except in the north. Similar **Curved Hard-grass** *Parapholis incurva* is short, with curved spikes. Bare coastal grassland, S and SE England only.

Perennial Rye-grass *Lolium perenne* HEIGHT to 90cm
Tufted, hairless perennial with wiry stems. Grows in meadows but also cultivated on farmland. FLOWERS In unbranched heads, the spikelets green and *without awns* (May–Aug). FRUITS Small, dry nutlets. LEAVES Deep green, often *folded when young*. STATUS Common throughout.

Crested Dog's-tail *Cynosurus cristatus* HEIGHT to 50cm
Distinctive, tufted perennial with wiry stems. Grows in grassland and on roadside verges. FLOWERS In compact, flat heads, the spikelets usually greenish (June–Aug). FRUITS Small, dry nutlets. LEAVES Narrow, short, with narrow, blunt ligules. STATUS Widespread and common throughout. Similar **Fern Grass** *Catapodium rigidium* has fern-like inflorescences. Dry grassland, coastal and S England, coastal Wales and S Ireland.

Fern Grass

Wall Barley *Hordeum murinum* HEIGHT to 30cm
Tufted annual of bare ground, often coastal. FLOWERS In unbranched spikes, 9–10cm long, with spikelets in 3s, each with 3 stiff awns (May–July); flowering stems prostrate at base. FRUITS Small, dry nutlets. LEAVES 7–8mm wide, with short, blunt ligules. STATUS Widespread and common. **Meadow Barley** *H. secalinum* is similar but with shorter awns. On clay.

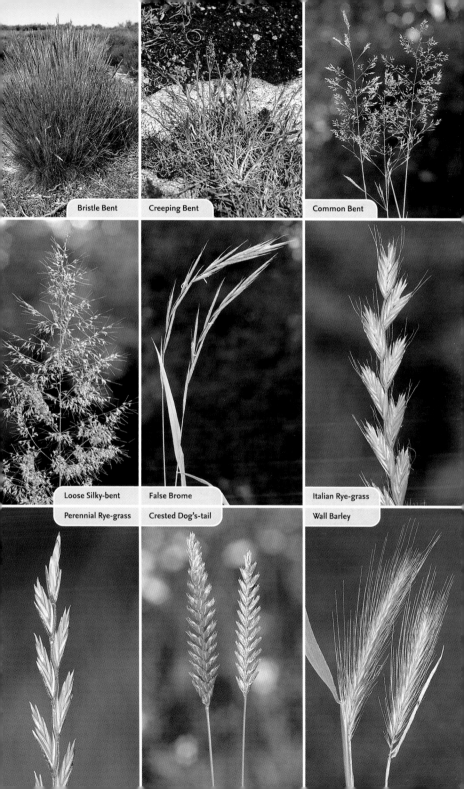

Bristle Bent

Creeping Bent

Common Bent

Loose Silky-bent

False Brome

Italian Rye-grass

Perennial Rye-grass

Crested Dog's-tail

Wall Barley

Sea Barley *Hordeum marinum* ❀ HEIGHT to 5cm
Tufted, *blue-green* annual of bare ground and dry, grassy places *near the sea*. FLOWERS In long, unbranched spikes, 7–8cm long, the spikelets in 3s, with stiff, *spreading* awns (July–Aug); flowering stems prostrate at base. FRUITS Small, dry nutlets. LEAVES 4–5mm wide. STATUS Local and exclusively coastal.

Meadow Foxtail *Alopecurus pratensis* HEIGHT to 1m
Tufted, hairless perennial that grows in meadows and on verges. FLOWERS In smooth, cylindrical, purplish-grey heads, 7–9cm long, of 1-flowered spikelets, with pointed glumes and long awns (Apr–June). FRUITS Small, dry nutlets. LEAVES Rough, 5–8mm wide with blunt ligules. STATUS Widespread and common throughout.

Marsh Foxtail *Alopecurus geniculatus* HEIGHT to 50cm
Tufted, grey-green perennial with stems bent at sharp angles at the base, and at joints. Grows in damp grassland. FLOWERS Borne in cylindrical, purplish heads, 5–6cm long, the spikelets with long awns and blunt ligules (June–Sep). FRUITS Small, dry nutlets. LEAVES Smooth below. STATUS Widespread and locally common. Similar **Bulbous Foxtail** *A. bulbosus* is much shorter and bulbous at the base. Coastal grassland, S England and S Wales only.

Marram *Ammophila arenaria* HEIGHT to 1m
Perennial of coastal dunes that colonises and stabilises shifting sands by means of its underground stems. FLOWERS In dense spikes, with 1-flowered, straw-coloured spikelets (July–Aug). FRUITS Small, dry nutlets. LEAVES Tough, grey-green, *rolled, sharply pointed*. STATUS Widespread and common on suitable coasts.

Bulbous Foxtail

Sweet Vernal-grass *Anthoxanthum odoratum* HEIGHT to 50cm
Tufted, downy perennial with a sweet smell when dried. Grows in grassland. FLOWERS In relatively dense spike-like clusters, 3–4cm long, of 3-flowered spikelets, each with 1 straight and 1 bent awn (Apr–July). FRUITS Small, dry nutlets. LEAVES Flat, with blunt ligules. STATUS Widespread and common.

False Oat-grass *Arrhenatherum elatius* HEIGHT to 1.5m
Tall, often tufted perennial of disturbed grassland, roadside verges and waysides. FLOWERS In an open inflorescence comprising numerous 2-flowered spikelets, one floral element of which has a long awn (May–Sep). FRUITS Small, dry nutlets. LEAVES Broad, long, with blunt ligules. STATUS Widespread and common.

Yellow Oat-grass *Trisetum flavescens* HEIGHT to 50cm
Slender, softly hairy perennial of dry grassland, usually on calcareous soils. FLOWERS In an open inflorescence of *yellowish*, 2–4-flowered spikelets, each with a *bent awn* (June–July). FRUITS Small, dry nutlets. LEAVES Narrow, flat with a blunt ligule. STATUS Widespread and locally common. Similar **Downy Oat-grass** *Helictotrichon pubescens* has hairy leaves and sheathes and silvery, bent-awned spikelets. Widespread but local in dry grassland.

Wild-oat *Avena fatua* HEIGHT to 1m
Distinctive annual of arable crops, also found on waste ground. FLOWERS In an inflorescence comprising an open array of stalked, dangling spikelets, each of which is shrouded by the glumes and has a long awn (June–Aug). FRUITS Small, dry nutlets. LEAVES Dark green, broad, flat. STATUS Widespread and common.

Downy Oat-grass

Quaking-grass *Briza media* HEIGHT to 40cm
Distinctive perennial of dry grassland, usually on calcareous soils. FLOWERS In an open inflorescence, the dangling spikelets resembling miniature hops or cones and carried on wiry stalks (June–Sep). FRUITS Small, dry nutlets. LEAVES Pale green, forming loose tufts. STATUS Widespread and locally common.

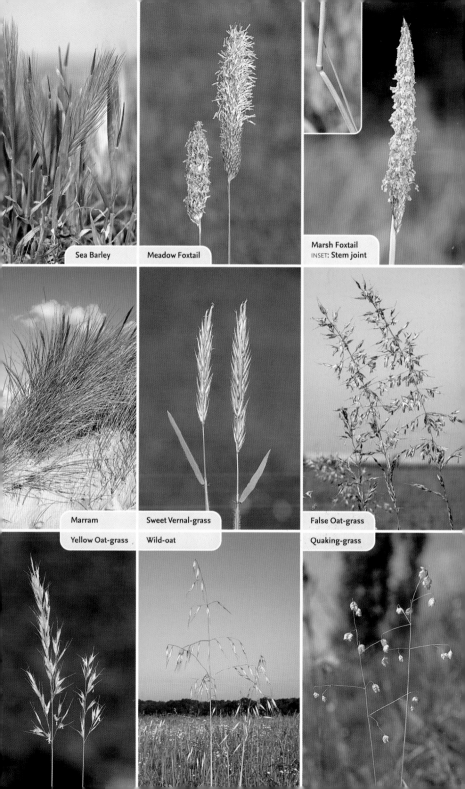

Sea Barley

Meadow Foxtail

Marsh Foxtail
INSET: **Stem joint**

Marram

Sweet Vernal-grass

False Oat-grass

Yellow Oat-grass

Wild-oat

Quaking-grass

Cock's-foot *Dactylis glomerata* HEIGHT to 1m
Tufted, tussock-forming perennial of grassland and woodland rides.
FLOWERS In an inflorescence of long-stalked, dense, egg-shaped heads
that spread and then fancifully resemble a bird's foot (June–July).
FRUITS Small, dry nutlets. LEAVES Rough, with slightly inrolled
margins. STATUS Widespread and common.

Tufted Hair-grass *Deschampsia cespitosa* HEIGHT to 1.5m
Tufted, clump-forming perennial of damp grassland. FLOWERS In a
long-stemmed inflorescence comprising spreading clusters of 2-flowered,
silvery-purple spikelets (June–July). FRUITS Small, dry nutlets. LEAVES
Dark green, wiry, narrow with rough edges. STATUS Common.

Cocksfoot, compact form

Wavy Hair-grass *Deschampsia flexuosa* HEIGHT to 1m
Tufted perennial of dry ground on heaths and moors, usually on acid
soils. FLOWERS In inflorescences comprising open clusters of purplish spikelets
with a long, bent awn (June–July). FRUITS Small, dry nutlets. LEAVES Inrolled,
hair-like. STATUS Locally common in Britain; scarce in Ireland. **Early Hair-grass**
Aira praecox is much shorter (to 12cm) with a spike-like inflorescence of silvery
spikelets each with a bent awn. Leaves bristle-like. Acid grassland.

Annual Beard-grass *Polypogon monspeliensis* ✿✿ HEIGHT to 80cm
Distinctive annual of bare, grassy places, especially near the sea. FLOWERS In a dense
inflorescence with long awns, green at first, turning silky white later, sometimes
partly shrouded by uppermost leaf (June–Aug). FRUITS Dry nutlets. LEAVES
Rough and flat. STATUS Rare, mainly coastal S England but increasingly inland too.

Lyme-grass *Leymus arenarius* ✿ HEIGHT to 1.5m
Blue-grey perennial of sand dunes and sandy beaches. FLOWERS In tall heads of
paired, grey-green spikelets (June–Aug). FRUITS Small, dry nutlets. LEAVES To
15mm wide, with inrolled margins. STATUS Widespread and common
on E coast of Britain; scarce or absent elsewhere.

Common Couch *Elytrigia repens* HEIGHT to 1.2m
Tough, creeping perennial that grows in cultivated and disturbed ground.
FLOWERS In a stiff, unbranched inflorescence with many-flowered,
yellowish-green spikelets arranged alternately (June–Aug). FRUITS
Small, dry nutlets. LEAVES Flat, green, downy above. STATUS Widespread
and common. **Sea Couch** *E. atherica* is similar but with sharp-pointed,
inrolled leaves. Maritime grassland in England, Wales and S Ireland.

Bearded Couch *Elymus caninus* HEIGHT to 1m
Tufted perennial with downy stem joints. Grows in damp, shady places
in woods and hedgerows. FLOWERS In a somewhat lax, unbranched
inflorescence, the spikelets alternate and with a long, straight awn
(June–Aug). FRUITS Small, dry nutlets. LEAVES Flat. STATUS Widespread
and locally common in England and Wales.

Sea Couch

Red Fescue *Festuca rubra* HEIGHT to 50cm
Clump-forming perennial of grassy places. FLOWERS In an inflorescence,
the spikelets 7–10mm long and usually reddish (May–July). FRUITS Small,
dry nutlets. LEAVES Either narrow, wiry and stiff, or flat (on flowering
stems). STATUS Common. **Viviparous Fescue** *F. vivipara*, an upland
species, produces green bulbils, not flowers.

Meadow Fescue *Festuca pratensis* HEIGHT to 1m
Tufted, hairless perennial that grows in damp meadows. FLOWERS In
a 1-sided inflorescence with open spikelets carried on unequal, paired
branches, the shorter one with a single spikelet (June–Aug). FRUITS
Small, dry nutlets. LEAVES Flat, 4mm across. STATUS Common.

Viviparous Fescue

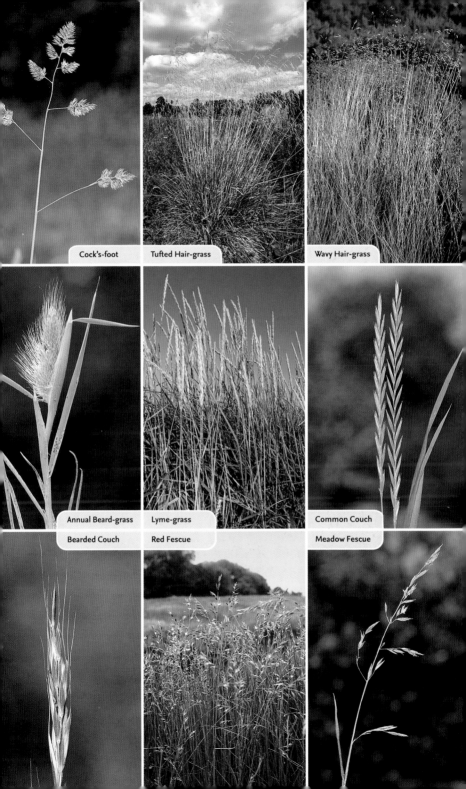

Cock's-foot

Tufted Hair-grass

Wavy Hair-grass

Annual Beard-grass

Lyme-grass

Common Couch

Bearded Couch

Red Fescue

Meadow Fescue

Sheep's-fescue *Festuca ovina* HEIGHT to 30cm
Variable, tufted, hairless perennial of dry calcareous grassland. **FLOWERS** In branched but compact heads of grey-green spikelets, each with a short awn (May–July). **FRUITS** Small, dry nutlets. **LEAVES** Short, narrow, inrolled, hair-like, waxy. **STATUS** Locally common. **Giant Fescue** *F. gigantea* is much larger (to 1.5m) and grows in shady woods. Flowers in an open inflorescence, leaves rough-edged and shiny. Widespread.

Barren Brome *Anisantha sterilis* HEIGHT to 1m
Rather floppy annual of hedgerows and verges. **FLOWERS** In a nodding inflorescence, usually with just one long-awned spikelet per branch (Apr–July). **FRUITS** Small, dry nutlets. **LEAVES** Downy with hairy ligules. **STATUS** Widespread and common.

Soft-brome *Bromus hordaceus* HEIGHT to 1m
Softly downy annual or biennial of meadows and verges. **FLOWERS** In compact heads with short-stalked, hairy, egg-shaped spikelets (June–Aug). **FRUITS** Small, dry nutlets. **LEAVES** Greyish green and rolled when young, with hairy sheaths. **STATUS** Common. **Meadow-brome** *B. commutatus* is similar but with a larger, more nodding inflorescence and hairless upper leaf sheaths. Unimproved grassland, mainly in S England.

Meadow-brome

Hairy-brome *Bromopsis ramosa* HEIGHT to 1.8m
Stout, elegant, tufted perennial of woods and shady places. **FLOWERS** In open, arching and drooping inflorescences with long-stalked, slender purplish spikelets, each 2cm long with a long awn (July–Aug). **FRUITS** Small, dry nutlets. **LEAVES** Dark green, drooping. **STATUS** Widespread and common.

Floating Sweet-grass *Glyceria fluitans* FLOATING
Aquatic grass of still and slow-flowing lowland fresh water. **FLOWERS** In open inflorescences comprising an open array of narrow spikelets (July–Aug). **FRUITS** Small, dry nutlets. **LEAVES** Broad, green, usually seen floating at the water's surface. **STATUS** Locally common.

Hairy-brome

Reed Sweet-grass *Glyceria maxima* HEIGHT to 2m
Impressive plant of shallow fresh water and marshy ground, often forming large patches. **FLOWERS** In a large inflorescence that is much branched with narrow spikelets (July–Aug). **FRUITS** Small, dry nutlets. **LEAVES** Bright green, long, 2cm wide, with a dark mark at the junction. **STATUS** Locally common only in SE England.

Wood Melick *Melica uniflora* HEIGHT to 50cm
Delicate, creeping perennial of dry, shady woodland, often on chalk and under Beech. **FLOWERS** In a loose, open inflorescence with brown, egg-shaped, stalked spikelets along the side branches (May–July). **FRUITS** Small, brown nutlets. **LEAVES** Pale green, lax. **STATUS** Locally common.

Timothy *Phleum pratense* HEIGHT to 1.5m
Robust, hairless, tufted perennial of meadows, agricultural land and waysides. **FLOWERS** In dense, cylindrical, rough heads, *13–16cm long*, with purplish-green spikelets, each with a short awn (June–Aug). **FRUITS** Small, dry nutlets. **LEAVES** Broad, rough, flat, with *blunt ligules*. **STATUS** Widespread and common. Similar **Black-grass** *Alopecurus myosuroides* has a slender, tapering inflorescence. Arable weed. Locally common, S and E England. *See also* foxtails (pp.262–263).

Black-grass

Smaller Cat's-tail *Phleum bertolonii* HEIGHT to 60cm
Tufted perennial of grassy places, often on calcareous soils. Similar to Timothy but smaller in all respects. **FLOWERS** In dense, cylindrical heads, *6–8cm long* (June–July). **FRUITS** Small, dry nutlets. **LEAVES** Rough, flat, with *pointed ligules*. **STATUS** Widespread and locally common, except in the north.

■ *See also* Alpine Cat's-tail (p.284) and Holy-grass (p.285)

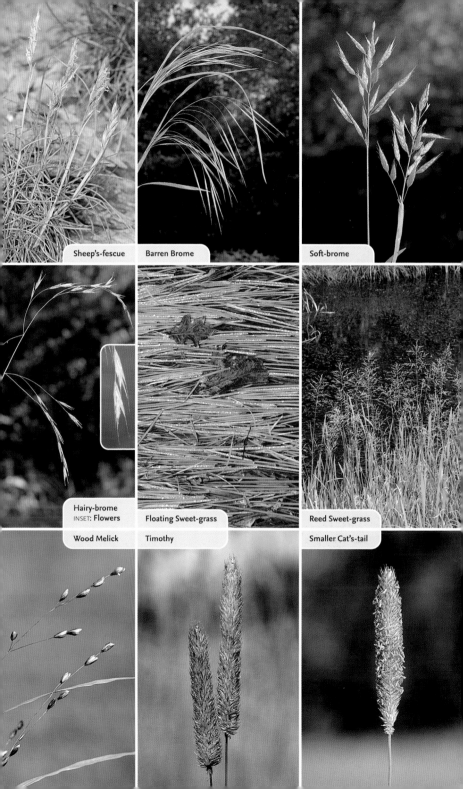

Sheep's-fescue

Barren Brome

Soft-brome

Hairy-brome
INSET: **Flowers**

Floating Sweet-grass

Reed Sweet-grass

Wood Melick

Timothy

Smaller Cat's-tail

Yorkshire Fog *Holcus lanatus* HEIGHT to 1m
Variable, tufted perennial with grey-green, *downy stems*. Grows in meadows, woods and waste ground. FLOWERS In heads that are tightly packed at first but then spread; comprising reddish-tipped, grey-green, 2-flowered spikelets (May–Aug). FRUITS Small, dry nutlets. LEAVES Grey-green, downy. STATUS Widespread and common.

Creeping Soft-grass *Holcus mollis* HEIGHT to 60cm
Similar to Yorkshire Fog but more slender; *stems downy only at the joints*. Grows in woods and on heaths, mainly on acid soils. FLOWERS In heads, compact at first then spreading, with purplish-green spikelets, each with a bent awn (June–Aug). FRUITS Small, dry nutlets. LEAVES Grey-green. STATUS Widespread and common.

Annual Meadow-grass *Poa annua* HEIGHT to 25cm
Annual or short-lived perennial of bare grassland and disturbed ground. FLOWERS In an inflorescence that is roughly triangular in outline, comprising branches with oval spikelets at their tips (Jan–Dec). FRUITS Small, dry nutlets. LEAVES Pale green, blunt-tipped, often wrinkled. STATUS Widespread and common.

Rough Meadow-grass *Poa trivialis* HEIGHT to 90cm
Loosely tufted perennial with creeping runners. Grows in damp, often shady, places. FLOWERS In a pyramidal inflorescence, the purplish-brown spikelets carried on whorls of stalks (May–July). FRUITS Small, dry nutlets. LEAVES Pale green, soft, with a pointed ligule and a *rough sheath*. STATUS Widespread and common. **Smooth Meadow-grass** *P. pratensis* is similar but the leaves are green and tough, with a blunt ligule and a smooth sheath. Widespread and common in meadows and on verges.

Flattened Meadow-grass *Poa compressa* HEIGHT to 40cm
Upright, tufted and hairless perennial with flattened stems. Grows in dry, grassy places. FLOWERS In a pyramidal inflorescence, the purplish-brown spikelets carried on whorls of stalks (May–July). FRUITS Small, dry nutlets. LEAVES With a hooded tip and blunt ligule. STATUS Widespread but local. **Alpine Meadow-grass** *P. alpina* has flowers replaced by plantlets. Damp mountains, central Scotland and N Wales.

Alpine
Meadow-grass

Blue Moor-grass *Sesleria caerulea* 🌼 HEIGHT to 45cm
Blue-green, tufted perennial of dry limestone grassland; often forms large patches. FLOWERS In dense, egg-shaped heads with bluish-green spikelets (Apr–June). FRUITS Small, dry nutlets. LEAVES Rough-edged, blunt, with a fine point at the tip. STATUS Locally common in north and west of region.

Mat-grass *Nardus stricta* HEIGHT to 20cm
Densely tufted, *wiry* perennial that often forms large patches on moors, mountain grassland and (more rarely) on heaths. FLOWERS In narrow, *1-sided spikes*, the spikelets in 2 rows (June–Aug). FRUITS Small, dry nutlets. LEAVES *Grey-green, wiry*. STATUS Locally common in upland regions; scarce or absent elsewhere.

Common Cord-grass *Spartina anglica* 🌼 HEIGHT to 1.3m
Tufted perennial, of hybrid origin, found on mudflats and saltmarshes. FLOWERS In a stiff inflorescence of elongated clusters of 3–6 yellowish flower heads, up to 35cm long (July–Sep). FRUITS Small, dry nutlets. LEAVES Grey-green, tough. STATUS Widespread on coasts of England, Wales and E and S Ireland.

Common Saltmarsh-grass *Puccinellia maritima* HEIGHT to 30cm
Hairless, tufted perennial. Grows in saltmarshes and forms swards. FLOWERS In spike-like heads, with spikelets *along all the branches*, which are mainly upright, not spreading (July–Aug). FRUITS Small, dry nutlets. LEAVES Grey-green, often inrolled. STATUS Widespread and locally common. **Reflexed saltmarsh-grass** *P. distans* is similar but inflorescence branches reflexed in fruit. Mainly coastal but also inland in E England beside salted roads.

Reflexed Saltmarsh-grass

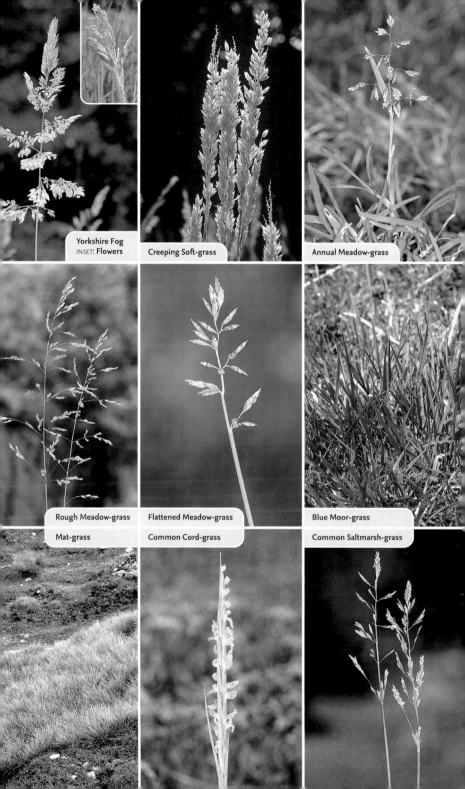

Yorkshire Fog
INSET: **Flowers**

Creeping Soft-grass

Annual Meadow-grass

Rough Meadow-grass

Flattened Meadow-grass

Blue Moor-grass

Mat-grass

Common Cord-grass

Common Saltmarsh-grass

Wherever you live in Britain or Ireland you are likely to find plenty of botanical interest close by, and with little difficulty you should be able to discover several hundred species of flowering plant within a few miles of your home. Consequently, many botanists find there is enough floral scope to keep them happy without travelling any great distance. And the content of the main section of *Complete British Wild Flowers* reflects this, being devoted to plants that, for the most part, are at least reasonably widespread. However, sooner or later many botanists develop the urge to travel further afield in search of local specialities, or displays that are at their best in (or sometimes unique to) selected parts of our region. This Botanical Hotspots section caters for this interest and describes some of the more exciting destinations and their notable plants.

THE WEST COUNTRY

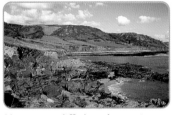

The great geological diversity of this region is reflected in the floral wealth and the number of special plants found here. For the purposes of this book, the West Country includes the counties of Cornwall (apart from the Lizard and Isles of Scilly), Devon, Dorset and Somerset. The region's stunning coastline, which is a magnet to holidaymakers, boasts granite, sandstone and limestone cliffs, broad estuaries, extensive beaches, and freshwater lakes and rivers. Inland there is moorland and heathland and, botanically, these areas complement the rolling farmland and lowland meadows.

Shore Dock *Rumex rupestris* (Polygonaceae) **HEIGHT** to 1m
Similar to Clustered Dock (*see* p.28) but the whorled *inflorescence is leafy only at the base* (June–July). The leaves are greyish and blunt, and the plant grows on rocky and stony coasts, mainly in S Cornwall. It is also found on the Scilly Isles.

Sea Knotgrass *Polygonum maritimum* (Polygonaceae) **PROSTRATE**
Similar to Ray's Knotgrass (*see* p.24) but perennial and woody at the base. The leaves are grey-green and rolled under at the margins. The flowers are pinkish, arising in the leaf axils, and the fruits are nut-like and protrude well beyond the perianth (July–Sep). The species is rare on sand and shingle beaches. It sometimes occurs on the coasts of S Ireland too.

Lundy Cabbage *Coincya wrightii* (Brassicaceae) **HEIGHT** to 90cm
Entirely restricted to the island of Lundy in the Bristol Channel. It is easy to spot if you visit the island in spring or early summer (May–July), when its showy heads of bright yellow flowers can be seen on either side of the road that leads from the landing bay to the village.

Cheddar Pink *Dianthus gratianopolitanus* (Caryophyllaceae) **HEIGHT** to 20cm
Charming, tufted perennial that is restricted to the limestone slopes and crags of Cheddar Gorge. The flowers are pink, 2–3cm across and are solitary on slender stalks (May–July). The leaves are grey and narrow.

Strapwort *Corrigiola litoralis* (Caryophyllaceae) **PROSTRATE**
Low-growing plant found on the drying margins of Slapton Ley in S Devon. The leaves are greyish green and blunt, and the flowers are tiny, whitish and borne in clusters (June–Sep). Strapwort is an ephemeral plant, appearing in good numbers in some years but seemingly absent in others.

Bladderseed *Physospermum cornubiense*
(Apiaceae) **HEIGHT** to 1m
Hairless perennial with striped, solid stems.
Umbels are 2–5cm across, with whitish flowers
(June–July). The fruits are inflated and resemble
small bladders. This rare plant occurs in Cornwall
(it is the only British flower with a reference to Cornwall
in its scientific name) and also in Buckinghamshire.

Small Hare's-ear *Bupleurum baldense* (Apiaceae) **HEIGHT** to 2cm
This is a tiny, atypical umbellifer, the tiny flower umbels shrouded by
pointed green bracts (June–July); the leaves are narrow and strap-like.
The plant's main stronghold is now Berry Head in the south of Devon,
but it also occurs on the Channel Islands. However, it is hard to believe
that such a small and insignificant plant has not been overlooked
elsewhere.

Field Eryngo *Eryngium campestre* (Apiaceae) **HEIGHT** to 50cm
Similar to Sea-holly (*see* p.120) but yellowish green, with narrower,
more deeply divided leaves and smaller flower umbels (June–July). It
grows on dry ground, often near the sea, and is regular at a site near
Plymouth; elsewhere its appearance is ephemeral and
possibly the result of introductions.

Flax-leaved St John's-wort *Hypericum linarifolium* **HEIGHT** to 30cm
Recalls Wavy St John's-wort (*see* p.110) but with narrow leaves, to 3cm
long, that are not wavy. Flowers are yellow (June–July). Extremely local
on rocky ground in SW England; also in N Wales.

Sand Toadflax *Linaria arenaria* **HEIGHT** to 10cm
A stickily hairy annual with yellow flowers that are
4–6mm long (June–July). Introduced to Braunton
Burrows and now naturalised there on bare sandy
ground, and locally common.

Sand Crocus *Romulea columnae* (Iridaceae)
HEIGHT to 1cm (photo right)
Rare, low-growing perennial with curly, basal leaves up to 10cm
long, and a star-shaped flower 1cm across, which opens only in
sunshine (Mar–May). Sand Crocus grows in short turf at Dawlish
Warren in Devon, and is also found at one site on the Cornish
coast and on the Channel Islands.

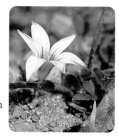

Goldilocks Aster *Aster linosyris* (Asteraceae) **HEIGHT** to 60cm (photo right)
Attractive upright perennial with numerous long, slender leaves and an
inflorescence comprising numerous heads of yellow flowers (July–Sep). This
rare plant is restricted to limestone outcrops on the coasts of Somerset and
S Devon.

Portland Sea-lavender *Limonium recurvum* ssp. *portlandicum*
(Plumbaginaceae) **HEIGHT** to 30cm
Entirely restricted to limestone cliffs and crags around the coasts
of Portland in Dorset where it is relatively easy to find. Its
pinkish-lilac flowers are similar to those of Rock Sea-lavender
(*see* p.140) but are borne in *dense, curved sprays* (July–Aug).

Round-headed Leek *Allium sphaerocephalon* **HEIGHT** to 1m (photo right)
An impressive plant, whose spherical heads of reddish-pink flowers are
carried on a long, slender stem (June–July). Restricted to limestone rocks in
the Avon Gorge; also found on dunes on Jersey.

THE LIZARD

The Lizard, with its spectacular coastline, is the most south-westerly peninsula in mainland Britain and consequently its climate is extremely mild. Much of its underlying soil is acid, which encourages extensive areas of heathland. However, in a few locations outcrops of base-rich Serpentine can be found and it is in these areas that the region's specialities tend to be concentrated.

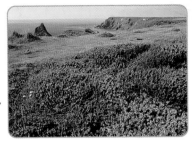

Long-headed Clover *Trifolium incarnatum* ssp. *molinerii*
(Fabaceae) **HEIGHT** to 30cm
Robust, downy annual with pale pink flowers in cylindrical heads, 3–4cm long (May–June). Locally common on the coast, especially around the lighthouse. It also grows on Jersey.

Hairy Greenweed *Genista pilosa* (Fabaceae) **HEIGHT** to 1m, but often almost prostrate

Low-growing shrub. It recalls Petty Whin (*see* p.84) but is *spineless*, and Dyer's Greenweed (*see* p.84), but *its leaves are silvery-downy below*. The flowers are yellow, in terminal heads (May–June). It grows on maritime heaths and sea cliffs. It is also found, locally, on the N Cornish coast and in W Wales.

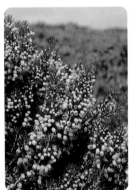

Cornish Heath *Erica vagans* (Ericaceae) **HEIGHT** to 90cm
Forms low shrubs and, in suitable locations, covers extensive areas; it puts on a particularly spectacular flowering display around Kynance Cove. The flowers are small, pale pink, and in tall, dense spikes (Aug–Sep); the leaves are in 4s or 5s. The species also occurs, very locally, in Ireland.

Fringed Rupturewort
Herniaria ciliolata (Caryophyllaceae)
PROSTRATE
Spreading, evergreen perennial with woody, hairy stems. It grows on sandy and rocky ground and can be found around Kynance Cove; it also grows in the Channel Islands.

Upright Clover *Trifolium strictum* (Fabaceae)
HEIGHT to 15cm
Upright, hairless annual with pale pink flowers in rounded heads 7–10mm across, on long stalks. It favours bare ground on Serpentine outcrops. It also grows, very locally, in S Wales and the Channel Islands.

Dwarf Rush *Juncus capitatus*
(Juncaceae) **HEIGHT** to 5cm
Tiny, tufted annual that grows in damp, bare mud (often on tracks), usually near the coast. The leaves are entirely basal and soon wither; indeed, the whole plant soon turns reddish. The flowers are in a terminal cluster with 2 leaf-like bracts (May–June). The species is also found, locally, on Anglesey and the Channel Islands.

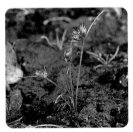

THE ISLES OF SCILLY

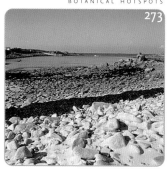

The location of this island group in the far south-west of our region ensures that it experiences a mild climate – often described as subtropical – and frosts are almost unknown. Maritime plants such as Thrift flourish and a number of arable 'weeds' put on marvellous displays in spring and early summer, although even here they are declining, as elsewhere in Britain and Ireland. The islands are also the prime, or only, British location for a select group of plants at the northernmost limit of their otherwise southerly European ranges.

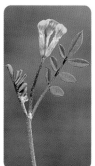

Orange Bird's-foot *Ornithopus pinnatus* (Fabaceae)
HEIGHT to 20cm
Straggly annual, similar to Bird's-foot (*see* p.92) but with *orange-yellow flowers* (Apr–Sep). It grows on maritime heath and is easiest to find on Tresco. It also occurs on the Channel Islands.

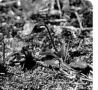

Dwarf Pansy *Viola kitaibeliana* (Violaceae)
HEIGHT to 10cm
Clearly recognisable as a member of the violet family but low-growing, with *tiny flowers* (5mm long). It is found in short turf on sandy ground and flowers in early spring (Apr–May). Look for it on Bryher. The species also occurs on the Channel Islands.

Scilly Buttercup *Ranunculus muricatus* (Ranunculaceae)
HEIGHT to 30cm
Associated with cultivated bulb fields; an established introduction. Its flowers are yellow and 12–15mm across (Apr–June), and its *seeds are prickly*. The species occurs occasionally in Cornwall as well.

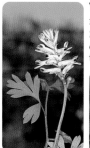

Western Ramping-fumitory *Fumaria occidentalis* (Fumariaceae)
HEIGHT to 15cm
Similar to Common Ramping-fumitory (*see* p.52) but with *larger, more colourful flowers* in tall heads (May–Oct). It grows in disturbed and cultivated ground. It can also be found, very locally, in Cornwall.

Bermuda-buttercup *Oxalis pes-caprae*
(Oxalidaceae) HEIGHT to 10cm
Distinctive hairless perennial of bare ground and grassy places. The flowers are 2–3cm across and bright yellow (Mar–June), and the leaves are trifoliate and clover-like. It persists locally as a relict of cultivation in SW England, and is sometimes naturalised.

Western Clover *Trifolium occidentale* (Fabaceae) PROSTRATE
Superficially similar to White Clover (*see* p.96) but its *leaves are unmarked* and its *flower heads are reddish-centred* (Apr–July). Look for it on dry ground, often beside coastal paths. It is also found, very locally, in Cornwall and the Channel Islands.

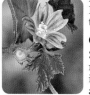

Cretan Mallow *Lavatera cretica* (Malvaceae) HEIGHT to 75cm
Similar to Common Mallow (*see* p.106) but flowers are smaller with narrower petals that are rather waxy-translucent (May–July, and again in autumn). Grows in field margins and disturbed ground, particularly around Old Town on St Mary's.

CHANNEL ISLANDS

Given their proximity to France, it is hardly surprising that the Channel Islands' flora contains many elements otherwise confined to mainland Europe. The islands enjoy a mild climate, and although much of the land area is either inhabited or cultivated, the coasts are generally unspoilt and hold the richest rewards for the botanist.

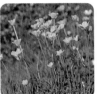

Jersey Buttercup *Ranunculus paludosus* (Ranunculaceae) **HEIGHT** to 50cm
Hairy perennial with 3-lobed leaves; on the stem leaves, the *central lobe is itself stalked*. The flowers are 2–3cm across and distinctly buttercup-like (May–July). Look for this species in winter-wet hollows on Jersey; absent from the other islands and from mainland Britain.

Purple Spurge *Euphorbia peplis* (Euphorbiaceae) **PROSTRATE**
Spreading annual with diagnostic *forked reddish-purple stems*; the leaves are ovate and greyish green, and the flowers are tiny (July–Sep). This species grows on sandy and gravel beaches, and its appearance from one year to the next is unpredictable. Occasionally it is discovered on Cornish beaches.

Spotted Rock-rose *Tuberaria guttata* (Cistaceae) **HEIGHT** to 30cm
Hairy annual with leaves in a basal rosette and in opposite pairs on the stem. The flowers are 1–2cm across and yellow with a *red spot at each petal base* (Apr–Aug). The petals are easily dislodged and usually fall by midday. It grows in dry, grassy places and also occurs in N Wales and W Ireland.

Jersey Thrift *Armeria arenaria* (Plumbaginaceae) **HEIGHT** to 30cm
Similar to Thrift (*see p.140*) but with far fewer leaves, and the pink flower heads are on more slender stalks (May–July). It grows on dry ground and, in our region, is entirely restricted to coastal dunes on Jersey.

Purple Viper's-bugloss
Echium plantagineum (Boraginaceae) **HEIGHT** to 50cm

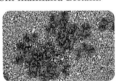

Similar to Viper's-bugloss (*see p.154*) but shorter and more softly hairy. The flowers are purplish blue, funnel-shaped and in curved clusters (June–Sep). This species grows on dry, sandy ground. It is also found, very locally, in W Cornwall.

Jersey Cudweed *Gnaphalium luteoalbum* (Asteraceae) **HEIGHT** to 40cm
Upright, mainly unbranched, *extremely woolly* greyish annual. The flowers are yellowish brown, egg-shaped and in terminal clusters (June–Aug). Jersey Cudweed grows on damp, sandy ground. It also occurs, extremely locally, near the coasts of N Norfolk and S Dorset.

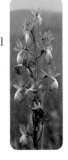

Loose-flowered Orchid *Anacamptis laxiflora* (Orchidaceae) **HEIGHT** to 1m
Tall, elegant perennial. Its pinkish-purple flowers recall those of Early Purple Orchid (*see p.230*) but are more showy and borne on long stalks in open spikes (May–July). It grows in damp grassland and, in our region, is confined to the Channel Islands.

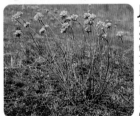

THE NEW FOREST AND ISLE OF WIGHT

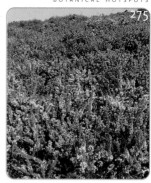

Situated in the south of Hampshire, these two distinct regions have plenty to offer botanical visitors. Although ancient woodland is certainly a feature of the New Forest, in visual terms, at least, the region's heaths and bogs are the crowning glory, providing stunningly colourful displays in August. Ponies and other free-roaming livestock are a feature, and many of the region's specialities are found in heavily grazed areas. By contrast to the New Forest's largely acid underlying soils, those of the Isle of Wight are more varied and there are superb areas of chalk downland.

Wild Gladiolus *Gladiolus illyricus* (Iridaceae) **HEIGHT** to 90cm
Upright, hairless perennial. The slender, grass-like leaves are easily overlooked but not so the striking, pinkish-purple flowers, 3–4cm long and in tall spikes (June–July). Wild Gladiolus grows among Bracken on the margins of open woodland and heaths in the New Forest.

Coral-necklace *Illecebrum verticillatum* (Caryophyllaceae) **PROSTRATE**
Charming, distinctive annual with square reddish stems along which are borne discrete, rounded clusters of white flowers (June–Sep).
The plant grows in damp ground, often in trampled hollows at the margins of drying ponds and ruts in the New Forest.

Small Fleabane *Pulicaria vulgaris* (Asteraceae) **HEIGHT** to 40cm
Recalls Common Fleabane (*see p.200*) but more branched, with much smaller flower heads, *1cm across, with short ray florets* (Aug–Oct). It grows around the trampled and grazed margins of pools in the New Forest, its best location in our region.

Hampshire-purslane *Ludwigia palustris* (Onagraceae) **HEIGHT** to 30cm
Creeping perennial that is rather undistinguished but nevertheless quite distinctive. It has reddish stems and oval, opposite leaves that are also strongly tinged reddish brown. The flowers are tiny and inconspicuous (June–Aug). Hampshire-purslane grows at the margins of ponds and is almost confined to the New Forest.

Pennyroyal *Mentha pulegium* (Lamiaceae) **HEIGHT** to 30cm
Mint-scented, creeping, downy perennial with upright flowering stems carrying *discrete whorls of mauve flowers* (Aug–Oct). It grows in damp, grazed ground beside ponds; the New Forest is the best place in the region to see it.

Early Gentian *Gentianella anglica* (Gentianaceae) **HEIGHT** to 15cm
Similar to Autumn Gentian (*see p.144*) but much shorter, and flowering in spring (Apr–June). The flowers are reddish purple and borne in terminal and axillary clusters. Early Gentian grows in short, chalk grassland on the Isle of Wight. It also occurs, locally, in a few coastal locations elsewhere in S England.

Wood Calamint *Clinopodium menthifolium* (Lamiaceae) **HEIGHT** to 60cm
Similar to Common Calamint (*see p.164*) but with *larger leaves and larger, pinker flowers*; these are stalked and in open heads (July–Oct). It grows on chalk scrub and, in our region, is confined to the Isle of Wight.

SOUTH-EAST ENGLAND'S ESTUARIES AND COASTS

From a naturalist's perspective, much of the coastline of south-east England has been ruined by a combination of development, industry and an excessive number of visitors. However, pockets of coastal land that are still rich in wildlife manage to persist, although generally only where they are protected by nature reserve status. Among the highlights are splendid saltmarsh communities at Pagham Harbour in Sussex and around the Isle of Sheppey on the Thames Estuary, shingle expanses at Dungeness in Kent and Rye Harbour in Sussex, and sand dune systems at Sandwich Bay in Kent.

Saltmarsh Goosefoot *Chenopodium chenopodioides* (Chenopodiaceae) HEIGHT to 30cm
Recalls Red Goosefoot (*see* p.30) but the *mature leaves are always red below* and indeed the *whole plant is often red-tinged*. The reddish-green flowers are borne in clusters (July–Sep) and the plant grows on drying mud in saltmarshes, with north Kent as its stronghold in our region.

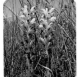

Suffocated Clover *Trifolium suffocatum* (Fabaceae) PROSTRATE
Easily overlooked because it is low-growing and soon withers and dries. The stalked leaves are arranged around a *stalkless cluster of whitish flowers with pointed bracts* (Apr–May). The plant grows on bare shingle and sand near the coast and occurs, very locally, from Pagham Harbour to east Kent.

Bedstraw Broomrape *Orobanche caryophyllacea* (Orobanchaceae) HEIGHT to 30cm
A distinctive plant, as broomrapes go. Its flowers are pinkish white or creamy yellow, *clove-scented*, and borne in spikes (June–July). As its name suggests, the plant is a parasite of bedstraws and grows in grassland, mainly on dunes but rarely also on downland. It is easiest to locate at Sandwich Bay in Kent.

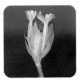

Least Lettuce *Lactuca saligna* (Asteraceae) HEIGHT to 1m
Slender annual that is easy to overlook when its flower heads are not open; frustratingly, this happens only on sunny days, between around 9 and 11am. The flower heads themselves are yellow, around 1cm across and are borne at intervals up the stem (July–Aug). Least Lettuce grows on dry ground near the sea and is found locally along the north Kent marshes and at Rye Harbour in Sussex.

Childing Pink *Petrorhagia nanteuilii* (Caryophyllaceae) HEIGHT to 40cm
Slender annual with greyish leaves and stem. The flowers are 6–8mm across and terminal (July–Sep). Childing Pink grows on stabilised coastal shingle. More widespread in the past, nowadays it is only reliably seen at Pagham Harbour in Sussex, where it is very locally common.

Stinking Hawk's-beard *Crepis foetida* (Asteraceae) HEIGHT to 50cm
Similar to Smooth Hawk's-beard (*see* p.218) but *smells of bitter almonds when bruised* and has *flower heads that droop in bud*. The flower heads, which are 10–15mm across when they open, typically do so only in morning sunshine (June–Oct). It grows on stabilised shingle and is restricted to Dungeness in Kent, where its occurrence from year to year is rather unpredictable.

THE SOUTH AND NORTH DOWNS

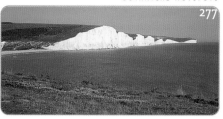

Topographically, south-east England is dominated by two extensive chalk ridges, the North and South downs. Both are oriented roughly east to west, and stretch from north Kent to Surrey, and from south Kent to Hampshire respectively. Much of the true downland has been lost to the plough but areas too steep for cultivation, or those protected by nature reserve status, still harbour some of the region's specialities. Even in unpromising areas of farmland, the calcareous influence can usually be detected by the botanical composition of hedgerows and verges.

Moon Carrot *Seseli libanotis* (Apiaceae)
HEIGHT to 70cm

Has ridged stems and is superficially similar to Wild Carrot (*see* p.128), alongside which it often grows. The flowers are white, in domed umbels with narrow bracts below (June–Aug); the base of the plant is often shrouded by old leaf remains. Moon Carrot grows on coastal downs near Seaford in Sussex. It is also found, locally, near Cambridge and Hitchin in Hertfordshire.

Fly Honeysuckle *Lonicera xylosteum* (Caprifoliaceae)
HEIGHT to 3m

A more dainty and delicate relative of Honeysuckle (*see* p.190). The yellow flowers are 1–2cm long and borne in pairs (May–June), and the leaves are ovate and stalked. It grows on steep chalk slopes on the South Downs, mainly in the vicinity of Arundel.

Dwarf Milkwort *Polygala amarella* (Polygalaceae)
HEIGHT to 10cm

Delicate downland perennial. It is similar to Chalk Milkwort (*see* p.104) but is smaller overall with tiny, usually pinkish flowers, 3–5mm long (May–Aug). It grows on chalk downs in Kent.

Late Spider-orchid
Ophrys fuciflora (Orchidaceae)
HEIGHT to 50cm

Superficially similar to both Bee Orchid and Early Spider Orchid (*see* p.230). It differs from the former in its broader, less rounded lip, the tip of which has a green, upturned appendage; and from the latter in its pink, not green, outer perianth segments. It is restricted to chalk downs in Kent.

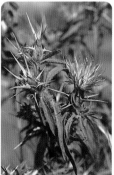

Red Star-thistle *Centaurea calcitrapa* (Asteraceae)
HEIGHT to 70cm

Branched, superficially thistle-like biennial. The reddish-purple flowers are borne in heads 8–10mm across, surrounded by much longer spiny bracts (July–Sep). It was introduced into Britain but is now established in a few sites, chiefly at Cuckmere Haven in Sussex.

EAST ANGLIA

At first glance, the vast area of low-lying land that makes up the bulk of East Anglia would seem to have little to commend it, both in terms of visual appeal and botanical composition. However, look closer and you will discover a selection of natural and semi-natural habitats and a surprising wealth of plants, some of which are, in the British context, entirely restricted to the region. Pockets

of Breckland habitat (dry, sandy grassland, often referred to as the Brecks) still persist in a few, protected areas, as do some splendid fens and marshes. However, the saltmarshes that fringe the north Norfolk coast are arguably the highlight in visual terms at least: they may lack the botanical rarities of, say, the fens, but this is more than made up for by the profusion of colour seen in July and early August.

Field Wormwood *Artemisia campestris* (Asteraceae) HEIGHT to 1m
Similar to Sea Wormwood (*see* p.204) but *almost hairless and unscented,* with reddish stems and yellowish flowers in open sprays (Aug–Sep). In Britain, Field Wormwood is restricted to a few areas of Breckland grassland.

Spiked Speedwell *Veronica spicata*
(Scrophulariaceae) HEIGHT to 60cm (photo right) Familiar garden perennial that is also a rare native of Breckland grassland; in addition, it occurs, very locally, in Wales and W England. The bluish flowers are borne in spikes 8–10cm long (July–Sep).

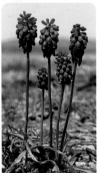

Grape-hyacinth *Muscari armeniacum* (Liliaceae)
HEIGHT to 25cm (photo left) Often grown in gardens but also thought to be native to Britain at a few Breckland sites. The leaves are narrow, bright green and basal, and the flowers are blue, egg-shaped and in conical spikes 3–4cm long (Apr–May).

Spanish Catchfly *Silene otites* (Caryophyllaceae)
HEIGHT to 80cm (photo left) Upright annual that is stickily hairy at the base. The flowers are *greenish yellow with narrow, divided petals;* they are borne in clusters on spikes (June–Sep). This classic Breckland species occurs at a few sites in the region but is often nibbled by Rabbits.

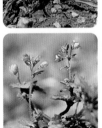

Breckland Speedwell *Veronica praecox* (photo far left)
(Scrophulariaceae) HEIGHT to 10cm Tiny annual, rather similar to Wall Speedwell (*see* p.174) but with rounded, *toothed leaves* and tiny blue *flowers on slender axillary stalks* (Mar–June). It is a rare plant of unsprayed field margins in the Brecks.

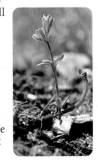

Fingered Speedwell *Veronica triphyllos* (Scrophulariaceae)
HEIGHT to 10cm (photo right) Also rather similar to Wall Speedwell (*see* p.174) but note the *palmately divided leaves, the lobes of which fancifully resemble fingers.* The flowers are tiny and blue and borne on slender stalks (Apr–July). It is a rare plant of unsprayed field margins in the Brecks.

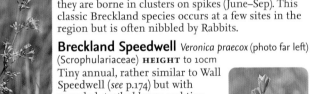

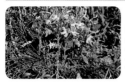

Breckland Thyme *Thymus serpyllum* CREEPING
Similar to Wild Thyme (*see* p.166) but the rounded flower stems are coated in whitish hairs all over. Flowers are similar to those of its relative (May–Sep). Restricted to Breckland heaths.

Sickle Medick *Medicago sativa* ssp. *falcata* (Fabaceae) HEIGHT to 70cm
The native form of cultivated Lucerne (*see* p.92), from which it differs in its *yellow flowers* and its *sickle-shaped (not spiral) pods*. It grows in grassy places in the Brecks, and is sometimes found on roadside verges.

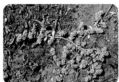

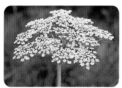

Smooth Rupturewort *Herniaria glabra*
(Caryophyllaceae) PROSTRATE
Hairless annual with spreading shoots. The leaves are elliptical and fresh green, and the flowers are tiny with minute green petals (May–Sep). The plant grows on bare sandy ground, often in the wake of disturbance.

Fen Violet *Viola persicifolia* (Violaceae) HEIGHT to 20cm
Charming, scarce perennial, similar to Marsh Violet (*see* p. 112) but the rounded *petals are bluish white* (not lilac) and the *spur is short and greenish* (not lilac) (May–June). It grows in a few East Anglian fens and, locally, in W Ireland too.

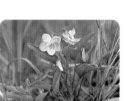

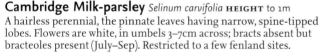

Milk-parsley *Peucedanum palustre*
(Apiaceae) HEIGHT to 1.5m
Hairless biennial with ridged stems that are often blotched purple. The umbels of white flowers, 3–8cm across, have long, sometimes forked, bracts below (July–Sep) and the leaves are deeply pinnately divided. It grows in East Anglian fens.

Cambridge Milk-parsley *Selinum carvifolia* HEIGHT to 1m
A hairless perennial, the pinnate leaves having narrow, spine-tipped lobes. Flowers are white, in umbels 3–7cm across; bracts absent but bracteoles present (July–Sep). Restricted to a few fenland sites.

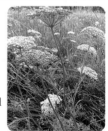

Fen Ragwort *Senecio paludosus* HEIGHT to 2m (photo right)
A tall, downy perennial of damp soils. Flowers are yellow and 3–4cm across (June–Aug), and the leaves are narrow, lanceolate toothed and 15–20cm long. Rare and restricted to a few fenland sites.

Matted Sea-lavender *Limonium bellidifolium*
(Plumbaginaceae) HEIGHT to 25cm (photo left)
Compact perennial that grows in saltmarshes and is restricted mainly to the N Norfolk coast. The spoon-shaped basal leaves mostly wither before the appearance of spreading, arching sprays of pinkish-lilac flowers, with many non-flowering shoots below (July–Aug).

Fen Orchid *Liparis loeselii* (Orchidaceae) HEIGHT to 20cm
Rather curious yellow flowers with narrow, spreading perianth segments; the flowers are in spikes (June–July) that arise from the cup-like arrangement comprising the basal pair of leaves. Fen Orchid grows in a few fen locations in Norfolk, with additional sites in S Wales and N Devon.

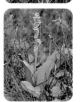

THE CHILTERNS AND COTSWOLDS

Calcareous soils always seem to add sparkle to the botanical scene and areas where these conditions prevail in central England are no exception. The underlying limestone of the Cotswolds encourages a rich diversity of grassland plants, along with a number of notable regional specialities. However, pride of place must go to the Chilterns, whose chalky soils support a number of extremely unusual orchids.

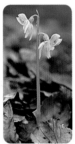

Ghost Orchid *Epipogium aphyllum* (Orchidaceae) **HEIGHT** to 15cm
Pinkish-yellow saprophyte that grows in deep shade under Beech. Despite its rather unassuming appearance, it is something of a Holy Grail for botanists. Known from just a few sites, mainly in the Chilterns, it does not appear every year, and indeed has not been seen since the 1980s. Furthermore, Ghost Orchids can appear at any time from June to September and seldom last more than a few days, often being consumed by slugs. Count yourself extremely lucky if you see one.

Military Orchid *Orchis militaris* (Orchidaceae) **HEIGHT** to 45cm
Stately orchid whose individual flowers are superficially similar to those of the Monkey Orchid, differing in their shorter 'legs' and 'arms'; the flower spike opens from the bottom upwards (May–June). Military Orchids were formerly quite widespread in the Chilterns but are now restricted to just a couple of sites, along with a location in Suffolk.

Monkey Orchid *Orchis simia* (Orchidaceae) **HEIGHT** to 45cm
Fancifully monkey-like flowers are borne in cylindrical heads; unlike most other orchids, the flowers open in succession from the top downwards (May–June). The Monkey Orchid grows at a few locations in Oxfordshire, with further isolated sites in Kent and Yorkshire.

Chiltern Gentian *Gentianella germanica* (Gentianaceae) **HEIGHT** to 30cm
Similar to Autumn Gentian (*see* p.144) but with *larger flowers, 2cm across* (Aug–Oct). It grows on chalk downland and is confined mainly to the Chilterns, with outposts south to N Hampshire.

Green Hound's-tongue
Cynoglossum germanicum (Boraginaceae) **HEIGHT** to 70cm (photo right)
Similar to Common Hound's-tongue (*see* p.152) but the *leaves are green and bristly (not hairy)*. The flowers are bell-shaped and 5–6mm across (May–July). It grows in chalk scrub and hedgerows, mainly on the edge of the Cotswolds.

Perfoliate Penny-cress *Thlaspi perfoliatum* (Brassicaceae) **HEIGHT** to 25cm (photo left)
Annual with a basal rosette of oblong leaves and *clasping, perfoliate stem leaves* with rounded bases. The flowers are white (Apr–May) and the fruits are heart-shaped. It is found on stony ground in the Cotswolds.

ENGLISH AND WELSH UPLANDS

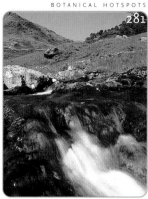

Compared to their cousins north of the border, the uplands of England and Wales can seem a bit like the poor relations of the mountains of the Scottish Highlands. While it is true that only in Snowdonia and the Lake District are there peaks that truly qualify as mountains, and that most are overrun with people, there are nevertheless several botanical highlights. Some of these plants have their most important, or their only, British sites in these uplands and are scarce or absent further north. In common with many other regions, a significant proportion of these upland specialities are concentrated in areas where base-rich rocks and soils occur.

Alpine Catchfly Lychnis alpina (Caryophyllaceae)
HEIGHT to 15cm

Attractive, low-growing perennial. Most of its spoon-shaped leaves are found as a basal rosette and the pink flowers, 6–12mm across, are borne in dense, terminal heads (June–July). Alpine Catchfly grows in the Lake District, and is also very scarce in Scotland.

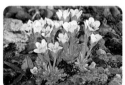

Lady's-slipper Orchid Cypripedium calceolus (Orchidaceae)
HEIGHT to 50cm

Unmistakable, with a truly magnificent flower comprising maroon outer perianth segments and an inflated yellow lip, 4–5cm across (May–June). It grows on limestone soils in N England, where it is extremely rare and its known sites are protected. Occasionally, the species is discovered elsewhere in N England, although the native origin of some of these plants is doubtful.

Early Star-of-Bethlehem Gagea bohemica (Liliaceae)
HEIGHT to 2cm

Low-growing perennial with narrow, wiry leaves and yellow, star-like flowers around 1cm across (Jan–Mar). Its presence at its sole British location in central Wales was recognised only in 1978.

Tufted Saxifrage Saxifraga cespitosa
(Saxifragaceae) **HEIGHT** to 10cm

Tufted, cushion-forming perennial with leaves divided into finger-like lobes and white flowers up to 1cm across (June–July). Tufted Saxifrage grows on mountain rocks in Snowdonia and also occurs, extremely rarely, in Scotland.

Perennial Knawel Scleranthus perennis (Caryophyllaceae)
HEIGHT to 15cm

Similar to Annual Knawel (see p.42) but perennial, woody at the base, and more upright. The flowers are tiny but the blunt, white-bordered sepals are conspicuous (May–Oct). It grows on rocky outcrops in central Wales and, extremely locally, in E Anglia.

Snowdon Lily Lloydia serotina (Liliaceae) **HEIGHT** to 12cm

Wiry leaves and cup-shaped flowers 15–20mm across, white with purplish veins (May–July). Restricted, in Britain, to the eponymous mountain range in N Wales, where it is rare and typically found on inaccessible ledges.

SCOTTISH HIGHLANDS AND WESTERN ISLES

Given the scale and the remoteness of much of upland Scotland it is hardly surprising that many areas retain a true wilderness feel. Where acid rocks predominate, the vegetation tends to be rather uniform although still of botanical interest. However, in locations where base- or metal-rich rocks put in an appearance, keen-eyed observers can usually discover some of the region's specialities, and places like Ben Lawers and Glen Clova are firmly established sites of pilgrimage for the keen botanist. The Scottish mountains harbour an intriguing mix of species whose main range is in the Arctic, and ones with a distribution centred on European mountain ranges, particularly the Alps.

Drooping Saxifrage *Saxifraga cernua* (Saxifragaceae)
HEIGHT to 15cm

Slender perennial with neatly lobed, fresh green leaves. The flowers, which are white and 12–18mm across, are frequently absent and replaced by *red bulbils* (June–July). It is a rare plant in the Scottish Highlands, Ben Lawers being a classic location.

Alpine Saxifrage
Saxifraga nivalis (Saxifragaceae)
HEIGHT to 20cm (photo right)

A tough little perennial with *glandular hairs on the purplish stems and margins of the leaves*, which are purplish below. The flowers are white or pink, in terminal clusters (July–Aug). It is a rare plant of the Scottish Highlands, and also occurs, extremely rarely, in England, N Wales and W Ireland.

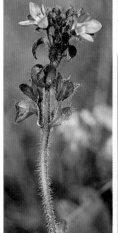

Alpine Forget-me-not *Myosotis alpestris* (Boraginaceae)
HEIGHT to 25cm

Tufted perennial resembling Wood Forget-me-not (*see* p.154) but much shorter and with deep blue (not pale blue) flowers (July–Sep). Its main British location is the Scottish Highlands, where it is very locally common, but it is also found in Upper Teesdale.

Rock Whitlowgrass
Draba norvegica (Brassicaceae)
HEIGHT to 5cm

Tufted, hairy perennial with leaves in a basal rosette. The flowers are 4–5mm across, white and in clusters (July–Aug); the fruits are oval, flattened and 5–6mm long. It is a rare plant found in only a handful of sites in the Scottish Highlands.

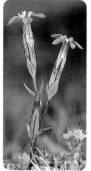

Alpine Gentian *Gentiana nivalis* (Gentianaceae)
HEIGHT to 8cm
Tiny annual that is easily overlooked when the flowers are closed (they open only in sunshine). The bright blue flowers are 5–8mm across (when open) and often solitary (June–Aug). It is a rare plant, restricted to a few Scottish mountains, Ben Lawers being a key location.

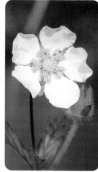

Rock Cinquefoil
Potentilla rupestris (Rosaceae)
HEIGHT to 50cm
Hairy perennial of calcareous rocks. Flowers 15-25mm across with 5 white petals (May-Jun). Rare, restricted to a few sites in mid-Wales and NE Scotland.

Arctic Sandwort

Arenaria norvegica ssp. *norvegica* (Caryophyllaceae) **HEIGHT** to 3cm
Low-growing perennial with rather fleshy leaves. The flowers are white and 10–12mm across, with yellow anthers (June–July). It grows on bare, gravelly and stony ground, and it is rare in mountains in western parts of Scotland and adjacent islands.

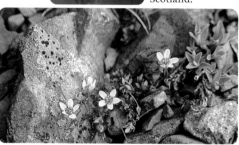

Alpine Pearlwort *Sagina saginoides* (Caryophyllaceae)
HEIGHT to 7cm
Tufted perennial whose long-awned leaves form a basal rosette. The flowers comprise white petals and similarly sized sepals and are borne on slender stalks (June–Sep). The species is rare in the Scottish Highlands and on Skye.

Alpine Milk-vetch *Astragalus alpinus* (Fabaceae)
HEIGHT to 15cm
Straggly, spreading perennial. The leaves comprise 7–15 pairs of leaflets and the flowers are pale mauve, in clustered heads on stalks (July–Aug). It is a rare plant found on mountains in central Scotland.

Yellow Oxytropis *Oxytropis campestris* (Fabaceae)
HEIGHT to 20cm
Perennial with silky hairs and leaves comprising 10–15 pairs of narrow leaflets. The flowers are yellow, in clustered, egg-shaped heads, 2–3cm long (June–July). A rare plant, restricted to mountains in central Scotland (photo right).

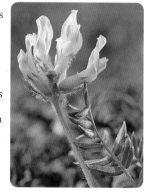

Alpine Fleabane *Erigeron borealis*
(Asteraceae) **HEIGHT** to 25cm
Rare plant of the E Highlands, with a basal rosette of hairy, lanceolate leaves and upright stems that carry solitary heads of pinkish-lilac ray florets and yellowish disc florets, 2cm across (July–Aug) (photo left).

One-flowered Wintergreen *Moneses uniflora*
(Pyrolaceae) HEIGHT to 20cm
An easily overlooked plant, growing as it does in the
dappled light of the woodland floor. The leaves are ovate
and the solitary flower is *white, 15–20mm across and
nodding*, with a projecting style (June–Aug). Found in
a few locations in ancient pine forests on the fringes
of the Scottish Highlands.

Blue Heath *Phyllodoce caerulea*
(Ericaceae) HEIGHT to 10cm
Low-growing, spreading shrub
with upright flowering stems.
The leaves are narrow, leathery
and Heather-like, while the
flowers are pinkish purple,
bell-shaped, pendulous and in
pairs (June–Aug). It grows on
acid soils in the Highlands.

Blue Heath

One-flowered Wintergreen

Rannoch-rush *Scheuchzeria
palustris* (Scheuchzeriaceae)
HEIGHT to 40cm
Upright perennial with narrow,
rush-like leaves and yellowish
flowers, 4–5mm across, in
terminal clusters (June–Aug).
As its name suggests, it is
restricted to Rannoch Moor.

Alpine Cat's-tail *Phleum
alpinum* HEIGHT to 40cm
A distinctive upland grass with
ovoid flower heads (July–Aug).
Restricted to a few base-rich
flushes on damp, rocky ground
and ledges in the central
Highlands.

Rannoch-rush

Alpine Cat's-tail

Two-flowered Rush *Juncus
biglumis* HEIGHT to 15cm
Has thread-like leaves and a
head comprising just two dark
brown flowers, one above the
other (June–July). Restricted
to a few sites on bare, base-rich
damp ground in mountains
in the west.

Iceland Purslane *Koenigia
islandica* HEIGHT to 10cm
A low-growing annual with
reddish stems and rounded,
opposite and reddish leaves.
Flowers are tiny and whitish.
A rare plant of bare, damp
ground in mountains of
Mull and Skye.

Two-flowered Rush

Iceland Purslane

SHETLAND AND ORKNEY ISLES

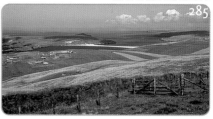

Renowned for their seabird colonies, these windswept islands – the most northerly in Britain – are also extremely botanically rich. An excellent network of ferries makes an island-hopping holiday straightforward. Meadows and grassy areas have been much less affected by the agricultural change that has blighted much of lowland Britain, and consequently during the summer months the islands' meadows boast an almost unbelievable diversity and abundance of flowering plants. While the southernmost Orkney island can be seen from mainland Scotland, Unst, the northernmost island in the Shetland archipelago, is about as close to Norway as it is to John o' Groats. It's hardly surprising then that the flora of many of the islands has an Arctic influence.

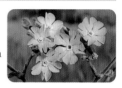

Shetland Red Campion *Silene dioica* ssp. *zetlandica*
(Caryophyllaceae) HEIGHT to 1m
Hard to miss if you visit Shetland in July and August – roadside verges and hay meadows are full of it. It is similar to Red Campion (*see* p.40) but the flowers are larger and a deeper pink. Some authorities do not recognise its subspecies status.

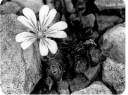

Holy-grass *Hierochloë odorata* (Poaceae) HEIGHT to 60cm
Rare, creeping and pleasantly *aromatic* perennial found in damp ground, often beside lakes, in a few spots in Shetland and Orkney. The leaves are bright green and the flowers comprise a pyramidal head of stalked, rounded to egg-shaped spikelets (June–July).

Oysterplant *Mertensia maritima*
(Boraginaceae) PROSTRATE
Spreading plant found on stony beaches, around the high-tide mark. Shetland and Orkney are the best British locations for the species and it is very locally common. It can be recognised by its fleshy, blue-green leaves and bell-shaped flowers that are pink in bud but soon turn blue (June–Aug).

Scottish Primrose *Primula scotica* (Primulaceae) HEIGHT to 10cm
A charming little plant that is very locally common in short, coastal turf on W Mainland, Orkney, it is also found, very locally, on the NE Scottish mainland but grows nowhere else in the world. The leaves form a basal rosette from which arises a stalk bearing a terminal head of purplish, yellow-centred flowers (May–June and Aug).

Arctic Eyebright *Euphorbia arctica* (Euphorbiaceae) HEIGHT to 35cm
Annual that is semi-parasitic on the roots of other plants. Eyebrights generally are very much a feature of Orkney and Shetland meadows. There is considerable variation to be found and authorities recognise a range of species, confusingly similar, to the untrained eye, to other eyebrights (*see* p.180), which are widespread elsewhere in Britain; of these, Arctic Eyebright has the showiest flowers (July–Sep).

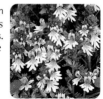

Shetland Mouse-ear *Cerastium nigrescens*
(Caryophyllaceae) HEIGHT to 6cm
Low-growing perennial, restricted to outcrops of Serpentine on Shetland, growing in crevices between shattered rock fragments. The leaves are purplish green and the white flowers are 15–17mm across (June–Aug).

IRELAND

Ireland is a botanically rich island that has many floral elements in common with England, Wales and Scotland, particularly the western half of those countries. However, subtle differences also exist, with species additions from south-west Europe (the so-called Lusitanian influence) as well as some plants, including Irish Lady's-tresses (*see* p.240), whose ranges continue in North America.

Irish Heath *Erica erigena* (Ericaceae) **HEIGHT** to 2m
Hairless shrub with leaves arranged in 4s. The flowers are pink, 5–7mm long, and similar to those of Cornish Heath (*see* p.272); they are borne in long spikes *in spring* (Mar–May), not late summer. The plant is very locally common in the west, growing on the drier margins of bogs. It grows nowhere else in our region.

Strawberry-tree *Arbutus unedo* (Ericaceae) **HEIGHT** to 12m
Evergreen shrub with elliptical, leathery leaves, and whitish, urn-shaped flowers (Sep–Dec). The fruits are reddish orange, warty and persisting. It is locally common in the south-west; its main range is SW Europe, and it grows nowhere else in our region as a native plant (photo right).

Cottonweed *Otanthus maritimus* (Asteraceae) **HEIGHT** to 50cm (photo left)
Distinctive perennial, the stems and leaves of which are coated in thick, white woolly hairs. The flower heads are yellow and terminal (Aug–Oct). It grows on stabilised shingle beaches and is now restricted to one location in the south-east.

Dense-flowered Orchid *Neotinea maculata* (Orchidaceae) **HEIGHT** to 30cm (photo right)
A stout little orchid with rather narrow leaves and a cylindrical head of flowers 2–6cm long (Apr–May). The individual flowers are pinkish white with a hood and the lower lip divided into 3 lobes. It grows on the Burren, in W Ireland, and also, very locally, on the Isle of Man.

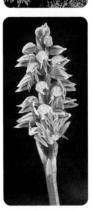

Pipewort *Eriocaulon aquaticum* (Eriocaulaceae) **AQUATIC** (photo left)
The narrow leaves are submerged but domed flower heads are borne on emergent stems, up to 60cm tall (July–Sep). It grows in peaty pools and lakes in the west, and also, very locally, in NW Scotland, but its main global range is North America.

Blue-eyed Grass *Sisyrinchium bermudianum* (Iridaceae) **HEIGHT** to 20cm (photo right)
Hairless perennial with flattened, winged stems and narrow, basal leaves. The flowers are blue and 15–20mm across; they are borne in small, terminal clusters (July–Aug). It grows in damp grassland and is native to N and W Ireland; elsewhere in our region it is naturalised.

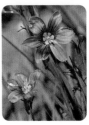

FURTHER READING AND USEFUL ORGANIZATIONS

FURTHER READING

British Wildlife. A magazine for the modern naturalist (6 issues per year). British Wildlife Publishing.

BSBI Handbooks. A series of identification guides to selected plant groups or families. Botanical Society of the British Isles.

Fitter, A. (1978). *An Atlas of the Wild Flowers of Britain and Northern Europe*. Collins.

Fitter, R., Fitter, A. and Blamey, M. (1974). *The Wild Flowers of Britain and Northern Europe*. Collins.

Fitter, R., Fitter, A. and Farrer, A. (1989). *Collins Guide to the Grasses, Sedges, Rushes and Ferns of Britain and Northern Europe*. Collins.

Garrard, I. and Streeter, D. (1983). *The Wild Flowers of the British Isles*. Macmillan London.

Gibbons, R. and Brough, P. (1992). *The Hamlyn Photographic Guide to the Wild Flowers of Britain and Northern Europe*. Hamlyn.

Preston, C.D., Pearman, D.A. and Dines, T.D. (2002). *New Atlas of the British and Irish Flora*. Oxford University Press.

Rose, F. (illustrated by Davis, R.B., Mason, L., Barber, N. and Derrick, J.) (1981). *The Wild Flower Key*. Warne.

Rose, F. (illustrated by Mason, L., Dalby, C. and Davis, R.B.) (1989). *Colour Identification Guide to the Grasses, Sedges, Rushes and Ferns of the British Isles and North-western Europe*. Viking.

Stace, C. (1997). *New Flora of the British Isles*, second edition. Cambridge University Press.

USEFUL ORGANISATIONS

Botanical Society of the British Isles (BSBI). www.bsbi.org.uk
Campaign to Protect Rural England (CPRE). www.cpre.org.uk
Countryside Council for Wales. www.ccw.gov.uk
English Nature. www.english-nature.org.uk
Joint Nature Conservation Committee. www.jncc.gov.uk
The National Trust. www.nationaltrust.org.uk
The National Trust for Scotland. www.nts.org.uk
Plantlife International. www.plantlife.org.uk
Scottish Natural Heritage. www.snh.org.uk
The Wildlife Trusts. www.wildlifetrusts.org
The Woodland Trust. www.woodland-trust.org.uk

INDEX

PICTURE CREDITS